D0468679

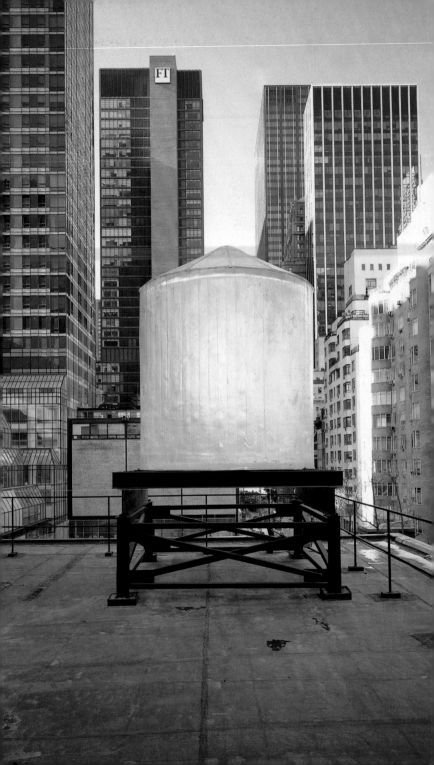

MoMA Highlights

350 Works from
The Museum of Modern Art, New York

The Museum of Modern Art, New York

Generous support for this publication is provided by the Research and Scholarly Publications Program of The Museum of Modern Art, which was initiated with the support of a grant from The Andrew W. Mellon Foundation. Publication is made possible by an endowment fund established by The Andrew W. Mellon Foundation, the Edward John Noble Foundation, Mr. and Mrs. Perry R. Bass, and the National Endowment for the Humanities' Challenge Grant Program.

Produced by the Department of Publications
The Museum of Modern Art, New York

Edited by Harriet Schoenholz Bee, Cassandra Heliczer, and Sarah McFadden
Designed by Katy Homans
Production by Matthew Pimm
Color separations by Evergreen Colour Separation (International) Co., Ltd., Hong Kong
Printed in China by OGI/1010 Printing International Ltd.

This book is typeset in Berthold Akzidenz Grotesk and Franklin Gothic. The paper is 95gsm Hi-Q Matt Art.

© 1999, 2004, 2013 The Museum of Modern Art, New York.
Third revised edition 2013, Third printing 2014

Library of Congress Control Number: 2012954960
ISBN: 978-0-87070-846-6

Published by The Museum of Modern Art
11 West 53 Street
New York, NY 10019-5497
www.moma.org

Distributed in the United States and Canada by ARTBOOK I D.A.P., New York
155 Sixth Avenue, 2nd floor, New York, NY 10013
www.artbook.com

Distributed outside the United States and Canada by Thames & Hudson Ltd
181A High Holborn, London WC1V 7QX
www.thamesandhudson.com

Cover: Andy Warhol. *Campbell's Soup Cans* (detail). 1962. See p. 234. Back cover: The Abby Aldrich Rockefeller Sculpture Garden, looking west from the MoMA lobby, with Hector Guimard's Entrance Gate to Paris Subway (Métropolitain) Station, c. 1900. See p. 27. Title spread (p. 2): Rachel Whiteread. *Water Tower*. 1998. See p. 334. P. 7: Vincent van Gogh. *The Starry Night* (detail). 1889. See p. 25. P. 9: Maya Deren. *Meshes of the Afternoon*. 1943. See p. 151.

Printed in China

Introduction

What is The Museum of Modern Art? At first glance, this seems like a relatively straightforward question. But the answer is neither simple nor straightforward, and any attempt to answer it almost immediately reveals a complex institution that, from its inception, has engendered a variety of meanings. For some, MoMA is a cherished place, a sanctuary in the heart of midtown Manhattan. For others, it is an idea represented by its collection and amplified by its exhibition program. For still others, it is a laboratory of learning, a place where the most challenging and difficult art of our time can be measured against the achievements of the immediate past.

MoMA is, of course, all of this and more. Yet, in 1929, its founders dreamed, and its friends, trustees, and staff have dreamed since, that its multiple meanings and potential would ultimately be resolved into some final, fully formed equilibrium.

In 1939, for instance, in the catalogue for the Museum's tenth anniversary exhibition, the Museum's president, A. Conger Goodyear, proudly proclaimed that the institution had finally reached maturity. As we now realize, despite the achievements of the Museum's initial years, he could not have anticipated the challenges to come. The Museum was still at the beginning of an adventure that continues to unfold more than half a century later. At the age of ten the Museum was (and at eight times ten moves onward as) an exploratory enterprise whose parameters and possibilities remain open.

From temporary quarters at 730 Fifth Avenue to its current building occupying most of a city block at 11 West 53rd Street, from a single curatorial department to seven (including the most recently established one, Media and Performance Art, founded in 2006), and from a program without a permanent collection to a collection of over 100,000 objects, MoMA has regularly grown, changed, and rethought itself. In doing so it has undergone seven major architectural expansions and renovations since the completion of its first building in 1939, with its most recent expansion, designed by the celebrated Japanese architect Yoshio Taniguchi, finished in late 2004. This virtually continuous process of physical growth reflects the institution's ongoing efforts to honor its own changing programmatic and intellectual needs by constantly adjusting, and frequently rethinking, the topography of its space. Each evolution has opened up the possibility for the institution's next iteration, creating a kind of permanent self-renewing debate within MoMA about both its future and its relationship to the past. With each change have come new expectations and challenges, and this is especially true today.

The Museum of Modern Art is predicated on a relatively simple proposition, that the art of our time—modern art—is as vital as the art of the past. A corollary of this proposition is that the aesthetic and intellectual interests that shape modern art can be seen in mediums as different as painting and sculpture, film, photography, media and performance, architecture and design, prints and illustrated books, and drawings—the Museum's current curatorial departments. From the outset, MoMA has been a laboratory for the study of the ways in which modernity has manifested itself in the visual arts.

There has been, of course, and there will continue to be, a great deal of debate over what is actually meant by the term "modern" in relation to art. Does it connote a moment in time? An idea? A particular set of values? Whatever definition is favored, it seems clear that any discussion of the concept must take into account the role MoMA has played in attempting to define, by its focus and the intellectual arguments of its staff, a canon of modern and contemporary art. These efforts at definition have often been controversial, as the Museum has sought to navigate between the interests of the avant-garde, which it seeks to promote, and the general public, which it seeks to serve.

The story of how MoMA came to be so intimately associated with the history of modern art forms a rich narrative that, over time, has acquired the potency of a founding myth. Like all such myths, it is part fiction and part truth, built upon the reality of the Museum's unparalleled collection. Various accounts—from Russell Lynes's 1937 book *Good Old Modern* to the Museum's own volume of 1984, *The Museum of Modern Art, New York: The History and the Collection*—give MoMA's story at length, and this is not the place to repeat or enlarge upon it. What is worth considering, however, is that over eighty years after the Museum first opened its doors, many of those associated with its beginnings—Abby Aldrich Rockefeller, a founding trustee; Alfred H. Barr, Jr., the first director; Philip Johnson, who established the architecture and design department; and Dorothy C. Miller, one of the Museum's first curators, to name only a few—remain vivid figures whose ideas and personalities continue to reverberate through the institution. This is true in part because there are still many people involved with the Museum who knew them, and have preserved and burnished their memories, but it is also because they are, or were, such fascinating figures, whose vision and drive gave birth to an institution that was the first, and rapidly became the foremost, museum of its kind in the world.

Given the resonance of this founding legacy, the challenge for MoMA today is to build upon this past without being delimited or constrained by it. This is by no means a simple task. To keep the Museum open to new ideas and possibilities also means reevaluating and changing its perception of its past. As the Museum has become increasingly established and respected, its sense of responsibility to its own prior achievements has grown. In many ways, it has become an agent implicated in the growth of the very tradition it seeks to explore and explicate: through its pioneering exhibitions, often based upon its permanent collection; its International Program, which has promoted modern art by circulating exhibitions around the world; and its acquisitions, publications, and public programs. Thus it must constantly seek an appropriate critical distance, one that allows it to observe as well as to be observed. While this distance may be impossible to achieve fully, the effort to do so has resulted in a commitment to an intense internal debate, and an openness to sharing ideas with the public in a quest to promote an ever deeper engagement with modern art for the largest possible audience.

Any understanding of MoMA must begin with the recognition that the very idea of a museum of modern art implies an institution that is forever willing to court risks and controversy. The challenge for the Museum is to periodically reinvent itself, to map new space,

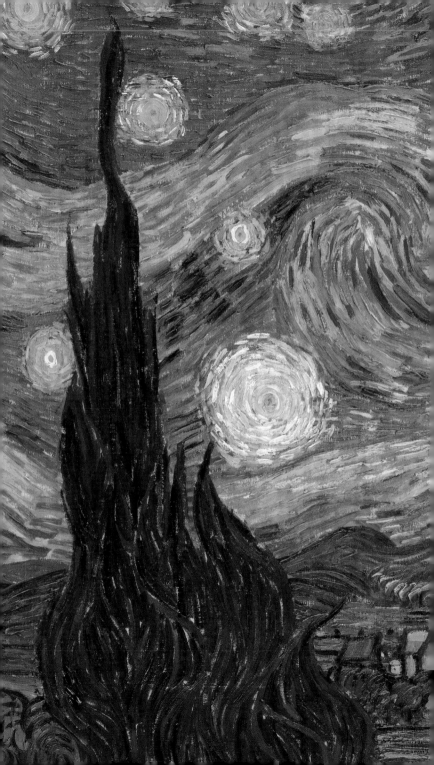

metaphorically as well as practically; to do this it must be its own severest critic. Programmed, therefore, into MoMA and its history—and by implication its future—are a series of contradictions and confliicts. Put differently, the Museum grew out of a disruption with the past, as it committed itself to artists and audiences who had previously been ignored or at best grudgingly recognized—and if it wishes to remain engaged with contemporary art, it must find ways to remain disruptive and open to new ideas and approaches. It was for this reason that the Museum merged in 2000 with P.S.1, a center for contemporary art in Long Island City, Queens, two subway stops from 53rd Street, that had championed emerging artists and had and continues to have a different audience from the Museum's. But to be disruptive means to live with fierce divisions, internal as well as external, over such diverse issues as, for example, the importance of abstract art, how to deal with the representation of alternative modernisms within the collection, and whether the Museum should continue to collect contemporary art. Rather than resolve such divisions, MoMA has had the strength to live with them. This has ensured that the Museum remains an extremely lively place, where issues and ideas are argued over with an often startling intellectual intensity.

Working within its current configuration of seven curatorial departments that collect, MoMA has built an unparalleled collection that now spans over 150 years, from the mid-nineteenth century to the present. Defined by their focus on different mediums, the curatorial departments reflect the Museum's interest in examining the various ways in which modern ideas and ideals have manifested themselves across disciplines. While the roles of the departments were initially relatively fluid, during the late 1960s and 1970s they became more codified, as each department became responsible for developing its collection independently of the other departments.

This approach has enabled MoMA to study and organize the vast array of art that it owns. It has led, as well, to the layout of the Museum's galleries in recent times by department. This fundamentally taxonomic approach has sometimes resulted in a relatively static reading of modern art, with a clearly defined set of physical and conceptual paths through the collection. Over the last fifteen years, however, the Museum has become increasingly aware of the importance of interdisciplinary approaches to the presentation of its collection. The division of the galleries into discrete departmental spaces is gradually being balanced by a more synthetic and inclusive reading of the collection that complicates, rather than simplifies, relationships among works of art.

The growth of the Museum's collection has been steady and sometimes dramatic. MoMA acquired its first works, including Aristide Maillol's sculpture *Ile de France*, in 1929, the year it was established. Only in 1931, however, after founding trustee Lillie P. Bliss bequeathed to the Museum a superb group of 116 paintings, prints, and drawings, including Paul Cézanne's *The Bather*, *Pines and Rocks*, and *Still Life with Apples*, and Paul Gauguin's *The Moon and the Earth*, did the collection really began to develop. By 1940, the Museum's collection had grown to 2,590 objects, including 519 drawings, 1,466 prints, 436 photographs, 169 paintings, and 1,700 films. Twenty years later the collection had expanded to over 12,000 objects, and by 1980 it exceeded 52,000. Today, the Museum

owns over 6,000 drawings, 50,000 prints and illustrated books, 25,000 photographs, 3,200 paintings and sculptures, 24,000 works of architecture and design, and 20,000 films, videos, and other media works.

Many of the most important works in the collection—including Pablo Picasso's *Demoiselles d'Avignon*, Henri Matisse's *Blue Window*, Vincent van Gogh's *Starry Night*, and Piet Mondrian's *Broadway Boogie Woogie*—entered it during and immediately after World War II. There were many reasons for this, among them the Nazis' selling of so-called degenerate art from state collections; the economic might of the United States, especially after the war's end; and the war-induced emigration of European artists and collectors to the United States and elsewhere. Having helped to introduce American audiences to avant-garde European art throughout the 1930s, MoMA became a haven for art, artists, and collectors—all victims of Nazi persecution.

Collections are complex entities that evolve in different ways. They are all the result, however, of discrete decisions made by individuals. In MoMA's case, these decisions rest with the director and chief curators. In addition, each curatorial department has a working committee, authorized by the Board of Trustees, to act on its behalf in the acquisition process. Since the development of the Museum's collection, like that of most museums, has occurred over time, each generation's choices are woven into the collection's fabric so that a continuous thread of ideas and interests emerges. The result reflects the unfolding pattern of the Museum's history in a collection that is nuanced, inflected, and altered by the tastes and ideas of individual directors and curators, and by the responses those tastes and ideas engender in

their successors as holes are filled in the collection and areas of overemphasis are modified.

The vast majority of the objects in MoMA's collection have been acquired as gifts and bequests, which are often the fruit of relationships nurtured through the years, from generous donors and friends. The Museum's trustees have played a particularly important role in this regard, and the recent bequests of Louise Reinhardt Smith and Florene May Schoenborn, and the gifts of David and Peggy Rockefeller, Philip Johnson, Elaine Dannheisser, Agnes Gund, Ronald S. Lauder, the Judith Rothschild Foundation, Gilbert and Lila Silverman, Herman and Nicole Daled, and the Woodner family are among the most recent examples of a tradition that includes such extraordinary bequests as those of Lillie P. Bliss, William S. Paley, and Gordon Bunshaft. In addition, major gifts from such close friends of the Museum as Sidney and Harriet Janis, Mary Sisler, Mr. and Mrs. John Hay Whitney, and many others have also strengthened the collection.

The Museum also purchases works of art, and it occasionally deaccessions an object in order to refine and enhance its collection. Perhaps the most celebrated instance of this was the sale of an Edgar Degas, along with several other works from the Lillie P. Bliss bequest, that enabled the Museum to acquire Picasso's *Demoiselles d'Avignon*, one of the most important paintings of the twentieth century and a cornerstone of the Museum's collection. Deaccessioning also permitted the Museum to acquire Van Gogh's *Portrait of Joseph Roulin*, in 1989; Gerhard Richter's celebrated fifteen-work group *October 18, 1977*, in 1995; and Jasper Johns's *Diver*, in 2003, among other important works.

The principal reason the Museum has the most comprehensive collection of modern art in the world is that from the outset it has accepted only unconditional gifts, with very few exceptions. This has allowed it periodically to reassess the relative importance of any work of art in its collection, but the price has been that of occasionally seeing artworks go to other institutions (such as the Walter and Louise Arensberg Collection, which went to the Philadelphia Museum of Art when MoMA was unable to accept the conditions imposed by the donors). Nevertheless, the policy has also given MoMA the ability to reconsider and revise its collection, allowing it to exist in what Barr would have called a metabolic state of self-renewal. An additional consequence of the Museum's policy on gifts is that the institution has been free to integrate works into its collection in an unrestricted way, permitting the development of a coherent, relatively unencumbered presentation of its collection, confined only by the limitations of its space.

Given that great collections are inevitably mosaics that shift and change over time, the cumulative results of individual tastes and idiosyncrasies and of the vagaries of historical opportunities, it is through the ordering and presentation of their collections that museums encode their ideas and narratives. This is especially true in MoMA's case, as the collection is the principal means by which it argues for its reading of modern art. Thus the publication of this third edition of *MoMA Highlights* celebrates the richness of the Museum's collection and the variety of issues and ideas embraced here. The book is not meant to be comprehensive, nor to provide a definitive statement on the Museum's collection. On the contrary, it is intended to be provocative, one of

many such publications to come designed to explore the complexity and variety of possibilities that exist within the collection, and to suggest new and imaginative ways of understanding the different works of art that constitute it. Organized in a general but not rigid chronological order, the book endeavors to juxtapose works from different parts of the collection in surprising, revealing, and sometimes arbitrary ways. Compare, for example, Pierre Bonnard's *The Bathroom* and Picasso's *Girl before a Mirror*, both painted in 1932. Each, in a very different way, explores questions of intimacy and introspection, Bonnard by examining his wife as she dries herself off after a bath, Picasso by studying his mistress Marie-Thérèse Walter as she contemplates herself in a mirror. Bonnard, known for his optical acuity and coloristic effects, reveals himself here to be a master of subtle psychological probing, while Picasso uses his prodigious talent to examine the complex boundary between mystery and Eros, developing a rich and powerful image built of flat, bold colors surrounded by thick black contours that give his painting an almost iconic quality. Another pairing, Sven Wingquist's *Self-Aligning Ball Bearing* of 1907 and Stuart Davis's *Odol* of 1924, examines the rising impact of industrial design and consumerist society. Not every juxtaposition is meant to be read as a comparison or confrontation—some are simply the result of two interesting works of art brought together for consideration on facing pages. In preparing this volume, we have tried to demonstrate that MoMA's collection is the result of both considered, careful research and fortuitous opportunities that have allowed us to assemble often disparate works of art in new and intriguing relationships.

Modern art began as a great experiment, and it continues to be one today. Much of the Museum's early effort was given over to trying to make order out of the seemingly confused, even at times baffling nature of this art. While these efforts helped to explain the complicated relationships among different movements and counter-movements (such as Cubism, Suprematism, Dada, Conceptual art, and Minimalism, to name a few), they also, inadvertently, tended to simplify and reconcile competing and contradictory ideas. The positivist assertion of the first decades of the Museum's existence—that modern art formed a single coherent narrative that could be reflected in the Museum's galleries—needs to be tempered by the recognition that the very ideas of modern and contemporary art imply the possibility of multiple, even contradictory narratives. To a large degree, of course, the Museum's founders were aware of the richness of this tradition, and their pioneering efforts initially embraced a broad range of interests, including tribal, naïve, and folk art. But the relatively limited space of the galleries and their linear configuration, compounded by their dramatic growth, inevitably led to a reductivist approach.

Today, contemporary artists challenge us in many of the same ways that artists of the avant-garde of forty years ago (many of whom are now regarded as modern masters) challenged viewers of their day. That we have come to accept the achievements of Picasso and Matisse, Mondrian and Jackson Pollock, does not necessarily mean that their work is either fully understood or that this acceptance is universal. For The Museum of Modern Art, this means that its collection must be a laboratory where the public can explore the relationship between contemporary art and the art of the immediate past, in an ongoing effort to continue to define modern art. By locating objects and people in time as well as space, the Museum is constantly mapping relationships between works of art and their viewers, so that the space of the Museum becomes a site of narration where many individual stories can be developed and realized. This process of experimentation and narration also allows us to create a dialogue between artists (and ideas) of the first years of the twentieth century and those of the century's final years. To do this successfully, the Museum is committed to developing new ways of understanding and presenting its collection. The first edition of this handbook, with its multidisciplinary approach, was one of the first steps in this process. Another was the Museum's year-long project of three cycles of exhibitions presented in celebration of the millennium, from fall 1999 through early 2001, which examined its permanent collection in new ways that parallel many of the themes developed in this volume. The opening of the new MoMA in November 2004, with its expanded galleries and layout, continues this process of exploring the richness and complexity of the Museum's diverse holdings.

While this process of reconsidering modern and contemporary art was given new impetus with the completion of the Museum's new building and the merger with P.S.1 (renamed MoMA PS1 in 2010), it is an ongoing exercise. This edition of highlights of the Museum's collection, featuring over 100 works not included in the earlier editions, may thus be taken as yet another chapter in that story and as both a record of the Museum's past and a statement in anticipation of an exciting future.

—**Glenn D. Lowry, Director**

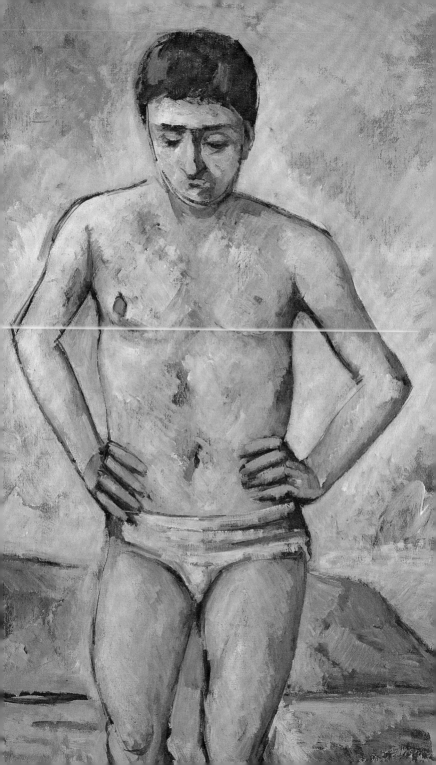

Paul Cézanne French, 1839–1906

The Bather. c. 1885

Oil on canvas, 50 × 38⅛" (127 × 96.8 cm)
Lillie P. Bliss Collection

The Bather is one of Cézanne's most evocative paintings of the figure, although the unmuscled torso and arms have no heroic pretensions, and the drawing, in traditional, nineteenth-century terms, is awkward and imprecise. The bather's left, forward leg is placed firmly on the ground, but his right leg trails and carries no weight. The right side of his body is pulled higher than the left, the chin curves lopsidedly, and the right arm is elongated and oblique. The landscape is as bare as a desert, but its green, violet, and rose coloration refuses that name. Its dreaming expanse matches the bather's pensiveness. Likewise, the shadows on the body, rather than shifting to black, share the colors of the air, land, and water; and the brushwork throughout is a network of hatch marks and dapples, restless yet extraordinarily refined. The figure moves toward us but does not meet our gaze.

These disturbances can be characterized as modern: they indicate that while Cézanne had an acute respect for much of traditional art, he did not represent the male nude the way the classical and Renaissance artists had done. He wanted to make an art that was "solid and durable like the art of the museums" but that also reflected a modern sensibility incorporating the new understanding of vision and light developed by the Impressionists. He wanted to make an art of his own time that rivaled the traditions of the past.

William Henry Fox Talbot British, 1800–1877

Lace. 1845

Salted paper print, 6½ × 8¾" (16.5 × 22.3 cm)
Acquired through the generosity of Dr. Stefan Stein

To make this picture, Talbot laid a piece of lace on chemically sensitized paper and allowed the light of the sun gradually to fix its negative image precisely, down to the smallest fold or imperfection. This simple operation had never been possible before photography was invented.

The invention was made public in January 1839, when France announced the daguerreotype as its gift to the world. Talbot, who independently had invented another form of photography several years earlier, then quickly stated his own claim. His process, in which any number of positive paper prints could be made from a single negative, soon triumphed over the daguerreotype process, which produced unique pictures on metal.

Talbot's *Lace* is not merely a copy of unprecedented ease and fidelity. It is also a picture, which transposed the lace from the realm of objects to the realm of pictures, where it has enjoyed a new and unpredictable life.

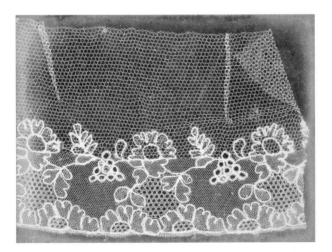

Paul Signac French, 1863–1935

Opus 217. Sur l'émail d'un fond rhythmique des mesures et d'angles, de tons et des teintes, portrait de M. Félix Fénéon en 1890 (Opus 217. Against the Enamel of a Background Rhythmic with Beats and Angles, Tones and Tints, Portrait of Mr. Félix Fénéon in 1890). 1890

Oil on canvas, 29 × 36½" (73.5 × 92.5 cm)
Fractional gift of Mr. and Mrs. David Rockefeller

Félix Fénéon was an editor, translator, art dealer, anarchist activist, and the critic who coined the term "Neo-Impressionism" to describe the works of Signac and Georges Seurat in the late 1880s. In this portrait, Signac depicts Fénéon in left profile. The lines of the subject's nose, elbow, and cane descend in a zigzag pattern, like the "rhythmic beats and angles" of the title, and the flower that he holds rhymes with the upturned curl of his goatee. Attention to abstract patterns continues in the kaleidoscopic pin-wheel of the backdrop, likely an allusion to the aesthetic theory of Charles Henry, whose books on color theory and the "algebra" of visual rhythm Signac had recently illustrated.

Fénéon's relation to the decorative background may be symbolic. In 1887 he had defended the Neo-Impressionists against criticism that their application of paint in uniform dots resembled mosaics or tapestries. "Take a few steps back," Fénéon urged, and "the technique . . . vanishes; the eye is no longer attracted by anything but that which is essentially painting." But what was painting's essence at that historical moment? Was it a means of relaying nature's ephemeral bloom to the viewer, or the craft of composing paint on canvas? In this portrait, the answer is both, and neither. As Fénéon saw it, painting was the creation of a superior and purified reality transfused with the artist's personality.

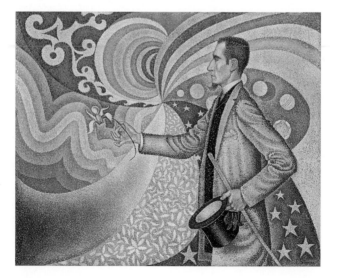

Christopher Dresser British, 1834–1904

Claret Pitcher. c. 1880

Glass, silver plate, and ebony, 16⅝ ×
9¹⁵⁄₁₆ × 4" (42.2 × 25.2 × 10.2 cm)
Gift of Blanchette Hooker Rockefeller

The simple geometry of this elongated claret pitcher is characteristic of Dresser's designs, which stand in stark contrast to the heavily ornamented styles of his time. Dresser had studied Japanese decorative arts, which influenced his own designs and those of his more progressive contemporaries. In this pitcher, the long, vertical ebony handle is almost a direct quotation of the bamboo handles on Japanese vessels. As in many of his designs for metalwork, the fittings on the claret pitcher are made from electroplated metal, a technological innovation that made silverware available to a growing middle class before the turn of the century. The exposed rivets and joints presage the enthusiasm for the machine aesthetic in industrial design of several decades later.

A trained botanist as well as a designer, Dresser was strongly inspired by the underlying structures of natural forms and by his interest in technological progress. While he shared some of the theories of the English Arts and Crafts movement, which sought to replace the often shoddy design of mass-produced goods with skilled handcraftsmanship, Dresser was completely committed to quality design for machine production, and was one of the world's first industrial designers.

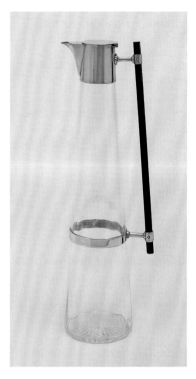

Carleton Watkins American, 1829–1916

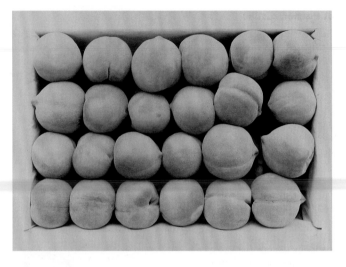

Late George Cling Peaches. 1889

Albumen silver print, 12¹⁵⁄₁₆ × 19¹³⁄₁₆"
(32.8 × 50.3 cm)
Acquired through the generosity of Jon L.
Stryker

Carleton Watkins was a great artist,
but he was a terrible businessman.
In 1875 he lost his San Francisco stu-
dio and his entire stock of negatives to
creditors. As a result of this loss he
was actively soliciting commissions
when he might otherwise have relied on
income from printing existing negatives.

One of Watkins's best clients hired
him to conduct a visual inventory of his
vast property near Bakersfield in Kern
County, California, to entice people to
buy land and settle there. Watkins
obliged by exposing at least 700 8-by-
10-inch glass plate negatives, along
with numerous "mammoth" plates, of
which this is undeniably his finest.

On a printed label beneath the pho-
tograph are two statements: one by
the property owner, attesting to the fer-
tility of the land; another by the Kern

County Board of Trade, certifying that
the owner's statement is true.
Photography's usefulness as evidence
was established with its invention in
1839, and its fictive possibilities began
to be exploited not long after that (thus
the need for Kern County's certificate).

Late George Cling Peaches distills
space in a strikingly modern way,
decades before such disturbances
became commonplace; the void on the
right-hand side of the image, created
by disrupting two points of contact
between these fuzzy fruits, animates
the eye's path with the metaphorical
potential of impenetrable depth.

Edwin S. Porter American, 1870–1941

The Great Train Robbery. 1903

35mm film, black and white with color tinting, silent, 11 minutes (approx.)
Preserved with funding from the Celeste Bartos Film Preservation Fund, the National Endowment for the Arts, and The Film Foundation

The Great Train Robbery is not the earliest film in which the former showman and film exhibitor, Porter, told a story through the editing together of images in sequence, nor is it the first Western. Nevertheless, it is a milestone in American film history for combining these two elements into what was, for 1903, an exceptionally long film at eleven minutes and one that captured the imagination of the moviegoing public worldwide. In the film, bandits hold up a train and rob passengers. After an escape and chase on horseback, the bandits are caught. The outlaw fires at the viewers as if they are the passengers, in an extra shot that, Porter noted, could be shown at the beginning or the end of the film.

With *The Great Train Robbery* Porter pulled the American film business out of its early doldrums, using cameras mounted on moving trains, special optical effects, hand-colored images of gunshots and explosions, and trick photography—all to tell a story drawn blatantly from the popular dime novels of the day.

Porter had begun his career at the turn of the century as a designer and builder of cameras for the Edison Company factory in West Orange, New Jersey, and eventually became a cameraman and director in charge of all work turned out by the Edison Studio in New York City. This is his best-known film.

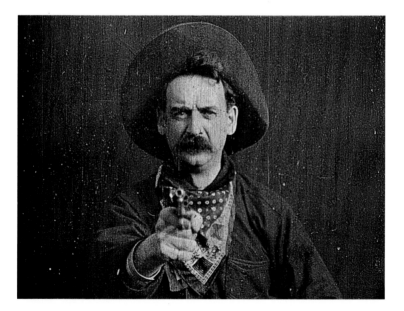

Auguste Rodin French, 1840–1917

Monument to Balzac. 1898

Bronze (cast 1954), 9' 3" × 48¼" × 41"
(282 × 122.5 × 104.2 cm)
Presented in memory of Curt Valentin by
his friends

Commissioned to honor one of France's
greatest novelists, Rodin spent seven
years preparing for *Monument to
Balzac*, studying the writer's life and
work, posing models who resembled
him, and ordering clothes to his mea-
surements. Ultimately, though, Rodin's
aim was less Honoré de Balzac's physi-
cal likeness than an idea or spirit of
the man, and a sense of his creative
vitality: "I think of his intense labor,
of the difficulty of his life, of his inces-
sant battles and of his great courage.
I would express all that."

Several studies for the work are
nudes, but Rodin finally clothed the fig-
ure in a robe inspired by the dressing
gown that Balzac often wore when writ-
ing at night. The effect is to make the
figure a monolith, a single, phallic,
upward-thrusting form crowned by the
craggy ridges and cavities that define
the head and face. *Monument to
Balzac* is a visual metaphor for the
author's energy and genius, yet when
the plaster original was exhibited in
Paris in 1898, it was widely attacked.
Critics likened it to a sack of coal, a
snowman, a seal, and the literary soci-
ety that had commissioned the work
dismissed it as a "crude sketch." Rodin
retired the plaster model to his home
in the Paris suburbs. It was not cast in
bronze until years after his death.

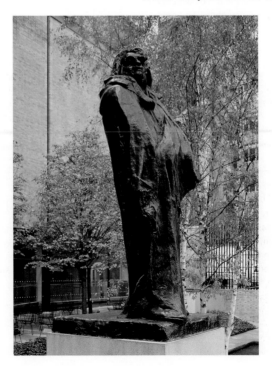

Édouard Vuillard French, 1868–1940

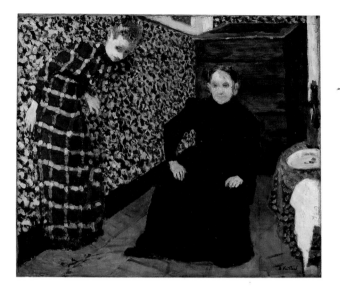

Interior, Mother and Sister of the Artist. c. 1893

Oil on canvas, 18¼ × 22¼" (46.3 × 56.5 cm)
Gift of Mrs. Saidie A. May

In this painting, Vuillard's mother and sister are depicted at home. A widow who had supported her family by running her own business, his mother commands a powerful presence. Her pose is solid and stable, her dress is the painting's largest unbroken form, and her face and hands stand out against browns and blacks, and against the extraordinary trapezoid of mottled color that describes the room's wallpaper. Her daughter, by contrast, almost disintegrates into this surface, as if its dots had temporarily organized themselves into the checkered pattern of her dress. Pressing herself awkwardly against the wall, she bends her head and shoulders, apparently greeting a visitor but also, it seems, forced to bow if she is to fit in the picture's frame.

Intimate in scale, this scene is deceptively casual. Relying on imaginative insight as well as on the direct observation prized by the Impressionists, Vuillard constructs a psychologically suggestive space: the table, the bulky chest of drawers, the overactive wallpaper, and the steeply rising perspective of the floor make a crowded container for the figures. The claustrophobia this suggests is heightened by converging angles, an imperfectly centered composition, and the daughter's off-balance posture. The whole space seems apt to fall inward at Mme Vuillard, a dominating, even oppressive presence in the room (and, we suspect, in the family); she is also the gravitational principle that prevents a collapse.

Paul Gauguin French, 1848–1903

The Seed of the Areoi (Te aa no areois). 1892

Oil on burlap, 36¼ × 28⅜" (92.1 × 72.1 cm)
The William S. Paley Collection

The Polynesian goddess sits on a blue-and-white cloth. Gauguin's style fuses various non-European sources: ancient Egyptian (in the hieratic pose), Japanese (in the relative absence of shadow and modeling, and in the areas of flat color), and Javanese (in the position of the arms, influenced by a relief in the temple of Borobudur). But there are also signs of the West, specifically through aspects of the pose derived from a work by the French Symbolist painter Pierre Puvis de Chavannes. The color, too, is eclectic: although Gauguin claimed to have found his palette in the Tahitian landscape, the exquisite chromatic chords in *The Seed of the Areoi* owe more to his aesthetic invention than to the island's visual realities.

In the origin myth of the Areoi, a Polynesian secret society, a male sun god mates with the most beautiful of all women, Vaïraümati, to found a new race. By painting his Tahitian mistress Tehura as Vaïraümati, Gauguin implied a continuity between the island's past and its life during his own stay there. In fact, Tahiti had been profoundly altered by colonialism (the Areoi society itself had disappeared), but Gauguin's anachronistic vision of the place gave him an ideal model for his painting. This vision was particularly powerful for him in its contrast with the West, which, he believed, had fallen into "a state of decay."

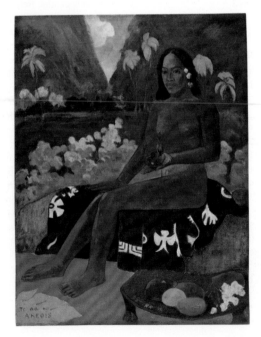

Henri Rousseau French, 1844–1910

The Sleeping Gypsy. 1897

Oil on canvas, 51" × 6' 7" (129.5 ×
200.7 cm)
Gift of Mrs. Simon Guggenheim

As a musician, the gypsy in this paint-
ing is an artist; as a traveler, she has
no clear social place. Lost in the self-
absorption that is deep, dreaming
sleep, she is dangerously vulnerable—
yet the lion is calmed and entranced.

The Sleeping Gypsy is formally
exacting—its contours precise, its color
crystalline, its lines, surfaces, and
accents carefully rhymed. Rousseau
plays delicately with light on the lion's
body. A letter of his describes the
painting's subject: "A wandering
Negress, a mandolin player, lies with
her jar beside her (a vase with drinking
water), overcome by fatigue in a deep
sleep. A lion chances to pass by, picks
up her scent yet does not devour her.
There is a moonlight effect, very
poetic. The scene is set in a com-
pletely arid desert. The gypsy is
dressed in oriental costume."

A sometime *douanier* (toll collector)
for the city of Paris, Rousseau was
a self-taught painter whose work
seemed entirely unsophisticated to
most of its early viewers. Much in his
art, however, found modernist echoes:
the flattened shapes and perspectives,
the freedom of color and style, the sub-
ordination of realistic description to
imagination and invention. As a conse-
quence, critics and artists appreciated
Rousseau long before the general
public did.

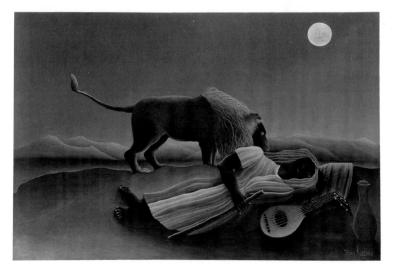

Georges-Pierre Seurat French, 1859–1891

Evening, Honfleur. 1886

Oil on canvas, 25¾ × 32" (65.4 × 81.1 cm)
Gift of Mrs. David M. Levy

Seurat spent the summer of 1886 in the resort town of Honfleur, on the northern French coast, a region of turbulent seas and rugged shorelines to which artists had long been attracted. But Seurat's evening scene is hushed and still. Vast sky and tranquil sea bring a sense of spacious light to the picture, yet also have a peculiar visual density. Long lines of cloud echo the breakwaters on the beach—signs of human life and order.

Seurat had used his readings of optical theory to develop a systematic technique, known as pointillism, that involved the creation of form out of small dots of pure color. In the viewer's eye, these dots can both coalesce into shapes and remain separate particles, generating a magical shimmer. A contemporary critic described the light in *Evening, Honfleur* and related works as a "gray dust," as if the transparency of the sky were filled with, or even constituted by, barely visible matter—a sensitive response to the paint's movement between illusion and material substance, as the dots both merge to describe the scene and break into grains of pigment.

Seurat painted a frame around the scene, buffering a transition between the world of the painting and reality. At the upper right, the dots on the frame grow lighter, lengthening the rays of the setting sun.

Vincent van Gogh Dutch, 1853–1890

The Starry Night. 1889

Oil on canvas, 29 × 36¼" (73.7 × 92.1 cm)
Acquired through the Lillie P. Bliss Bequest

Van Gogh's night sky is a field of roiling energy. Below the exploding stars, the village is a place of quiet order. Connecting earth and sky is the flame-like cypress, a tree traditionally associated with graveyards and mourning. But death was not ominous for van Gogh. "Looking at the stars always makes me dream," he said. "Why, I ask myself, shouldn't the shining dots of the sky be as accessible as the black dots on the map of France? Just as we take the train to get to Tarascon or Rouen, we take death to reach a star."

The artist wrote of his experience to his brother Theo: "This morning I saw the country from my window a long time before sunrise, with nothing but the morning star, which looked very big." This morning star, or Venus, may be the large white star just left of center in *The Starry Night*. The hamlet, on the other hand, is invented, and the church spire evokes van Gogh's native land, the Netherlands. The painting, like its daytime companion, *The Olive Trees*, is rooted in imagination and memory. Leaving behind the Impressionist doctrine of truth to nature in favor of restless feeling and intense color, as in this highly charged picture, van Gogh made his work a touchstone for all subsequent Expressionist painting.

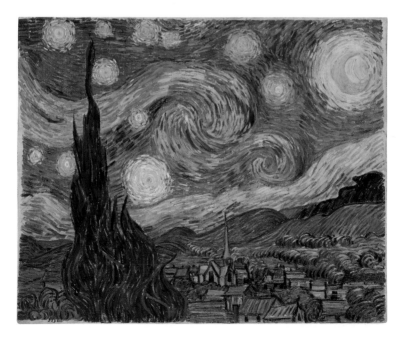

Alfred Roller
Austrian, born Moravia (now Czech Republic). 1864–1935

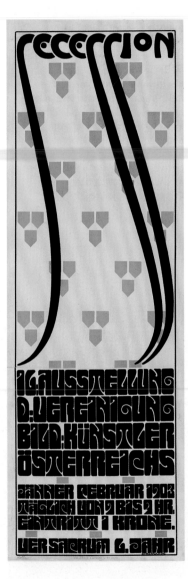

Poster for the 16th Secession exhibition. 1902

Color lithograph
37⅜ × 12⅝" (95 × 32 cm)
Gift of Jo Carole and Ronald S. Lauder

A founding member of the Vienna Secession and the group's president in 1902, Roller created several iconic posters for the 16th Secession exhibition of 1903, all distinguished by their typographic innovation and striking use of color and ornament. In this one, the composition is dominated by the word "Secession," with its sinuous trailing letters that both emphasize the vertical format and set up a rhythmic tension against the repeating pattern in the background. Tendril forms such as these had become a favored ornamental motif for Art Nouveau designers across Europe.

In contrast to the title's graphic linearity and open spacing, the exhibition details are presented with boldly stylized, dense lettering inside a chunky rectangular block. The combination of soft pink on a white ground with a bold black overlay is unexpected, one of many contrasts played out in the composition between constraint and freedom, sensuality and order, femininity and masculinity, and between the fluidity of modern life and echoes of a heraldic past. The motif of three abstract shields in the background symbolizes the three so-called "sister arts" (painting, architecture, and sculpture), which the Viennese Secessionists were keen to unite. Roller himself had studied architecture and painting at the Vienna Academy of Fine Arts and combined these different art forms in his work for the Vienna State Opera.

Hector Guimard
French, 1867–1942

Entrance Gate to Paris Subway (Métropolitain) Station. c. 1900

Painted cast iron, glazed lava, and glass,
13' 11" × 17' 10" × 32" (424 × 544 × 81 cm)
Gift of Régie Autonome des Transports
Parisiens

The emergence of the Art Nouveau style toward the end of the nineteenth century resulted from a search for a new aesthetic that was not based on historical or classical models. The sinuous, organic lines of Guimard's design and the stylized, giant stalks drooping under the weight of what seem to be swollen tropical flowers, but are actually amber glass lamps, make this a quintessentially Art Nouveau piece. Guimard's designs for this famous entrance arch and two others were intended to visually enhance the experience of underground travel on the new subway system for Paris.

Paris was not the first city to implement an underground system (London already had one), but the approaching Paris Exposition of 1900 accelerated the need for an efficient and attractive means of mass transportation. Although Guimard never formally entered the competition launched in 1898 by the Compagnie du Métropolitain for the design of the system's entrance gates, he won the commission with his avant-garde schemes, all using standardized cast-iron components to facilitate manufacture, transport, and assembly.

While Parisians were at first hesitant in their response to Guimard's use of an unfamiliar vocabulary associated with the luxury market, the Métro gates, installed throughout the city, effectively brought the Art Nouveau style into the realm of popular culture.

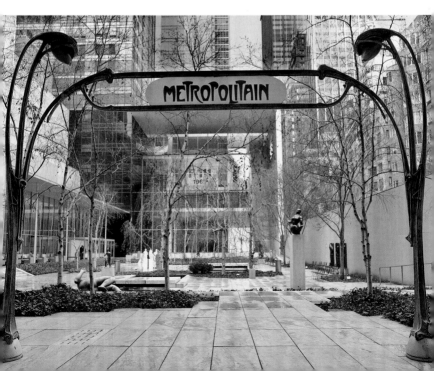

Louis Lumière French, 1864–1948

Repas de bébé (Feeding the Baby). 1895

35mm film, black and white, silent,
45 seconds (approx.)
Acquired from the LeRoy Collection
*Auguste Lumière, Mrs. Auguste Lumière,
and their daughter*

Feeding the Baby is one of the films
that mark the official birth of cinema
as a theater-going experience. It was on
the program of short films that Lumière
and his brother Auguste projected
on December 28, 1895 for a paying
audience at the Grand Café on the
Boulevard des Capucines in Paris.
Filmed by Louis and less than a minute
long, *Feeding the Baby* shows Auguste
and his wife having a meal with their
child. While presented as a documen-
tary, the film shows a domestic scene
arranged for the camera; as such, it
falls somewhere between the Lumières'
usual strict recordings of actual events
and their staged comedies.

The Lumière brothers were already
well-established photographers and
manufacturers of photographic equip-
ment when, in 1894, they witnessed
a demonstration of Thomas Edison's
Kinetoscope in Paris. The American
invention was a peepshow device,
accommodating only one viewer at a
time. The Lumières quickly set out to
create a combination camera and pro-
jector. Their new, simplified, and porta-
ble apparatus, which they called the
Cinématographe, was the leap of tech-
nical imagination needed for a cine-
matic culture to emerge from Edison's
novelty.

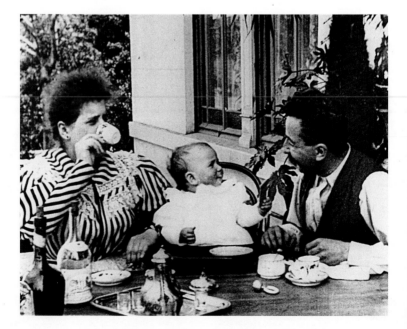

James Ensor Belgian, 1860–1949

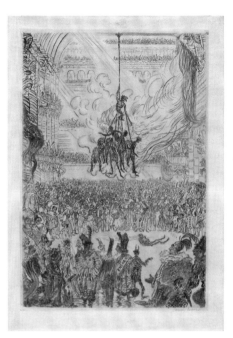

Hop-Frog's Revenge. 1898

Etching and drypoint with colored pencil and
watercolor additions, plate: 13¾ × 9⅝"
(35 × 24.5 cm)
Publisher: the artist, Ostend, Belgium
Edition: one of approximately 20 hand-colored
impressions
The Sue and Edgar Wachenheim III Endowment for Prints and Illustrated Books

The bizarre scene in this meticulously crafted etching is based on a short story written in 1845 by Edgar Allan Poe, one of Ensor's favorite authors. The story recounts the revenge of a court jester, a crippled dwarf named Hop-Frog, against an unjust king and his seven corrupt ministers. On the occasion of a masquerade ball, Hop-Frog persuades the king, who loves practical jokes, to play a trick on his guests by disguising himself and his ministers as orangutans. Ensor has pictured the story's final scene, in which Hop-Frog arranges to have the ministers and the king chained together in a ring, hooked up to a chandelier and hoisted above the party. Hop-Frog then uses a torch to set the eight on fire, in full view of the horrified crowd.

The theme of class injustice that Ensor treats here is one that resonates in many of his paintings and prints. His use of grotesque allegory was meant to satirize the social and political foibles of his day. As a printmaker, Ensor worked mainly in etching, a technique well suited to his penchant for fine linear detail. Occasionally, as here, he hand-colored his etchings, not only to embellish the image but also to clarify its structure and enhance the legibility of the narrative.

Henri de Toulouse-Lautrec French, 1864–1901

Divan Japonais. 1893

Lithographed poster, comp.: 31⅝ × 23⅞"
(80.3 × 60.7 cm)
Publisher: Édouard Fournier, Paris
Abby Aldrich Rockefeller Fund

The Divan Japonais, a cabaret in
Montmartre, an artists' quarter in
Paris, was newly redecorated in 1893
with fashionable Japanese motifs and
lanterns. Its owner, Édouard Fournier,
commissioned this poster—depicting
singers, dancers, and patrons—from
Toulouse-Lautrec to attract customers
to the opening of his nightclub. In
the immediate foreground, Toulouse-
Lautrec depicts two of his good friends
in the audience: on the right, Édouard
Dujardin, an art critic and founder of
the literary journal *Revue wagnérienne,*
and, at the center, the famous cancan
dancer Jane Avril, whose elegant black

silhouette dominates the scene. In
the background, another well-known
entertainer of the period, the singer
Yvette Guilbert, performs on stage.
Although her head is abruptly cropped
in this composition—reflecting the
influence of photography and Japanese
prints—Guilbert was immediately
known to contemporary patrons by the
dramatic gesture of her signature long
black gloves.

Lithographed posters proliferated
during the 1890s due to technical
advances in color printing and the relax-
ation of laws restricting the placement
of posters. Dance halls, *café-concerts,*
and festive street life invigorated night-
time activities. Toulouse-Lautrec's
brilliant posters, made as advertise-
ments, captured the vibrant appeal of
the prosperous Belle Époque.

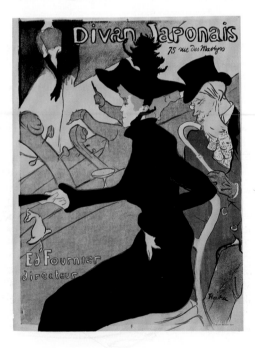

Hilaire-Germain-Edgar Degas French, 1834–1917

At the Milliner's. c. 1882

Pastel on paper mounted on board,
27⅝ × 27¾" (70.2 × 70.5 cm)
Gift of Mrs. David M. Levy

This cameo of nineteenth-century life maintains its intimacy through Degas's use of pastel, whose chalky texture quiets the scene in multiple veils of color. Pastel, an important drawing medium at the end of the nineteenth century due in part to a new preoccupation with color, appropriately expresses, through its inherent fragility, the ephemeral encounter between two women of different milieus that lies at the heart of Degas's composition.

Degas often accompanied his female friends to the dressmaker's and the milliner's. Here, one of them, the American artist Mary Cassatt, serves as the model and tries on hats while an attendant waits expectantly behind her. Cassatt's expression of contented self-assurance contrasts sharply with the apprehensive posture of the shopgirl, a figure obscured by cropping and the lack of delineation of her facial features.

In this daring, nuanced composition about modern life—the subject is the fleeting encounter rather than the women themselves—Degas heeded the advice of the critic Edmond Duranty. In his 1876 pamphlet *The New Painting*, about the art that came to be known as Impressionism, Duranty wrote: "Let us take leave of the stylized human body, which is treated like a vase. What we need is the characteristic modern person in his clothes, in the midst of his social surroundings, at home or out in the street."

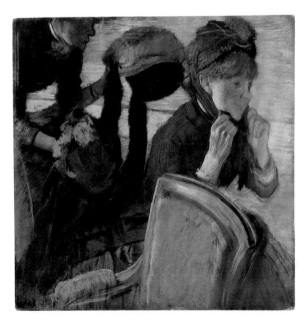

Edvard Munch Norwegian, 1863–1944

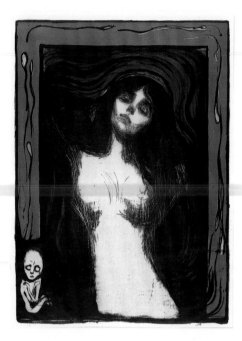

Madonna. 1895–1902

Lithograph and woodcut, comp.: 23¾ × 17½"
(60.5 × 44.5 cm)
Publisher: the artist. Edition: approx. 150
The William B. Jaffe and Evelyn A. J. Hall
Collection

Alluring and inviting, disturbing and
threatening, Munch's *Madonna* is
above all mysterious. This erotic nude
appears to float in a dreamlike space,
with swirling strokes of deep black
almost enveloping her. An odd-looking,
small fetuslike figure or just-born
infant hovers at the lower left with
crossed skeletal arms and huge fright-
ened eyes. Forms resembling sperm
pervade the surrounding border of this
print. Little about the *Madonna* seems
to conform to her holy title, save for a
narrow dark gold band atop her head.
This haunting apparition reflects
Munch's alliance with Symbolist artists
and writers.

Woman, in varying roles from
mother-protector to sexual partner to
devouring vampire and harbinger of
death, serves as the chief protagonist
in a series of paintings and correspond-
ing prints about love, anxiety, and death
that Munch grouped together under
enigmatic headings. *Madonna* was
first executed as a black-and-white
lithograph in 1895. During the next
seven years, Munch hand-colored sev-
eral impressions. Finally, the image
was revised in 1902, using additional
lithographic stones for color and a
woodblock for the textured blue sky.
Self-trained in printmaking, Munch often
used its mediums in experimental
ways, such as the unusual composition
of woodcut and lithography seen here.

Emil Nolde German, 1867–1956

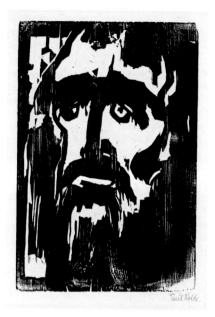

Prophet. 1912

Woodcut, comp.: 12⅝ × 8¾" (32.1 × 22.2 cm)
Publisher: the artist. Edition: 20–30
Given anonymously (by exchange)

This brooding face confronts the viewer with an immediacy and deep emotion that leave no doubt about the prophet's spirituality. His hollow eyes, furrowed brow, sunken cheeks, and solemn countenance express his innermost feelings. Three years before Nolde executed this print, he had experienced a religious transformation while recovering from an illness. Following this episode, he began depicting religious subjects in paintings and prints, such as the image seen here.

Nolde had joined the German Expressionist group *Die Brücke* (The Bridge) in 1906, participating in its exhibitions and in its exchange of ideas and techniques. He taught etching to his fellow members, and they introduced him to woodcuts. During the 1890s, woodcuts had undergone a resurgence and revamping, when artists such as Paul Gauguin and Edvard Munch used them to create bold images that expressed strong emotional content. In *Prophet*, Nolde also exploits the characteristics inherent to the medium. Coarsely gouged-out areas, jagged lines, and the textured grain of the wood effectively combine in this portrayal of a fervent believer—a quintessential German Expressionist print.

Alfred Kubin Austrian, 1877–1959

Untitled (The Eternal Flame).
c. 1900

Watercolor and ink on paper, 13 × 10¾"
(33 × 27.3 cm)
John S. Newberry Collection

This drawing is related to a later series of Kubin's works, *The Eternal Flame,* based on German folk tales and myths. A flaming cauldron placed in the center of the composition is a recurring motif in the series. The feeling of horror and mystery of this image is created through a subtle play of light and dark that envelops the foreground figures in an enigmatic veil. Light dramatizes and brings forth from the shadows both the flame and the floating skull, thus heightening the effect of a hallucinatory vision.

Most of Kubin's drawings evoke a fantastic nightmarish mood, high drama, and mystery. The eerie, unreal quality characteristic of his work may possibly be related to his early apprenticeship to a photographer, since Kubin's images seem to emerge out of the darkness, much as negatives develop in a darkroom.

Although most of Kubin's adult life falls within the twentieth century, his art—primarily drawings—belongs to the Austrian Symbolism of the end of the nineteenth century. The graphic work of Francisco Goya, James Ensor, Otto Klinger, Odilon Redon, and particularly Hieronymus Bosch offered him stylistic inspiration, while his subject matter was steeped in the incompatible philosophies of Friedrich Nietzsche and Arthur Schopenhauer.

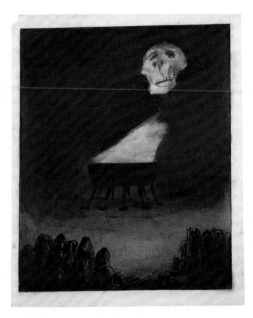

Georges Méliès French, 1861–1938

Le Voyage dans la lune (A Trip to the Moon). 1902

35mm film, black and white, silent,
11 minutes (approx.)
Acquired from the LeRoy Collection
Bluette Bernon

A Trip to the Moon is a satire in which the innate conservatism of the scientific community is overcome by the convictions of a lone charismatic figure (played by the filmmaker himself). This one-reel film spared no effect or expense in bringing to life Méliès's intensely personal vision. Astronauts prepare for a rocket-launching, take off, land on the moon (hitting it in the eye), and finally splash down back on earth.

Perhaps the greatest tribute paid to Méliès by his peers was the fact that, rather than attempting to duplicate the marvels contained in *A Trip to the Moon*, they simply stole it and released it under their own names, particularly in the United States. Méliès produced hundreds of films over the next decade. He had been a renowned magician and showman who first became fascinated with projected images when he incorporated magic lanterns (early slide projectors) into his stage presentations at the Théâtre Robert-Houdin in Paris. Inspired by the work of the Lumière brothers, Méliès went on to build Europe's first true film studio, at Montreuil, and began to make films indoors in a stagelike space with artificial lighting. He produced action shorts, fictional tales, and spectacles; but he was most successful with his fantasy works, the most famous of which is *A Trip to the Moon*.

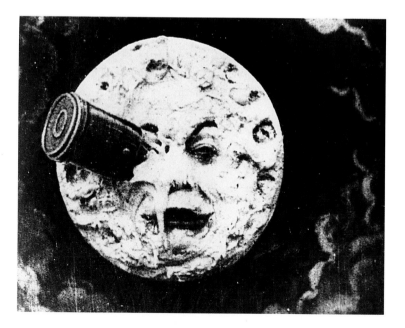

Paul Cézanne French, 1839–1906

Foliage. 1895–1900

Watercolor and pencil on paper, 17⅝ × 22⅜"
(44.8 × 56.8 cm)
Lillie P. Bliss Collection

At first glance, this work might strike the viewer as unfinished, given the blank areas left on the paper. But Cézanne meant *Foliage* to be a study in color and line depicting the rhythms of rustling leaves, which appear to move across the page. His brushstrokes deliver deposits of pigment that create the illusion of light and shadow. Nature is evoked in the lightness and transparency of the medium, in the placement of the subject, and in the inferred movement.

Cézanne's late watercolors, of which this is a superb example, "are acts of construction in color." Here he applied discrete unblended lines and patches of color around lightly sketched pencil contours and built depth from color by translating dark-light gradations into cool-warm ones. In this mosaic, colored lines and planes and overlapping shades together fix the depth of the subject to the surface of the paper—the white surface that is the final arbiter of pictorial coherence.

In this way Cézanne redefined modern drawing according to color "modulation," his term for that which enabled him not only to capture the light of southern France, where he lived and worked, but also to approach abstraction.

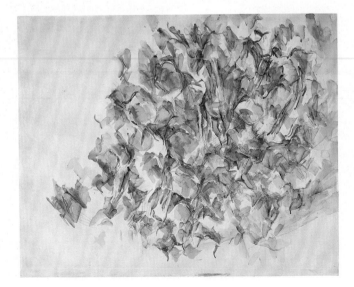

André Derain French, 1880–1954

Bridge over the Riou. 1906

Oil on canvas, 32½ × 40" (82.5 × 101.6 cm)
The William S. Paley Collection

Although *Bridge over the Riou* describes
a place in the south of France, its com-
plexly patterned composition suggests
a gradual reworking and reshaping
rather than a quick and fluid response
to what Derain saw there. From the
foreground bank, over the river, to
the higher ground beyond, the space
is compressed and flattened, but
the scene can still be identified—the
bridge at the lower right, a cabin down
in the ravine, the beehive form of a
covered well. Houses appear beyond
the river, behind the trees.

In 1905 Derain and his peers in
the Fauvist group had created a *succès
de scandale* through their radical use
of color, but they still accepted from

Impressionism the idea that a painting
should follow nature, and should try
to capture the passing moment of con-
temporary life. By 1906, however,
Derain wanted to create images that
would "belong to all time" as well as
to his own period, and the separate
strokes of color seen in his paintings
of 1905 are here subsumed into larger
colored shapes, some of them outlined
in exotic blues or lavenders, or an
Indian red or pink, say, for a tree trunk.
This emotionally high-keyed color
relates to the intensity of the light in
the south of France, yet belongs less
to nature than to art.

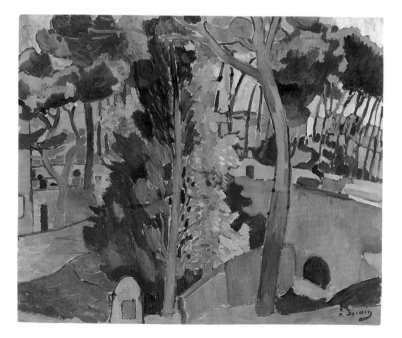

Edward Steichen American, born Luxembourg. 1879–1973

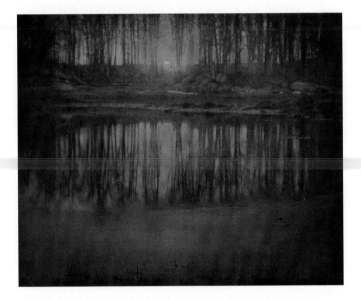

Moonrise, Mamaroneck, New York. 1904

Platinum and ferroprussiate print,
15⁵⁄₁₆ × 19" (38.9 × 48.2 cm)
Gift of the photographer

The colors in this photograph were not captured in the camera but were concocted later by Steichen in the darkroom, where he also sketched the reeds and grasses in the foreground. These marks of the artist's hand were the young photographer's way of showing that the picture was not an ordinary photograph but a work of art.

Raised in Wisconsin, Steichen made his way in 1900 to New York, where he met the older and more seasoned photographer Alfred Stieglitz and soon joined him in a vigorous campaign to establish photography as a fine art.

Although they failed at first to impress a broad public, they encouraged many talented young photographers to think of themselves as artists and so initiated a rich tradition that flourished for more than half a century.

For Stieglitz and Steichen, pursuing the artistic potential of photography meant rejecting its practical functions in the modern industrialized world. They retreated into an aesthetic realm of refinement and comforting values, such as the purity of nature. Pure as it was, however, the nature that they photographed was rarely wild. Mamaroneck surely was more peaceful a century ago than it is today, but it was already a suburb of New York to which Steichen often went to escape from the rigors of city life.

Odilon Redon French, 1840–1916

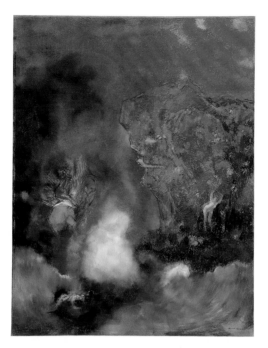

Roger and Angelica. c. 1910

Pastel on paper on canvas, 36½ × 28¾"
(92.7 × 73 cm)
Lillie P. Bliss Collection

In this evocation of a scene from the sixteenth-century romance *Orlando Furioso*, the knight Roger appears on his fiery steed to save the maiden Angelica from a horrible fate: the dragon, with its evil inner glow, is looming at the lower left. Tendrils of threatening mist curling up from below menace the maiden, while angry storm clouds hover above. The figures themselves are small and sketchily rendered; it is the picture's atmospheric effects, conveyed with light-and-dark contrasts and shots of dazzling color—including those of the imposing crag on which Angelica is stranded—that create the high drama of this tension-ridden scene.

The young Redon is said to have watched the clouds scudding over the flat Bordeaux landscape where he was raised and imagined in them the fantastic beings that he would later conjure up in his paintings, drawings, lithographs, and pastels. *Roger and Angelica*, executed in the last period of his career, when color had bewitched him, exemplifies Redon's consummate ability to imbue his wildly imaginative fantasies with color, light, and shadow, using the mere strokes of a crayon.

Although this work was created in the twentieth century, it reflects the Romanticism of the nineteenth century, in which feeling triumphed over form, and color was the primary vehicle of expression.

Gustav Klimt Austrian, 1862–1918

Hope, II. 1907–08

Oil, gold, and platinum on canvas, 43½ ×
43½" (110.5 × 110.5 cm)
Jo Carole and Ronald S. Lauder and Helen
Acheson Funds, and Serge Sabarsky

A pregnant woman bows her head and
closes her eyes, as if praying for the
safety of her child. Peeping out from
behind her stomach is a death's head,
sign of the danger she faces. At her
feet, three women with bowed heads
raise their hands, presumably also in
prayer—although their solemnity might
also imply mourning, as if they foresaw
the child's fate.

Why, then, the painting's title?
Although Klimt himself called this work
Vision, he had called an earlier, related
painting of a pregnant woman *Hope*. By
association with the earlier work, this
one has become known as *Hope, II.*
There is, however, a richness here to
balance the women's gravity.

Klimt was among the many artists
of his time who were inspired by
sources not only within Europe but far
beyond it. He lived in Vienna, a cross-
roads of East and West, and he drew
on such sources as Byzantine art,
Mycenean metalwork, Persian rugs
and miniatures, the mosaics of the
Ravenna churches, and Japanese
screens. In this painting the woman's
gold-patterned robe—drawn flat, as
clothes are in Russian icons, although
her skin is rounded and dimensional—
has an extraordinary decorative beauty.
Here, birth, death, and the sensuality
of the living exist side by side sus-
pended in equilibrium.

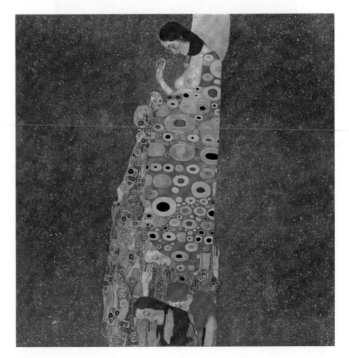

Egon Schiele Austrian, 1890–1918

Girl with Black Hair. 1911

Gouache, watercolor and pencil on paper,
22⅜ × 15⅞" (56.8 × 40.3 cm)
Gift of the Galerie St. Etienne, New York, in
memory of Dr. Otto Kallir; promised gift of
Jo Carole and Ronald S. Lauder; and purchase

Girl with Black Hair is one of two erotic
watercolors of the same subject, both
of which are closely related composi-
tionally. Here the young woman, in a
half-seated, half-reclining pose, dis-
plays her genitalia unashamedly; her
partly closed eyes do not confront
the artist or the viewer but stare into
space with detachment and boredom.
Her black skirt, bunched up around her
waist, reflects the form of her abun-
dant black hair.

The pose of the girl suggests that
the work was executed from a vantage
point above the figure. Reportedly,
Schiele's favorite mode of working was
to observe his models from above
(using a stool or ladder) while they
reclined on a low couch expressly built
by him for this purpose.

Young women in various stages of
undress or nude constituted one of
Schiele's favorite subjects. His models
were often pubescent girls of working-
class background or even young prosti-
tutes, since the artist, having been cut
off from financial support by his family,
could not afford to hire professional
models. During 1911–12 he executed
some of his most provocative depic-
tions of female nudes—often in con-
torted and unnatural poses: standing,
sitting, reclining, or kneeling. Such
drawings, exhibiting a bold expressive-
ness of body language and a masterful
handling of the watercolor medium,
were in great demand among Schiele's
Viennese patrons.

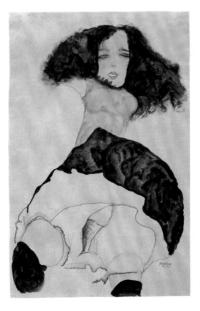

Oskar Kokoschka
British, born Austria. 1886–1980

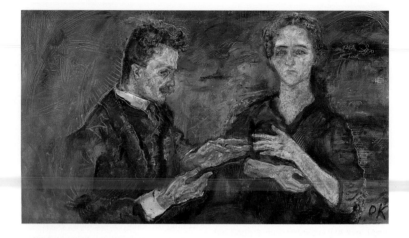

Hans Tietze and Erica Tietze-Conrat. 1909

Oil on canvas, 30⅛ × 53⅝" (76.5 × 136.2 cm)
Abby Aldrich Rockefeller Fund

The Tietzes were socially prominent art historians, but Kokoschka ignores their public personas to find a mysterious delicacy in their private relationship. Erica gazes out toward us; Hans looks at Erica's hand, and reaches for it without touching it, so that his hands and her left arm form an arch that is broken at its summit by a narrow gap, a space with a psychic charge. The couple emerge from a shimmering ground of russets and dim blues into which their outlines seem to melt in places. Scratches in the thin oil—made, according to Erica Tietze-Conrat, with the artist's fingernails—create a texture of ghostly half-marks around the figures, a subtle halo of crackling energy.

Like his Viennese compatriot Egon Schiele, Kokoschka tried to transcend academic formulas with an art of emotional and physical immediacy—an art,

in his words, "to render the vision of people being alive." *Hans Tietze and Erica Tietze-Conrat* is one of his "black portraits," in which he tried to penetrate his subjects' "closed personalities so full of tension." (His Vienna was also the home of Sigmund Freud.)

Constantin Brancusi French, born Romania, 1876–1957

Maiastra. 1910–12

White marble 22" (55.9 cm) high, on three-part limestone pedestal 70" (177.8 cm) high, of which the middle section is *Double Caryatid*, c. 1908
Katherine S. Dreier Bequest

Maiastra is a towering sculpture composed of four distinct parts. The lower sections comprise two rectilinear limestone blocks separated by a roughly hewn carving that Brancusi first exhibited as an independent sculpture titled *Double Caryatid* in 1908. Perched atop the tower, a marble bird is reduced to its defining characteristics of ovoid body, elongated neck, beak, and plume of tail feathers, a magical creature from a Romanian fairy tale for which the sculpture is named. *Maiastra* is Brancusi's first work to feature a bird, a subject to which he would return throughout his career.

As a composite of formally disjunctive elements, *Maiastra* is exemplary of the artist's practice. For Brancusi, the base was a crucial sculptural component, and he experimented with a variety of bases until arriving at a combination of elements he found satisfying, often documenting the process photographically along the way. In *Maiastra,* the rounded, smoothly polished surface of the marble bird stands in sharp contrast to both the stark angularity of the limestone cubes and the coarsely textured, schematic carving of *Double Caryatid.* This juxtaposition of materials and methods embodies the perpetual dialogue between the reality of the everyday and the mystical or otherworldly aspect of the spirit.

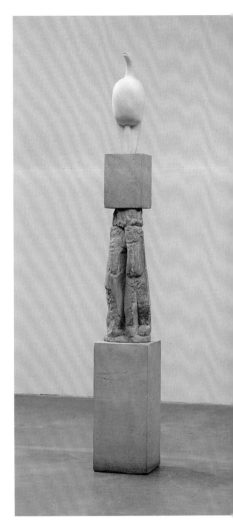

Josef Hoffmann
Austrian, 1870–1956

Sitzmaschine Chair with Adjustable
Back. c. 1905

Bent beechwood and sycamore panels,
43½ × 28¼ × 32" (110.5 × 71.8 × 81.3 cm)
Manufacturer: J. & J. Kohn, Austria
Gift of Jo Carole and Ronald S. Lauder

The *Sitzmaschine*, that is, the "machine
for sitting," was originally designed
by Hoffmann for his Purkersdorf
Sanatorium in Vienna. The sanatorium
was one of the first important commis-
sions given to the Wiener Werkstätte,
a collaborative founded in 1903 by
Hoffmann and Koloman Moser and
which espoused many of the English
Arts and Crafts movement's tenets of
good design and high-quality craftsman-
ship. It represents one of Hoffmann's
earliest experiments in unifying a build-
ing and its furnishings as a total work
of art.

The *Sitzmaschine* makes clear ref-
erence to an adjustable-back English

Arts and Crafts chair known as the
Morris chair, designed by Philip Webb
around 1866. It also stands as an alle-
gorical celebration of the machine. This
armchair, with its exposed structure,
demonstrates a rational simplification
of forms suited to machine production.
Yet, at the same time, the grid of
squares piercing the rectangular back
splat, the bentwood loops that form
the armrests and legs, and the rows
of knobs on the adjustable back illus-
trate the fusion of decorative and struc-
tural elements typical of the Wiener
Werkstätte style. J. & J. Kohn produced
and sold this chair in a number of ver-
sions, most of which had cushions on
the seat and back, until at least 1916.
The Kohn firm produced many designs
by Hoffmann, forming one of the
first successful alliances between a
designer and industry in Vienna.

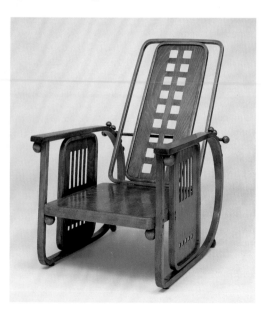

Frances Benjamin Johnston American, 1864–1952

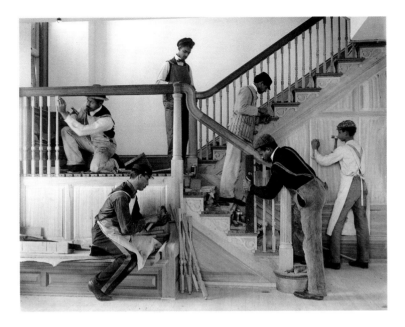

Stairway of Treasurer's Residence: Students at Work.

From the Hampton Album. 1899–1900

Platinum print, 7⁹⁄₁₆ × 9⁹⁄₁₆" (19.2 × 24.3 cm)
Gift of Lincoln Kirstein

Johnston was a professional photographer, noted for her portraits of Washington politicians and her photographs of coal miners, iron workers, and women workers in the New England textile mills. In 1899 Hampton Institute, in Hampton, Virginia, commissioned her to make photographs at the school for an exhibition about contemporary African-American life. The exhibition was to be shown at the Paris Exposition of 1900. This picture exemplifies Johnston's classical sense of composition and her practice of carefully arranging her subjects. Her complete control over the scene is readily apparent, yet the grace of the men's poses—evenly bathed in natural light—seems to justify her artifice.

Hampton Institute had been established in 1868, three years after the Civil War ended, when the educator and philanthropist Samuel C. Armstrong persuaded the American Missionary Association to fund a school for the vocational training of African Americans. Armstrong admired the "excellent qualities and capacities" of the freed black soldiers who had fought in the War under his command, and he believed that education was essential to them if they were to achieve productive independence.

Erich Heckel German, 1883–1970

Fränzi Reclining. 1910

Woodcut, comp.: 8¹⁵⁄₁₆ × 16⁹⁄₁₆"
(22.6 × 42.1 cm) (irreg.)
Publisher: the artist. Edition: approx 30–50
Gift of Mr. and Mrs. Otto Gerson

Fränzi, shown here at the age of twelve, posed frequently for Heckel and other German Expressionists, who were drawn to the natural yet awkward positions that she assumed because they were so unlike the artificial stances of professional models. The woodcut medium was a perfect vehicle to express thick, angular outlines for her figure, with its distorted arm and jagged fingers, and exaggerated masklike features for her face. This bold new imagery found its source in African sculptures that Heckel had studied in the Dresden Ethnological Museum.

Heckel also took a cue from Edvard Munch, the Norwegian painter much admired by *Die Brücke* artists, and employed one of his unusual printing techniques. Like Munch, he sawed the woodblock into pieces, cutting out the three red background areas, inking the components separately, and then reassembling them like a jigsaw puzzle before printing.

Ernst Ludwig Kirchner German, 1880–1938

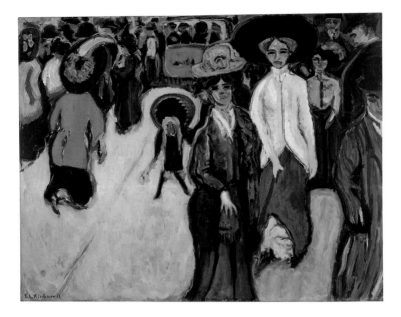

Street, Dresden. 1908 (reworked 1919; date on painting 1907)

Oil on canvas, 59¼" × 6' 6⅞" (150.5 × 200.4 cm)
Purchase

Street, Dresden is Kirchner's bold, discomfiting attempt to render the jarring experience of modern urban bustle. The scene radiates tension. Its packed pedestrians are locked in a constricting space; the plane of the sidewalk, in an unsettlingly intense pink (part of a palette of shrill and clashing colors), slopes steeply upward, and exit to the rear is blocked by a trolley car. The street—Dresden's fashionable Königstrasse—is crowded, even claustrophobically so, yet everyone seems alone. The women at the right, one clutching her purse, the other her skirt, are holding themselves in, and their faces are expressionless, almost mask-like. A little girl is dwarfed by her hat, one in a network of eddying, whorling shapes that entwine and enmesh the human figures.

Developing in parallel with the French Fauves, and influenced by them and by the Norwegian painter Edvard Munch, the German artists of *Die Brücke,* an association cofounded by Kirchner, explored the expressive possibilities of color, form, and composition in creating images of contemporary life. *Street, Dresden* is a bold expression of the intensity, dissonance, and anxiety of the modern city. Kirchner later wrote, "The more I mixed with people the more I felt my loneliness."

Vasily Kandinsky French, born Russia. 1866–1944

Picture with an Archer. 1909

Oil on canvas, 68⅞ × 57⅜" (175 × 144.6 cm)
Gift and bequest of Louise Reinhardt Smith

The color in *Picture with an Archer* is vibrantly alive—so much so that the scene is initially hard to make out. The patchwork surface seems to be shrugging off the task of describing a space or form. Kandinsky was the first modern artist to paint an entirely abstract composition; at the time of *Picture with an Archer*, that work was just a few months away.

Kandinsky took his approach from Paris—particularly from the Fauves—but used it to create an Eastern landscape suffused with a folk-tale mood. Galloping under the trees of a wildly radiant countryside, a horseman turns in his saddle and aims his bow. In the left foreground stand men in Russian dress; behind them are a house, a domed tower, and two bulbous mountainy pinnacles, cousins of the bent-necked spire in the picture's center. Russian icons show similar rocks, which do exist in places in the East, but even so have a fantastical air. The lone rider with his archaic weapon, the traditional costumes and buildings, and the rural setting intensify the note of fantasy or poetic romance. There is a nostalgia here for a time or perhaps for a place: in 1909 Kandinsky was living in Germany, far from his native Russia. But in the glowing energy of the painting's color there is also excitement and promise.

Marc Chagall
French, born Belarus. 1887–1985

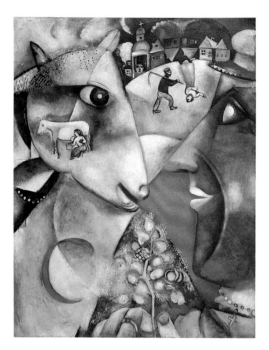

I and the Village. 1911

Oil on canvas, 6' 3⅝" × 59⅝"
(192.1 × 151.4 cm)
Mrs. Simon Guggenheim Fund

Painted the year after Chagall came
to Paris, *I and the Village* evokes his
memories of his native Hasidic com-
munity outside Vitebsk. In the village,
peasants and animals lived side by
side, in a mutual dependence here
signified by the line from peasant to
cow, connecting their eyes. The peas-
ant's flowering sprig, symbolically a
tree of life, is the reward of their part-
nership. For the Hasidim, animals were
also humanity's link to the universe,
and the painting's large circular forms
suggest the orbiting sun, moon (in
eclipse at the lower left), and earth.

The geometries of *I and the
Village* are inspired by the broken

planes of Cubism, but Chagall's is a
personalized version of that style. As a
boy he had loved geometry: "Lines,
angles, triangles, squares," he would
later recall, "carried me far away to
enchanting horizons." Conversely, in
Paris he used a disjunctive geometric
structure to carry him back home.
Where Cubism was mainly an art of
urban avant-garde society, *I and the
Village* is nostalgic and magical, a rural
fairy tale: objects jumble together,
scale shifts abruptly, and a woman and
two houses, at the painting's top,
stand upside-down. "For the Cubists,"
Chagall said, "a painting was a surface
covered with forms in a certain order.
For me a painting is a surface covered
with representations of things . . . in
which logic and illustration have no
importance."

Pablo Picasso Spanish, 1881–1973

Les Demoiselles d'Avignon. 1907

Oil on canvas, 8' × 7' 8" (243.9 × 233.7 cm)
Acquired through the Lillie P. Bliss Bequest

Les Demoiselles d'Avignon is one of the most important works in the genesis of modern art. The painting depicts five naked prostitutes in a brothel; two of them push aside curtains around the space where the other women strike seductive and erotic poses—but their figures are composed of flat, splintered planes rather than rounded volumes, their eyes are lopsided or staring or asymmetrical, and the two women at the right have threatening masks for heads. The space, too, which should recede, comes forward in jagged shards, like broken glass. In the still life at the bottom, a piece of melon slices the air like a scythe.

The faces of the figures at the right are influenced by African masks, which Picasso assumed had functioned as magical protectors against dangerous spirits: this work, he said later, was his "first exorcism painting." A specific danger he had in mind was life-threatening sexual disease, a source of considerable anxiety in Paris at the time; earlier sketches for the painting more clearly link sexual pleasure to mortality. In its brutal treatment of the body and its clashes of color and style (other sources for this work include ancient Iberian statuary and the work of Paul Cézanne), *Les Demoiselles d'Avignon* marks a radical break from traditional composition and perspective.

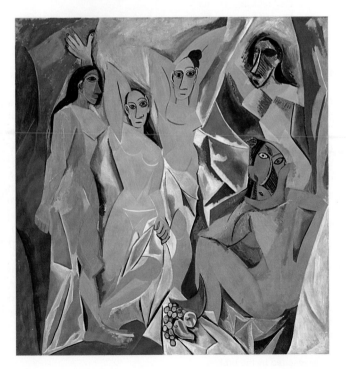

Henri Matisse French, 1869–1954

Dance (I). 1909

Oil on canvas, 8' 6½" × 12' 9½"
(259.7 × 390.1 cm)
Gift of Nelson A. Rockefeller in honor of
Alfred H. Barr, Jr.

A monumental image of joy and energy, *Dance* is also strikingly daring. Matisse made the painting while preparing a decorative commission for the Moscow collector Sergei Shchukin, whose final version of the scene, *Dance (II)*, was shown in Paris in 1910. Nearly identical in composition to this work, its simplifications of the human body were attacked as inept or willfully crude. Also noted was the work's radical visual flatness: the elimination of perspective and foreshortening that makes nearer and farther figures the same size, and the sky a plane of blue. This is true, as well, of the first version.

Here, the figure at the left moves purposefully; the strength of her body is emphasized by the sweeping unbroken contour from her rear foot up to her breast. The other dancers seem so light they nearly float. The woman at the far right is barely sketched in, her foot dissolving in runny paint as she reels backward. The arm of the dancer to her left literally stretches as it reaches toward the leader's hand, where momentum has broken the circle. The dancers' speed is barely contained by the edges of the canvas.

Dance (II) is more intense in color than this first version, and the dancers' bodies—there deep red—are more sinewy and energetic. In whatever canvas they appear, these are no ordinary dancers, but mythical creatures in a timeless landscape. Dance, Matisse once said, meant "life and rhythm."

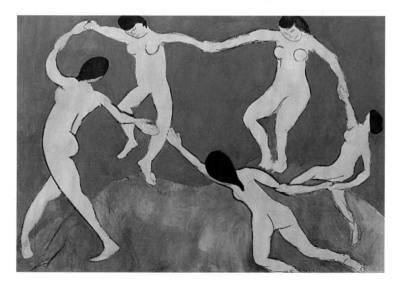

Pablo Picasso Spanish, 1881–1973

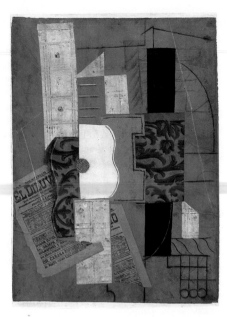

Guitar. After March 31, 1913

Cut-and-pasted paper and printed paper,
charcoal, ink, and chalk on colored paper on
board, 26⅛ × 19½" (66.4 × 49.6 cm)
Nelson A. Rockefeller Bequest

Picasso executed this *papier collé* the
year after he and Georges Braque first
began their radical experimentation
with collage. Taking the flattening of
forms from painted Cubism a step fur-
ther, this new medium dispensed with
illusionism by introducing "real" ele-
ments from everyday life into the
picture plane.

The guitar was a favorite subject
for Picasso. Here, in a schematic ren-
dering of light and shadow, white paper
corresponds to the right half of the
instrument's body, and patterned wall-
paper represents the left half. Bridging
the two sides, a small circle of newspa-
per stands for the guitar's sound hole.
The fretwork is suggested by the box

pattern on a strip of ivory and gold
paper, and by a series of adjacent hori-
zontal lines. A strip of black paper at
the right denotes the shadow of the
guitar's neck.

Picasso reveled in the capacity of
papier collé to carry multiple meanings.
The guitar's sinuous forms can also be
seen as feminine curves; in this inter-
pretation, the sound hole doubles as
a navel. A page from the Barcelona
newspaper *El Diluvio* is cropped so that
the title reads as "El Diluv," a sly,
homophonic reference to the Musée du
Louvre, which would not have recog-
nized this modern work's merit. At the
bottom of the sheet, an advertisement
for an ophthalmologist, "Dr. Dolcet,
oculista," emphasizes the act of visual
analysis that such a work demands.

Piet Mondrian
Dutch, 1872–1944

Pier and Ocean (Sea and Starry Sky). 1915 (inscribed 1914)

Charcoal and watercolor on paper,
34⅝ × 44" (87.9 × 111.2 cm)
Mrs. Simon Guggenheim Fund

At first glance, this drawing appears to be totally abstract, despite its descriptive title. In fact, the vertical lines at the base of the oval represent a pier that stretches into an ocean of short horizontal and vertical lines above and around it. At times crossing or lying perpendicular to one another, these lines reflect the rhythmic ebb and flow of the sea, and, with the areas of white paint, the reflected starlight overhead.

Mondrian had begun to experiment with abstraction before 1912, when he left for Paris, where for two years he was exposed to Cubism. He returned to the Netherlands with renewed determination to create a purer abstract form at the expense of more illustrative elements. His highly individual version of Cubism simplified it into a vertical-horizontal grid, in which shading was flattened to the surface to form areas of muted color.

In the Pier and Ocean series of 1914–15, color is eliminated, and the grid opens to form a cluster of "plus-and-minus" signs within a Cubist oval. The reduction to vertical and horizontal generalizes the artist's sources in nature into a symbolic structure representing what Mondrian saw as a cosmic dualism between the masculine and spiritual (vertical) and the feminine and material (horizontal). His system of cruciform signs here speaks to flickering light and movement on water and also to a spiritual structure within nature itself—in his words, "a true vision of reality."

© 2013 Mondrian/Holtzman Trust, c/o HCR International

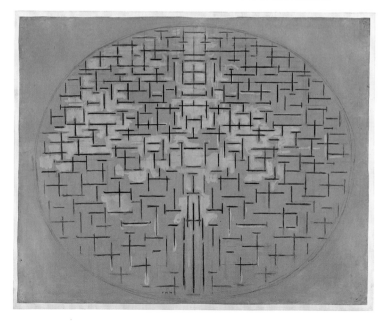

Georges Braque French, 1882–1963

Homage to J.S. Bach. Winter 1911–12

Oil on canvas, 21¼ × 28¾" (54 × 73 cm)
The Sidney and Harriet Janis Collection,
acquired through the Nelson A. Rockefeller
Bequest Fund and the Richard S. Zeisler
Bequest (both by exchange) and anonymous
promised gift, 2008

Images of violin parts slip in and out among the shifting orthogonals of this Cubist composition and announce its musical theme. Braque had studied classical music and believed that instruments added a tactile dimension to the visual image. The reference to J. S. Bach creates an analogy between the German composer's rigorously constructed compositions and the radical structural innovations of Cubism. Braque employs such intricate structures in this painting to create a contrapuntal effect between the flat surface of the canvas and the deep space of the image. The punning of "Braque" and "Bach" adds an aural dimension:

the artist's signature appears below and to the left of the composer's name, which is depicted in blocky type as if on a printed sheet of music.

The winter of 1911–12 was an intensive period in Braque's and Picasso's development of Analytic Cubism and their challenge to the dominance of illusionism in painting. This canvas exhibits many of their important innovations in this project, including a restricted palette and the use of modes of representation from outside the fine arts, exemplified by the imitation wood grain in the lower left and the stenciled words and letters. These last two were Braque's invention. The artist trained as a housepainter and decorator, and in *Homage to J.S. Bach* he deployed techniques used in those trades.

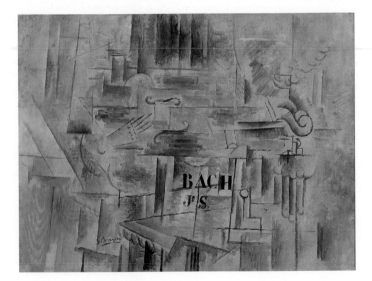

Giacomo Balla Italian, 1871–1958

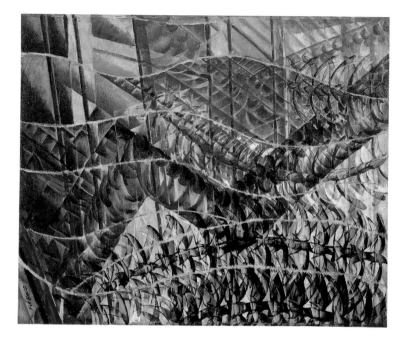

Swifts: Paths of Movement + Dynamic Sequences. 1913

Oil on canvas, 38⅛ × 47¼" (96.8 × 120 cm)
Purchase

"All things move, all things run, all things are rapidly changing," wrote the Futurists, one of them Balla, in 1910. Elaborating on Cubism's experiment in fracturing forms into planes, the Futurists further tried to make painting answer to movement: while the Cubists were concentrating on still lifes and portraits—in other words, were examining stationary bodies—the Futurists were looking at speed. They said: "The gesture which we would reproduce on canvas shall no longer be a fixed *moment* in universal dynamism. It shall simply be the dynamic sensation itself."

The backdrop to this painting is fixed architecture—a window, a drainpipe, a balcony—but the arcs that snake across the foreground are pure rush. The shapes of the swifts (are there four or forty of them?) repeat in stuttering bands, but their substance seems to evaporate: melting into light, the birds are lost in the paths of their own swooping soar. "Dynamic sensation," in Balla's time, was newly susceptible to scientific and visual analysis. Balla knew the photography of Étienne-Jules Marey, which described the movements of animals—including birds—through closely spaced sequences of images; *Swifts* emulates Marey's scientific visual analysis, which, in Balla's time, subjected "dynamic sensation to scrutiny," but adds to it a sense of exhilarated pleasure.

Umberto Boccioni
Italian, 1882–1916

Unique Forms of Continuity in Space. 1913

Bronze (cast 1931), 43⅞ × 34⅞ × 15¾"
(111.2 × 88.5 × 40 cm)
Acquired through the Lillie P. Bliss Bequest

In *Unique Forms of Continuity in Space*, Boccioni put speed and force into sculptural form. The figure strides forward. Surpassing the limits of the body, its lines ripple outward in curving and streamlined flags, as if molded by the wind of its passing. Boccioni had developed these shapes over two years in paintings, drawings, and sculptures, exacting studies of human musculature. The result is a three-dimensional portrait of a powerful body in action.

In the early twentieth century, the new speed and force of machinery seemed to pour its power into radical social energy. The new technologies and the ideas attached to them would later reveal threatening aspects, but for Futurist artists like Boccioni, they were tremendously exhilarating. Innovative as Boccioni was, he fell short of his own ambition. In 1912, he had attacked the domination of sculpture by "the blind and foolish imitation of formulas inherited from the past," and particularly by "the burdensome weight of Greece." Yet *Unique Forms of Continuity in Space* bears an underlying resemblance to a classical work over 2,000 years old, the *Nike of Samothrace*. There, however, speed is encoded in the flowing stone draperies that wash around, and in the wake of, the figure. Here the body itself is reshaped, as if the new conditions of modernity were producing a new man.

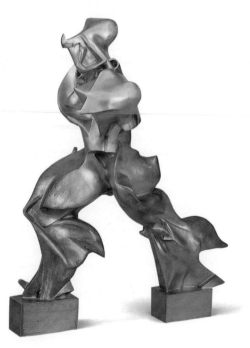

Gino Severini Italian, 1883–1966

Armored Train in Action. 1915

Charcoal on paper, 22½ × 18¾"
(56.9 × 47.5 cm)
Benjamin Scharps and David Scharps Fund

This study for the most famous of the Futurist war paintings, *The Armored Train* (1915), incorporates an unusual aerial perspective in its depiction of a train filled with armed soldiers. Severini enjoyed a unique vantage point—his Paris studio overlooked the Denfert-Rochereau station, from which he was able to observe the constant movement of trains filled with soldiers, supplies, and weaponry. Although Severini remained a noncombatant during World War I, he took the advice of fellow Futurist artist Filippo Tommaso Marinetti to "try to live the war pictorially, studying it in all its marvelous mechanical forms."

The Futurists glorified modern technology, and World War I, the first war of the twentieth century to employ the technological achievements of the industrial age in a program of mass destruction, was for them the most important spectacle of the modern era. Their admiration for speed—made possible by machinery—is represented here by the fractured landscape, which accentuates the train's force and momentum as it cuts through the countryside.

Armored Train in Action foreshadows a fundamental principle of Severini's later art: the "image-idea," in which a single image expresses the essence of an idea. Through a depiction of the plastic realities of war—a train, cannon, guns, and soldiers—he provides a pictorial vocabulary necessary to grasp its deeper symbolism.

Juan Gris Spanish, 1887–1927

Breakfast. 1914

Gouache, oil, and crayon on cut-and-pasted
printed paper on canvas with oil and crayon,
31⅞ × 23½" (80.9 × 59.7 cm)
Acquired through the Lillie P. Bliss Bequest

The *papier collé*, invented by Georges
Braque and Pablo Picasso in 1912,
found a rich and complex expression in
the 1914 works of Gris. In conception,
Gris's *papiers collés* are closer to
paintings than are the sparely drawn
compositions of his forerunners; unlike
them Gris covers the whole surface
with pasted papers and paint. In works
such as *Breakfast*, Gris's use of
printed papers is more literal than
theirs: the wood-grained fragments usu-
ally follow some of the contours of a
table and are therefore integral to the
composition; and his perspectival cues
are relatively legible and precise. His
superimposed drawings of domestic

objects, fragmented yet softly modeled
and most often seen from above, com-
bine to create a more representational
pictorial composition than those of
Braque and Picasso.

Despite these observations,
Breakfast is full of troubling contradic-
tions. The striped wallpaper background
spills across the table; certain objects
(a glass on the left, a bottle in the
upper right) appear as ghostly pres-
ences; the coffeepot is disjointed; the
tobacco packet is painted and drawn in
photographically realistic trompe l'oeil,
but its label is real. Thus, while aspects
of domestic comfort are captured in
this image, Gris also raises many sub-
jective and objective questions about
how reality is perceived.

Henri Matisse French, 1869–1954

The Red Studio. 1911

Oil on canvas, 71¼" × 7' 2¼"
(181 × 219.1 cm)
Mrs. Simon Guggenheim Fund

"Modern art," said Matisse, "spreads joy around it by its color, which calms us." In this radiant painting he saturates a room—his own studio—with red. Art and decorative objects are painted solidly, but furniture and architecture are linear diagrams, silhouetted by "gaps" in the red surface. These gaps reveal earlier layers of yellow and blue paint beneath the red; Matisse changed the colors until they felt right to him. (The studio was actually white.)

The studio is an important place for any artist, and this one Matisse had built for himself, encouraged by new patronage in 1909. He shows in it a carefully arranged exhibition of his own works. Angled lines suggest depth, and the blue-green light of the window intensifies the sense of interior space, but the expanse of red flattens the image. Matisse heightens this effect by, for example, omitting the vertical line of the corner of the room.

The entire composition is clustered around the enigmatic axis of the grandfather clock, a flat rectangle whose face has no hands. Time is suspended in this magical space. On the foreground table, an open box of crayons, perhaps a symbolic stand-in for the artist, invites us into the room. But the studio itself, defined by ethereal lines and subtle spatial discontinuities, remains Matisse's private universe.

Robert Delaunay French, 1885–1941

Simultaneous Contrasts: Sun and Moon. 1913 (dated 1912)

Oil on canvas, 53" (134.5 cm) diam.
Mrs. Simon Guggenheim Fund

Delaunay was fascinated by how the interaction of colors produces sensations of depth and movement, without reference to the natural world. In *Simultaneous Contrasts* that movement is the rhythm of the cosmos, for the painting's circular frame is a sign for the universe, and its flux of reds and oranges, greens and blues, is attuned to the sun and the moon, the rotation of day and night. But the star and planet, refracted by light, go undescribed in any literal way. "The breaking up of form by light creates colored planes," Delaunay said. "These colored planes are the structure of the picture, and nature is no longer a subject for description but a pretext." Indeed, he had decided to abandon "images or reality that come to corrupt the order of color."

The poet Guillaume Apollinaire named Delaunay's style "Orphism," after Orpheus, the musician of Greek legend whose eloquence on the lyre is a mythic archetype for the power of art. The musicality of Delaunay's work lay in color, which he studied closely. In fact, he derived the phrase "Simultaneous Contrasts" from the treatise *On the Law of the Simultaneous Contrast of Colors*, published in 1839 by Michel-Eugène Chevreul. Absorbing Chevreul's scientific analyses, Delaunay has here gone beyond them into a mystical belief in color, its fusion into unity symbolizing the possibility for harmony in the chaos of the modern world.

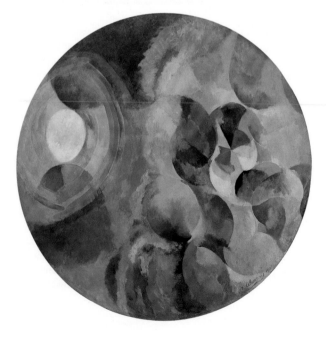

Sonia Delaunay-Terk French, born Russia. 1885–1979

La Prose du Transsibérien et de la petite Jehanne de France by
Blaise Cendrars. 1913

Illustrated book with pochoir, 6' 9⅝" × 14¼"
(207.4 × 36.4 cm)
Publisher: Éditions des Hommes Nouveaux
(Blaise Cendrars). Edition: 150 announced;
60–100 printed
Purchase

Brilliant swirls of color cascade down
the left side of this elongated composi-
tion, ending with a simplified represen-
tation of a red Eiffel Tower. Juxtaposed
on the right, in a parallel arrangement,
are the words of the poet Cendrars,
which end with the text "O Paris."
Colors and words drift in a nonlinear
fashion similar to a stream of con-
sciousness, a state in which time and
location are irrelevant. Delaunay-Terk's
hues and Cendrars's prose interact on
a simultaneous journey, producing syn-
chronized rhythms of art and poetry.

The text of *La Prose du Trans-
sibérien et de la petite Jehanne de
France* (*Prose of the Trans-Siberian and
of Little Jehanne of France*) contains
Cendrars's sporadic flashbacks and
flashforwards to other times and
places, and recounts his railroad jour-
ney from Moscow to the Sea of Japan
in 1904. It also includes recollections
of a train ride with his young French
mistress, the "petite Jehanne" of the
title, who repeatedly asked, "Are we
very far from Montmartre?"

Calling their creation "the first
simultaneous book," Delaunay-Terk and
Cendrars drew on the artistic theory of
simultaneity, espoused by the artist's
husband, the painter Robert Delaunay,
and modern poets.

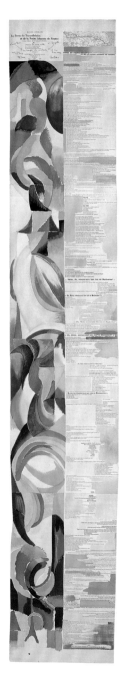

Giorgio de Chirico Italian, born Greece. 1888–1978

The Song of Love. 1914

Oil on canvas, 28¾ × 23⅜" (73 × 59.1 cm)
Nelson A. Rockefeller Bequest

"M. Giorgio de Chirico has just bought a red rubber glove"—so wrote the French poet Guillaume Apollinaire in July of 1914, noting the purchase because, he went on to say, he knew the glove's appearance in de Chirico's paintings would add to the works' uncanny power. Implying human presence, as a mold of the hand, yet also inhuman, a clammily limp fragment distinctly unfleshlike in color, the glove in *The Song of Love* has an unsettling authority. Why is this surgical garment pinned to a board or canvas, alongside a plaster head copied from a classical statue, relic of a noble vanished age?

What is the meaning of the green ball? And what is the whole ensemble doing in the outdoor setting insinuated by the building and the passing train?

Unlikely meetings among dissimilar objects were to become a strong theme in modern art (they soon became an explicit goal of the Surrealists), but de Chirico sought more than surprise: in works like this one, for which Apollinaire used the term "metaphysical," he wanted to evoke an enduring level of reality hidden beyond outward appearances. Perhaps this is why he gives us a geometric form (the spherical ball), a schematic building rather than a specific one, and inert and partial images of the human body rather than a living, mortal being.

Sophie Taeuber-Arp Swiss, 1889–1943

Tête Dada (Dada Head). 1920

Painted wood with glass beads on wire,
9¼" high (23.5 cm)
Mrs. John Hay Whitney Bequest (by exchange)
and Committee on Painting and Sculpture
Funds

The elegant symmetry of the sculpture's base and head stems from the mechanical precision of a lathe, while the unruly, earring-like beaded appendages bear the idiosyncrasies of premodern handicraft. In the context of the fine arts, *Tête Dada* might be classified as a sculptural bust; in the applied arts, a miniature hat stand or doll; and in an ethnographic museum, a fetish object with spiritual powers. As an artist trained in textile design, Taeuber was keenly aware of the conventions defining each category. Her refusal to allow *Tête Dada* to conform to any single one is what makes it a "Dada object," a new category that Taeuber helped to construct during the Dada movement's initial phase in Zurich during World War I.

Other classifications conjoined in this work include painting and sculpture, human and object, authentic and artificial, spiritual and commercial. The sculpture's surface doubles as an abstract painting for which Taeuber employs her design expertise to wrap linear geometric shapes around a curved form. But this abstraction, like that of the African masks that interested many artists of the period, also breeds empathy, tapping into primordial instincts that project sentience into the protruding "nose" and semicircular "eye." Similarity to a mannequin brings the work back to modernity and commerce, fusing (or confusing) the painted faces of spiritual ritual with the look of contemporary fashion.

Olga Rozanova Russian, 1886–1918

Airplanes over the City from Voina (War). 1916

Linoleum cut and collage, from an illustrated
book with ten linoleum cuts, page: 16¼ x
12¹⁄₁₆" (41.2 x 30.6 cm)
Publisher: Andrei Shemshurin, Petrograd
Edition: 100 announced (few known complete
copies)
Gift of The Judith Rothschild Foundation

Soaring airplanes, a black bomb, a
toppled red building, and a figure
free-falling through space: although
Rozanova's collage of cut-out shapes
and linoleum-printed papers may at
first glance look like an abstraction, in
fact it illustrates the chaos of a bomb-
ing raid. The sheet is one of fifteen
pages in the illustrated book Voina,
which Rozanova produced with her
companion and frequent collaborator,
the Russian Futurist poet Aleksei
Kruchenykh. She used the fractured,
shifting forms of Cubism and Futurism
to convey the mass confusion and
destruction experienced in her native
Russia during World War I.

For Rozanova and her generation
of Russian artists, the book was a
key site for radical experimentation.
Working closely with poets, including
Kruchenykh, to create an entirely new
kind of handmade, often self-published
book, they combined innovative poetry
with deliberately crude illustrations
that were meant to shock the bourgeoi-
sie and repudiate the tasteful refine-
ment of traditional fine press artists'
books. For Voina, Rozanova used the
then-new and unorthodox medium of
linoleum cut, printed on cheap paper
with uneven edges. The book marked a
major highpoint in Rozanova's brief but
illustrious career, which lasted only
about a decade. She died of diphtheria
in 1918.

Liubov Sergeievna Popova Russian, 1889–1924

Painterly Architectonic. 1917

Oil on canvas, 31½ × 38⅝" (80 × 98 cm)
Philip Johnson Fund

In *Painterly Architectonic*, one of a series of works by this title, Popova arranged areas of white, red, black, gray, and pink to suggest straight-edged planes laid one on top of the other over a white ground, like differently shaped papers in a collage. The space is not completely flat, however, for the rounded lower rim of the gray plane implies that this surface is arching upward against the red triangle. This pressure finds matches in the shapes and placements of the planes, which shun both right angles and vertical or horizontal lines, so that the picture becomes a taut net of slants and diagonals. The composition's orderly spatial recession is energized by these dynamic vectors, along which the viewer's gaze alternately slides and lifts.

Influenced by her long visits to Europe before World War I, Popova helped to introduce the Cubist and Futurist ideas of France and Italy into Russian art. But, no matter how abstract European Cubism and Futurism became, they never completely abandoned recognizable imagery, whereas Popova developed an entirely nonrepresentational idiom based on layered planes of color. The catalyst in this transition was Kazimir Malevich's Suprematism, an art of austere geometric shapes. But where Suprematism was infused with the desire for a spiritual or cosmic space, Popova's concerns were purely pictorial.

El Lissitzky Russian, 1890–1941

Proun 19D. 1920 or 1921

Gesso, oil, crayon, sandpaper, graph paper
on cardboard, metallic paint and metal foil on
plywood, 38⅜ × 38¼" (97.5 × 97.2 cm)
Katherine S. Dreier Bequest

In 1920, El Lissitzky announced a
new type of artwork, which he called
"Proun"—"project for the affirmation
of the new." Just three years after the
Russian Revolution, with battles still
raging for control of the country, the
new was serious business. At the art
school in Vitebsk, v and the
Suprematist Kazimir Malevich were
pursuing a new art for the new, post-
revolutionary world.

 Lissitzky coined a slogan for his
Prouns: "not a way to see the world,
but a real world." The abstract forms
of *Proun 19D* bespeak a flat-out rejec-
tion of illusionism, in art as in politics.
In making the work, Lissitzky began
with an exercise he called *ekskartina*
(ex-painting). After drawing a geometric
figure according to the rules of per-
spective, he rotated the canvas ninety
degrees, adding new volumes that
corresponded to the work's new orien-
tation, then continued until he had
carried out this procedure on all four
sides, shattering the single coherent
viewpoint of linear perspective as
he proceeded. His insistence on creat-
ing a non-illusionistic surface is further
seen in the remarkable inventory of
materials he applied to the plywood
support: transparent varnish, chalky
gesso, cardboard, metallic and graph
papers. For Lissitzky, the "real world"
of the Proun had use value: it offered
a blueprint for constructing the future.
"The Proun begins with surface arrange-
ments," he wrote, "then moves to spa-
tially modeled constructions, before
reaching the state of constructing all
forms of life."

Kazimir Malevich · Russian, born Ukraine. 1878–1935

Suprematist Composition: White on White. 1918

Oil on canvas, 31¼ × 31¼" (79.4 × 79.4 cm)
1935 Acquisition confirmed in 1999 by agreement with the Estate of Kazimir Malevich and made possible with funds from the Mrs. John Hay Whitney Bequest (by exchange)

A white square floating weightlessly in a white field, *Suprematist Composition: White on White* was one of the most radical paintings of its day: a geometric abstraction without reference to external reality. Yet the picture is not impersonal: we see the artist's hand in the texture of the paint, and in the subtle variations of the whites. The square is not exactly symmetrical, and its lines, imprecisely ruled, have a breathing quality, generating a feeling not of borders defining a shape but of a space without limits.

After the revolution, Russian intellectuals hoped that human reason and modern technology would engineer a perfect society. Malevich was fascinated with technology, and particularly with the airplane. He studied aerial photography and wanted *White on White* to create a sense of floating and transcendence. White was for Malevich the color of infinity, and signified a realm of higher feeling.

For Malevich, that realm, a utopian world of pure form, was attainable only through nonobjective art. Indeed, he named his theory of art Suprematism to signify "the supremacy of pure feeling or perception in the pictorial arts"; and pure perception demanded that a picture's forms "have nothing in common with nature." Malevich imagined Suprematism as a universal language that would free viewers from the material world.

Frank Lloyd Wright American, 1867–1959

Two Clerestory Windows from Avery Coonley Playhouse, Riverside, Illinois. 1912

Color and clear glass, leaded,
each 18⁵⁄₁₆ × 34³⁄₁₆"(46.5 × 86.8 cm)
Joseph H. Heil Fund

To enliven the interior of his Avery Coonley Playhouse, a private kindergarten in the suburbs of Chicago, Frank Lloyd Wright designed stained-glass clerestory windows, which formed a continuous band around the top of the playroom. Each window in the series featured lively combinations of simple geometric motifs in bright colors. Inspired by the sights of a parade, their shapes were abstracted from balloons, confetti, and even an American flag.

Wright designed the interior furnishings for almost all of his buildings,

thereby creating an organic unity of the whole and its parts. Art glass was integral to the architectural fabric of many of his early works. The arranging of shapes into patterns in the Coonley Playhouse windows relates to the formal strategies Wright adopted in his architecture. His belief in the universality of fundamental geometric forms was as much a response to rational methods of modern machine production as an intuitive understanding that abstract forms carried shared spiritual values. Geometric forms had played a role in Wright's own childhood education through a German system of educational toys, the Froebel blocks, which he later credited as a major influence on his ideas about architecture.

Gerrit Rietveld Dutch, 1888–1964

Red Blue Chair. c. 1923

Painted wood, 34⅛ × 26 × 33"
(86.7 × 66 × 83.8 cm)
Gift of Philip Johnson

In the Red Blue Chair, Rietveld manipulated rectilinear volumes and examined the interaction of vertical and horizontal planes, much as he did in his architecture. Although the chair was originally designed in 1918, its color scheme of primary colors (red, yellow, blue) plus black—so closely associated with the de Stijl group and its most famous theorist and practitioner Piet Mondrian—was applied to it around 1923. Hoping that much of his furniture would eventually be mass-produced rather than handcrafted, Rietveld

aimed for simplicity in construction. The pieces of wood that comprise the Red Blue Chair are in the standard lumber sizes readily available at the time.

Rietveld believed there was a greater goal for the furniture designer than just physical comfort: the well-being and comfort of the spirit. Rietveld and his colleagues in the de Stijl art and architecture movement sought to create a utopia based on a harmonic human-made order, which they believed could renew Europe after the devastating turmoil of World War I. New forms, in their view, were essential to this rebuilding.

Max Ernst French, born Germany. 1891–1976

The Hat Makes the Man. 1920

Gouache, pencil, oil, and ink on cut-and-
pasted printed paper on paper, 13⅞ × 17¾"
(35.2 × 45.1 cm)
Purchase

Pictures of ordinary hats cut out of a
catalogue are stacked one atop the
other in constructions that resemble
both organic, plantlike forms and
anthropomorphic phalluses. With the
inscription, "seed-covered stacked-up
man seedless waterformer ('edel-
former') well-fitting nervous system
also tightly fitted nerves! (the hat
makes the man) (style is the tailor),"
Ernst incorporates verbal humor into
this subversive visual pun.

The artist was a major figure of
the Dada group, which embraced the
concepts of irrationality and obscure
meaning. *The Hat Makes the Man*
illustrates the use of mechanical repro-
ductions to record Ernst's own halluci-
natory, often erotic visions. The origin
of this collage is a sculpture made
from wood hat molds that Ernst cre-
ated in 1920 for a Dada exhibition in
Cologne. The repetition of the hat,
indicative of part of the bourgeois uni-
form, suggests the Dadaist view of
modern man as a conformist puppet.
Thus, in true Dada fashion, Ernst com-
bines the contradictory elements of an
inanimate object with references to
man and to nature; symbols of social
conventionality are equated with sexu-
ally charged ones.

Marcel Duchamp American, born France. 1887–1968

Bicycle Wheel. 1951 (third version, after lost original of 1913)

Assemblage: metal wheel, 25½" (63.8 cm) diam., mounted on painted wood stool, 23¾" (60.2 cm) high; overall, 50½ × 25½ × 16⅝" (128.3 × 63.8 × 42 cm)
The Sidney and Harriet Janis Collection

Bicycle Wheel is Duchamp's first Readymade, a class of artworks that raised fundamental questions about artmaking and, in fact, about art's very definition. This example is actually an "assisted Readymade": a common object (a bicycle wheel) slightly altered, in this case by being mounted upside-down on another common object (a kitchen stool). Duchamp was not the first to kidnap everyday stuff for art; the Cubists had done so in collages, which, however, required aesthetic judgment in the shaping and placing of materials. The Readymade, on the other hand, implied that the production of art need be no more than a matter of selection—of choosing a preexisting object. In radically subverting earlier assumptions about what the artmaking process entailed, this idea had enormous influence on later artists, particularly after the broader dissemination of Duchamp's thought in the 1950s and 1960s.

The components of *Bicycle Wheel*, being mass-produced, are anonymous, identical or similar to countless others. In addition, the fact that this version of the piece is not the original seems inconsequential, at least in terms of visual experience. (Having lost the original *Bicycle Wheel*, Duchamp simply remade it almost four decades later.) Duchamp claimed to like the work's appearance, "to feel that the wheel turning was very soothing." Even now, *Bicycle Wheel* retains an absurdist visual surprise. Its greatest power, however, is as a conceptual proposition.

Jean (Hans) Arp French, born Germany (Alsace). 1886–1966

Untitled (Collage with Squares Arranged according to the Laws of Chance). 1916–17

Torn-and-pasted paper and colored paper on colored paper, 19⅛ × 13⅝" (48.6 × 34.6 cm)
Purchase

This elegantly composed collage of torn-and-pasted paper is a playful, almost syncopated composition in which uneven squares seem to dance within the space. As the title suggests, it was created not by the artist's design, but by chance. In 1915 Arp began to develop a method of making collages by dropping pieces of torn paper on the floor and arranging them on a piece of paper more or less the way they had fallen. He did this in order to create a work that was free of human intervention and closer to nature. The incorporation of chance operations was a way of removing the

artist's will from the creative act, much as his earlier, more severely geometric collages had substituted a paper cutter for scissors, so as to divorce his work from "the life of the hand."

Arp was a founding member of the first Dada group that coalesced in Zurich in 1916 around the Cabaret Voltaire of Hugo Ball, the poet and performer. Dada—its name a nonsensical word chosen at random from the dictionary—was formed to prove the bankruptcy of existing styles of artistic expression rather than to promote a particular style itself. "Dada," wrote Arp, "wished to destroy the hoaxes of reason and to discover an unreasoned order." While this work is far less violent than some of the rhetoric of Dada, Arp's exemplary use of serendipitous composition here perfectly embodies what has been called the heart of Dada practice—the gratuitous act.

Marcel Duchamp American, born France, 1887–1968

3 Standard Stoppages. 1913–14

Assemblage: three threads glued to three painted canvas strips, each 5¼ × 47¼" (13.3 × 120 cm), each mounted on a glass planel, 7¼ × 49⅜ × ¼" (18.4 × 125.4 × .6 cm); three wood slats, 2½ × 43 × ⅛" (6.2 × 109.2 × .2 cm), 2½ × 47⅛" (6.1 × 109.7 × .2 cm), shaped along one edge to match the curves of the threads; the whole fitted into a wood box, 11⅛ × 50⅞ × 9" (28.2 × 129.2 × 22.7 cm)
Katherine S. Dreier Bequest

A working note of Duchamp's describes his idea for this enigmatic work: "A straight horizontal thread one meter long falls from a height of one meter onto a horizontal plane twisting *as it pleases* and creates a new image of the unit of length." Here, three such threads, each fixed to its own canvas with varnish, and each canvas glued to its own glass panel, are enclosed in a box, along with three lengths of wood (draftsman's straightedges) cut into the shapes drawn by the three threads.

Duchamp later said that *3 Standard Stoppages* opened the way "to escape from those traditional methods of expression long associated with art," such as what Duchamp called "retinal painting," art designed for the luxuriance of the eye. This required formal intelligence and a skillful hand on the part of the artist. The Stoppages, on the other hand, depended on chance—which, paradoxically, they fixed and "standardized." (Duchamp used the phrase "canned chance.") Subordinating art to accident and to something approximating the scientific method (which they simultaneously parodied), *3 Standard Stoppages* advanced a conceptual approach, an absurdist strain, and a way of commenting on both art and the broader culture that inspired countless later artists of many different kinds.

Francis Picabia French, 1879–1953

I See Again in Memory My Dear Udnie. (1914, perhaps begun 1913)

Oil on canvas, 8' 2½" × 6' 6¼"
(250.2 × 198.8 cm)
Hillman Periodicals Fund

Like the Futurists and like his friend Marcel Duchamp, Picabia recognized the importance of the machine in the dawning technological age. The hard-edged, evenly rounded shapes of *I See Again in Memory My Dear Udnie*, some of them in metallic grays, parallel fusions of the mechanical and the organic in Duchamp's painting and anticipate more overt references of this kind in Picabia's later work. Perspectival lines at the painting's sides suggest a space around this fragmented body, which seems to stand on a kind of stage. Segmented tubes among the curling forms may have a sexual subtext, and Picabia himself described his art of this period as trying "to render external an internal state of mind or feeling."

The "Udnie" of this work's title was surely a certain Mlle Napierskowska, a professional dancer whom Picabia met on the ocean liner that took him to the United States to participate in the famous Armory Show of 1913. Fascinated by Napierskowska's performances (which were suggestive enough to provoke her arrest during her American tour), Picabia began to produce gouaches and watercolors inspired by her even before landing in New York. Over the following year, he extended this imagery in paintings, titling one of them *Udnie (Young American Girl)*—and thus suggesting that the abstract planes of these works relate to the human form.

Lois Weber American, 1882–1939
Phillips Smalley American, 1875–1939

Suspense. 1913

35mm film, black and white, silent,
12 minutes (approx.)
National Film and Television Archive, British
Film Institute (by exchange)
Sam Kaufman, Valentine Paul, Lois Weber

The story of *Suspense*, a one-reel thriller, is a simple one—a tramp threatens a mother and child, while the father races home to their rescue—but the techniques used to tell it are complex. Weber and Smalley employ a dizzying array of formal devices. The approach of an automobile is reflected in another car's side-view mirror. We catch our first glimpse of the burglar from the same angle as the wife does—from directly above while he glares straight up. Three simultaneous actions are shown, not sequentially but as a triptych within one frame.

Smalley and Weber began their film careers as a husband-and-wife team acting under the direction of Edwin S. Porter at the Rex Company, one of the many early independent film studios established to combat the power of the Motion Picture Patents Company, a conglomeration of the major producers and distributors in the United States. By the time Porter left Rex, in 1912, Smalley and Weber had graduated to directing and were fully responsible for the small studio's output. *Suspense* is one of the very few films made at Rex that survives, and its staggering originality raises a tantalizing question: is it a fascinating anomaly or a representative sample of the studio's overall production?

Paul Strand　American, 1890–1976

Fifth Avenue, New York. 1915

Platinum print, 12¼ × 8¼" (31.2 × 20.8 cm)
Gift of the photographer

The shallow composition, as in a Japanese print, empty at the center and crowded at the edges; the muted tones, as in a print by James MacNeill Whistler; and the elegant shape made by the tethered flag, which rhymes with the spires of the church: these are survivals of photography's aesthetic movement at the turn of the century.

Strand's momentary glimpse of individual pedestrians strolling near a specific church—St. Patrick's Cathedral—on a particular stretch of Fifth Avenue in New York hints of concrete experience and points toward the challenges that the art of photography faced as it emerged from its aesthetic cloister. A woman in the foreground makes eye contact with the photographer. As a result, she is transformed from an element in a decorative frieze into a person with a mind of her own.

John Marin American, 1870–1953

Brooklyn Bridge (Mosaic). 1913

Etching and drypoint, plate: 11¼ × 8⅞"
(28.6 × 22.5 cm)
Publisher: 291 (Alfred Stieglitz), New York.
Edition: approx. 20
Gift of Abby Aldrich Rockefeller

The Brooklyn Bridge, a world-renowned symbol of New York City and an icon of technological achievement, has been an attractive subject for artists since its completion in 1883. Marin's etched image presents its pointed cathedral-like arches and strong, steel suspension cables in a bold and heroic fashion. At the same time, the work generates a sense of the hustle and bustle of city life through the dynamic groupings of lines that break up the composition.

Brooklyn Bridge (Mosaic) was created two years after Marin returned to New York from Paris and is an example of how much this American city energized the artist, who found the people, the skyscrapers, and the bridges "alive" and, in their interaction, playing "great music." It is one of a group of six New York etchings made by Marin and published by the photographer and art dealer Alfred Stieglitz, who showed them at his gallery at 291 Fifth Avenue. Stieglitz championed a circle of young American artists and was particularly supportive of Marin.

D. W. Griffith American, 1875–1948

Intolerance. 1916

35mm film, black and white and color-tinted,
silent, 196 minutes (approx.)
Acquired from the artist

Intolerance is one of the earliest formal masterpieces of cinema. Its ambitious scale and lavish production—exemplified by the enormous, if historically inaccurate, set for the court of Babylon—were unprecedented at the time it was made. The film was to serve as a mighty sermon against the hideous effects of intolerance; in it, Griffith proposed his view of history and myth. *Intolerance* interweaves his unfinished work, *The Mother and the Law*, a contemporary melodrama about the hypocrisy of well-off do-gooders set in the United States, with three parallel stories of earlier times: Christ at Calvary, the razing of Babylon by Persians, and the persecution of the Huguenots in France. Griffith explained the film: "The stories begin like four currents looked at from a hilltop. At first the four currents flow apart, slowly and quietly. But as they flow, they grow nearer and nearer together, and faster and faster, until in the end, in the last act, they mingle in one mighty river of expressed emotion."

The scale and extravagance of *Intolerance* brought Hollywood to the fore as the center for American film production. The film also exercised enormous international influence, particularly in post-Revolutionary Russia, where Lenin commended the scope and purpose of the film. But the complexity of the structure seemed to baffle early audiences, and *Intolerance* was a box-office failure, although Griffith's previous film, *The Birth of a Nation* (1915), had been a great success.

Claude Monet French, 1840–1926

Water Lilies. 1914–26

Oil on canvas, triptych, each panel 6' 6" × 14' (200 × 425 cm)
Mrs. Simon Guggenheim Fund

Visitors to Monet's Giverny studio in 1918 found "a dozen canvases placed in a circle on the floor . . . [creating] a panorama made up of water and lilies, of light and sky. In that infinitude, water and sky have neither beginning nor end." What they had seen was a group of paintings that Monet planned to install abutting each other in an oval, encompassing the viewer in a sensually enveloping space. The aim, he said, was to supply "the illusion of an endless whole, of water without horizon or bank." The *Water Lilies* triptych comes from this series, which describes a scene Monet not only showed in art but shaped in life: the pond in his own garden.

Like his fellow Impressionists, Monet, when young, had attempted a faithfulness to perceived reality, trying to capture the constantly changing quality of natural light and color. The *Water Lilies*, though, seem nearly abstract, for their scale and allover splendor so immerse us in visual experience that spatial cues dissolve: above and below, near and far, water and sky commingle. Perhaps this was the quality that led Monet's visitors to say, "We seem to be present at one of the first hours in the birth of the world." Yet Monet's desire that the installation create "the refuge of a peaceful meditation" seems equally to have been fulfilled.

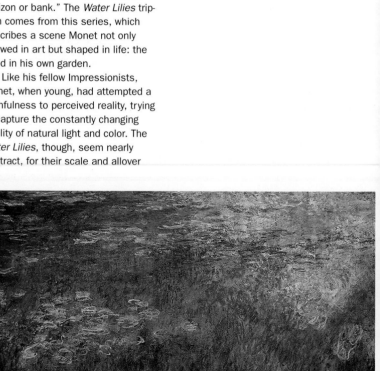

Frank Lloyd Wright American, 1867–1959

La Miniatura, Mrs. George Madison Millard House, Pasadena, California. 1923

Perspective: colored pencil and pencil on gampi paper, 20⁹⁄₁₆ × 19¹¹⁄₁₆" (52.2 × 50 cm)
Gift of Mr. and Mrs. Walter Hochschild

La Miniatura, the Millard House in Pasadena, is the earliest in a series known as the Textile Block houses, designed by Wright in the 1920s; all are located in southern California. This color rendering depicts the Millard House in its lush surroundings. The house is constructed of a combination of plain-faced and ornamental concrete blocks, which were cast on the site from molds designed by Wright. The square blocks, with perforated, glass-filled apertures, form a continuous interior and exterior fabric. The relatively small scale of the blocks allows for a design that closely follows the contours of the landscape.

In his autobiography Wright wrote: "The concrete block? The cheapest (and ugliest) thing in the building world. . . . Why not see what could be done with that gutter-rat?" In his Textile Block houses Wright attempted to introduce a flexible building system, marrying the merits of standardized machine production to the innovative, creative vision of the artist. While the block system was intended to be an efficient, low-cost method of building that incorporated ornament, it proved to be time consuming and more expensive than traditional construction.

Joan Miró Spanish, 1893–1983

The Birth of the World. 1925

Oil on canvas, 8' 2¾" × 6' 6¾"
(250.8 × 200 cm)
Acquired through an anonymous fund, the
Mr. and Mrs. Joseph Slifka and Armand G. Erpf
Funds, and by gift of the artist

According to the first Surrealist mani-
festo of 1924, "the real functioning
of the mind" could be expressed by
a "pure psychic automatism," "the
absence of any control exercised by rea-
son." Miró was influenced by Surrealist
ideas, and said, "Rather than setting
out to paint something, I begin painting
and as I paint, the picture begins to
assert itself. . . . The first stage is free,
unconscious." But, he added, "The
second stage is carefully calculated."

The Birth of the World reflects just
this combination of chance and plan.
Miró primed the canvas unevenly, so

that paint would here sit on the sur-
face, there soak into it. His methods of
applying paint allowed varying degrees
of control—pouring, brushing, flinging,
spreading with a rag. The biomorphic
and geometric elements, meanwhile,
he drew deliberately, working them out
in a preparatory drawing.

Miró's works in this vein suggest
something both familiar and unidentifi-
able, yet even at his most ethereal,
Miró never loses touch with the real
world: we see a bird, or a kite; a shoot-
ing star, a balloon on a string, or a
spermatozoa; a character with a white
head. The Birth of the World is the
first of many Surrealist works that deal
metaphorically with artistic creation
through an image of the creation of a
universe. In Miró's words, it describes
"a sort of genesis."

Max Ernst French, born Germany. 1891–1976

Two Children Are Threatened by a Nightingale. 1924

Oil on wood with wood construction, 27½ × 22½ × 4½" (69.8 × 57.1 × 11.4 cm)
Purchase

In *Two Children Are Threatened by a Nightingale*, a girl, frightened by the bird's flight (birds appear often in Ernst's work), brandishes a knife; another faints away. A man carrying a baby balances on the roof of a hut, which, like the work's gate (which makes sense in the picture) and knob (which does not), is a three-dimensional supplement to the canvas. This combination of unlike elements, flat and volumetric, extends the collage technique, which Ernst cherished for its "systematic displacement." "He who speaks of collage," the artist believed, "speaks of the irrational." But even if the scene were entirely a painted illusion, it would have a hallucinatory unreality, and indeed Ernst linked his work of this period to childhood memories and dreams.

Ernst was one of many artists who emerged from service in World War I deeply alienated from the conventional values of his European world. In truth, his alienation predated the war; he would later describe himself when young as avoiding "any studies which might degenerate into bread winning," preferring "those considered futile by his professors—predominantly painting. Other futile pursuits: reading seditious philosophers and unorthodox poetry." The war years, however, focused Ernst's revolt and put him in contact with kindred spirits in the Dada movement. He later became a leader in the emergence of Surrealism.

Tullio d'Albisola
(Tullio Spartaco Mazzotti) Italian, 1899–1971

Parole in libertà futuriste, tattili-termiche olfattive by Filippo Tommaso Marinetti. 1932–34

Illustrated book with 26 lithographs on metal, page: 9³⁄₁₆ × 8¹¹⁄₁₆" (23.3 × 22 cm)
Publisher: Edizioni Futuriste di Poesia, Rome.
Edition: approx. 25
Gift of The Associates of the Department of Prints and Illustrated Books and of Elaine Lustig Cohen in memory of Arthur A. Cohen

This extraordinary book, with its cover and bound pages made completely of metal, heralds technological achievement in the service of art. Marinetti, the Futurist artist, poet-author, and force behind this project, consulted with workers in a can factory in Savona, Italy, which had printed a poem on a sheet of tin in 1931.

The making of this book, however, posed special difficulties in devising a spine that allowed the heavy pages to turn freely. The solution was the cylindrical mechanism seen at the left edge of the cover. The layout of the book was designed by Marinetti and d'Albisola, a sculptor and ceramist who executed the lithographs, combining typography with crisp geometric shapes. As seen on this cover, the artist created dynamic compositions, using sleek modern typefaces in boldly distorted sizes.

The Futurists promoted free verse and poetry based on sound rather than meaning, expanding their reach to the visual and performing arts. They exalted the machine, with its seemingly limitless possibilities for the future, as a symbol of the modern age. *Parole in libertà futuriste* represents a remarkable collaboration of artist, artisan, technician, and machine, which resulted in the first mechanical book.

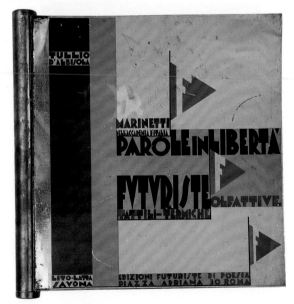

Carl Theodor Dreyer Danish, 1889–1968

La Passion de Jeanne d'Arc (The Passion of Joan of Arc). 1928

35mm film, black and white, silent,
89 minutes (approx.)
Acquired by exchange with Cinémathèque
Française
Renée (Maria) Falconetti

Made at the end of the silent-film era, Dreyer's version of the trial and execution at the stake of Joan of Arc, her ecstasy, and above all her suffering, is the filmmaker's great work. The setting is austere, the architecture grim, as the film's physical imagery heightens the sense of tragedy during the long interrogation of the maid of Orleans. Huge close-ups of faces dominate the drama; many appear without the context of establishing shots. Oblique camera angles and distorting facial expressions are used for expressive effect. The film's pace is measured and the conclusion inexorable.

Dreyer based the chronicle of Joan's demise on contemporary court documents of her trial but reduced days of questioning into one and offered little historical context in the film's intertitles, which provide the dialogue of the interrogation. Although the rare appearance on film of the French dramatist and poet Antonin Artaud (as a prosecutor) is of historical interest, it is Falconetti, as Joan, who gives one of the most intense performances in the history of cinema, heightening the work's transcendental power.

F. W. Murnau German, 1888–1931

Der letzte Mann (The Last Laugh).
1924

35mm film, black and white, silent,
77 minutes (approx.)
Acquired from Universum Film (UFA)
Emil Jannings

Murnau's silent film *The Last Laugh* tells the tragic story of a self-confident hotel porter, brilliantly portrayed by Jannings, who is demoted to lavatory attendant. The porter's entire identity is based upon his position and especially on his uniform, which symbolizes power and respectability to his lower-middle-class community of family and friends. The film's most shocking and brutal moment comes when the hotel manager unrelentingly strips the pleading porter of his uniform; it is as if the porter's skin were being ripped off. But this is only the beginning of his trials. The film's unexpected deus-ex-machina ending tries to whitewash the porter's suffering, but his tragic decline remains unforgettable.

Dispensing with the customary intertitles, and filming while moving the camera in extraordinarily inventive ways, Murnau and his cinematographer, Karl Freund, transformed the language of film. In shooting the opening sequence, the camera descended in the hotel's glass elevator and was then carried on a bicycle through the lobby. In addition, *The Last Laugh* succeeds in combining expressionist elements, such as extreme camera angles, distorted dream imagery, and disturbing light and shadow effects, with a complex psychological study of the main character in his fall from privilege.

Fernand Léger French, 1881–1955

Three Women. 1921

Oil on canvas, 6' ¼" × 8' 3"
(183.5 × 251.5 cm)
Mrs. Simon Guggenheim Fund

In *Three Women*, Léger translates a common theme in art history—the reclining nude—into a modern idiom, simplifying the female figure into a mass of rounded and somewhat dislocated forms, the skin not soft but firm, even unyielding. The machinelike precision and solidity that Léger gives his women's bodies relate to his faith in modern industry and to his hope that art and the machine age would together remake the world. The painting's geometric equilibrium, its black bands and panels of white, suggest his awareness of Mondrian, an artist then becoming popular. Another stylistic trait is the return to variants of classicism, which was widespread in French art after the chaos of World War I. Though buffed and polished, the simplified volumes of Léger's figures are, nonetheless, in the tradition of classicists of the previous century.

A group of naked women taking tea or coffee together may also recall paintings of harem scenes, for example, by Jean-Auguste-Dominique Ingres, although there the drink might be wine. Updating the repast, Léger also updates the setting—a chic apartment, decorated with fashionable vibrancy. And the women, with their flat-ironed hair hanging to one side, have a Hollywood glamour. The painting is like a beautiful engine, its parts meshing smoothly and in harmony.

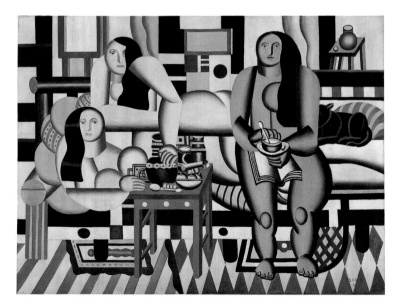

Eugène Atget French, 1857–1927

Store, avenue des Gobelins. 1925

Albumen silver print, 8⅛ × 6⁵⁄₁₆" (20.6 × 16 cm) Abbott-Levy Collection. Partial gift of Shirley C. Burden

For more than three decades, Atget photographed Paris—its ancient streets and monuments and finely wrought details, its corners and hovels and modern commerce, and its outlying parks. He was not an artist in the conventional sense but a specialized craftsman who supplied pictorial records of French culture to artists, antiquarians, and librarians. That, at least, is how he earned his living. Shortly before his death, however, other photographers began to recognize that Atget's work is art in everything but name: full of wit, invention, beauty, wisdom, and the disciplined cultivation of original perceptions.

This picture of the front of a men's clothing store belongs to a series of photographs of store windows that Atget made in the highly creative last years of his life. He easily could have minimized the reflection in the window, in which we see part of the Gobelins complex, where tapestries had been made for nearly three centuries. Instead, he welcomed it. Indelibly melding two images into one, the photograph simultaneously evokes France's modern fashions and one of her most noble artistic traditions.

René Magritte Belgian, 1898–1967

The False Mirror. 1929

Oil on canvas, 21¼ × 31⅞" (54 × 80.9 cm)
Purchase

A huge, isolated eye stares out at the viewer. Its left inner corner has a vivid, viscous quality. The anatomical detailing of this area and its surface sheen contrast with the matte, dead-black of the eye's pupil that floats, unmoored, against a limpid, cloud-filled sky of cerulean blue. Although the areas surrounding the eye's iris and pupil are carefully shaded and modeled, giving the illusion of a play of light on three-dimensional form, the sky displays no trace of convexity; its puffy clouds are beautifully modeled, but not its blue expanse. As a result, the sky appears as though seen through a circular window rather than mirrored in the spherical, liquid surface of an eye's iris.

The eye was a subject that fascinated many Surrealist poets and visual artists, given its threshold position between inner, subjective self and the external world. The Surrealist photographer Man Ray once owned *The False Mirror*, which he memorably described as a painting that "sees as much as it itself is seen." His words capture the work's unsettling character: it places the viewer on the spot, caught between looking through and being watched by an eye that proves to be empty. It opens onto a void that, for all its radiant, cumulus-cloud-filled beauty, seems to deny the possibility of human existence.

El Lissitzky (Lazar Markovich Lissitzky) Russian, 1890–1941

USSR Russische Ausstellung (USSR Russian Exhibition). 1929

Poster: gravure, 49 × 35¼" (124.5 × 89.5 cm)
Jan Tschichold Collection. Gift of Philip Johnson

This propaganda poster, publicizing an exhibition in Switzerland about the Soviet Union, shows El Lissitzky's characteristic application of the photomontage technique, part of the new visual vocabulary employed in the graphic arts, replacing the objective art of illustration with collage. The two idealized portraits show young Soviets peering happily into Russia's bright future. Their androgyny and joined faces suggest the equal roles young men and women were to play in building the new Soviet society.

Visual artists in the Soviet Union rejected the fine arts in favor of the functional arts after the Bolshevik Revolution of 1917. It was believed that while painting and sculpture would have little utility in the burgeoning socialist regime, design could help advance the goals of the Revolution. Graphic design became the medium of choice for promoting specific political agendas.

El Lissitzky traveled more frequently than many of his Russian colleagues and thus was an important link between developments at the German Bauhaus, the Dutch de Stijl and the Russian Constructivist movements of the 1920s and 1930s. His use of montage, straightforward typography, and dynamic compositions greatly influenced the evolution of modern graphic design.

Aleksandr Rodchenko Russian, 1891–1956

Spatial Construction Number 12.
c. 1920

Plywood, open construction partially painted
with aluminum paint, and wire, 24 × 33 ×
18½" (61 × 83.7 × 47 cm)
Acquisition made possible through the extraor-
dinary efforts of George and Zinaida Costakis,
and through the Nate B. and Frances Spin-
gold, Matthew H. and Erna Futter, and Enid A.
Haupt Funds

Made up of different-sized ovals that
nest and intersect, *Spatial Construction
Number 12* hangs suspended, moving
slowly with any current of air. The ovals
were measured out on a single flat
sheet of plywood, precisely cut, then
rotated within each other to make a
three-dimensional object resembling a
gyroscope. The resulting form suggests
a chart of planetary orbits, a cosmic
structure. In companion pieces,

Rodchenko applied the same principle
and method to other basic geometric
forms, such as the square, but those
works no longer survive.

Rodchenko's interest in mathemat-
ical systems reflects the scientific bent
of the Russian Constructivists, artists
who aspired to create a radically new,
radically rational art for the society
that came into being with the Russian
Revolution. *Spatial Construction* is a
stage in Rodchenko's progress away
from conventional painting and toward
an art taking place in space—ultimately,
an art of social involvement. The work
has no top, no bottom, no base to rest
on. It is virtually weightless, with sus-
pension and movement replacing mass.
In short, it was designed to be every-
thing traditional sculpture was not—to
reimagine art from ground zero.

Dziga Vertov Russian, 1896–1954

Chelovek S Kinoapparatom (The Man with the Movie Camera).
1929

35mm film, black and white, silent,
65 minutes (approx.)
Acquired by exchange with Gosfilmofond

As *The Man with the Movie Camera* begins, the cameraman climbs out of the "head" of the camera. The film then takes its viewer on a kaleidoscopic, humorous ride through Soviet cities while drawing parallels between the moviemaker and the factory laborer, and exposing the filmmaking process. At one moment, Vertov presents a man riding a motorcycle, and then, surprisingly, shows us shots of the cameraman filming the motorcycle, then shots of the editor editing these shots. By making use of all filming strategies then available—including superimposition, split screens, and varied speed—Vertov created a revolution in cinematic art with his defiant deconstruction of moviemaking and dramatic norms.

Vertov, who adopted this pseudonym meaning "spinning top," stated: "We proclaim the old films, based on romance, theatrical films and the like, to be . . . mortally dangerous! Contagious!" Under the influence of Futurist art theories and Futurism's confidence in the machine, the medical student Denis Kaufman renamed himself and began experiments with sound recording and assemblage. After the Bolshevik Revolution, along with his wife/editor and brother/cameraman, he made films and developed polemics that called for the death of filmmaking and relied on artifice and drama. Like others of his generation, Vertov wanted to replace the human eye with the *kinoki*, an objective cinematic eye, in order to help build a new proletarian society.

Aleksandr Rodchenko

Russian, 1891–1956

Assembling for a Demonstration.
1928–30

Gelatin silver print, 19½ × 13⅞"
(49.5 × 35.3 cm)
Mr. and Mrs. John Spencer Fund

Photographs made from above or below or at odd angles are all around us today—in magazine and television ads, for example—but for Rodchenko and his contemporaries they were a fresh discovery. To Rodchenko they represented freedom and modernity because they invited people to see and think about familiar things in new ways. This courtyard certainly was familiar to Rodchenko; he made the picture from the balcony of his own Moscow apartment.

The photograph strikes a perfect balance between plunging depth and a flat pattern—two darker forms enclosing a lighter one—and between this simple pattern and the many irregular details that enliven it. Rodchenko's control over the image is suggested by his particular point of view: to keep the balcony below him from intruding its dark form into the lighter courtyard, he was obliged to lean rather precariously over the railing of his own balcony.

Sergei Eisenstein Russian, 1898–1948

Bronenosets Potemkin (Potemkin). 1925

35mm film, black and white and hand-colored,
silent, 75 minutes (approx.)
Acquired from Reichsfilmarchiv

Eisenstein used the events of the 1905 rebellion against czarist troops in the port of Odessa to give meaning to the Russian Revolution of 1917. *Bronenosets Potemkin* is made up of five major sequences: the rebellion of the ship's sailors over rotten food, the mutiny on the quarterdeck, the display of the martyr's body on the quay, the massacre of civilians on the Odessa steps, and the triumphant sailing of the battleship to meet the fleet. All of them exhibit Eisenstein's self-conscious manipulation of the medium of film. One of the most memorable shots, comprising the Odessa steps sequence, for example, captures the horror of the massacre in a close-up of a woman screaming after she has been wounded by the advancing soldiers. Eisenstein's brilliantly percussive editing, detailed shots, repetitions, contrasts, compressions and expansions of time, and collisions of images ran counter to the trend toward a seamless illusion of reality found in other national cinemas of the 1920s.

With this film, Soviet cinema took a central place on the world scene, in spite of the fact that the film was censored, even banned, in many countries for its powerful glorification of the Soviet ideal. After the Revolution, young film directors searched for a cinematic style that, by destroying tradition, would help to bring about a new society. In films on revolutionary subjects, they abandoned conventional structure, experimented with new techniques, and used montage. Eisenstein, in particular, believed that juxtapositions of images would shock viewers into becoming active cinematic agents.

Käthe Kollwitz German, 1867–1945

The Widow I, The Mothers, and The Volunteers from the portfolio **War.** 1922–24

Woodcuts, each sheet 18⅝ × 26"
(46.7 × 66 cm) (approx.)
Publisher: Emil Richter, Dresden. Edition: 200
Gift of the Arnhold Family in memory of
Sigrid Edwards

These prints express the raw agony that war inflicts on humanity. In *The Widow I*, a woman hugs herself in anguish. Her rounded form and the tender contact of her massive hands over her chest and abdomen suggest that she may be pregnant, lending further poignancy to her situation. In *The Mothers*, a group of women locked in tight embrace console each other, while two frightened children peer out from beneath their protective huddle. In *The Volunteers*, four young men, whose distressed faces and clenched fists betray their sense of doom yet determination, volunteer to fight as they follow a drumming figure with a deathlike mask. Grief and torment pervade each of these images, so graphically conveyed by the crude slashes and gouges of the woodcut medium.

War is one of several portfolios of prints by German artists focusing on the savagery of World War I. But rather than show the brutalities of warfare and bombing experienced by soldiers, the artist portrays the emotional responses of civilians. Although her sense of loss was very personal—her younger son Peter was killed in combat in Flanders—Kollwitz presents universal visions of the unending sorrow generated by war for those left behind.

Kurt Schwitters German, 1887–1948

Merz Picture 32 A (The Cherry Picture). 1921

Cut-and-pasted colored and printed paper, cloth, wood, metal, cork, oil, pencil, and ink on paperboard, 36⅛ × 27¾" (91.8 × 70.5 cm)
Mr. and Mrs. A. Atwater Kent, Jr. Fund

This highly animated picture is dominated by rectangular pieces of paper that cover the surface of the work. Schwitters created the illusion of depth by placing those papers with darker components behind those that are lighter in aspect. The brightest piece of paper, in the center of the composition, shows an eye-catching cluster of cherries and the printed German and French words for the fruit.

In the winter of 1918–19 Schwitters had collected bits of newspaper, candy wrappers, and other debris, and began making the collages and assemblages for which he is best known today. *The Cherry Picture* belongs to a group of these works he called *Merz*, a nonsensical word that he made up by cutting a scrap from a newspaper: the second syllable of the German word *Kommerz*, or commerce.

By 1921 Schwitters had been painting seriously for ten years, largely in different naturalistic styles. In doing so, he learned how all art was based on measurement and adjustment and the manipulation of a variable but finite number of pictorial elements. He never forgot these lessons, which form a bridge between his earlier, representational work and the purely formal manipulation of found materials in the *Merz* pictures.

Hannah Höch  German, 1889–1978

Indian Dancer: From an Ethnographic Museum. 1930

Cut-and-pasted printed paper and metallic foil on paper, 10⅛ × 8⅞" (25.7 × 22.4 cm)
Frances Keech Fund

In this collage Höch obliquely makes reference to Joan of Arc, the androgynous heroine who went to battle dressed as a man, was later charged with heresy, burned at the stake, and subsequently regarded as a martyr. The mask covering the mouth and one eye may be read as an effort to restrain the figure, while the cutlery on the crown emphasizes the domestic role that women usually play. The paper framing the truncated head simulates the museological presentation of an object. In this compellingly strange image, it is the modern woman rather than a colonized artifact that is on display.

The woman in the photograph affixed to this work is the actress Renée (Maria) Falconetti portraying the title role in Carl Theodor Dreyer's 1928 film *The Passion of Joan of Arc.* Over the mournful face, Höch pasted a fragmented photograph of an African wood dance mask and, on top, a paper-and-foil headdress ornamented with cutouts of knives and spoons. This work belongs to a series of photomontages called From an Ethnographic Museum (1924–34), most of which juxtapose images of women and magazine reproductions of tribal art. Höch cited a visit to an ethnographic museum as an influence in the conception of this series; however, she used ethnographic material mostly as a point of departure in order to comment on the status of women in contemporary German society.

Paul Klee German, born Switzerland. 1879–1940

Twittering Machine. 1922

Oil transfer drawing, watercolor and ink on
paper with gouache and ink borders on board,
25¼ × 19" (64.1 × 48.3 cm)
Purchase

The "twittering" in the title doubtless
refers to the birds, while the "machine"
is suggested by the hand crank. The
two elements are, literally, a fusing of
the natural with the industrial world.
Each bird stands with beak open,
poised as if to announce the moment
when the misty cool blue of night gives
way to the pink glow of dawn. The scene
evokes an abbreviated pastoral—but
the birds are shackled to their perch,
which is in turn connected to the
hand crank.

Upon closer inspection, however, an
uneasy sensation of looming menace
begins to manifest itself. Composed of
a wiry, nervous line, these creatures
bear a resemblance to birds only in
their beaks and feathered silhouettes;
they appear closer to deformations of
nature. The hand crank conjures up
the idea that this "machine" is a music
box, where the birds function as bait
to lure victims to the pit over which the
machine hovers. We can imagine the
fiendish cacophony made by the shriek-
ing birds, their legs drawn thin and taut
as they strain against the machine to
which they are fused.

Klee's art, with its extraordinary
technical facility and expressive color,
draws comparisons to caricature,
children's art, and the automatic draw-
ing technique of the Surrealists. In
Twittering Machine, his affinity for the
contrasting sensibilities of humor and
monstrosity converges with formal
elements to create a work as intriguing
in its technical composition as it is in
its multiplicity of meanings.

Oskar Schlemmer German, 1888–1943

Bauhaus Stairway. 1932

Oil on canvas, 63⅞ × 45" (162.3 × 114.3 cm)
Gift of Philip Johnson

Visiting Stuttgart in the spring of 1933, Alfred H. Barr, Jr., the founding director of The Museum of Modern Art, discovered that an exhibition by Schlemmer had closed after a brutal and intimidating review in a Nazi paper. Barr responded by cabling Philip Johnson, already a frequent donor to The Museum of Modern Art, to ask him to acquire *Bauhaus Stairway* as an eventual gift. Barr acted, he later wrote, "partly to spite the Nazis just after they had closed [Schlemmer's] exhibition."

Schlemmer painted *Bauhaus Stairway* three years after leaving his teaching post at the Bauhaus, the famous school of modern art, architecture, and design. The work's gridded structure celebrates Bauhaus design principles, and its upward movement, including the man *en pointe* at top left (Schlemmer had worked in dance), evokes the school's former optimism. Encouraging our involvement in this mood are the figures facing the same way we do, some of them partly cut off by the frame, as if they were in our space. Their simplified, almost modular shapes giving them an Everyman quality, they step up into the picture and then on up the stair.

Schlemmer's several staircase scenes of the early 1930s may reflect a desire to transcend a threatening period in German history. He exhibited this particular work soon after hearing that the Nazis had shut down the Bauhaus.

Marcel Breuer American, born Hungary. 1902–1981

Club Chair (B3). 1927–28

Chrome-plated tubular steel and canvas,
28⅛ × 30¼ × 27¾" (71.4 × 76.8 × 70.5 cm)
Manufacturer: attributed to Standard Möbel,
Germany
Gift of Herbert Bayer

While teaching at the Bauhaus, Breuer often rode a bicycle, a pastime that led him to what is perhaps the single most important innovation in furniture design in the twentieth century: the use of tubular steel. The tubular steel of his bicycle's handlebars was strong, lightweight, and lent itself to mass-production. Breuer reasoned that if it could be bent into handlebars, it could be bent into furniture forms.

The model for this chair is the traditional overstuffed club chair; yet all that remains is its mere outline, an elegant composition traced in gleaming steel. The canvas seat, back, and arms seem to float in space. The body of the sitter does not touch the steel framework. Breuer spoke of the chair as "my most extreme work . . . the least artistic, the most logical, the least 'cozy' and the most mechanical." What he might have added is that it was also his most influential work. An earlier version of this chair was designed by Breuer in 1925, and within a year, designers everywhere were experimenting with tubular steel, which would take furniture in a radically new direction. The chair was dubbed the "Wassily" after the painter Kandinsky, Breuer's friend and fellow Bauhaus instructor, who praised the design when it was first produced.

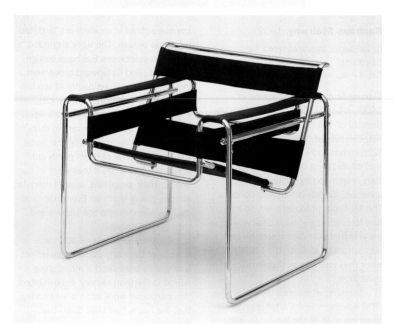

Wilhelm Wagenfeld German, 1900–1990

Carl J. Jucker Swiss, 1902–1997

Table Lamp. 1923–24

Glass and chrome-plated metal,
18 × 8" (45.7 × 20.3 cm) diam., 5½" (14 cm)
diam. at base
Manufacturer: Bauhaus Metal Workshop,
Germany
Gift of Philip Johnson

This object, known as the "Bauhaus lamp," embodies an essential idea—form follows function—advanced by the influential Bauhaus school. Founded in 1919 by the architect Walter Gropius, the school taught a modern synthesis of both fine and applied arts. Through the employment of simple geometric shapes—circular base, cylindrical shaft, and spherical shade—Wagenfeld and Jucker achieved "both maximum simplicity and, in terms of time and materials, greatest economy." The lamp's working parts are visible; the opaque glass shade, a type formerly used only for industrial lighting, helps to diffuse the light.

The lamp was produced in the Bauhaus metal workshop after its reorganization under the direction of the artist László Moholy-Nagy in 1923. The workshop promoted the use of new materials and favored mass production under a collaborative, rather than individual, approach.

Initial attempts at marketing the lamp in 1924 were unsuccessful, primarily because most of its parts were still laboriously hand-assembled at the Bauhaus. Today, the lamp is produced on an industrial scale by Tecnolumen of Bremen, Germany, and is generally perceived as an icon of modern industrial design.

Grete Schütte-Lihotzky Austrian, 1897–2000

Frankfurt Kitchen, from the Ginnheim-Höhenblick Housing Estate, Frankfurt am Main, Germany. 1926–1927

Various materials, 8' 9" × 12' 10" × 6' 10"
(266.7 × 391.2 × 208.3 cm)
Gift of Joan R. Brewster by exchange and the
Architecture and Design Purchase Fund

In the late 1920s, approximately 10,000 kitchens designed by Grete Schütte-Lihotzky were at the core of a far-reaching program to modernize public housing and infrastructure in Frankfurt, Germany. Inflation and war had precipitated a housing crisis in all major German cities. Under the direction of chief city architect Ernst May, the so-called "New Frankfurt" became a testing ground for modern architectural forms, new materials, and new construction methods.

The Frankfurt Kitchen was designed like a laboratory or factory and in accordance with contemporary theories of efficiency, hygiene, and workflow. Schütte-Lihotzky's primary goal was to reduce the burden of women's labor in the home. In planning the design, she conducted detailed time-motion studies and interviews with housewives and women's groups. Each kitchen came with a revolving stool, gas stove, built-in storage, foldaway ironing board, adjustable ceiling light, and removable garbage drawer. Labeled aluminum storage bins were provided for staples like sugar and rice, and they were designed with spouts for easy pouring. Careful thought was given to the choice of materials: oak was used for flour containers (to repel mealworms) and beech for cutting surfaces (to resist staining and knife marks). The result was one of modernism's most famous cooking spaces.

Ludwig Mies van der Rohe
American, born Germany,
1886–1969

Friedrichstrasse Skyscraper Project, Berlin-Mitte, Germany, 1921

Perspective from north: charcoal and graphite on paper mounted on board, 68¼ × 48" (173.4 × 121.9 cm)
Mies van der Rohe Archive. Gift of the architect

This design for a crystal tower was unprecedented in 1921. It was based on the untried idea that a supporting steel skeleton would be able to free the exterior walls from their load-bearing function, allowing a building to have a surface that is more translucent than solid. Mies van der Rohe determined the faceted, prismatic shapes of its three connecting towers by experiment-ing with light reflections on a glass model. While the design anticipates his later preference for steel and glass, here a highly expressionistic character is more evident than any kind of ratio-nalist intention.

A leader of the revolutionary mod-ern movement in architecture, Mies designed a series of five startlingly innovative projects in the early 1920s, each of which had a profound influence on progressive architects all over the world. This competition entry was one of them. Code-named "Honeycomb," the Friedrichstrasse Skyscraper was distinguished by its daring use of glass, which symbolized the dawning of a new culture, and by an expressive shape that seems to owe nothing to history.

László Moholy-Nagy American, born Hungary. 1895–1946

Head. c. 1926

Gelatin silver print, 14⁹⁄₁₆ × 10⅝" (37 × 27 cm)
Given anonymously

The term "abstraction," as it is generally applied to photography, is misleading. Completely indecipherable photographs are quite rare and usually quite boring. More common and more interesting are pictures such as this one, in which an unfamiliar configuration of form competes for our attention with what we are inclined to call the subject—in this case, the woman's face. That competition is the true subject of the picture.

Moholy-Nagy taught at the Bauhaus in Germany between 1920 and 1933. He began his career as a painter, but in the mid-1920s he came to regard photography as the universal visual language of the modern era because it was mechanical and impersonal and, therefore, objective—no matter how unexpected the results might be. Perhaps it was precisely the unpredictability of photography that he loved, because it unveiled fresh experiences.

In 1925 he published a picture book titled *Painting, Photography, Film*, which illustrated the many ways in which photography challenged old habits of seeing—by showing very distant or very small things, for example, or by looking up or down. The great majority of the illustrations were the work of scientists, journalists, amateurs, and illustrators—not of artists. The message was clear: photography had revolutionized modern vision without the aid of "art."

Eileen Gray · Irish, 1878–1976

Screen. 1922

Lacquered wood and metal rods, 6' 2½" × 53½" × ¾" (189.2 × 135.9 × 2 cm)
Hector Guimard Fund

This black lacquered wood screen, composed of seven horizontal rows of panels joined by thin vertical metal rods, is not only a movable wall that serves to demarcate space but also a sculpture composed of solids and voids with an underlying Cubist influence. It is one of the most striking and elegant creations by Gray, who was one of the leading designers working in Paris after World War I. Gray popularized and perfected the art of lacquered furnishings, and her preference for its meticulous finish reveals a predilection for exotic materials, in particular those used in Japanese decorative arts.

Based on a larger version that Gray designed in 1922 for the Paris apartment of Madame Mathieu-Lévy, the owner of an exclusive millinery shop, the freestanding block screen can be seen as a bridge between furniture, architecture, and sculpture. Gray also became an accomplished textile designer and architect. Her first major architectural project, the E-1027 House in Roquebrune-Cap-Martin, France, was composed of multifunctional rooms and furniture, and was much admired by the Swiss-French architect Le Corbusier. The flexibility inherent in this project continued Gray's primary fascination in her earlier designs: pivoting parts and movable elements that transform both object and space.

Theo van Doesburg Dutch, 1883–1931

Cornelis van Eesteren Dutch, 1897–1988

Color Construction. 1923

Project for a private house: axonometric
drawing, gouache on paper, 22½ × 22½"
(57.2 × 57.2 cm)
Gift of Edgar Kaufmann, Jr.

Van Doesburg, a painter, writer, editor,
and architect, was a founder and
driving force behind the de Stijl move-
ment, which was centered in the
Netherlands in the late 1910s and
early 1920s. Cornelis van Eesteren, an
architect, joined the group in 1922.
Artists and others contributing to
van Doesburg's periodical, *De Stijl*,
attempted to create a new harmonic
order in the aftermath of World War I.
They attempted to construct a utopian
solidarity between art and life under
the influence of Piet Mondrian's early
theories of Neo-Plasticism, which pro-

posed that the essence of the imag-
ined and seen world could be conveyed
only through a logical system of
abstraction based on the line, square,
and rectangle and the primary colors
plus black and white.

According to van Doesburg, archi-
tecture had to be approached in an
entirely new way which would ultimately
give rise to a universal aggregate of
easel painting, sculpture, and architec-
ture. As suggested by this axonometric
drawing for a house that was never
built, architecture, enlivened by flat
colors, was to be economical and
dynamic, with planar elements bal-
anced asymmetrically around an open
core. Such structures would allow the
modern individual to achieve harmony
with his or her surroundings.

Anni Albers
American, born Germany. 1899–1994

Design for Smyrna Rug. 1925

Watercolor, gouache, and pencil on paper,
8⅛ × 6⁹⁄₁₆" (20.6 × 16.7 cm)
Gift of the designer

Albers was one of the most esteemed students of the weaving workshop at the Bauhaus, which she attended from 1920 to 1922 before teaching there herself until 1929. She often began her weaving projects with design sketches, such as this drawing for a rug. In this study, she explored the theme of horizontal-vertical construction using color, shape, proportion, and rhythm. The design reveals her admiration for the work of the painter Paul Klee, who also taught at the Bauhaus.

Of the weaving workshop she later observed: "Technique was acquired as it was needed and as a foundation for future attempts. Unburdened by any practical considerations, this play with materials produced amazing results, textiles striking in their novelty, their fullness of color and texture, and possessing often a quite barbaric beauty."

Albers used textiles as her primary artistic medium for almost forty years, experimenting directly with innovative materials and creating prototypes for industrial production. She became as acclaimed for her activities as a teacher and writer on design and weaving as for her textile designs. Albers continued to explore relationships of color and line most markedly after 1963, when her interest shifted to printmaking.

Man Ray (Emmanuel Radnitzky)

American, 1890–1976

Rayograph. 1922

Gelatin silver print, 9⅜ × 11¾" (23.9 × 30 cm)

Gift of James Thrall Soby

A photogram is a picture made on photographic paper without the aid of a camera. To make this one, Man Ray exposed the paper to light at least three times. Each time a different set of objects acted as a stencil: a pair of hands, a pair of heads kissing, and two darkroom trays, which seem almost to kiss each other with their corner spouts. With each exposure, the paper darkened where it was not masked.

"It is impossible to say which planes of the picture are to be interpreted as existing closer or deeper in space. The picture is a visual invention: an image without a real-life model to which we can compare it," notes curator John Szarkowski. A Surrealist might have said, instead, that it discloses a reality all the more precious because it is otherwise invisible.

Man Ray claimed to have invented the photogram not long after he emigrated from New York to Paris in 1921. Although, in fact, the practice had existed since the earliest days of photography, he was justified in the artistic sense, for in his hands the photogram was not a mechanical copy but an unpredictable pictorial adventure. He called his photograms "rayographs."

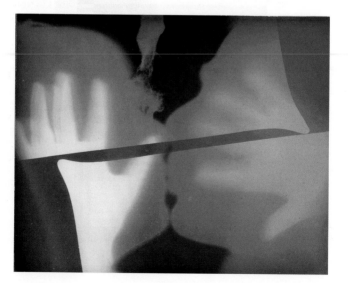

Josef von Sternberg
American, born Austria. 1894–1969

The Blue Angel (Der blaue Engel).
1930

35mm film, black and white, sound,
109 minutes
Acquired from Cinémathèque Française
Marlene Dietrich

In *The Blue Angel,* which was shot in both English and German versions, Marlene Dietrich plays popular cabaret star Lola-Lola, who sings and performs at a dingy small-town cabaret, *Der blaue Engel*. Provocatively dressed, the siren lures a respected schoolmaster, Immanuel Rath (Emil Jannings), away from his orderly, secure, and predictable world into her bizarre demimonde of magicians, clowns, and other seedy performers. Fascinated and seduced by her charismatic aura, the aging teacher marries Lola-Lola and trades his teaching position for servitude to her. After years pass by, the humiliated Rath is ultimately broken by his wife's open affair with a young man.

Meticulously lit and embellished by extravagant costumes and props, Lola-Lola's stunning stage numbers leave the film's audience as attracted to her as is Rath, who can be seen as a stand-in for the viewer's own masochistic desire to fall victim to Dietrich's destructive charms, a relationship about which she sings: "Men flutter round me like moths around a flame/ And if they get burned, well then I am not to blame."

Based upon Heinrich Mann's 1905 novel *Professor Unrat*, this was the first of seven films on which von Sternberg and Dietrich collaborated between 1930 and 1935. It catapulted the German actress to immediate stardom, turned her into one of cinema's most unforgettable femmes fatales, and paved her way to Hollywood.

George Grosz American, born Germany. 1893–1959

"The Convict": Monteur John Heartfield after Franz Jung's Attempt to Get Him Up on His Feet. 1920

Watercolor, ink, pencil, and cut-and-pasted printed paper on paper, 16½ × 12"
(41.9 × 30.5 cm)
Gift of A. Conger Goodyear

In this work Grosz combines traditional, delicately hued watercolor with pasted photomechanical reproductions in an unreal space, inspired by the work of the Italian painter Giorgio de Chirico. These pictorial devices convey the satirical ideology that Grosz shared with his subject, John Heartfield, a friend and fellow Berlin Dada artist with whom he frequently collaborated. Heartfield is depicted as bald, grim-faced, and with clenched fists and a machine heart— the personification of the politically defiant anti-authoritarian, which was a stance that Heartfield took in his own art.

His uniform and the drab walls and floor suggest a prisoner in his cell, and the segmented view of a building in the distance, as if glimpsed through a narrow window, bears the mordant inscription: "Lots of luck in your new home." The mechanical gears indicate Heartfield's identity as an engineer or constructor (*monteur*) of photomontages. In fact, Heartfield called himself a *monteur-dada* rather than an artist, and conceived of his own assembled works as images intended only for mass reproduction in magazines and on book covers and posters.

Otto Dix German, 1891–1969

Dr. Mayer-Hermann. 1926

Oil and tempera on wood, 58¾ × 39"
(149.2 × 99.1 cm)
Gift of Philip Johnson

When Dix painted this picture of
Wilhelm Mayer-Hermann, a prominent
Berlin doctor, he was a favorite portrait-
ist of Germany's cultural bohemia
and its patrons. Yet his eye could be
coolly unflattering. Dix had fought in
World War I, a crucial formative experi-
ence: "It is necessary to see people in
this unchained condition in order to
know something about man," he said,
and he came out of the war wanting
"to depict things as they really are."
Having experimented earlier with
Expressionist and other modern styles,
in 1920 he abandoned them for an
approach and technique modeled on
fifteenth- and sixteenth-century German
art. In the process he was identified
with what became known as the
Neue Sachlichkeit (New Objectivity)
movement, which advocated an unsen-
timental realism in the treatment of
modern life.

Dix may portray the doctor exact-
ingly, but the pose and the setting
seem chosen to stress his rotundity.
Everything is round: the face, the
bags under the eyes, the double chin,
the shoulders, the position of the
arms, the tummy. Circles define the
setting as well: a clock, an electrical
socket, an X-ray machine, and the
doctor's headgear. Despite the high
degree of stylization, Dix provides an
incisive portrait.

Jean Renoir French, 1894–1979

La Grande Illusion (Grand Illusion). 1937

35mm film, black and white, sound, 93 minutes
Gift of Thomas Brandon
Erich von Stroheim, Pierre Fresnay, Jean Gabin

Renoir's *La Grande Illusion* is his best-known film and one of his most personal. It includes reminiscences of his World War I experience in the French Flying Corps and pays homage to an early mentor, Erich von Stroheim, who appears as the elegantly civilized commandant of a maximum-security German prison camp. The escape of two French officers is presented as an intellectual game that depends upon the cooperation of soldiers of different nations; the act of parting from the other prisoners, indicated by an emotional series of farewells, dominates the film.

While *La Grande Illusion* may be considered the preeminent antiwar movie, it is far more inclusive and universal than that, posing questions about human existence that offer much food for thought. The film is a passionate statement of Renoir's belief in the commonality of all human beings, regardless of race, class, or nationality, which was to become a pervasive theme in his career. It is that passion, that emotional intensity, that makes Renoir's entire body of work so distinctive. Whether his films are directed at conjugal love, nature, the theater, the Paris that was, or prisoners of war, Renoir makes the viewer complicit in his obsessive devotion to his subjects.

August Sander German, 1876–1964

Member of Parliament and First Deputy of the Democratic Party (Johannes Scheerer). 1928

Gelatin silver print, 11⅝ × 8¾"
(29.6 × 22.3 cm)
Gift of the photographer

Photographic works have often taken the form of an extended series of photographs presented in a book or album. Among the most ambitious projects in the history of photography was Sander's brilliant, unfinished *Citizens of the Twentieth Century*, a systematic survey of German society comprising portraits of representative types from all walks of life.

Here, the politician's cape sweeps upward in an unbroken line that extends to the tip of his umbrella—an appropriate attribute of a representative of the people—which he holds with proper German rectitude.

In 1929 Sander published a book of sixty photographs. Accompanying the book was an invitation to subscribe to the eventual publication of the entire body of portraits, which the photographer claimed to have made "without prejudice for or against any party, alignment, class, society." In 1934, the year after the Nazis came to power, they seized the book and destroyed its plates.

Walt Disney <small>American, 1901–1966</small>

Steamboat Willie. 1928

35mm film, black and white, sound, 8 minutes
Gift of the artist
Mickey Mouse

Disney's *Steamboat Willie* is a landmark in the history of animation. It was the first Mickey Mouse film released and the first cartoon with synchronized sound. It threw silent animation into obsolescence and launched an empire. Previously, there had been little to distinguish Disney's cartoons from those of his competitors. He was facing bankruptcy when Alan Crosland's *The Jazz Singer*, with long sequences of song and dialogue, took America by storm in 1927. Sensing that sound movies meant big business, Disney decided to stake all on his talking mouse. The movie opened at the Colony Theater in New York on November 18, 1928, a date that would become known as Mickey's birthday.

Audiences were stunned by the vitality of the film's characters. Unhampered by the difficulties of using new equipment with live actors, Disney was able to fuse technology with hand-craftsmanship, naturalism with abstraction, an ability that, over time, proved him to be a great artist. So strong was the audience demand for *Steamboat Willie* that two weeks after its premiere Disney re-released it at the largest theater in the world, the Roxy in New York City. Critics came to see in Mickey Mouse a blend of Charlie Chaplin in his championing of the underdog, Douglas Fairbanks in his rascally adventurous spirit, and Fred Astaire in his grace and freedom from gravity's laws.

© Disney

Buster Keaton American, 1895–1966
Clyde Bruckman American, 1894–1955

The General. 1927

35mm film, black and white, silent,
80 minutes (approx.)
Buster Keaton

Keaton, his ear to the cannon, always seems to be listening for the sound of silence. His "great stone face" is eloquent enough in repose, but even when his mouth opens it is often in mute amazement at the workings of a world beyond a sensible man's understanding. In many of Keaton's films, machinery has a will of its own, and humans tend to follow along without quite knowing why.

The General is considered Keaton's masterpiece, perhaps because its adventure, drawn from a Civil War incident, has a propulsive force that accommodates all the ingenious comic asides devised by Keaton and codirector Clyde Bruckman without losing its narrative momentum. While Keaton's character, a Confederate engineer, pursues a woman, this is above all the love story of a boy and his train, the ideal conveyance, companion, and mute friend.

Keaton's greatest collaborator was not an actor, director, or writer but the motion-picture camera, with which he perfected the physical beauty of silent comedy and expanded its emotive possibilities. His remarkable performances are rooted in his childhood experience as a comic acrobat, who was regularly tossed around the vaudeville stage by his performing parents. By the end of the 1920s, the infant tyrant—talking pictures—had silenced Keaton's genius.

Charles Chaplin British, 1889–1977

The Gold Rush. 1925

35mm film, black and white, silent, 66 minutes (approx.)
Charlie Chaplin

The Gold Rush was the last movie Chaplin made before the specter of the "talkies" began to haunt him. Its brilliant set-pieces—Chaplin's character, the Little Tramp, performing the dance of the dinner rolls, Mack Swain hungrily mistaking the Tramp for a giant chicken, Swain and the Tramp feasting upon the latter's shoe, and the cabin teetering on the edge of the abyss—are among the highlights included in any assemblage of the classic moments of silent-film comedy. While all of Chaplin's silent features are somewhat episodic, they are held together by his sublime performances and inventive imagination.

The Gold Rush is Chaplin's most famous film, but it is atypical of his work in several ways. Its snowy wastes are far removed from his usual urban and rural settings. Cannibalism and murder seem peculiarly dark subjects for a comedy made in the middle of the twentieth century's most upbeat decade. The film also ends strangely, with the Tramp marrying and becoming a millionaire. *The Gold Rush* captured Chaplin in a time of relative contentment—one of the century's great geniuses at a moment of confidence in his ability to control his destiny and his art. Nevertheless, he returned in three later films as unshackled and poverty-stricken as ever.

Edward Hopper
American, 1882–1967

House by the Railroad. 1925

Oil on canvas, 24 × 29" (61 × 73.7 cm)
Given anonymously

Past and present meet in Hopper's picture: the railroad, symbol of modern industry, slices through a rural America embodied by a forlorn Victorian mansion. This once grand home stands tall but blank, isolated against the sky, and its verandah, designed for the leisurely contemplation of nature, now looks out on the steel tracks that cut across the foreground, obscuring both the horizon and the house's foundations in the earth. There is no human presence, but the window shades—some closed, others half open—suggest that the house may not be abandoned. Adding to the mystery and drama is the light flooding in from the left, reflecting an almost blinding white off part of the house but hiding the rest in deep shadow.

As a stubborn realist painter in a century of aesthetic innovation, Hopper had something in common with the building in *House by the Railroad*, old-fashioned in a changing world. But the color and the construction of Hopper's painting are precise and perduring, and his brand of realism has a haunting emotional quality. He finds the pathos in the slightly fussy grandiosity of this aging architecture, which, unlike the railroad tracks, isn't going anywhere.

Alfred Stieglitz American, 1864–1946

Apples and Gable, Lake George.
1922

Gelatin silver print, 4⅝ × 3⁹⁄₁₆" (11.6 × 9.1 cm)
Anonymous gift

This picture may be read as a symbol— of Eve's temptation in the Garden of Eden, perhaps, or of harmony between nature and mankind. Yet it presents itself as an immediate, sensual experience. You can almost feel yourself reaching up to the apples covered with dew and ripe for the picking.

Stieglitz was fifty-eight years old when he made this photograph at his family's estate on Lake George, New York, where he spent his summers from childhood to old age. At the turn of the century, it had seemed to him that photography, to become an art, must emulate the other arts and so restrain or disguise its earthbound realism.

Later, in the 1920s, he helped to prove in his own photographs that engaging the stubborn specificity of his medium was itself a fine art.

Georgia O'Keeffe American, 1887–1986

Farmhouse Window and Door.
1929

Oil on canvas, 40 × 30" (101.6 × 76.2 cm)
Acquired through the Richard D. Brixey Bequest

Farmhouse Window and Door shows a detail of the farmhouse on Lake George, in northern New York State, where O'Keeffe and her husband, the photographer Alfred Stieglitz, spent many summers. The window's structure, flanking shutters, and ornamental pediment can all be recognized in many of Stieglitz's photographs of the house, but O'Keeffe concentrates them into an image that is simultaneously an essence of Americana and a near abstraction. Viewing the window straight on and close up, she evens and flattens its forms; framing it tightly to show only narrow bands of the wall around it, she almost erases its con-

text. The composition becomes a geometric arrangement of rectangles, broken by the decorative curves and triangle of the pediment.

The clean straight lines and right angles of *Farmhouse Window and Door* reflect a Precisionist side of O'Keeffe's work, which elsewhere entails a sensual response to organic shapes and a luxurious delicacy of color. But the austerity of the painting's flat planes and limited palette disguises a conceptual puzzle: the shutters announce a window but apparently hold a door as well, with rectangular panels below and a glass pane—the green rectangle—above. These features seem to offer a pun on transparency, while the green links the "interior" to the clapboard siding. O'Keeffe could see a universe of color in a petal; through this clear glass, though, she finds a dense opacity.

119

Dorothea Lange American, 1895–1965

Woman of the High Plains, Texas Panhandle. 1938

Gelatin silver print, 12⅜ × 10"
(31.5 × 25.4 cm)
Purchase

Seen from slightly below, the woman in this photograph has become a monumental figure, set against the open sky and the unforgiving earth. Her gesture is full of suffering but tells us nothing specific about her life or travails. Yet the sunlight falls on the palpable flesh of a person and on the worn cloth of her shift.

The picture exemplifies Lange's exceptional talent for making the leap from concrete fact to arching symbol without leaving reality behind. She made it for the Farm Security Administration, a government agency whose photographic unit was charged with documenting the plight of the rural poor in the 1930s. Her work created a lasting image of the Great Depression. It also deepened the link between the descriptive style of documentary photography and the ideal of social engagement, becoming a touchstone for photographers who felt that their work should not only record social conditions but try to persuade people to improve them.

Robert J. Flaherty American, 1884–1951

Nanook of the North. 1922

35mm film, black and white and color tinted,
silent, 56 minutes (approx.)
Acquired from World Films

In undertaking to shoot a narrative-based film that would demonstrate the character and majesty of the Inuit people of the Hudson Bay, Canada, Flaherty chose as his protagonist a revered hunter. He accompanied the man, named Nanook in the film, and his extended family for a year from igloo to igloo, from kill to kill. Technical ingenuity and the collaboration of the Inuit were key to the film's success. When an actual seal killing could not be filmed, for example, the Inuit dragged a carcass under the ice and re-created its fight for life.

An explorer who charted the Canadian tundra for mineral and rail-road interests, Flaherty first brought a movie camera with him on an expedition of 1913 in order to make visual notes. Filmmaking soon became his primary focus. *Nanook of the North* was financed by a French furrier, Revillon Frères, and distributed by the French movie giant Pathé. America's top movie companies had turned it down, but the film became a huge critical and commercial success, and the progenitor of all documentaries to come. Unlike the typically detached travelogue, *Nanook of the North* blended realistic, stark, and beautifully composed images with a loose story line and a strong central character. Moreover, with its fictionalization of real-life events, and with Flaherty's romanticization of his subject, the film continues to raise issues about the objectivity of the documentary genre.

Charles Sheeler American, 1883–1965

American Landscape. 1930

Oil on canvas, 24 × 31" (61 × 78.8 cm)
Gift of Abby Aldrich Rockefeller

A photographer as well as a painter, Sheeler was hired in 1927 by the Ford Motor Company's Philadelphia advertising firm to shoot at the Ford plant in River Rouge, Michigan, outside Detroit. *American Landscape* derives from one of the pictures he took there. Choosing a detail of the photograph, he copied it quite closely, but the different framing creates a clear pictorial structure of horizontal bands regularly divided by the verticals of the smokestack, the crane, and their reflections in the water.

The painting's clean, hard-edged look reflects Sheeler's belief in the need for a machine-age aesthetic. In the twentieth century, he argued, "Industry concerns the greatest numbers. . . . The Language of the Arts

should be in keeping with the Spirit of the Age." Sheeler had studied Cubism and knew the machine-derived imagery of Marcel Duchamp and Francis Picabia, but wanted to "remove the method of painting . . . from being a hindrance in seeing." He and other artists therefore devised a smooth, transparent, near-photographic style, called Precisionism, to address America's industrial scene.

Sheeler shows the Ford plant as literally impersonal—emptied of people. But for the tiny figure on the railroad tracks, there is no sign of the labor force, let alone of the complexities of labor relations in heavy industry. The plant also seems implausibly tidy—although its neatness did impress visitors of the period.

Le Corbusier (Charles-Édouard Jeanneret) French, born Switzerland. 1887–1965
with Pierre Jeanneret Swiss, 1896–1967

Villa Savoye, Poissy-sur-Seine, France. 1929–31

Model: wood, aluminum, and plastic,
14½ × 31½ × 34" (36.8 × 80 × 86.4 cm)
Modelmaker: Theodore Conrad (1932)
Purchase

The Villa Savoye, a weekend house outside Paris, is perhaps the finest example of Le Corbusier's early work. Le Corbusier, along with his brother Pierre, planned the entire composition as a sequence of spatial effects. Arriving by automobile, the visitor drives underneath the house, circling around to the main entrance. From the entrance hall, he or she ascends the spiral stairs or the ramp to the main-level living area. The ramp continues from the central terrace to the upper-level sun deck. Sheltered by brightly colored wind screens, it is a perfect vantage point for savoring sunlight, fresh air, and nature.

In his famous book of 1923, *Vers une architecture* (*Toward an Architecture*), arguably the most influential architecture book of the twentieth century, Le Corbusier declared houses to be "machines for living in." Villa Savoye, a white rectilinear volume on a flat landscape, celebrates Le Corbusier's belief that ideal, universal forms, although rooted in the classical tradition, were appropriate to architecture for the machine age. The design incorporates Le Corbusier's "five points of architecture," which he believed to be indispensable elements: *pilotis* (reinforced-concrete columns), the free plan, the free facade, horizontal bands of windows, and the roof garden.

In 1932, this model was included in The Museum of Modern Art's first architecture exhibition, which documented the various trends that came to be known as the International Style.

Leo McCarey American, 1898–1969

Duck Soup. 1933

35mm film, black and white, sound, 70 minutes
Acquired from Paramount Pictures
Groucho Marx

In its brilliant combination of silent-film pantomime and verbal fireworks, *Duck Soup* is the distillation of all the best elements to be found in the Marx brothers' comedies. In the film, under the leadership of Groucho's unforgettable prime minister Rufus T. Firefly, Freedonia goes to war with neighboring Sylvania for no reason whatsoever. Among the film's famous scenes are the moment when Groucho mistakes Harpo for his own mirror image, and the barrage of oranges and grapefruits that greet Margaret Dumont as she sings the national anthem in the film's riotous finale. *Duck Soup* is also filled with inimitable dialogue and the confusions of word play—double entendres, non sequiturs, and puns. In the film, the Marx brothers, with McCarey, present a world in which organized groups, political parties, nations, and social classes seem foolish, and court jesters sane.

Critics and moviegoers around the world regard *Duck Soup* as one of the Marx brothers' finest comedies. Yet the film was such a failure when it opened in 1933 that Paramount dropped its contract with the Marx brothers. With the American economy in collapse, Hitler on the rise in Germany, and democracy faltering at home and abroad, audiences were simply not in the mood for a political satire that held nothing sacred and left nothing unscathed. Though *Duck Soup* was provocative enough to have been banned in Italy by Mussolini, McCarey insisted that the only political message intended was "to kid dictators."

George Stevens American, 1904–1975

Swing Time. 1936

35mm film, black and white, sound,
103 minutes
Acquired from RKO Pictures
Fred Astaire, Ginger Rogers

There is no cinematic iconography more emblematic of the Hollywood musical than the dancing figures of Fred Astaire and Ginger Rogers. In Stevens's film, dance is used as an expression of romantic developments, a device typical of musicals of the 1930s. In the film, Lucky Garnett (Fred Astaire), a dancer and sometime gambler, arrives late for his marriage to Margaret Watson (Betty Furness) only to find that her furious father, the judge (Landers Stevens), has called off the wedding. The judge challenges Lucky to go to New York and earn $25,000 in order to win back Margaret's hand. In New York, Lucky meets Penny (Ginger Rogers), a dance instructor, who loses her job as a result of their chance encounter. The pair are, however, sent to audition at the Silver Sandal nightclub, where they eventually dazzle the patrons and are hired. When Margaret arrives in New York to tell Lucky she has met and fallen in love with another man, Lucky and Penny are free to pursue their relationship as lovers and dancers.

Swing Time marks the introduction of special effects into Astaire's dance routines. In the "Bojangles" number, Astaire dances with huge shadows of himself. To achieve this effect, the dance was filmed twice under different lighting conditions. The version with the strong shadow was then optically tripled in the lab and combined with the film made under standard lighting.

Stuart Davis American, 1892–1964

Odol. 1924

Oil on cardboard, 24 × 18" (60.9 × 45.6 cm)
Mary Sisler Bequest (by exchange) and
purchase

Davis said that his pictures "have their
originating impulse in the impact of the
contemporary American environment."
In the early decades of the twentieth
century, that environment was boldly
and innovatively modern—more so
than its European counterparts, reined
in by history, tradition, and an older
physical infrastructure. Yet at the same
time that French artists like Fernand
Léger saw America as the model of
modernity, they were themselves the
innovators in art. Americans like Davis
looked to the work of Europeans for
ways to assimilate their experience of
their own society.

Odol exemplifies this two-way traffic:

Davis has applied Léger's monumental-
izing simplicity and geometrized planes
of color, as well as the Cubist interest
in the logos and packaging of the new
mass products, to a study of American
commercial design. The bottle for a
popular brand of mouthwash stands
between a slanting transparent box
and a display of green and white check-
ering. This anonymous space frames
and accentuates the bottle's bold let-
tering and idiosyncratic shape, calcu-
lated both for convenience and for
punchy distinctiveness in a market-
place fueled by modern advertising.

Davis's choice of product—an
agent of personal hygiene—may slyly
echo the modernist rhetoric of cleans-
ing and washing away the debris of his-
tory. He had argued that the artwork
"must be positive and direct"; positive
and direct *Odol* is, and, "It Purifies."

Sven Wingquist Swedish, 1876–1959

Self-Aligning Ball Bearing. 1907

Chrome-plated steel, 1¾ × 8½"
(4.4 × 21.6 cm) diam.
Manufacturer: SKF Industries, Inc., USA
Gift of the manufacturer

Both efficient and pleasing to the eye, the ball bearing can be seen as an emblem of the machine age—a name often used to define the 1920s and 1930s, when industrial designers as well as consumers took a new interest in the look and style of commercial products. Even parts of machines could be appreciated for their beauty, which came from the purity of abstract geometry. Modernists considered good design essential to the elevation of society, and in 1934, this ball bearing was among the first works to enter The Museum of Modern Art's design collection.

Designed by Wingquist, this sturdy steel ball bearing is composed of a double layer of balls in a race. This type of bearing was structurally superior to the sliding bearing, which wastes energy in realigning machinery shafts thrown off during assembly-line manufacturing. The self-aligning quality of the ball bearing made it a superior product, since the bearing could absorb some shaft misalignment without lowering its endurance.

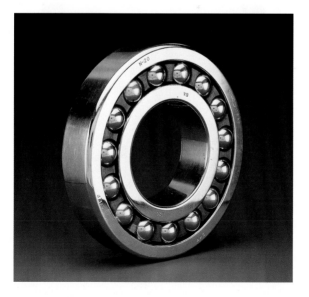

Edward Weston American, 1886–1958

Mexico, D.F. 1925

Platinum print, 9⁹⁄₁₆ × 7³⁄₁₆" (24.3 × 18.3 cm)
Gift of the photographer

It would be difficult to imagine a more austere nude. Framed in isolation against a dark, empty ground, the body has become a simple, symmetrical shape. This is as close as photography has come to achieving an image of ideal form, uncomplicated by earthly experience. And yet we see right away that it is a human body with volume and weight: an undeniably physical presence.

Weston's work of the 1920s, especially his nudes and photographs of vegetables and shells and other organic forms, set a new and demanding standard for modern photography. Nothing was left to chance in his pictures, no detail distracted from the

power and clarity of the whole. At the same time, the photographs were unmistakably direct descriptions of particular things. The enormous influence of Weston's aesthetic rested on his ability to discover the abstract ideal within the perfectly real.

The title refers to Mexico, Distrito Federal—Mexico City—where Weston was living when he made the picture.

Alvar Aalto Finnish, 1898–1976

Paimio Chair. 1931–32

Bent plywood, bent laminated birch, and solid
birch, 26 × 24 × 34½" (66 × 61 × 87.6 cm)
Manufacturer: Artek, Finland
Gift of Edgar Kaufmann, Jr.

Admired as much for its sculptural
presence as for its comfort, the Paimio
Chair is a tour de force in bentwood
that seems to test the limits of ply-
wood manufacturing. The chair's frame-
work consists of two closed loops of
laminated wood, forming arms, legs,
and floor runners, between which rides
the seat—a thin sheet of plywood
tightly bent at both top and bottom into
sinuous scrolls, giving it added resil-
iency. Inspired by Marcel Breuer's
tubular-steel Club Chair of 1927–28,
Aalto chose, instead, native birch
for its natural feel and insulating
properties, and developed a more
organic form.

The Paimio Chair, the best-known
piece of furniture designed by Aalto,
is named for the town in southwestern
Finland for which Aalto designed a
tuberculosis sanatorium and all its fur-
nishings. The chair was used in the
patients' lounge; the angle of the back
of the armchair was intended to help
sitters breathe more easily.

Aalto's bentwood furniture had a
great influence on the American design-
ers Charles and Ray Eames and the
Finnish-born Eero Saarinen. In 1935
the Artek company was established in
Finland to mass-produce and distribute
wood furniture designed by Aalto and
his wife, Aino. Most of their designs
remain in production.

Salvador Dalí Spanish, 1904–1989

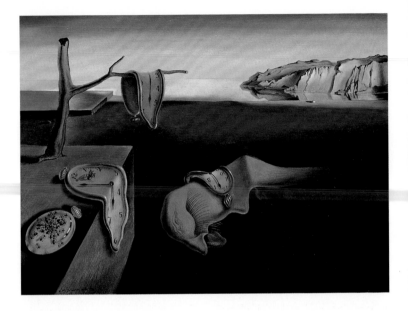

The Persistence of Memory. 1931

Oil on canvas, 9½ × 13" (24.1 × 33 cm)
Given anonymously

The Persistence of Memory is aptly named, for the scene is indelibly memorable. Hard objects become inexplicably limp in this bleak and infinite dreamscape, while metal attracts ants like rotting flesh. Mastering what he called "the usual paralyzing tricks of eye-fooling," Dalí painted with what he called "the most imperialist fury of precision," but only, he said, "to systematize confusion and thus to help discredit completely the world of reality." It is the classical Surrealist ambition, yet some literal reality is included too: the distant golden cliffs are the coast of Catalonia, Dalí's home.

Those limp watches are as soft as overripe cheese—indeed "the camembert of time," in Dalí's phrase. Here time must lose all meaning. Permanence goes with it: ants, a common theme in Dalí's work, represent decay, particularly when they attack a gold watch, and become grotesquely organic. The monstrous fleshy creature draped across the painting's center is at once alien and familiar: an approximation of Dalí's own face in profile, its long eyelashes seem disturbingly insectlike or even sexual, as does what may or may not be a tongue oozing from its nose like a fat snail.

The year before this picture was painted, Dalí formulated his "paranoiac-critical method," cultivating self-induced psychotic hallucinations in order to create art. "The difference between a madman and me," he said, "is that I am not mad."

Meret Oppenheim
Swiss, born Germany. 1913–1985

Objet (Le Déjeuner en fourrure) (Object [Lunch in Fur]). 1936

Fur-covered cup, saucer, and spoon; cup 4⅜" (10.9 cm) diameter; saucer, 9⅜" (23.7 cm) diameter; spoon 8" (20.2 cm) long; overall height 2⅞" (7.3 cm)
Purchase

Oppenheim's fur-lined teacup is perhaps the single most notorious Surrealist object. Its subtle perversity was inspired by a conversation between Oppenheim, Pablo Picasso, and the photographer Dora Maar at a Paris café. Admiring Oppenheim's fur-trimmed bracelets, Picasso remarked that one could cover just about anything with fur. "Even this cup and saucer," Oppenheim replied.

In the 1930s, many Surrealist artists were arranging found objects in bizarre combinations that challenged reason and summoned unconscious and poetic associations. Objet—titled Le Déjeuner en fourrure (Lunch in Fur) by the Surrealist leader André Breton—is a cup and saucer set that was purchased at a Paris department store and lined with the pelt of a Chinese gazelle. The work highlights specificities of sensual pleasure: fur may delight the touch but it repels the tongue. And a cup and spoon, of course, are made to be put in the mouth.

A small concave object covered with fur, Objet may also have a sexual connotation and political import: working in a male-dominated art world, perhaps Oppenheim was mocking the prevailing "masculinity" of sculpture, which conventionally adopts a hard substance and vertical orientation that can be seen as almost absurdly self-referential. Chic, wry, and simultaneously attractive and disturbing, Objet is shrewdly and quietly aggressive.

Henri Cartier-Bresson French, 1908–2004

Seville. 1933

Gelatin silver print, 9³⁄₁₆ × 13⁹⁄₁₆"
(23.4 × 34.5 cm)
Gift of the photographer

This picture describes a group of children both as living individuals and as shapes deployed against the jagged forms of the crumbling walls, and its vitality arises from the reciprocal relationship between these two ways of looking at the world. In fact, only two of the boys are in motion, but the vitality of graphic pattern infuses the whole picture with the antic energy of youth. Cartier-Bresson coined a term for the instant at which the interplay of human meaning and photographic form can yield such a surprise. He called it "the decisive moment."

Later, as a photojournalist after World War II, Cartier-Bresson earned the envy of his peers for his ability to seem invisible—to capture an event without disturbing it by his presence. In many of his early photographs, however, his subjects were aware of and even performed for him, as the boy at the upper right does here. It is as if the unpredictable theater of the street had been choreographed for the photographer alone.

This photograph has sometimes been misinterpreted as a document of the Spanish Civil War, but it was made three years before that war began. However, its social dimension—the photographer's identification with the poor and disenfranchised—is quite real.

Walker Evans American, 1903–1975

Penny Picture Display, Savannah, Georgia. 1936

Gelatin silver print, 8⅝ × 6¹⁵⁄₁₆"
(21.9 × 17.6 cm)
Gift of Willard Van Dyke

In the Savannah photographer's window there are fifteen blocks of fifteen pictures each, for a total of 225 portraits, less the ones hidden by the letters. Most of the sitters appear at least twice, but altogether there are more than one hundred different men, women, and children: a community.

Evans explored the United States of the 1930s—its people, its architecture, its cultural symbols (including photographs)—with the disinterested eye of an archaeologist studying an ancient civilization. *Penny Picture Display* might be interpreted as a celebration of democracy or as a condemnation of conformity. Evans takes no side.

The photograph is very much a modern picture—crisp, planar, and resolutely self-contained. But instead of reconfirming a timeless ideal, as artistically ambitious American photographers before Evans generally had aimed to do, it engages a contemporary particular, rooted in history. And it announces Evans's allegiance to the plainspoken vernacular of ordinary photographers, such as the Savannah portraitist who made the pictures in the window.

Joaquín Torres-García
Uruguayan, 1874–1949

Construction in White and Black.
1938

Oil on paper mounted on wood, 31¾ × 40⅛"
Gift of Patricia Phelps de Cisneros in honor of
David Rockefeller

Torres-García rejected the opposition of figuration and abstraction, preferring to think of his painting as "constructive" and emphasizing facture rather than the final image. In this example, the contrast between black and white is the sole means used to construct a syncopated grid which seems to protrude outward as much as it recedes into the picture plane. The effect of volume and irregular geometry evoke primal architectonic structures like those of the Incan stonework in which Torres-García was particularly interested.

In the late 1930s, Torres-García developed a personal philosophy of art that he called Constructive Universalism. Through it, he advanced his views of art as a means to organize the natural world and human experience according to universal laws of unity. His ideas were influenced greatly by the geometric abstraction practiced by the artists in the group Cercle et Carré (Circle and Square), which he helped to found in Paris in 1930. When Torres-García returned to his native Uruguay in 1934, he worked to synthesize European modernism and indigenous traditions. The inscription AAC in the lower right refers to the Asociación de Arte Constructivo (Association of Constructive Art), which the artist established to disseminate modern art in South America and adapt it to local traditions.

Alexander Calder American, 1898–1976

Gibraltar. 1936

Construction of lignum vitae, walnut, steel
rods, and painted wood, 51⅞ × 24¼ × 11⅜"
(131.7 × 61.3 × 28.7 cm)
Gift of the artist

Although *Gibraltar* is abstract, the con-
nection is easily made between its
base—a weighty lump of lignum vitae
(a tropical hardwood)—and the Medi-
terranean rock that gives the work its
name. This mass of wood is rough and
solid, and seemingly unshaped. More
delicate, and more clearly marked by
human artifice, are the work's sloping
plane of walnut, its painted wood ball,
and its two steel rods balancing a
crescent and a sphere, respectively.
Gibraltar recalls the biomorphic forms
in Surrealist art, particularly that of
Joan Miró. But there is also a poetic
whimsy that is Calder's alone.

The sculpture is contradictory in
its qualities. The rods are thin and lin-
ear, and express an upward, airborne
drive and eccentric balance; the lignum
vitae is heavy, earth-hugging, solid.
The surfaces, too, show various mate-
rials being variously treated, implying
methods from machine-making to
hand-polishing to leaving well enough
alone. These disjunctions have a good-
humored wit, which does not disguise
the work's grace. Calder once said that
"the underlying sense of form" in his
work was "the system of the Universe,"
and *Gibraltar*, with its sun, moon, and
heavy earth, explores the spatial drama
of the solar system in miniature—a sys-
tem revealed as a fine-tuned balance
of opposites.

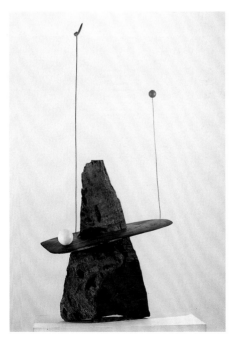

Pierre Bonnard French, 1867–1947

The Bathroom. 1932

Oil on canvas, 47⅝ × 46½" (121 × 118.1 cm)

Florene May Schoenborn Bequest

The scene is the bathroom of Bonnard's own home—Le Bosquet, his house near Cannes—and the woman naked at her *toilette* is the artist's wife, Marthe. The choice of both space and figure, then, is intensely personal, and the work maintains a sense of privacy and even of confinement. Although Marthe appears in many of Bonnard's paintings, seldom is her face fully visible: here she bows her head low. The window is shuttered, sealing off the outside world. A painting in which the whites of bath and stool are brighter and more vibrant than the barred panel of daylight suggests claustrophobia as well as intimacy, even though Bonnard's extraordinary painted color implies the richness of the domestic and interior life.

Bonnard's composition is asymmetrical, darker on the right than on the left, and its human subject is off-center and out of focus. His technique and use of color emerge from Impressionism but advance the independence of paint quality and surface from form. Indeed the work's intensity as a field of color may outweigh its descriptiveness: overlapping planes, indistinct patterns, balanced areas of coolness and warmth, and close-valued hues create a blurring of edges and textures, a shimmer. Behind the curving foreground forms, systematic grids of rectangles and lozenges create a structure of eminent logic.

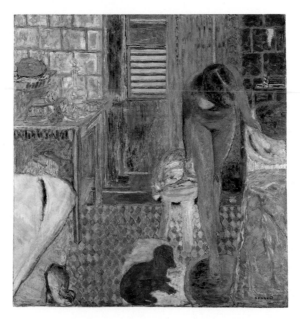

Pablo Picasso  Spanish, 1881–1973

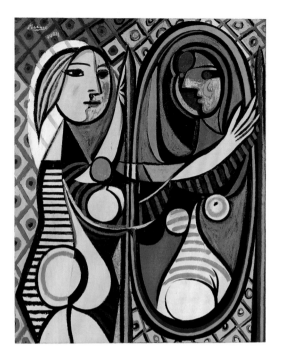

Girl before a Mirror. 1932

Oil on canvas, 64 × 51¼" (162.3 × 130.2 cm)
Gift of Mrs. Simon Guggenheim

Girl before a Mirror shows Picasso's young mistress Marie-Thérèse Walter, one of his favorite subjects in the early 1930s. Her white-haloed profile, rendered in a smooth lavender pink, appears serene. But it merges with a more roughly painted, frontal view of her face—a crescent, like the moon, yet intensely yellow, like the sun, and "made up" with a gilding of rouge, lipstick, and green eye shadow. Perhaps the painting suggests Walter's day-self and her night-self, her tranquillity and her vitality, but also her transition from innocent girl to a worldly woman aware of her own sexuality.

It is also a complex variant on the traditional Vanity—the image of a woman confronting her mortality in a mirror, which reflects her as a death's head. On the right, the mirror reflection suggests a supernatural X-ray of the girl's soul, her future, her fate. Her face is darkened, her eyes are round and hollow, and her intensely feminine body is twisted and contorted. She seems older and more anxious. The girl reaches out to the reflection, as if trying to unite her different "selves." The diamond-patterned wallpaper recalls the costume of the Harlequin, the comic character from the commedia dell'arte with whom Picasso often indentified himself—here a silent witness to the girl's psychic and physical transformations.

Pablo Picasso Spanish, 1881–1974

The Weeping Woman, I, state VII.
1937

Drypoint, aquatint, etching and scraper, plate:
27³⁄₁₆ × 19½" (69 × 49.5 cm)
Publisher: the artist, Paris. Edition: 15
Acquired through the generosity of David
Rockefeller, Steven A. and Alexandra M.
Cohen, Debra and Leon Black, Jo Carole
and Ronald S. Lauder, Sue and Edgar
Wachenheim III, Joan H. Tisch, Alice and Tom
Tisch, Marlene Hess and James D. Zirin,
Marie-Josée and Henry Kravis, Katherine
Farley and Jerry Speyer, Mary M. Spencer,
Donald B. Marron, and Agnes Gund in mem-
ory of Joanne M. Stern

The Weeping Woman, I is an elaboration
of one of the central figures in Picasso's
famous mural, *Guernica*, executed
some months earlier. Like *Guernica*,
this print was created in reaction to the
bombing on April 26, 1937 of the
defenseless town of Guernica during
the Spanish Civil War. The image stands
as an emblem of the artist's homeland
torn apart by that conflict and, more
universally, of the horrors of war.

The portrait also refers to Picasso's
conflicted love life, appearing to con-
flate the features of two women with
whom he was then involved. Dora Maar,
known for her volatile temper, is repre-
sented by the glossy black hair, tapered
fingernails, and tearful state in which
Picasso often portrayed her. Marie-
Thérèse Walter is referenced in the dis-
tinctive nose and forehead, features
the artist frequently depicted in the
1930s. The image is composed of bul-
bous, contorted, and distended shapes
and a veritable battlefield of tangled
lines that heighten the sense of explo-
sive emotion. Picasso also capitalized
on the potential of etching and drypoint
to create sharply incised details such
as nail-like tears and scissor-like fingers
that reinforce the notion of pain being
inflicted. He accorded great significance
to this large etching, which he devel-
oped and reworked through seven inde-
pendent stages, or states. This is the
seventh and final state.

Max Beckmann German, 1884–1950

Departure. 1932–33

Oil on canvas; triptych, center panel, 7' ¾" ×
45⅜" (215.3 × 115.2 cm), side panels,
each 7' ¾" × 39¼" (215.3 × 99.7 cm)
Given anonymously (by exchange)

In the right panel of *Departure*,
Beckmann once said, "You can see
yourself trying to find your way in the
darkness, lighting the hall and stair-
case with a miserable lamp, dragging
along tied to you, as part of yourself,
the corpse of your memories." The trip-
tych is full of personal meaning, and
also of mysteries. The often-appearing
fish, for example, are ancient symbols
of redemption, but may also connote
sexuality. Perhaps the woman under
torture gazes prophetically into a crys-
tal ball—but what she seems to see is
the daily paper. Men's faces are hid-
den: averted in the side panels,
masked in the center. Is it the same
couple whose fate each image tracks?

Beckmann's accounts of *Departure*
are fragmentary, and, in any case, he
believed that "if people cannot under-
stand it of their own accord, . . . there
is no sense in showing it." But the
work, however elusive in its details,
is clear overall: painted at a dark time
in Germany (that of Hitler's rise to
power), it tells of harsh burdens and
sadistic brutalities through which the
human spirit, regally crowned, may
somehow sail in serenity. Beckmann
called the center panel "The Home-
coming," and said of it, "The Queen
carries the greatest treasure—
Freedom—as her child in her lap.
Freedom is the one thing that matters—
it is the departure, the new start."

Brassaï (Gyula Halász) French, born Transylvania. 1899–1984

Kiki Singing, Cabaret des Fleurs, Montparnasse. 1933

Gelatin silver print, 15⅝ × 11¾"
(39.7 × 29.8 cm)
David H. McAlpin Fund

Kiki was celebrated among avant-garde artists who haunted the bars and cabarets of Montparnasse, her Paris neighborhood, in the 1920s. She is pictured here in the full glow of her own professional persona, as an authentic descendant of the ribald heroines of the fifteenth-century poet François Villon. The accordionist, who gazes at her with awe and affection, is unidentified.

Brassaï's photographs are the last great expression of a tradition of picturing Parisian popular culture that included such masters as Edgar Degas and Henri de Toulouse-Lautrec. By the time this image was made, that tradition had become tinged with nostalgia for the past and was soon to be obliterated by the engines of modernity and the business of tourism.

Brassaï's blunt, no-nonsense pictures, such as this one, in which the subject is often fixed by the unapologetic scrutiny of a flash, remain a model of photography's fierce curiosity and proof of the mystery of unvarnished photographic fact—a foundation of what came to be called the documentary tradition.

Balthus (Baltusz Klossowski de Rola)

French, 1908–2001

The Street. 1933

Oil on canvas, 6' 4¾" × 7' 10½"
(195 × 240 cm)
James Thrall Soby Bequest

Though set in a real place—the rue Bourbon-le-Château, Paris—*The Street* has the intensity of a dream. The figures in this strange frozen dance are precisely placed in a shallow, friezelike line, yet except for the struggling couple on the left, they don't interact at all. The toque-wearing chef isn't even human—he is a pavement sign for a restaurant—but he stands no more stiffly than the other characters, who, stylized and solid, seem less to walk than to pose.

Part of the work's tension comes from the diversity in the traditions it fuses. Its receding architectural perspective emulates Renaissance geometry, for Balthus much admired Quattrocento artists, particularly Piero della Francesca. But another, quite different influence links him to his Surrealist peers: long after painting *The Street*, he would still say that he had never stopped seeing things as he saw them in childhood. He well knew children's books such as Lewis Carroll's "Alice" stories, with their illustrations by John Tenniel, and, indeed, the girl caught in the tussle has been said to be Alice herself; the youth in the center resembles Tweedledum or Tweedledee; and the man with the plank could be Carroll's carpenter, without his walrus companion—though his simultaneous resemblance to a figure in Piero's *Discovery and Proving of the True Cross*, at Arezzo (c. 1455), suggests a different symbolic register.

Aristide Maillol French, 1861–1944

The River. 1938–43

Lead (cast 1948), 53¾" × 7' 6" × 66"
(136.5 × 228.6 × 167.7 cm), on lead base
designed by the artist, 9¾ × 67 × 27¾"
(24.8 × 170.1 × 70.4 cm)
Mrs. Simon Guggenheim Fund

The daring instability and torsion of
The River are rare in Maillol's sculp-
ture. Instead of trying to emulate the
dynamism of twentieth-century life, as
did so many artists of his time, Maillol
usually sought an art of serenity and
stillness, of classical nobility and sim-
plicity. As late as 1937, in fact, he
remarked, "For my taste, there should
be as little movement as possible
in sculpture." Yet within a year or so
afterward he had conceived *The River*,
a work in which the movement is
almost reckless.

Commissioned to create a monu-
ment to a notable pacifist, the French
writer Henri Barbusse, Maillol con-
ceived the sculpture as a work on the
theme of war: a woman stabbed in the
back, and falling. When the commis-
sion fell through, he transformed the
idea into *The River*. In a departure
from the usual conventions of monu-
mental sculpture, the figure lies low
to the ground and rests apparently
precariously on the pedestal, even
hanging below its edge. Twisting and
turning, her raised arms suggesting
the pressure of some powerful current,
this woman is the personification of
moving water.

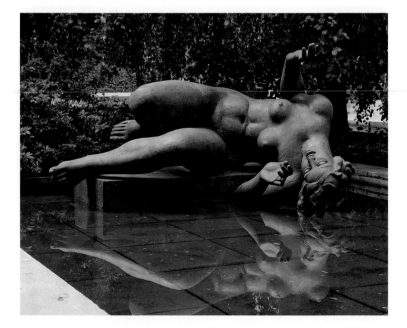

Manuel Álvarez Bravo
Mexican, 1902–2002

La Hija de los Danzantes (The Daughter of the Dancers). 1933

Gelatin silver print, 9¼ × 6¹¹⁄₁₆" (23.5 × 17 cm)
Purchase

In this picture, as in many of Álvarez Bravo's photographs, our experience begins with the theme of looking: we must wonder what it is that the girl sees, or what she seeks. It has been suggested that her awkwardly placed feet, with one foot atop the other as she stands on her toes, evokes the figures in Mexican reliefs and carvings made before the Spanish conquest, and that the girl, dressed in traditional Mexican costume, may be interpreted as representing a Mexico searching for its past through the window in the well-worn wall. Clearly, the picture was staged, and we know that the pho-tographer has intentionally provoked our curiosity.

Photography has an inherent power to create mystery because it only describes aspects of things and never tells the whole story. In the hands of a skillful photographer, this capacity to intrigue can become the foundation of an aesthetic, a way of working. Throughout his seventy-year career, the Mexican photographer Álvarez Bravo consistently made deeply human pho-tographs rife with enigma.

Robert Capa (born Endre Friedmann) American, born Hungary, 1913–1954

Death of a Loyalist Militiaman, Córdoba Front, Spain. Late August–early September, 1936

Gelatin silver print, 7⅛ × 9⅜" (18.1 × 23.8 cm)
Gift of Edward Steichen

Robert Capa's photograph of a Spanish militiaman frozen in mid-collapse, taken at the instant he is killed by a Francoist's bullet, is among the most famous images of war ever captured on camera. Capa's work packs an undeniable visual punch: the soldier is isolated against an eerily serene expanse of sky, arm outstretched in a crucifixion-like pose, rifle flying out of his slackened grip.

Capa was twenty-two years old when he took this photograph while covering the early years of the Spanish Civil War. Before widespread access to broadcast television, the public was exposed to images of the war primarily through print publications, and Capa's widely disseminated picture, first published in the September 23, 1936 issue of the French magazine *Vu*, was a revelation. Capa's photograph epitomizes his medium's unique relationship to fact, commemoration, and dramatization, in this case immortalizing the precise moment of death as never done before. Yet since the mid-1970s, scholars fascinated by missing details surrounding the image have raised questions about the identity of the anarchist militiaman and the location of his shooting, pointing to an uneasy relationship between truth and fiction in war photography.

Diego Rivera Mexican, 1886–1957

Agrarian Leader Zapata. 1931

Fresco, 7' 9¾" × 6' 2" (238.1 × 188 cm)
Abby Aldrich Rockefeller Fund

In the 1920s, after the end of the Mexican Revolution, Rivera was among the painters who developed an art of public murals to celebrate Mexico's indigenous culture and to teach the nation's people about their own history and the new government's dreams for their future. Rivera had lived in Paris and knew modernist painting well. He had also visited Italy to study Renaissance frescoes; Mexican artists and politicians recognized the value of this mural form as a medium of education and inspiration. Returning to Mexico in 1921, Rivera began a remarkable series of frescoes—paintings made on moist plaster, so that the pigments fuse with the plaster as it dries.

Agrarian Leader Zapata, which Rivera created for his exhibition at The Museum of Modern Art in 1931, replicates part of a fresco he had painted in 1930 in the Palace of Cortés, Cuernavaca. Emiliano Zapata had been a hero of the Mexican Revolution. (He was killed in 1919, a victim of the Revolution's internal struggles.) Rivera shows him wearing the local costume of the Cuernavaca region and carrying a sugarcane-cutter's machete. His followers, too, bear the rough tools of peasant soldiers. Yet the rider sent to oppose this ragged army lies in the dirt, and Zapata has seized his horse—whose shape Rivera borrowed from a work by the fifteenth-century Florentine painter Paolo Uccello.

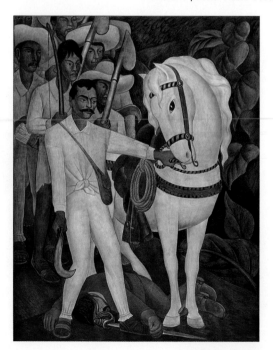

David Alfaro Siqueiros Mexican, 1896–1974

Collective Suicide. 1936

Enamel on wood with applied sections,
49" × 6' (124.5 × 182.9 cm)
Gift of Dr. Gregory Zilboorg

Collective Suicide is an apocalyptic vision of the Spanish conquest of Cuba, when many of the island's inhabitants killed themselves rather than submit to slavery. Siqueiros shows armored Spanish troops advancing on horseback, a bowed captive staggering before them in chains. The broken statue of a god demonstrates the ruin of the indigenous culture. Native islanders, separated from their tormentors by a churning pit, slaughter their own children, hang themselves, stab themselves with spears, or hurl themselves from cliffs. Mountainous forms create a backdrop crowned with swirling peaks, like fire or blood.

Siqueiros, one of the Mexican mural painters of the 1920s and 1930s, advocated what he called "a monumental, heroic, and public art."

An activist and propagandist for social reform, he was politically minded even in his choices of materials and formats: rejecting what he called "bourgeois easel art," he used commercial and industrial paints and methods. *Collective Suicide* is one of his relatively few easel paintings, but here, too, he used spray guns and stencils for the figures, and strategically let the paints—commercial enamels—flow together on the canvas. *Collective Suicide* is both a memorial to the doomed pre-Hispanic cultures of the Americas and a rallying cry against contemporary totalitarian regimes.

Alberto Giacometti Swiss, 1901–1966

The Palace at 4 A.M. 1932–33

Construction in wood, glass, wire, and string,
25 × 28¼ × 15¾" (63.5 × 71.8 × 40 cm)
Purchase

An empty architecture of wood scaffolding, *The Palace at 4 A.M.* undoes conventional ideas of sculptural mass. Even early on, Giacometti once wrote, he had struggled to describe a "sharpness" that he saw in reality, "a kind of skeleton in space"; human bodies, he added, "were never for me a compact mass but like a transparent construction." Here he extends that vision to render a building as a haunting stage set.

Haunting and haunted, for the palace is lived in: isolate forms and figures inhabit its spaces. The enigma of their connection charges the air that is the sculpture's principal medium.

Giacometti was a Surrealist when he made the *Palace*, and it has the requisite eerie mood. It was his practice, he said, to execute "sculptures that presented themselves to my mind entirely accomplished. I limited myself to reproducing them . . . without asking myself what they could mean."

Yet Giacometti did relate *The Palace at 4 A.M.* to a period he had spent with a woman who enchanted him, and with whom he had built "a fantastic palace at night, . . . a very fragile palace of matchsticks." He did not know why he had included the spinal column or the skeletal bird, though he associated both with her. As for "the red object in front of the board; I identify it with myself."

Joseph Cornell American, 1903–1972

Taglioni's Jewel Casket. 1940

Wood box containing glass ice cubes, jewelry,
etc., 4¾ × 11⅞ × 8¼" (12 × 30.2 × 21 cm)
Gift of James Thrall Soby

The art form that Cornell made his own
was the box, its contents carefully
arranged to evoke a mood or narrative.
These works may recall toys the artist
had played with as a child, but they
must also trace back to devices in
Surrealist art (which Cornell knew well)
and, earlier, in paintings by Giorgio
de Chirico. In *Taglioni's Jewel Casket*,
small glass cubes lie in a wood box.
Beneath them, and under blue glass,
necklaces, sand, crystal, and rhine-
stones rest on a mirrored surface. This
romantic scene of ice and jewels relates
to an event in the life of the legendary
nineteenth-century ballerina Marie
Taglioni.

A label in the box's lid tells the
story: "On a moonlight night in the
winter of 1835 the carriage of Marie
TAGLIONI was halted by a Russian high-
wayman, and that enchanting creature
commanded to dance for this audience
of one upon a panther's skin spread
over the snow beneath the stars. From
this actuality arose the legend that to
keep alive the memory of this adventure
so precious to her, TAGLIONI formed
the habit of placing a piece of artificial
ice in her jewel casket or dressing
table where, melting among the spar-
kling stones, there was evoked a hint
of the atmosphere of the starlit heav-
ens over the ice-covered landscape."

Ansel Adams American, 1902–1984

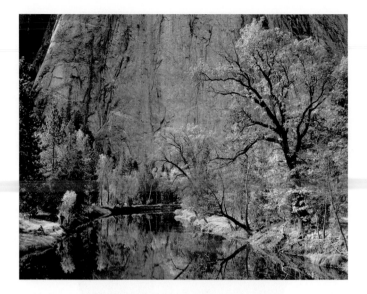

Autumn, Yosemite Valley. 1939

Gelatin silver print, 7¼ × 9½" (18.4 × 24.1 cm)
Gift of Albert M. Bender

From the late 1920s through the 1960s, Adams made hundreds of photographs of Yosemite Valley, and he often aimed to evoke its vastness and sublime grandeur. Many of his pictures, however, are quite intimate. In this view, for example, the cliffs do not seem to loom above us. Instead, along with the trees and the reflections in the water, the face of the cliff belongs to a gossamer tissue of glittering detail, animated by light.

Adams's devotion to wild nature made him a figurehead for conservationists, and his mastery of technique made him a hero to many who were unable to distinguish between the art and craft of photography. But all that came much later. When he made this picture, Adams was still practically unknown. His love of nature was a matter of private feeling, not political conviction; and his attention to craft was not a matter of slavish adherence to formulas and rules. It was made necessary by his art, in which the most ephemeral fluctuation of weather or light could be a major event.

Maya Deren American, born Russia. 1917–1961

Meshes of the Afternoon. 1943

16mm film, black and white, silent, 14 minutes
Purchase
Maya Deren

Meshes of the Afternoon is one of the most influential works in American experimental cinema. A non-narrative work, it has been identified as a key example of the "trance film," in which a protagonist appears in a dreamlike state, and where the camera conveys his or her subjective focus. The central figure in *Meshes of the Afternoon*, played by Deren, is attuned to her unconscious mind and caught in a web of dream events that spill over into reality. Symbolic objects, such as a key and a knife, recur throughout the film; events are open-ended and interrupted. Deren explained that she wanted "to put on film the feeling which a human being experiences about an incident, rather than to record the incident accurately."

Made by Deren with her husband, cinematographer Alexander Hammid, *Meshes of the Afternoon* established the independent avant-garde movement in film in the United States, which is known as the New American Cinema. It directly inspired early works by Kenneth Anger, Stan Brakhage, and other major experimental filmmakers. Beautifully shot by Hammid, a leading documentary filmmaker and cameraman in Europe (where he used the surname Hackenschmied) before he moved to New York, the film makes new and startling use of such standard cinematic devices as montage editing and matte shots. Through her extensive writings, lectures, and films, Deren became the preeminent voice of avant-garde cinema in the 1940s and the early 1950s.

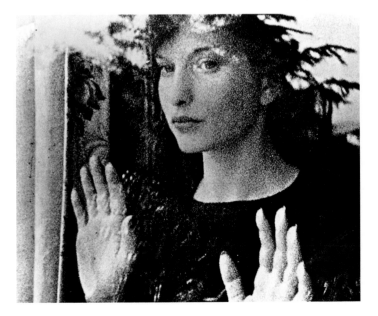

Howard Hawks American, 1896–1977

His Girl Friday. 1940

35mm film, black and white, sound,
92 minutes
Acquired from The New York Public Library,
Montgomery Clift Film Collection
*Rosalind Russell, Cary Grant, Billy Gilbert,
Clarence Kolb*

Fast and furiously funny, *His Girl Friday* blends two formulas popular in Hollywood movies of the late 1930s: scathing satire on political corruption and romantic, screwball comedy. In the film, newspaper managing editor Walter Burns (Cary Grant) ruthlessly scoops the competition by hiding a fugitive with his top reporter and writer Hildy Johnson (Rosalind Russell), who is also his ex-wife. While Burns and Johnson clash romantically and professionally, it is a given that he and the newspaper cannot get along without her. Adding to the hilarity are Johnson's fiancé (Ralph Bellamy), whose courting is sweetly inept, and the governor's messenger (Billy Gilbert) whose rejection of bribery is the film's wickedest moment of truth.

In *His Girl Friday* nothing is allowed to interfere with the dizzying pace set by the actors, who compete to interrupt each other. The talk crackles with wit; the overlapping dialogue of seasoned journalists and mayoral henchmen is smart, real, and mean. Like the stage play *The Front Page*, by Ben Hecht and Charles MacArthur, on which it is based, the film looks plain and feels tight, even claustrophobic, a feeling Hawks also achieved in his action movies, which test men's camaraderie and honor. The Hawksian comedy, here at its best, is a battle of the sexes, with roles reversed to allow for plenty of humiliation and triumph on both sides.

Helen Levitt American, 1913–2009

New York. 1938

Gelatin silver print, 5⅞ × 7⅜" (14.9 × 18.7 cm)
Bequest of Grace M. Mayer

Levitt devoted a lifetime of creative energy to photographing the poetry and drama of life on the streets of New York. This picture is from a series made in the late 1930s and early 1940s, when Levitt was in her twenties. It conveys the unrestrained emotions in the spontaneous gestures of children, who were often her subjects. The world-weary boy in the suit jacket in this picture was described by Levitt's friend, the writer James Agee: "He epitomizes for all human creatures in all times the moment when masks are laid aside." Indeed, he and his skeptical companion seem to form a backstage duo, resting between demanding performances.

Photographers had begun to explore the poetics of street life in the mid-1920s, with the advent of small handheld cameras, some of which used roll film, permitting the photographer to make a series of shots in rapid succession. The portability and ease of the small camera changed the way photographs could be made and, consequently, what could be photographed. The commonplace events of daily life could be transformed into art, as Levitt so gracefully demonstrated.

Orson Welles American, 1915–1985

Citizen Kane. 1941

35mm film, black and white, sound,
119 minutes
Acquired from RKO
Joseph Cotten, Orson Welles, Everett Sloane

Welles's first feature is probably the most respected, analyzed, and parodied of all films. Although its archival and historical value are unchallenged, *Citizen Kane*, nevertheless, seems fresh on each new viewing. The film touches on so many aspects of American life—politics and sex, friendship and betrayal, youth and old age—that it has become a film for all moods and generations. In its expansive way, it creates a kaleidoscopic panorama of a man's life. Loosely based on the life of the newspaper publisher William Randolph Hearst, *Citizen Kane* is the saga of the rise to power of a "poor little rich boy" starved for affection, as

Welles himself was after his parents' early deaths. It is also a meditation on emotional greed, the ease of amassing wealth, and the difficulty of sustaining love.

Welles completed it at the age of twenty-five. Here is a young director's movie, full of boyish bravado, impatient with the genteel traditions of seamless cinematic storytelling, and eager to plunder other media (incorporating the staccato rhythm of newsreel clips, the briskness of radio narrative, and the moodiness of stage lighting). Through its cunning flashback format, the film shows that the future is both inevitable and unknowable. *Citizen Kane* is a classic tour de force which Welles not only wrote, directed, and edited, but in which he played the title role as well.

Weegee (Arthur Fellig) American, born Austria. 1899–1968

Harry Maxwell Shot in a Car. 1941

Gelatin silver print, 13¹⁵⁄₁₆ × 10½"
(35.4 × 26.6 cm)
Gift of the photographer

Weegee, a news photographer, borrowed his professional name from the ouija board as a way of advertising his uncanny ability to show up in the right place at the right time. On this occasion, however, it appears that he was not the first to arrive at the scene. Instead of a grisly close-up of the corpse, he gives us a generous view of the aftermath of the crime: the cops have seen it all before and pass the time in bored distraction while the photographers work.

Photographs began to appear in newspapers around the turn of the century, and the heyday of newspaper photography did not get under way until the 1920s. But it did not take long thereafter to establish the staples of the trade: winners and losers, heroes and villains, catastrophes and celebrations—timeless dramas reinvigorated on a daily basis by the specificity of photographic fact. The genre was at its most pure in the tabloid papers, which dispensed with the facade of journalistic reserve in their headlong pursuit of sensation. Nevertheless, as the writer Luc Sante notes: "In Weegee's hands, this cynicism is so extreme it almost becomes a kind of innocence."

Frida Kahlo

Mexican, 1907–1954

Self-Portrait with Cropped Hair.
1940

Oil on canvas, 15¾ × 11" (40 × 27.9 cm)
Gift of Edgar Kaufmann, Jr.

Kahlo painted *Self-Portrait with Cropped Hair* shortly after she divorced her unfaithful husband, the artist Diego Rivera. As a painter of many self-portraits, she had often shown herself wearing a Mexican woman's traditional dresses and flowing hair; now, in renunciation of Rivera, she painted herself short haired and in a man's shirt, shoes, and oversized suit (presumably her former husband's).

Kahlo knew adventurous European and American art, and her own work was embraced by the Surrealists, whose leader, André Breton, described it as "a ribbon around a bomb." But her stylistic inspirations were chiefly Mexican, especially nineteenth-century religious painting, and she would say, "I do not know if my paintings are Surrealist or not, but I do know that they are the most frank expression of myself." The queasily animate locks of fresh-cut hair in this painting must also be linked to her feelings of estrangement from Rivera (whom she remarried the following year), and they also have the dreamlike quality of Surrealism. For, into the work she has written the lyric of a Mexican song: "Look, if I loved you it was because of your hair. Now that you are without hair, I don't love you anymore."

Jacob Lawrence American, 1917–2000

The Migration Series. 1940–41

Number 58, from a series of 60 works
(30 in the Museum):
tempera on gesso on composition board,
12 × 18" (30.5 × 45.7 cm)
Gift of Mrs. David M. Levy

During the first half of the twentieth century, as the expanding modern industries in America's northern cities demanded ever more workers, great numbers of African Americans saw in these jobs a chance to escape the poverty and discrimination of the rural South. Between 1916 and 1930 alone, over a million people moved north. Lawrence's own parents made this journey, and he grew up hearing stories about it; as a young artist living in Harlem, the heart of New York City's African-American community, he recognized it as an epic theme. Originally known as *The Migration of the Negro*, but renamed by the artist in 1993, this distinguished cycle of images chronicles a great exodus and arrival.

Visually, the cycle advances through panels of great incident and panels of near abstraction and emptiness. Using exaggerated perspectives, rhythmic constructions, astringent colors, and angular figures, Lawrence bends decorative forms to the task of history and makes Social Realism compatible with abstract art. Yet he never loses touch with the task of telling a complex story clearly and accessibly. Leaving hardships behind in the South, African Americans received a mixed reception in the North; along with the possibility of jobs, the vote, and education, the new life also brought unhealthy living conditions, race riots, and other trials all documented in Lawrence's cycle, along with his community's heroic perseverance in facing them. Each part of the story carries a legend by the artist; for the image shown here, the legend reads: "In the North the Negro had better educational facilities."

Joan Miró Spanish, 1893–1983

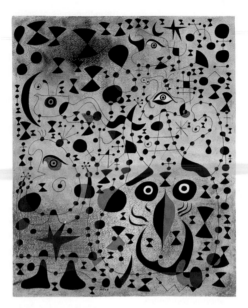

The Beautiful Bird Revealing the Unknown to a Pair of Lovers

(from the Constellation series). 1941

Gouache, oil wash, and charcoal on paper,
18 × 15" (45.7 × 38.1 cm)
Acquired through the Lillie P. Bliss Bequest

This is one of a celebrated group of twenty-four drawings, collectively referred to as the Constellation series, which was executed during a period of personal crisis for Miró triggered by the Spanish Civil War and World War II. Trapped in France from 1936 to 1940, the artist embarked on these obsessively meticulous works on paper in an attempt to commune with nature and escape the tragedies of current events. Despite their modest formats, they represented the most important works of his career up to that time, a fact he quickly realized.

The first eleven works in the series were executed in Normandy between December 1939 and May 1940. Although the motifs throughout correspond to Miró's classic repertory, in the earlier works the washed grounds are more saturated, the motifs larger, and the compositions looser than in those that would follow. In the later thirteen works, executed in Palma de Mallorca in 1940–41, of which *The Beautiful Bird Revealing the Unknown to a Pair of Lovers* is exemplary, the grounds are almost opalescent, and the familiar motifs are smaller and tightly woven into a continuous linear web. In its elusive poetry yet rigorous control, this work not only embodies Miró's artistic personality, but it also mirrors the luminous tracks of constellations in a clear night sky.

Piet Mondrian Dutch, 1872–1944

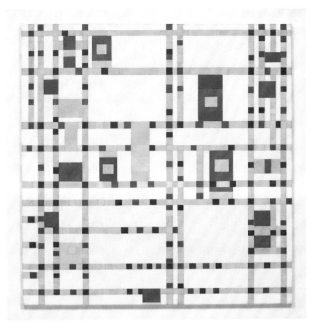

Broadway Boogie Woogie.
1942–43

Oil on canvas, 50 × 50" (127 × 127 cm)
Given anonymously

Mondrian arrived in New York in 1940, one of the many European artists who moved to the United States to escape World War II. He fell in love with the city immediately. He also fell in love with boogie-woogie music, to which he was introduced on his first evening in New York, and he soon began, as he said, to put a little boogie-woogie into his paintings.

Mondrian's aesthetic doctrine of Neo-Plasticism restricted the painter to the most basic kinds of line—that is, to straight horizontals and verticals— and to a similarly limited color range, the primary triad of red, yellow, and blue plus white, black, and the grays

between. But *Broadway Boogie Woogie* omits black and breaks Mondrian's once uniform bars of color into multi-colored segments. Bouncing against each other, these tiny, blinking blocks of color create a vital and pulsing rhythm, an optical vibration that jumps from intersection to intersection like the streets of New York. At the same time, the picture is carefully calibrated, its colors interspersed with gray and white blocks in an extraordinary balancing act.

Mondrian's love of boogie-woogie must have sprung partly from the fact that he saw its goals as analogous to his own: "destruction of melody which is the destruction of natural appear-ance; and construction through the continuous opposition of pure means— dynamic rhythm."

© 2013 Mondrian/Holtzman Trust, c/o HCR International

Arshile Gorky
American, born Armenia, 1904–1948

Diary of a Seducer. 1945

Oil on canvas, 50 × 62" (126.7 × 157.5 cm)
Gift of Mr. and Mrs. William A.M. Burden

Curator William Rubin called Gorky the "godfather" of the Abstract Expressionists, the loosely knit group of American artists working in New York during the 1940s and 1950s who were united in their ambitions if not their painterly styles. Like many of his generation, Gorky began his career as a traditional figurative painter and later discovered the work of modern masters such as Cézanne and Picasso. Distinctly influential for Gorky's mature style was the artist's sustained engagement with Surrealism, a connection made possible by historical circumstance. As World War II raged in Europe, exiled artists flocked to New York City, among them the Surrealists André Breton, Max Ernst, Yves Tanguy, André Masson, and Roberto Matta, several of whom Gorky would count as close friends. Gorky's paintings, like theirs, featured biomorphic forms and evoked the body, landscape, and the artist's unconscious impulses. Yet even in a highly atmospheric work such as *Diary of a Seducer*, Gorky kept the pictorial space shallow, directing attention to the surface of the canvas and the materiality of the oil paint, a practice that would become common among many Abstract Expressionists.

Gorky was a consummate draftsman. Despite its improvisatory spirit, *Diary of a Seducer*, like many of his paintings from this period, was based on drawings executed at his family's farm in Virginia.

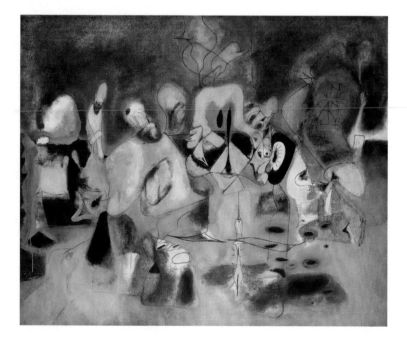

Louise Bourgeois
American, born France, 1911–2010

Quarantania I. 1947–53;
reassembled by the artist 1981

Painted wood on wood base 6' 9¼"
(206.4 cm) high, including base 6 × 27¼ ×
27" (15.2 × 69.1 × 68.6 cm)
Gift of Ruth Stephan Franklin

Unlike many modern sculptors, Louise
Bourgeois never abandoned repre-
sentation. *Quarantania I* is explicitly
anthropomorphic. Each of its elements
was originally made as an autonomous
work. The central figure, *Woman with
Packages* (1947–49), is surrounded
by four variations of Bourgeois's sculp-
ture *Shuttle Woman*. The intimate
arrangement suggests a gathering of
close friends or family members in con-
versation. Just over life-size, the five
"women" address viewers physically
as well as symbolically. Their standing
forms recall the shapes of wooden
weaving shuttles, traditional instru-
ments associated with distaff and with
the craft of tapestry-making and repair,
from which Bourgeois's parents earned
their livelihood.

The individual figures in
Quarantania I are typical of the totemic
painted wood sculptures—her first
works in three dimensions—that
Bourgeois produced in the 1940s and
1950s and which she later called
Personages. Despite their formal prox-
imity to Surrealist and Primitive works
with which she was familiar, the artist
asserted that the *Personages* "had
nothing to do with sculpture." She
called these works "manifestations of
homesickness" for aspects of the life
she had known before moving from
Paris to New York in 1938, the year
she began making them.

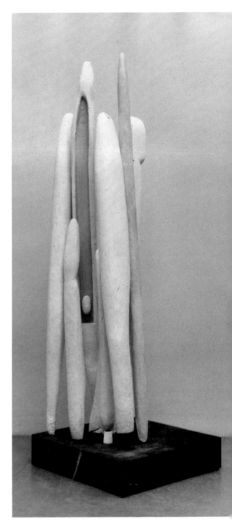

Wifredo Lam Cuban, 1902–1982

The Jungle. 1943

Gouache on paper, mounted on canvas,
7' 10¼" × 7' 6½" (239.4 × 229.9 cm)
Inter-American Fund

In this monumental and thematically complex gouache, masked figures simultaneously appear and disappear amid the thick foliage of sugarcane and bamboo. The multiperspectival rendering of these figures mirrors Cubist vocabulary, while the fantastical moonlit scene around these monstrous beings—half man, half animal—emerging out of a primeval jungle evokes the realm of the Surrealists. In his desire to express the spirit of Afro-Cuban culture, in particular that of the uprooted Africans "who brought their primitive culture, their magical religion, with its mystical side in close correspondence with nature," Lam reinforces the Surrealist aspect of this work.

Born in Cuba, Lam spent eighteen years in Europe (1923–41), which deeply affected his artistic vision. While there, he befriended Pablo Picasso and also established himself as an integral member of the Surrealist movement. The artistic and cultural traditions of Lam's homeland and Europe converged when he returned to Cuba and renewed his familiarity with its light, vegetation, and culture. In *The Jungle* the presence of the woman-horse, who in Afro-Cuban mysticism refers to a spirit in communication with the natural world, mirrors Lam's own confrontational dialogue with the so-called primitive interests expressed in advanced European painting. His work is an example of this confluence of two cultures.

Alfred Hitchcock American, born Great Britain, 1899–1980

Spellbound. 1945

35mm film, black and white, sound, 111 min.
Gift of ABC Pictures International

Spellbound is a taut psychological thriller made by the Master of Suspense six years and nine films into his long and illustrious career as a Hollywood director. Hitchcock set this film in a private psychiatric hospital, where the elderly Dr. Murchison's retirement prompts the arrival of his successor, Dr. Edwards (Gregory Peck). Edwards is eagerly awaited by the other doctors, especially the accomplished Constance Peterson (Ingrid Bergman), but the handsome newcomer is soon beset by catatonia whenever he sees parallel lines on a white background. A follower of Sigmund Freud's *Interpretation of Dreams*, Dr. Peterson engages Dr. Edwards in psychoanalysis to treat his neurosis. Through the analysis of Dr. Edwards's dreams, Dr. Peterson determines that her new colleague is an imposter and possibly the murderer of the real Dr. Edwards.

Always visually meticulous, Hitchcock wanted to depict the dream state with greater realism than could be obtained from standard out-of-focus treatment. He and his producer, David O. Selznick, himself a Freudian analysand, selected Salvador Dalí to design the crucial sequence. Known for the iconic Surrealist film *Un Chien andalou* (1929) and its opening scene of an eyeball being slit by a razor, Dalí crafts similar fantastic ocular references in *Spellbound*'s dream sequence, ultimately explaining the origin of Dr. Edwards's amnesia.

Roberto Matta (Roberto Sebastián Antonio Matta Echaurren) Chilean, 1911–2002

The Vertigo of Eros. 1944

Oil on canvas, 6' 5" × 8' 3" (195.6 × 251.5 cm)
Given anonymously

Matta's paintings do not describe the world we see when we open our eyes. Nor are these the dream or fantasy scenes of his fellow Surrealists Salvador Dalí and René Magritte, which include commonplace objects from waking life; the forms in Matta's works suggest many things but can be firmly identified with none. In the late 1930s and early 1940s Matta had produced works he called "inscapes," imaginary landscapes that he imagined as projections of psychological states. *The Vertigo of Eros* evokes an infinite space that suggests both the depths of the psyche and the vastness of the universe.

A galaxy of shapes suggesting liquid, fire, roots, and sexual parts floats in a dusky continuum of light. It is as if Matta's forms reached back beyond the level of the dream to propose an iconography of consciousness before it has hatched into the recognizable coordinates of everyday experience. There is a sense of suspension in space, and indeed the work's title relates to Freud's location of human consciousness as caught between Eros, the life force, and Thanatos, the death drive. Constantly challenged by Thanatos, Eros produces vertigo. The human problem, then, is to achieve physical and spiritual equilibrium.

In French, the work's title is a pun, *Le Vertige d'Eros* doubling as *Le Vert Tige des roses* (the green stem of the roses).

Clyfford Still
American, 1904–1980

1944-N No. 2. 1944

Oil on unprimed canvas, 8' 8¼" × 7' 3¼"
(264.5 × 221.4 cm)
The Sidney and Harriet Janis Collection

This painting is a powerful early example of Still's mature style. The surface is a black impasto, enlivened with knife marks. A jagged red line cuts high across the canvas and is intersected by two vertical, pointed shapes before plunging to the bottom edge. The size of paintings like this one, its largely empty expanse, and the lightning-bolt quality of the line have led some to see in Still's art a vision of the broad spaces of the Western prairies, where he grew up. But the artist himself believed that such associations only diminished his work.

Still commanded a new kind of abstraction, free from decipherable symbols. The tarry surface of *1944-N No. 2* concentrates attention on itself, denying the illusion of depth, and the intensely saturated hue carries emotional force without relying on associative imagery. More programmatically than any of the other Abstract Expressionists, Still consciously tried to erase any traces of modern European art from his painting and to develop a new art appropriate to the New World. "Pigment on canvas," he believed, "has a way of initiating conventional reactions. . . . Behind these reactions is a body of history matured into dogma, authority, tradition. The totalitarian hegemony of this tradition I despise, its presumptions I reject."

Barnett Newman American, 1905–1970

Vir Heroicus Sublimis. 1950–51

Oil on canvas, 7' 11⅜" × 17' 9¼"
(242.2 × 541.7 cm)
Gift of Mr. and Mrs. Ben Heller

Newman may appear to concentrate on shape and color, but he insisted that his canvases were charged with symbolic meaning. Like Piet Mondrian and Kazimir Malevich before him, he believed in the spiritual content of abstract art. The very title of this painting—in English, "Man, heroic and sublime"—points to aspirations of transcendence.

Abstract Expressionism is often called "action painting," but Newman was one of the several Abstract Expressionists who eliminated signs of the action of the painter's hand, preferring to work with broad, even expanses of deep color. *Vir Heroicus Sublimis* is large enough so that when the viewer stands close to it, as Newman intended, it creates an engulfing environment—a vast red field, broken by five thin vertical stripes. Newman admired Alberto Giacometti's bone-thin sculptures of the human figure, and his stripes, or "zips," as he called them, may be seen as symbolizing figures against a void. Here they vary in width, color, and firmness of edge: the white zip at center left, for example, looks almost like the gap between separate planes, while the maroon zip to its right seems to recede slightly into the red. These subtly differentiated verticals create a division of the canvas that is surprisingly complex and asymmetrical; right in the middle of the picture, however, they set off a perfect square.

Jackson Pollock American, 1912–1956

One (Number 31, 1950). 1950

Oil and enamel on unprimed canvas,
8' 10" × 17' 5⅝" (269.5 × 530.8 cm)
Sidney and Harriet Janis Collection Fund
(by exchange)

One is a masterpiece of the "drip," or pouring, technique, the radical method that Pollock contributed to Abstract Expressionism. Moving around an expanse of canvas laid on the floor, Pollock would fling and pour ropes of paint across the surface. *One* is among the largest of his works that bear evidence of these dynamic gestures. The canvas pulses with energy: strings and skeins of enamel, some matte, some glossy, weave and run, an intricate web of tans, blues, and grays lashed through with black and white. The way the paint lies on the canvas can suggest speed and force, and the image as a whole is dense and lush—yet its details have a delicacy and lyricism.

The Surrealists' embrace of accident as a way to bypass the conscious mind sparked Pollock's experiments with the chance effects of gravity and momentum on falling paint. Yet although works like *One* have neither a single point of focus nor any obvious repetition or pattern, they sustain a sense of underlying order. This and the physicality of Pollock's method have led to comparisons of his process with choreography, as if the works were the traces of a dance. Some see in paintings like *One* the nervous intensity of the modern city, others the primal rhythms of nature.

Mark Rothko American, born Latvia. 1903–1970

No. 3/No. 13. 1949

Oil on canvas, 7' 1⅜" × 65"
(216.5 × 164.8 cm)
Bequest of Mrs. Mark Rothko through
The Mark Rothko Foundation, Inc.

No. 3/No. 13 follows a compositional structure that Rothko explored for twenty-three years beginning in 1947. Narrowly separated, rectangular blocks of color hover against a colored ground. Their edges are soft and irregular, so that when Rothko uses closely related tones, the rectangles sometimes seem barely to emerge from the ground. The green bar in *No. 3/No. 13*, on the other hand, appears to vibrate against the orange around it, creating an optical flicker. In fact the canvas is full of gentle movement, as blocks emerge and recede, and surfaces breathe. Just as edges tend to fade and blur, colors are never completely flat, and the faint unevenness in their intensity, besides hinting at the artist's process in layering wash on wash, mobilizes an ambiguity, a shifting between solidity and impalpable depth.

The sense of boundlessness in Rothko's paintings has been related to the aesthetics of the sublime, an implicit or explicit concern of a number of his fellow painters in the New York School. In fact, the remarkable color in his paintings was for him only a means to a larger end: "I'm interested only in expressing basic human emotions— tragedy, ecstasy, doom," he said. "If you . . . are moved only by . . . color relationships, then you miss the point."

Yasujiro Ozu Japanese, 1903–1963

Tokyo Monogatari (Tokyo Story).
1953

35mm film, black and white, sound,
135 minutes
Acquired from New Yorker Films
Chiyeko Higashiyama, Setsuko Hara

Tokyo Monogatari is one of the greatest masterpieces of Japanese cinema. Its director, Ozu, is more firmly rooted in the twentieth century than any other Japanese director. His films do not rely on exotic historical spectacle, elaborate costumes, and tales of honor and conquest. He is also the filmmaker most committed to the traditional values of institutions such as the family. There is no exoticism in Ozu's *Tokyo Monogatari*, and no sweeping action, no horses, no historical reenactments, only people. But the viewer is compensated by the intensity of feeling that Ozu's domestic dramas engender and by the sincerity of their message. People sit around drinking green tea; they sit at noodle bars; they sit in offices. Ozu's contemplative camera hardly ever moves, and his actors seldom emote.

The understated performances of this film's well-matched actors complement the serenity of Ozu's atmosphere and the sparseness of his naturalistic dialogue. The film explores family dynamics and the conflict of the traditional versus the contemporary through an aging couple's visit to their adult children in the city. Although *Tokyo Monogatari* is about tangible loss, its radiant spirituality transcends death.

Andrew Wyeth American, 1917–2009

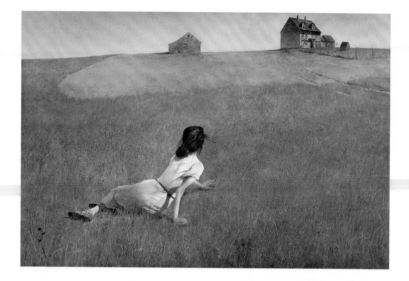

Christina's World. 1948

Tempera on panel, 32¼ × 47¾"
(81.9 × 121.3 cm)
Purchase

This striking landscape has a mysterious, melancholic atmosphere. A woman in a dusty pink housedress faces away from us as she gazes out at two houses set starkly across an arid field. Wyeth's crippled neighbor Anna Christina Olson inspired the composition, which is one of four paintings by Wyeth in which she appears. Olson was in her mid-fifties when *Christina's World* was painted, but her age is hardly apparent. Although Wyeth portrayed the figure's hands as gnarled and arthritic, he modeled the rest of the body on that of his young wife. Discussing the intentions behind *Christina's World*, the artist wrote, "If . . . I have been able . . . to make the viewer sense that her world may be limited physically but by no means spiritually, then I have achieved what I set out to do."

The painting's naturalistic style recalls works by nineteenth-century American painters such as Thomas Eakins and Winslow Homer. But to a far greater degree than his predecessors, Wyeth fastidiously rendered every blade of grass and strand of hair, to hyperrealist effect. The artist worked from multiple sketches to heighten the drama of the composition. As he once said, "When you lose simplicity, you lose drama, and drama is what interests me." MoMA acquired this painting the year after it was executed, and it has been a popular favorite ever since.

John Ford American, 1895–1973

My Darling Clementine. 1946

35mm film, black and white, sound, 97 minutes
Gift of Twentieth Century Fox Film Corp.
Henry Fonda

Among Ford's finest Westerns and one of the greatest of films for its sense of poetic tragedy, *My Darling Clementine* is pervaded by a feeling of loss—of family, place, honor, and self-worth. The reluctant hero, Wyatt Earp (Henry Fonda), can never find within himself the peace the church-going pioneer families pay him to establish. Equally, he is a reluctant romantic, deeply chivalrous like other Fordian leading men. Among the more elusive protagonists of the Western genre, Earp seems laid back, reserved, or repressed. His friend and ally, Doc Holliday (Victor Mature), is a dentist turned gambler who carries a tragic weight. Earp's sorrow is quieter, more introspective. His gentle attempts to achieve balance on a sunny Sunday morning yield one of cinema's most sublime moments.

Ford gave a lonely landscape a particular resonance. No other filmmaker is as identified with a specific location; none has imbued a site with greater meaning. His Westerns are an evocation of his strong feeling for the American past; the frontier is his landscape of memory. *My Darling Clementine* is a triumph of his unique Western mise-en-scène, rich characterization, and breathtaking black-and-white cinematography. The town of Tombstone, a settlement in the middle of nowhere, is a universe unto itself. It represents the civilization of the white man, with the Indian nation of no importance. Problems are caused by greed and drunkenness, clannish loyalties, and a thirst for revenge. The film plays freely with myth and legend, often departing from what is known about the historical figures who inspire the tale: the Earps, the Clantons, and Holliday.

Charles Eames American, 1907–1978
Ray Eames American, 1912–1988

Low Side Chair (model LCM).
1946

Molded walnut veneered plywood, chrome-plated steel rods, and rubber shock mounts, 27⅜ × 22¼ × 25⅜" (69.5 × 56.3 × 64.5 cm)
Manufacturer: Herman Miller Inc., USA
Gift of the manufacturer

The LCM (Lounge Chair Metal) was conceived by Eames, who, with his wife and professional partner, Ray, formed one of the most influential design teams of the twentieth century. First produced in 1946, the LCM and its companion, the DCM (Dining Chair Metal), met with great commercial success and have become icons of modern design. The LCM's molded-plywood seat and back sit on a chrome-plated steel frame, with rubber shock mounts in between. That the back and seat are separate pieces simplified production, while also providing visual interest.

Together with Eero Saarinen, Charles Eames had first experimented with bent plywood for a group of prize-winning designs they submitted to the 1940 competition "Organic Design in Home Furnishings," organized by The Museum of Modern Art. These, however, proved difficult to manufacture, and most were upholstered for comfort. Intent on producing high-quality objects at economical manufacturing costs, the Eameses devoted the better part of the next five years to refining the technique of molding plywood to create thin shells with compound curves. The chair was initially manufactured by the Evans Products Company; in 1949 Herman Miller Inc. bought the rights to produce it.

Ladislav Sutnar American, born Bohemia (now Czech Republic), 1897–1976

Prototype for Build the Town building blocks. 1940–43

Painted wood blocks, 29 units, various shapes and sizes
Gift of Ctislav Sutnar and Radoslav Sutnar

Between 1940 and 1943, Sutnar produced a series of prototypes for a set of painted wooden building blocks called *Build the Town*, the last in a series of construction toys he had begun in 1922 and that was central to his ideas about design and modern life. A designer at the forefront of inter-war modernism in Czechoslovakia, he viewed well-designed toys as an important means of shaping the values of a new generation living in a modern world. Even after Sutnar emigrated to the United States in 1939, he kept his ideas for a popular building toy alive. Like many design and educational reformers of the twentieth century, he believed in the cognitive power of a visual language rooted in elemental shapes and colors.

Like his earlier sets of blocks, *Build the Town* was inspired by contemporary American factories and the planned communities that often surrounded them. For Sutnar, building miniature cities with blocks gave children an awareness of form and structure—in this case, the forms and structures of modern functionalist architecture—and also a sense of the forces that shape a community. Although he was unable to find a reliable manufacturer for the blocks or to interest retailers in the project, Sutnar continued to work successfully in the field of graphic design and became a leading advocate of modernist principles in postwar commercial design.

Arthur Young American, 1905–1995

Bell-47D1 Helicopter. 1945

Aluminum, steel, and acrylic, 9' 2¾" ×
9' 11" × 41' 8¾" (281.3 × 302 × 1272.9 cm)
Manufacturer: Bell Helicopter Inc., U.S.A.
Marshall Cogan Purchase Fund

More than three thousand Bell-47D1 helicopters were made in the United States and sold in forty countries between 1946 and 1973, when production ceased. While the Bell-47D1 is a straightforward utilitarian craft, its designer, Arthur Young, who was also a poet and a painter, consciously juxtaposed its transparent plastic bubble with the open structure of its tail boom to create an object whose delicate beauty is inseparable from its efficiency. That the plastic bubble is made in one piece rather than in sections joined by metal seams sets the Bell-47D1 apart from other helicopters. The result is a cleaner, more unified appearance.

The bubble also lends the hovering craft an insectlike appearance, which generated its nickname, the "bug-eyed helicopter." It seems fitting, then, that one of the principal uses of the Bell-47D1 has been for pest control in crop dusting and spraying. It has also been used for traffic surveillance and for the delivery of mail and cargo to remote areas. During the Korean War, it served as an aerial ambulance.

Awarded the world's first commercial helicopter license by the Civil Aeronautics Administration (now the FAA), the Bell-47D1 weighs 1,380 pounds. Its maximum speed is 92 miles per hour, and its maximum range, 194 miles. It can hover like a dragonfly at altitudes up to 10,000 feet.

David Smith American, 1906–1965

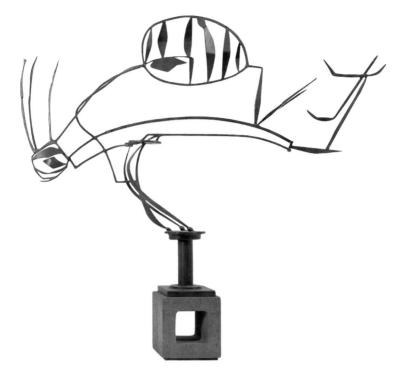

Australia. 1951

Painted steel, 6' 7½" × 8' 11⅞" × 16⅛"
(202 × 274 × 41 cm) on cinder block base,
14 × 14" (35.6 × 35.6 cm)
Gift of William Rubin

In *Australia* Smith uses thin rods and plates of steel, simultaneously delicate and strong, to draw in space. Sculpture has traditionally gained power from solidity and mass, but *Australia* is linear, a skeleton. The Constructivists were the first to explore this kind of penetration of sculpture by empty space. Smith learned about it from photographs of the welded sculpture of Pablo Picasso: he had begun his career as a painter, but he knew how to weld (he had worked as a riveter in the automobile industry) and Picasso's works

liberated him to start working in steel.

Like a painting or drawing, *Australia* must be seen frontally if its form is to be grasped. It has been identified as an abstraction of a kangaroo, and its lines have that animal's leaping vitality; but it is an essay in tension, balance, and shape more than it is any kind of representation. In calling the work *Australia*, Smith may have had in mind the passages on that country in James Joyce's novel *Finnegans Wake*. He may also have been thinking of the magazine illustration of aboriginal Australian cave drawings that the critic Clement Greenberg sent him in September of 1950, with the note, "The one of the warrior reminds me particularly of some of your sculpture."

Akira Kurosawa Japanese, 1910–1998

Rashomon. 1950

35mm film, black and white, sound, 88 min.
Gift of James Mulvey

"Rashomon" refers to a real place, specifically, an ancient gate that once stood at the entrance to Nara, the ancient capital of Japan. But "rashomon" is now more than just a place name. It has entered the English language (and probably other languages too) as a word used to designate the curious, multiple nature of truth. The term "rashomon effect" refers to the coexistence of diverging, contradictory and yet quite plausible versions of a single event.

Rashomon was Kurosawa's twelfth film and the first from Japan to receive international acclaim in the West after World War II. It established Kurosawa as one of the great makers of narrative cinema. Adapted from two short stories by Ryunosuke Akutagawa ("Rashomon," which gave the film its setting; and "In a Grove," which provided the "stories"), Kurosawa's fluid treatment of four competing tales of what happened in a grove where a man was murdered and a wife raped is a paradigm of cinematic storytelling. Under Kurosawa's direction, sweeping and graceful camera movements, dappled light both brilliant and shadowed, varieties of visual and aural rhythms, and a terrific cast all contribute to this most plastic and resonant of films.

Franz Kline American, 1910–1962

Chief. 1950

Oil on canvas, 58⅜" × 6' 1½"
(148.3 × 186.7 cm)
Gift of Mr. and Mrs. David M. Solinger

True to an alternate name for Abstract Expressionism, "action painting," Kline's pictures often suggest broad, confident, quickly executed gestures reflecting the artist's spontaneous impulses. Yet Kline seldom worked that way. In the late 1940s, chancing to project some of his many drawings on the wall, he found that their lines, when magnified, gained abstraction and sweeping force. This discovery inspired all of his subsequent painting; in fact many canvases reproduce a drawing on a much larger scale, fusing the improvised and the deliberate, the miniature and the monumental.

"Chief" was the name of a locomotive Kline remembered from his child-hood, when he had loved the railway. Many viewers see machinery in Kline's images, and there are lines in *Chief* that imply speed and power as they rush off the edge of the canvas, swelling tautly as they go. But Kline claimed to paint "not what I see but the feelings aroused in me by that looking," and *Chief* is abstract, an uneven framework of horizontals and verticals broken by loops and curves. The cipherlike quality of Kline's configurations, and his use of black and white, have provoked comparisons with Japanese calligraphy, but Kline did not see himself as painting black signs on a white ground; "I paint the white as well as the black," he said, "and the white is just as important."

Harry Callahan American, 1912–1999

Chicago. c. 1950

Gelatin silver print, 7⅝ × 9⁹/₁₆"
(19.4 × 24.3 cm)
Stephen R. Currier Memorial Fund

Alfred Stieglitz, Edward Weston, and others defined the dominant aesthetic of modern American photography of the 1920s. The formal rigor and precision of their pictures set forth an ideal of purity and contemplation, unsullied by the complexities of the modern world. It was their acute alertness to subtle particulars that saved their work from lifeless perfection.

Beginning in the early 1940s and for nearly half a century thereafter, Callahan extended the tradition by intensifying both of its poles. His pictures mark an extreme of austerity, but they are full of variety and playful experiment. Like snowflakes, they adhere to a rigid set of rules, but no two are the same.

Callahan's view of the shore of Lake Michigan reduces photography's unbroken scale of tones to the extreme white of the snow, the pure black of the trees, and a middle gray. Yet the distinction between water and sky is there—just barely. And, while the tree trunks make strong vertical accents, they vary in thickness and shape; and they group themselves into pairs, like three figures poised for action. As the trunks branch and branch again, they make a tapestry: flattened, whole, unbroken, but delicate and inexhaustibly intricate.

Charles White American, 1918–1979

Solid as a Rock (My God is Rock).
1958

Linoleum cut, sheet: 41⅛ × 17¹³⁄₁₆"
(104.5 × 45.2 cm)
Unpublished
Edition: 5 known examples
John B. Turner Fund with additional support
from Linda Barth Goldstein and Stephen F.
Dull

White's powerful, full-length portrait
Solid as a Rock (My God is a Rock)
depicts an African-American figure
as a monumental form, its sculptural
appearance rendered through the
boldly carved lines of linoleum cut. With
oversized hands and feet like those
associated with classical statuary, the
figure stands firmly, gazing outward, its
heavy robe cloaking individual traits to
create a universalizing representation.
This work signifies a key moment for
the artist—a transition between his
earlier Social Realist work produced for
the Works Progress Administration and
his increasing commitment to issues of
race and the black body, which occu-
pied his practice from the 1950s until
his death in 1979.

Printmaking was always an impor-
tant medium for the Chicago-born
artist, who believed that art could be
used as a weapon, "to say what I
have to say." He first experimented
with lithography for sociopolitical aims
at the revolutionary print shop Taller
de Gráfica Popular, in Mexico City,
where he spent time in the late 1940s
with his then-wife, the artist Elizabeth
Catlett. Following this experience, White
moved to New York and was active in
the Committee for the Negro Arts and
the Workshop for Graphic Art before
settling permanently in Los Angeles in
1956. He became an enormously influ-
ential mentor to that city's emerging
African-American artists—among them,
David Hammons.

Willem de Kooning
American, born the Netherlands, 1904–1997

Woman, I. 1950–52

Oil on canvas, 6' 3⅞" × 58"
(192.7 × 147.3 cm)
Purchase

Woman, I is the first in a series of de Kooning works on the theme of Woman. The group is influenced by images ranging from Paleolithic fertility fetishes to American billboards, and the attributes of this particular figure seem to range from the vengeful power of the goddess to the hollow seductiveness of the calendar pinup. Reversing traditional female representations, which he summarized as "the idol, the Venus, the nude," de Kooning paints a woman with gigantic eyes, massive breasts, and a toothy grin. Her body is outlined in thick and thin black lines, which continue in loops and streaks and drips, taking on an independent life of their own. Abrupt, angular strokes of orange, blue, yellow, and green pile up in multiple directions as layers of color are applied, scraped away, and restored.

When de Kooning painted *Woman, I*, artists and critics championing abstraction had declared the human figure obsolete in painting. Instead of abandoning the figure, however, de Kooning readdressed this age-old subject through the sweeping brushwork of Abstract Expressionism, the prevailing contemporary style. Does the woman partake of the brushwork's energy to confront us aggressively? Or is she herself under attack, nearly obliterated by the welter of violent marks? Perhaps something of both; and, in either case, she remains powerful and intimidating.

Robert Rauschenberg American, 1925–2008

Bed. 1955

Combine painting: oil and pencil on pillow,
quilt, and sheet on wood supports,
6' 3¼ × 31½" × 8" (191.1 × 80 × 20.3 cm)
Gift of Leo Castelli in honor of Alfred H. Barr, Jr.

Bed is one of Rauschenberg's first
Combines, his own term for his tech-
nique of attaching cast-off items, such
as rubber tires or old furniture, to a
traditional support. In this case he
framed a well-worn pillow, sheet, and
quilt, scribbled them with pencil, and
splashed them with paint, in a style
derived from Abstract Expressionism.
In mocking the seriousness of that
ambitious art, Rauschenberg predicted
an attitude more widespread among
later generations of artists—the Pop
artists, for example, who also appreci-
ated Rauschenberg's relish for every-
day objects.

Legend has it that the bedclothes
in *Bed* are Rauschenberg's own,
pressed into use when he lacked the
money to buy a canvas. Since the art-
ist himself probably slept under this
very sheet and quilt, *Bed* is as per-
sonal as a self-portrait, or more so—a
quality consistent with Rauschenberg's
statement, "Painting relates to both
art and life. . . . (I try to act in that gap
between the two)." Although the mate-
rials here come from a bed, and are
arranged like one, Rauschenberg hung
them on the wall, like a work of art.
So the bed loses its function, but not
its associations with sleep, dreams,
illness, sex—the most intimate
moments in life. Critics have also pro-
jected onto the fluid-drenched fabric
connotations of violence and morbidity.

Vittorio De Sica
Italian, 1901–1974

Ladri di biciclette (Bicycle Thief).
1948

35mm film, black and white, sound,
91 minutes
Acquired via exchange with Ceskoslovensky
Filmovy Archiv
Lamberto Maggiorani, Enzo Staiola

In *Ladri di biciclette*, a worker whose livelihood depends on his bicycle finds that it has been stolen, and spends a heartbreaking day with his young adoring son searching for it in the streets of Rome. The film represents a genre of Italian cinema known as Neorealism, an enormously influential style in which films were shot on location, outdoors, and with available light. Filmmakers such as De Sica, Roberto Rossellini, Giuseppe De Santis, and Luchino Visconti often used nonprofessional actors in their stories about common people adjusting to the brutal conditions of a society humbled and impoverished by war.

De Sica, an actor, directed his first film in 1939, but it was not until he made his postwar neo-realist masterworks, known in English as *Shoeshine, Bicycle Thief*, and *Umberto D*, in particular, that he became internationally celebrated. Despite having been initially censored in the United States, *Bicycle Thief* was so well received in America that the Academy of Motion Picture Arts and Sciences honored it with a special award two years before the Oscar for the best foreign-language film was inaugurated.

Elizabeth Catlett American and Mexican, born United States, 1915–2012

Sharecropper. 1952, published 1968–1970

Linoleum cut, composition: 17⅝ × 16¹⁵⁄₁₆"
(44.8 × 43 cm)
Publisher: the artist and Taller de Gráfica Popular, Mexico City
Edition: proof outside the edition of 60
The Ralph E. Shikes Fund and Purchase

The woman depicted in this print raises her head to gaze out from beneath a wide-brimmed straw hat, straightening her taut neck. She wears a thin jacket fastened with a safety pin. Although weary, the sharecropper's face reveals a dignified strength. Elizabeth Catlett saw in the downtrodden worker a source of power, and she created portraits such as this as a visual means to oppose oppression.

Raised in Washington, D.C., Catlett spent most of her life in Mexico, where she was drawn to the populist art of Diego Rivera and José Clemente Orozco. She first traveled there in 1946 and soon began frequenting the Taller de Gráfica Popular. This print workshop supported artwork aimed at the populace. It specialized in techniques like linoleum cut and lithography, which could be produced cheaply and disseminated widely. The printshop's agenda coincided with Catlett's own championing of laborers.

More so than the sculptures she produced, Catlett's printmaking conveyed her political convictions. "In the printmaking I'm thinking about something social or political," she said, "and in the sculpture I'm thinking about form. But I'm also thinking about women, black women." Across mediums, Catlett delved into her own background and depicted as noble and strong the people whose cause she advocated.

Henri Matisse French, 1869–1954

The Knife Thrower from **Jazz** by Henri Matisse. 1943–47

Illustrated book with 20 pochoirs, page: 16½ × 12¹¹⁄₁₆" (42 × 32.2 cm)
Publisher: Tériade Éditeur, Paris. Edition: 270
The Louis E. Stern Collection

The energetic, vivid fuchsia form shown here at the left represents a knife thrower, while the static, pale blue form with upraised arms at the right suggests his female partner in the popular circus act. Shapes resembling leaves float across the composition, providing a dreamlike atmosphere for this aesthetic vision. "These images, with their lively and violent tones, derive from crystallizations of memories of circuses, folktales, and voyages." So wrote Matisse in the poetic text accompanying his compositions for *Jazz*, his extraordinary artist's book. *The Knife Thrower* is one of twenty images in this volume, which are interleaved with pages on which his own handwritten words are printed.

Late in his career, after being bedridden following surgery in 1941, Matisse turned to making collages from painted papers. Using scissors, he cut curved shapes, which he then arranged in animated compositions. The adventurous publisher Tériade encouraged Matisse to create a book from these dazzling creations. The artist chose the printing technique of pochoir, which is notable for its ability to achieve saturated areas of flat, brilliant colors by a process of applying gouache inks through stencils.

Ellsworth Kelly American, born 1923

Colors for a Large Wall. 1951

Oil on canvas, mounted on sixty-four
wood panels; overall, 7' 10¼" × 7' 10½"
(239.3 × 239.9 cm)
Gift of the artist

"I have never been interested in painterliness," Kelly has said, using painterliness to mean "a very personal handwriting, putting marks on a canvas." There is no personal handwriting, nor even any marks as such, in *Colors for a Large Wall*, which comprises sixty-four abutting canvases, each the same size (a fraction under a foot square) and each painted a single color. Not even the colors themselves, or their position in relation to each other, could be called personal; Kelly derived them from commercial colored papers, and their sequence is arbitrary. Believing that "the work of an ordinary bricklayer

is more valid than the artwork of all but a very few artists," he fused methodical procedure and a kind of Apollonian detachment into a compositional principle.

As a serial, modular accumulation of objects simultaneously separate and alike, *Colors for a Large Wall* anticipated the Minimalism of the 1960s, but it is unlike Minimalism in the systematic randomness of its arrangement, which is founded on chance. Produced at the height of Abstract Expressionism (but quite independently of it, since Kelly had left New York for Paris), the work also has that art's mural scale, and Kelly thought deeply about the relationship of painting to architecture; but few Abstract Expressionists could have said, as he has, "I want to eliminate the '*I* made this' from my work."

Jean Dubuffet French, 1901–1985

Joë Bousquet in Bed from More Beautiful Than They Think: Portraits. 1947

Oil emulsion in water on canvas, 57⅝ × 44⅞"
(146.3 × 114 cm)
Mrs. Simon Guggenheim Fund

Joë Bousquet was a poet who had been paralyzed in World War I, and lived, bedridden, for over thirty years in Narbonne, in the south of France. Dubuffet shows him lying in bed. Beside him on the covers lie two of his books (*La Connaissance du soir* and *Traduit du silence*), a newspaper, two letters addressed to him, and a package of Gauloises cigarettes.

The newspaperlike brochure for Dubuffet's October 1947 show in Paris included the announcement, "People are more beautiful than they think they are. Long live their true faces. . . . Portraits with a resemblance extracted, with resemblance cooked and conserved in the memory, with a resemblance exploded in the memory of Mr. Jean Dubuffet, painter." At a time when few modern artists were producing portraits, the perpetually rebellious Dubuffet depicted the intellectuals who were his friends, but he made no effort at descriptive or psychological exactness. Inspired by the art of children, the insane, and the unschooled (all of which he collected under the name *l'art brut*), he made crude, caricatural images, roughly scratched into a thick impasto. Dubuffet's rejection of painterly elegance signaled his interest in inner beauty rather than physical attractiveness.

Francis Bacon British, 1909–1992

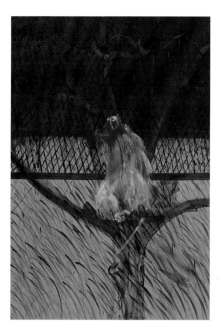

Study of a Baboon. 1953

Oil on canvas, 6' 6⅛" × 54⅛"
(198.3 × 137.3 cm)
William A. M. Burden Fund

By his own account, Bacon completed his first mature painting in 1944, during World War II. Appropriately to the time, he addressed themes not just of suffering but of torment, and drew from a combination of mythological and Christian sources to articulate themes of violent revenge. The mood endured throughout his work and certainly informed the somber *Study of a Baboon*.

Bacon often derived his images from photographs—from newsprint and film stills and, notably, a reproduction of a Diego Velázquez painting—and he copied this baboon from one of his favorite books, Marius Maxwell's *Stalking Big Game with a Camera in Equatorial Africa*, published in 1925. The photographs are chiefly of large wild animals such as the elephant and the rhinoceros, but among the plates is a startling reproduction of baboons in acacia trees. Bacon had traveled often in Africa and was reportedly fascinated to see monkeys and apes of various kinds caged in the parks, while outside others roamed in freedom. *Study of a Baboon* pointedly incarnates this duality. The baboon is half imprisoned, half free. The vigorously painted bars of the cage force the baboon uncomfortably close to the viewer. Its body is partly transparent and ghostly, but its sinister open maw and glinting white fangs mark a very real presence. Bacon pens the viewer into the enclosure with the ferocious creature, suggesting a close correlation between the two beings.

Alberto Giacometti Swiss, 1901–1966

Le Chariot (The Chariot). 1950

Painted bronze on wood base
57 × 26 × 26⅛" (144.8 × 65.8 × 66.2 cm),
base 9¾ × 4½ × 9¼" (24.8 × 11.5 ×
23.5 cm)
Purchase

Impossibly thin, attenuated figures
dominate Alberto Giacometti's sculp-
tural production in the years following
World War II. *Le Chariot* features a deli-
cately rendered female form standing
atop a platform of a horseless chariot,
itself elevated above the ground, bal-
ancing on two tapered wooden blocks.
According to the artist, *Le Chariot* was
partly inspired by the memory of a
"sparkling pharmacy cart" he saw
when briefly hospitalized. It was also
prompted by his desire to place the fig-
ure in empty space "in order to see it
better and to situate it at a precise dis-
tance from the floor." An allegory of
equilibrium, the chariot and its rider
are improbably still and seemingly
exempt from the laws of gravity, as
though forever frozen in time.

Giacometti began to pare down
and elongate his figures to give the
impression that they were being seen
from a distance. Painters achieve this
illusion by varying the size of objects
according to the rules of perspective.
Giacometti acknowledged that sculp-
ture was ill-equipped to represent dis-
tance within an individual work;
nevertheless, he was determined to
try. The resultant forms assumed addi-
tional gravitas in the aftermath of
World War II. If Giacometti's spare and
slender bodies evoke human fragility,
they are bolstered by the strength of
their materials. Although initially mod-
eled from plaster or clay, Giacometti's
works from this period, including *Le
Chariot,* were cast in bronze.

Lucio Fontana
Italian, born Argentina, 1899–1968

Concetto spaziale (Spatial Concept). 1957

Ink and pencil on paper on canvas,
55" × 78⅞" (139.7 × 200.4 cm)
Gift of Morton G. Neumann

The strongest visual device in *Concetto spaziale* is a wide, irregular oval of rough holes, their broken rims poking outward as if some force in the hidden dark behind the picture plane were struggling to break through. Scratches of black ink, most of them short and bristlelike, scatter in flurries across the surface; the lighter lines and whorls are abrasions scored in the thick paper, ridged scars that compensate for their relative faintness with their violence. Fontana's Spatial Concepts—the first of which dates from 1949—have a physical concreteness in tune with the anti-idealist mood of postwar Europe.

Fontana felt that scientific advances demanded parallel innovations in art, which, he declared, should reach out into its surroundings—should exist not in two dimensions but in space. Sculpture, being three-dimensional, did this necessarily, as did the kind of environmental installation that Fontana explored early on (the form has since become a whole genre of art). Painting, though, would demand radical surgery: the rupturing of the picture's flatness.

The canvas or paper support is a literal foundation of painting, the stage on which all of the picture's events must play themselves out. To puncture this plane, or to slash it with a knife, is a daring, even shocking act for a painter. *Concetto spaziale* clearly conveys the considerable psychological nerve Fontana's gesture took.

189

Ludwig Mies van der Rohe American, born Germany, 1886–1969

Farnsworth House, Plano, Illinois.
1946–51

Preliminary version, north elevation, 1945:
watercolor and graphite on tracing paper,
13 × 25" (33 × 63.5 cm)
Mies van der Rohe Archive.
Gift of the architect

The weekend house for Dr. Edith
Farnsworth represented by this render-
ing is one of Mies van der Rohe's
clearest expressions of his ideas about
the relationship between architecture
and landscape. The transcendent qual-
ity he achieved in his architecture is
epitomized by the reductive purity
and structural clarity of this steel and
glass structure. The space of the
house is defined by its roof and floor
planes, the whole supported by eight
steel columns. All the steel elements
are painted white. The architect
claimed: "We should strive to bring
Nature, houses, and people together
into a higher unity. When one looks at
Nature through the glass walls of
the Farnsworth House it takes on a
deeper significance than when one
stands outside. More of Nature is
thus expressed—it becomes part of

a greater whole."

Set in a meadow overlooking the
Fox River, which is prone to flooding,
the house is elevated above the
ground. Aesthetically, this contributes
to the effect of weightlessness, rein-
forced by the cantilevered roof and
floor planes and by the asymmetrical
placement of the two travertine ter-
races that imply an infinite extension
into space. Mies van der Rohe's trans-
formation of a classical pavilion into a
completely modern, abstract idiom—
based on a carefully studied sense of
proportion and structural logic—is a
sublime testament to his apocryphal
statement: "less is more."

Roberto Burle Marx Brazilian, 1909–1994

PLATE 17

Detail of plan for Ibirapuera Park, Quadricentennial Gardens project, São Paulo, Brazil. 1953

Gouache on board, 43 × 52⅛"
(109.2 × 132.4 cm)
Inter-American Fund

Burle Marx was the first Brazilian landscape architect to depart from the classical principles of formal garden design. His asymmetrical plans have influenced landscape artists around the world, as has his use of native vegetation, colorful pavements, and free-form bodies of water. His knowledge and cultivation of myriad species of plants have been cornerstones of his designs; by choosing plants that thrive naturally in the climate and soil of the site and by including evergreens and perennials, Burle Marx produced gardens that are easy to maintain and in keeping with the nature of modern living.

He was a painter by training, and his designs, with their careful juxtaposi-

tions of contrasting colors, shapes, and textures, have been likened to paintings, or living works of art. Whimsical and somewhat reminiscent of Surrealist compositional forms, they evoke the work of Jean Arp, Alexander Calder, and Joan Miró.

Burle Marx designed the landscaping for Ibirapuera Park in collaboration with the architect Oscar Niemeyer. The organically shaped planting beds, pathways, and bodies of water all aim to integrate landscape with architecture. Burle Marx and Niemeyer had worked together previously on several landmark projects. In the 1930s they collaborated with Le Corbusier and Lucia Costa on the Ministry of Education and Public Health Building in Rio de Janeiro.

Roy DeCarava American, 1919–2009

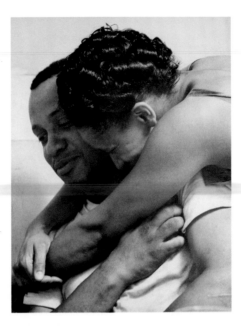

Shirley Embracing Sam. 1952

Gelatin silver print, 13⅜ × 10⅛"
(34 × 25.7 cm)
Gift of the photographer

This picture appeared in DeCarava's book *The Sweet Flypaper of Life*, in 1955, with a text by the American poet Langston Hughes. The book has been praised as a sympathetic view of everyday life in Harlem, New York, drawn by two members of the community rather than by visiting sociologists or reformers. The praise is reasonable as far as it goes, but it fails to note the originality of the photographs DeCarava made behind closed doors, which describe his friends with the same gentleness and warmth they accord to each other. No photographer before him had pictured domestic life—black or white—with such unsentimental tenderness.

To make a picture, a photographer must be in the presence of the subject. This simple fact, often overlooked, except where inaccessible mountain peaks or bloody battlefields plainly have demanded the photographer's resourcefulness or heroism, is a fundamental condition of photography. It helps to explain the relative rarity (apart from snapshots) of intimate pictures of domestic life: to photograph in another person's home, the photographer must be invited inside.

Helen Frankenthaler American, 1928–2011

Jacob's Ladder. 1957

Oil on unprimed canvas, 9' 5⅜" × 69⅞"
(287.9 × 177.5 cm)
Gift of Hyman N. Glickstein

The delicately colored *Jacob's Ladder* shows compositional echoes ranging back to Cubism and the early abstractions of Vasily Kandinsky, but as a young New York artist in the 1950s, Frankenthaler was most influenced by the Abstract Expressionists. Like Jackson Pollock, she explored working on canvases laid on the floor (rather than mounted on an easel or wall), a technique opening new possibilities in the handling of paint, and therefore in visual appearances. Letting paint fall onto canvas emphasized its physicality, and the physicality of the support too. Frankenthaler also admired the scale of Pollock's work, and she took from him, she said, her "concern with line, fluid line, calligraphy, and . . . experiments with line not as line but as shape."

Frankenthaler departed from Pollock's practice in the way she used areas of color and in her distinctive thinning of paint so that it soaked into her unprimed canvases. Because the image is so plainly embedded in the cloth, its presence as flat pigmented canvas tends to overrule any illusionistic reading of it—a priority in the painting of the time. Nor should the work's title suggest any preplanned illustrational intention. "The picture developed (bit by bit while I was working on it) into shapes symbolic of an exuberant figure and ladder," Frankenthaler said, "therefore *Jacob's Ladder.*"

Louise Nevelson
American, born Ukraine. 1899–1988

Sky Cathedral. 1958

Painted wood, 11' 3½" × 10' ¼" × 18"
(343.9 × 305.4 × 45.7 cm)
Gift of Mr. and Mrs. Ben Mildwoff

As a rectangular plane to be viewed from the front, *Sky Cathedral* has the pictorial quality of a painting—perhaps one of the preceding decade's Abstract Expressionist canvases, which share its mural scale. But this sculpture in relief commands a layered depth. Its intricacy lies in both the method of its construction—it is made of shallow open boxes fitted together in a jigsaw-like stack—and those boxes' contents, the salvaged wood bits and pieces with which Nevelson filled many of her works. These include moldings, dowels, spindles, chair parts, architectural ornaments, and scroll-sawed fragments.

Nevelson makes this material into a high wall variegated by a play of flatness and recession, straight lines and curves, overlaps and vacancies, that has been likened to the faceting of Cubism and has an absorbing visual complexity.

A Surrealist artist might have shared Nevelson's relish for curious bric-à-brac, but might also have arranged such a collection in jarring and disorienting juxtapositions. Nevelson, by contrast, paints every object and box the same dully glowing black, unifying them visually while also obscuring their original identities. The social archaeology suggested by the objects' individual histories and functions, then, is muted but not erased; it is as if we were looking at the wall of a library in which all of the books had been translated into another language.

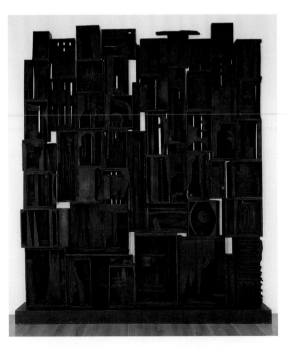

Oskar Fischinger German, 1900–1967

Motion Painting I. 1947

35mm film, animated, color, sound,
11 minutes

A film of extraordinary beauty and
rhythmic power, this eleven-minute
masterpiece is an abstract work cre-
ated by painting with oils on Plexiglas.
Set to an excerpt from J. S. Bach's
Brandenburg Concerto No. 3, it com-
prises a joyfully exuberant series of
intricate transformations, one every
twenty-fourth of a second, that explore
the dynamic relationship between
sound and image. A film whose unique
combination of visual and aural tonali-
ties never ceases to amaze and charm,
Motion Painting no. I is a testament to
one remarkable artist's passion for
experimentation and invention.

In 1936 Fischinger had accepted
an invitation from Paramount to come
to America and work for its studio in
Hollywood. In Germany he had been
a distinguished inventor, and maker
of abstract and industrial short films.

Once in the United States, however,
he soon found himself at odds with
the factorylike methods of the major
studios, and sought expression in the
creation of independently financed,
experimental films.

Courtesy and © Fischinger Trust.

Sam Francis American, 1923–1994

Big Red. 1953

Oil on canvas, 10' × 6' 4¼"
(303.2 × 194 cm)
Gift of Mr. and Mrs. David Rockefeller

The simple title of this painting belies the work's visual complexity. Red dominates the monumental canvas, but it is layered on top of blues, yellows, and oranges. Tracing the movement of the paint up, down, and across the vast field of the picture, the viewer awakens to its chromatic and gestural nuances. The vibrant hues cohere in a grid-like array of biomorphic shapes, creating an organic matrix that looks like a cellular structure. The biological metaphors at work in *Big Red* illustrate what the artist described as his interest in using painting to create a condition of "ceaseless instability."

Francis used painting to investigate color and energy, an approach which distinguished him from New York School painters such as Jackson Pollock and Clyfford Still, who favored painting as a medium of expression through gesture. In fact, Francis avoided New York. He began to paint in California after being injured in a plane crash during World War II. In 1948 he returned to Berkeley, where he had been a student before the war, to study art. *Big Red* was made in Paris, the artist's home through much of the 1950s. The painting was shipped to New York to be included in Dorothy Miller's *12 Americans* exhibition at MoMA in 1956.

Joan Mitchell American, 1925–1992

Ladybug. 1957

Oil on canvas, 6' 5⅞" × 9' (197.9 × 274 cm)
Purchase

The formal structure of Mitchell's paintings, their physical quality and sense of process, are extensions of Abstract Expressionism, but in some respects Mitchell challenged the conventional wisdom of the New York School. (She also left New York, joining Sam Francis and others of her generation in Paris.) Abstract though her paintings are, she saw them as dealing with nature—with the outside world, that is, rather than the inner one. In fact she shunned self-expression as such; her work, she said, was "about landscape, not about me." Nor did she consider herself an "action painter," since she worked more from thought than from instinct. "The freedom in my work is quite controlled," Mitchell said, "I don't close my eyes and hope for the best."

Ladybug abuts pure colors with colors that mix on the canvas, dense paint with liquid drips, flatness with relief. Empty areas at the work's edges suggest a basic ground, which seems to continue under the tracery of color; but the white patches here are actually more pigment, and shift in intensity and texture. Struggling out between short, firm, jaggedly arranged strokes of blue, mauve, green, brown, and red, the whites aerate this energized structure, appearing ambiguously both under and over it. No landscape is evident; Mitchell set out not to describe nature but "to paint what it leaves me with."

Vincente Minnelli American, 1903–1986

Meet Me in St. Louis. 1944

35mm film, color, sound, 113 minutes
Acquired via preservation work from negatives
on loan from George Eastman House
Tom Drake, Judy Garland

Meet Me in St. Louis grew out of a
series of decidedly undramatic stories
by Sally Benson about her midwestern
childhood. They were first published
in *The New Yorker* magazine. MGM
screenwriters labored to create a plot
until Arthur Freed, the head of MGM's
famed musical production unit, decided
the film should be a vehicle for former
child star Judy Garland. In the film,
Garland plays Esther, a daughter in the
Smith family of St. Louis, who sings
her way through the seasons from
summer 1903 to spring 1904, as the
city prepares for the 1904 Louisiana
Purchase Exposition. Among her many
tunes, Esther sings "The Trolley Song,"
discovering the clang, clang, clang of
her heartbeat because she is in love.

Minnelli highlighted the simplicity and
naturalness of her acting and singing,
which captivated audiences.

Following his success in the 1930s
as a director and designer for the
Broadway theater, Minnelli moved on to
Hollywood as a member of Freed's unit
at MGM, bringing to the American musi-
cal a fresh approach. Whereas others
were reluctant to use Technicolor,
Minnelli understood and embraced the
new process, showing off the dazzling
brightness of its colors. He became
one of Hollywood's most accomplished
colorists and a master of cinematic
musical comedy. Minnelli set a new
standard for the genre, smoothly
inserting dance numbers into the nar-
rative in a blend of naturalism and fan-
tasy, as realistic characters discover
and declare their hopes, fears, or
loves. He simultaneously hid and
revealed the darker side of domestic
America, the fragility of its structure
and the terror of possible change.

Irving Penn American, 1917–2009

Large Sleeve (Sunny Harnett), New York. 1951

Gelatin silver print, 13⁹⁄₁₆ × 13⁹⁄₁₆"
(34.5 × 34.5 cm)
Gift of the photographer

A fashion photograph aims to describe an ideal, one that we, as consumers, might aspire to. It is the creation of an illusion. In this picture, the curved forms—the woman's mouth, her neck, the shape of her hat, her left sleeve and, of course, her beautifully deployed right sleeve—are so exquisitely balanced that we accept as inevitable the photographer's daring cropping of the model's head.

Penn came into prominence as a photographer of fashion in 1950. His signature style, at once austere and elegant, swept away the elaborate theatrical trappings of the past. His pictures seemed to embody a new American confidence and taste for clarity in the aftermath of World War II. As times and fashions changed, however, the pictorial economy and rigorous craft of Penn's work—the poise and grace of his pictures—did not. Over the course of half a century, his stubborn pursuit of perfection indeed gave us something to aspire to.

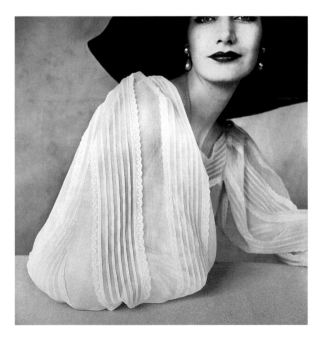

Robert Frank American, born Switzerland 1924

Parade–Hoboken, New Jersey.
1955

Gelatin silver print, 8⅛ × 12¹⁵⁄₁₆"
(20.6 × 31.2 cm)
Purchase

In this picture two citizens observe
a parade, and a flag is on display to
celebrate the patriotic occasion. The
mood is dark, however, and the faces
of the people are obscured, one of
them by the flag itself.

The photograph is from Frank's
book *The Americans*, first published in
France in 1958 and in the United
States the following year. In the years
before museums and galleries took
widespread notice of photography—
that is, before the 1970s—books
conceived and edited by the photogra-
pher whose work they featured played
a leading role in bringing advanced
photography to public notice. *The
Americans*, one of the touchstones of
this genre, helped to establish the

artistic significance of what photogra-
phers call "a body of work"—a series
of pictures unified by the author's
sensibility and outlook rather than by a
particular theme or by an assignment
from a magazine editor.

In fact, the nominal subject of *The
Americans* is so broad that it scarcely
serves as an organizing principle. The
book's coherence rests instead on
Frank's talent for transforming frag-
ments of observation into articulate
symbols, all of them tinged by his caus-
tic and forlorn vision of his adoptive
country. The pictures are knit together,
as well, by recurring icons of national
identity, notably the flag, which appears
and reappears on the scene like the
sinister protagonist of a tragedy.

Robert Rauschenberg American, 1925–2008

Canto XXXI: The Central Pit of Malebolge, The Giants from the series Thirty-four Illustrations for Dante's Inferno. 1959–60

Transfer drawing, colored pencil, gouache, and pencil on paper, 14½ × 11½" (36.8 × 29.3 cm)
Given anonymously

In eighteen months, Rauschenberg created thirty-four illustrations for Dante's *Inferno,* using the technique of transfer drawing. Each illustration, one for each canto, is intended to be read vertically from upper left to lower right as an episodic narrative with sequential events flowing into one another. Characters in the allegory are represented by photographs—culled from the mass media—of athletes, politicians, and astronauts, among others. In this image, Dante and his guide Virgil approach the eighth circle of Hell. Dante appears in the upper left-hand corner as a man wrapped in a towel. The guard-

ians of Hell, described in the poem as formidable giants, are shown at the lower right as Olympic athletes standing on a podium. The oversized chain link indicates the giants' power; it also refers to their being chained for their sins. Below, the tiny figures of the two poets are lowered into the pit. By using recognizable imagery to relate the classic text of a quest for divine truth, Rauschenberg integrated the high and the low, the real and the illusory, the past and the present.

In creating his illustrations, the artist clipped reproductions from magazines, coated them with chemical solvent, and placed them face down on the drawing surface. The reverse sides of the clippings were rubbed over with a pen, transferring the images onto the paper. Finally, an overlay of transparent washes of gouache and pencil marks was added to allude to different moods or emotional states.

Jasper Johns American, born 1930

Flag. 1954–55 (dated on reverse 1954)

Encaustic, oil, and collage on fabric, mounted on plywood, 42¼ × 60⅝" (107.3 × 153.8 cm)
Gift of Philip Johnson in honor of Alfred H. Barr, Jr.

When Johns made *Flag*, the dominant American art was Abstract Expressionism, which enthroned the bold, spontaneous use of gesture and color to evoke emotional response. Johns, though, had begun to paint common, instantly recognizable symbols—flags, targets, numbers, letters. Breaking with the idea of the canvas as a field for abstract personal expression, he painted "things the mind already knows." Using the flag, Johns said, "took care of a great deal for me because I didn't have to design it." That gave him "room to work on other levels"—to focus his attention on the making of the painting.

The color, for example, is applied not to canvas but to strips of news-paper—a material almost too ordinary to notice. Come close to the painting, though, and those scraps of newsprint are as hard to ignore as they are to read. Also, instead of working with oil paint, Johns chose encaustic, a mixture of pigment and molten wax that has left a surface of lumps and smears; so that even though you recognize the image in a second, close up it becomes textured and elaborate. It is at once impersonal, or public, and personal; abstract and representational; easily grasped and demanding of close attention.

Frank Stella
American, born 1936

The Marriage of Reason and Squalor, II. 1959

Enamel on canvas, 7' 6¾" × 11' ¾"
(230.5 × 337.2 cm)
Larry Aldrich Foundation Fund

In each half of *The Marriage of Reason and Squalor, II*, stripes outline stripes in an inverted U-shape, a regular, self-generating pattern. Filling the canvas according to a methodical program, Stella suggests an idea of the artist as laborer or worker. (He also uses commercial paint—black enamel—and a house-painter's brush.) The systematic quality of Stella's Black Paintings decisively departed from the ideas of inspired action associated with Abstract Expressionism, the art of the preceding generation, and anticipated the machine-made Minimal art of the 1960s. But many of the works in that series, like this one, are subtly personal: Stella painted freehand, and irregularities in the lines of the stripes reveal the slight waverings of his brush. His enamel, too, suggests a bow to the Abstract Expressionist Jackson Pollock, who had also used that kind of paint.

Stella's use of stripes was motivated by the work of Jasper Johns, particularly Johns's paintings of flags. "The thing that struck me most," Stella has said, "was the way he stuck to the motif . . . the idea of stripes—rhythm and interval—the idea of repetition." But Stella went farther than Johns in "sticking to the motif," removing the flag and leaving only the stripes. "My painting," he said, "is based on the fact that only what can be seen there *is* there. . . . What you see is what you see."

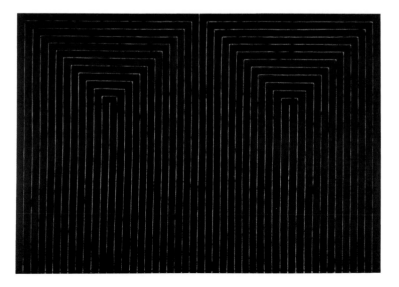

Satyajit Ray · Indian, 1921–1992

Pather Panchali. 1955

35mm film, black and white, sound, 112 minutes
Acquired by exchange with the distributor, Edward Harrison
Subir Banerjee

In *Pather Panchali*, the tale of a poor family living in its ancestral Bengali village, Ray employed unknown actors and shot the film on location. His use of neo-realist techniques challenged the song-and-dance melodramatic form then characteristic of Indian cinema. Over the course of this film and its two sequels, *Aparajito* and *The World of Apu*, viewers witness the world through the eyes of the young boy, Apu, whose developing consciousness parallels the changing face of a newly independent India.

A filmmaker who could capture the essential themes of his culture while also evoking universal truths and values, Ray is recognized worldwide as a great poetic realist. In the early 1950s he was working as a graphic artist when he decided to make a film from a book he was illustrating, the popular serial novel *Pather Panchali*. Ray had great difficulty financing his film throughout its production, and much of the work was done by amateurs. Although Ray was dissatisfied with its technical deficiencies, *Pather Panchali* is admired for its casual and direct style. The prolific body of cinematic work produced in India, which today ranks in ambition and popularity with that of the United States and Japan, owes much of its international stature to Ray's distinguished career, which was launched by this film.

James Rosenquist American, born 1933

F-111. 1964–65

Oil on canvas with aluminum, twenty-three
sections, overall 10 × 86'
(304.8 × 2,621.3 cm)
Gift of Mr. and Mrs. Alex L. Hillman and Lillie
P. Bliss Bequest (both by exchange)

"Painting is probably much more
exciting than advertising," Rosenquist
has said, "so why shouldn't it be
done with that power and gusto, with
that impact." Like other Pop artists,
Rosenquist is fascinated by commer-
cial and everyday images. He also
understands the power of advertising's
use of "things larger than life"—he
once painted billboards for a living—
and even in early abstractions he bor-
rowed the exaggeratedly cheerful
palette of the giant signs. His next step
was to explore the artistic potential
of the billboard's scale and photo-
graphic style.

 Rosenquist generally spikes that
style with disorienting fractures and
recombinations of images. *F-111*

becomes still more overwhelming
through its particularly enormous size
and panoramic shape: it is designed to
fill the four walls of a room, engulfing
and surrounding the viewer—unlike a
billboard, which, despite its magnitude,
can be viewed all at once. Also unlike
a billboard, *F-111* fuses pictures of
American prosperity with a darker
visual current. A diver's air bubbles are
rhymed by a mushroom cloud; a smil-
ing little girl sits under a missilelike
hairdryer; a sea of spaghetti looks
uncomfortably visceral; and weaving
through and around all these images is
the *F-111* itself, a U.S. Air Force fighter-
bomber. Painted during the Vietnam
War, *F-111* draws disturbing connec-
tions between militarism and the con-
sumerist structure of the American
economy.

Stanley Kubrick American, 1928–1999

2001: A Space Odyssey. 1968

35mm film, color, sound, 137 minutes
Acquired from Turner Entertainment Co.
Keir Dullea

This landmark science-fiction odyssey uses the idea of futuristic space travel to fashion an allegory on the nature of God, the evolution of life on earth, and the role of technology in human existence. Attempting to ask, not answer, the metaphysical questions that plague human existence, this film begins with "the dawn of man," when tools are first used, and ends as the human cycle is renewed in the year 2001.

In the film, astronauts are sent deep into the solar system to investigate the sound waves emanating from a black monolith discovered beneath the moon's surface. (This same structure is found on earth by the early hominids appearing at the beginning of the film.) During the journey, the HAL 9000, the computer that maintains the ship, becomes an independent thinker, not a tool, and attempts to kill the humans. One survives, disables the computer, and continues forward through time and space to an undefined interior, where he is confronted by his aged self and ultimately his death and rebirth.

Initially, many critics were hostile toward the film, which forced viewers to speculate and seemed confusing. Yet most, and certainly the large audiences that attended, found the film—with its innovative techniques, realistic effects, and graceful score—to be spellbinding and intelligent. *2001: A Space Odyssey* remains equally fresh and thought-provoking, at the highwater mark in the science-fiction genre.

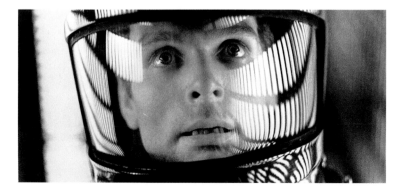

Roy Lichtenstein American, 1923–1997

Girl with Ball. 1961

Oil on canvas, 60¼ × 36¼" (153 × 91.9 cm)
Gift of Philip Johnson

Lichtenstein took the image for *Girl with Ball* straight from an advertisement for a hotel in the Pocono Mountains. In pirating the image, however, he transformed it, submitting the ad's photograph to the techniques of the comic-strip artist and printer—and transforming those techniques, too, into a painter's versions of them. The resulting simplifications intensify the artifice of the picture, curdling its careful dream of fun in the sun. The girl's rounded mouth is more doll-like than female; any sex appeal she had has become as plastic as her beach ball.

In choosing the banal subject matter of paintings like *Girl with Ball*, Lichtenstein challenged the aesthetic orthodoxy of the time, still permeated by the spiritual and conceptual ambitions of Abstract Expressionism. The moral seriousness of art, and art's longevity, seemed foreign to this cheap, transient ad from the consumer marketplace, a sector of roiling turnover. Startling though the image was as an artwork, it was already old-fashioned as an advertisement. His simulation of printing similarly robs the technology of the polish it had already achieved: overstating the dots of the Benday process, and limiting his palette to primary colors, he exaggerates the limitations of mechanical reproduction, which becomes as much the subject of the painting as the girl herself.

Richard Hamilton British, 1922–2011

Pin-up. 1961

Oil, cellulose, and collage on panel,
48 × 32 × 3" (121.9 × 81.3 × 7.6 cm)
Enid A. Haupt Fund and an anonymous fund

"Popular (designed for a mass audience), transient (short-term solution), expendable (easily forgotten), low cost, mass-produced, young (aimed at youth), witty, sexy, gimmicky, glamorous, big business." So Hamilton once described modern consumer culture—the culture that he and the other Pop artists (whether British, like Hamilton, or American) felt art had to confront. No surprise, then, that the sources of *Pin-up* include what Hamilton called "girlie pictures," both "the sophisticated and often exquisite photographs in *Playboy*" and the more "vulgar" images found in that magazine's "pulp equivalents." Less obvious, perhaps, are the references to art history—the

passages, for example, that Hamilton asserted "bear the marks of a close look at Renoir."

The nude, or the more provocative odalisque, is of course an enduring theme in art, and *Pin-up* advances an argument over what an appropriate contemporary treatment of a classic art-historical theme might be. Such a treatment, Hamilton believed, would demand a "diversifying" of the languages of art, thus he approached the odalisque tradition through a variety of pictorial modes: the hair, for example, is a stylized cartoon, the breasts appear both in drawing and in three-dimensional relief, and the bra is a photograph applied as collage. "Mixing idioms," Hamilton said, "is virtually a doctrine in *Pin-up*"—an image both tawdry and extraordinarily sophisticated.

Yves Klein French, 1928–1962

Anthropometry: Princess Helena.
1960

Oil on paper on wood, 6' 6" × 50½"
(198 × 128.2 cm)
Gift of Mr. and Mrs. Arthur Wiesenberger

Anthropometry is the science of measuring the human body. In Klein's series by that title, the artist eschewed scientific quantification in favor of recording the body's physical presence through direct impression. He produced these works at elaborate soirees for which he employed female models to act as "living paint brushes" (the title of this example refers to one of his favorite models, Elena Palumbo). An audience watched as the nude women "dipped" themselves in International Klein Blue, a color that Klein patented, and imprinted their bodies on large sheets of paper. While directing them, the artist wore white gloves to signal that his hands would not be dirtied by paint. Meanwhile, the spectators sipped matching blue cocktails, and musicians performed Klein's 1949 *Monotone Symphony*, a single note played for twenty minutes followed by twenty minutes of silence.

In the same year that this work was made, Klein signed a manifesto written by the French critic Pierre Restany for a new avant-garde movement, Nouveau Réalisme. The manifesto's one line read, "The New Realists have become conscious of their collective identity; New Realism=new perceptions of the real." While grounding his art in the physical reality of paint and bodies, Klein entirely redefined their traditional relationship.

Andy Warhol American, 1928–1987

Gold Marilyn Monroe. 1962

Silkscreen ink on synthetic polymer paint on canvas, 6' 11¼" × 57" (211.4 × 144.7 cm)
Gift of Philip Johnson

Marilyn Monroe was a legend when she committed suicide in August of 1962, but in retrospect her life seems a gradual martyrdom to the media and to her public. After her death, Warhol based many works on the same photograph of her, a publicity still for the 1953 movie *Niagara*. He would paint the canvas with a single color—turquoise, green, blue, lemon yellow—then silkscreen Monroe's face on top, sometimes alone, sometimes doubled, sometimes multiplied in a grid. As the surround for a face, the golden field in *Gold Marilyn Monroe* (the only one of Warhol's Marilyns to use this color) recalls the religious icons of Christian art history—a resonance, however, that the work suffuses with a morbid allure.

In reduplicating this photograph of a heroine shared by millions, Warhol denied the sense of the uniqueness of the artist's personality that had been implicit in the gestural painting of the 1950s. He also used a commercial technique—silkscreening—that gives the picture a crisp, artificial look; even as Warhol canonizes Monroe, he reveals her public image as a carefully structured illusion. Redolent of 1950s glamour, the face in *Gold Marilyn Monroe* is much like the star herself—high gloss, yet transient; bold, yet vulnerable; compelling, yet elusive. Surrounded by a void, it is like the fadeout at the end of a movie.

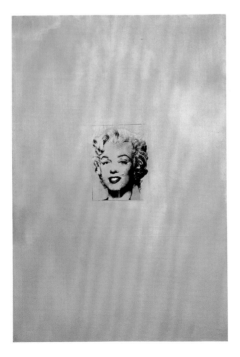

Diane Arbus
American, 1923–1971

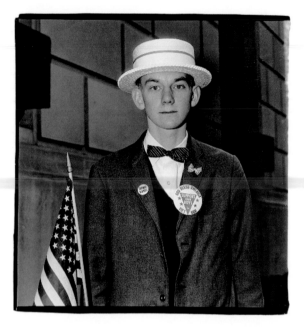

Boy with a Straw Hat Waiting to March in a Pro-War Parade, New York City. 1967

Gelatin silver print, 14¾ × 14½"
(37.5 × 36.8 cm)
The Ben Schultz Memorial Collection.
Gift of the photographer

Arbus approached photographic portraiture as a two-way street through which a relationship is established between the viewer (who has taken the place of the photographer) and the subject. To experience the picture is to enter into that relationship, whose candor and depth may be assessed in just the same way that we gauge the sincerity of others every day—and as they judge ours.

Many of Arbus's subjects are outcasts of one sort or another, and many viewers are at first repelled or merely fascinated by her pictures. Only after our defenses are set aside are we able to see that the vulnerability of her people invites us to recognize our own.

Apart from a handful of pictures, including this one, Arbus did not address political issues directly. But her unsparing frankness in confronting human frailty is one of the signal achievements of American art in the dark days of the Vietnam War.

Andy Warhol American, 1928–1987

Empire. 1964

16mm film, black and white, silent,
8 hours, 6 minutes (approx.)
Gift of The Andy Warhol Foundation for the
Visual Arts

Empire consists of one stationary shot of the Empire State Building taken from the forty-fourth floor of the Time-Life Building. Jonas Mekas served as cameraman. The shot was filmed from 8:06 p.m. to 2:42 a.m. on July 25–26, 1964. *Empire* consists of a number of one-hundred-foot rolls of film, each separated from the next by a flash of light. Each segment of film constitutes a piece of time. Warhol's clear delineation of the individual segments of film can be likened to the serial repetition of images in his silkscreen paintings, which also acknowledge their process and materials.

Warhol conceived a new relationship of the viewer to film in *Empire* and other early works, which are silent, explore perception, and establish a new sense of cinematic time. With their disengagement, lack of editing, and lengthy nonevents, these films were intended to be part of a larger environment. They also parody the goals of his avant-garde contemporaries who sought to convey the human psyche through film or used the medium as metaphor.

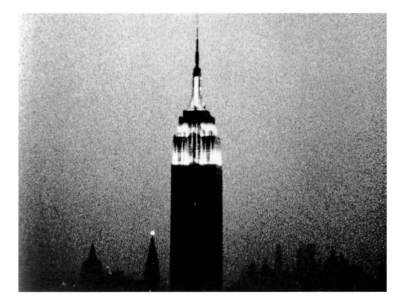

Yayoi Kusama Japanese, born 1929

No. F. 1959

Oil on canvas, 41½ × 52" (105.4 ×
132.1 cm)
Sid R. Bass Fund

No. F is one in a series of white on
white paintings that Yayoi Kusama
made barely a year after arriving in the
United States from Osaka, Japan. In it,
multitudes of similar, densely placed
small marks cohere in cell-like forma-
tions, covering the canvas from edge
to edge. Kusama called the motif the
Infinity Net. Inspired by a childhood
hallucination, it would become her sig-
nature motif.

Kusama's powers of concentration
over long periods—she sometimes
worked intensively for up to fifty hours
at a stretch—enabled her to paint
the Infinity Net pattern on room-size
supports as well as on easel-size
canvases in an effort, she claimed,
to cover the entire world. This desire
would lead her, by 1961, to expand
the Infinity Net and its variants, the
dot and the phallic protuberance, into
sculpture and, subsequently, installa-
tions. Today, more than fifty years after
her first Infinity Net painting, the octo-
genarian artist is still deploying this
motif in works in all mediums.

No. F was painted for a solo exhibi-
tion at the Gres Gallery in Washington,
D.C., an establishment owned by one
of Kusama's earliest patrons, Beatrice
Perry. Obsessively but not mechanically
painted, consistent but far from uniform,
the surface of the work exhibits distinct
campaigns of thick, expressive brush-
work, describing whorls of circular forms
that create an unsystematic pattern as
varied as one found in nature.

Ad Reinhardt American, 1913–1967

Abstract Painting. 1963

Oil on canvas, 60 × 60" (152.4 × 152.4 cm)
Gift of Mrs. Morton J. Hornick

To the hasty viewer, *Abstract Painting* must present a flat blackness. But the work holds more than one shade of black, and longer viewing reveals an abstract geometrical image. Reinhardt has divided the canvas into a three-by-three grid of squares. The black in each corner square has a reddish tone; the shape between them—a cross, filling the center square of the canvas and the square in the middle of each side—is a bluish black in its vertical bar and a greenish black in its horizontal one.

Works like this were strongly influential for the Minimalist and Conceptual artists of the 1960s, who admired their reductive and systematic rigor. But the poetry of their finely handled surfaces, and their deeply contemplative character, tie them to the Abstract Expressionist generation of which Reinhardt was a member, if a dissident one. Insisting on the separation of art from life, Reinhardt tried to erase from his work any content other than art itself. In the late black canvases that include *Abstract Painting* (he called them his "ultimate" paintings), he was trying to produce what he described as "a pure, abstract, non-objective, timeless, spaceless, changeless, relationless, disinterested painting—an object that is self-conscious (no unconsciousness), ideal, transcendent, aware of no thing but art."

Robert Motherwell American, 1915–1991

Elegy to the Spanish Republic, 108. 1965–67

Oil on canvas, 6' 10" × 11' 6¼"
(208.2 × 351.1 cm)
Charles Mergentime Fund

Elegy to the Spanish Republic, 108 describes a stately passage of the organic and the geometric, the accidental and the deliberate. Like other Abstract Expressionists, Motherwell was attracted to the Surrealist principle of automatism—of methods that escaped the artist's conscious intention—and his brushwork has an emotional charge, but within an overall structure of a certain severity. In fact Motherwell saw careful arrangements of color and form as the heart of abstract art, which, he said, "is stripped bare of other things in order to intensify it, its rhythms, spatial intervals, and color structure."

Motherwell intended his Elegies to the Spanish Republic (over 100 paintings, completed between 1948 and 1967) as a "lamentation or funeral song" after the Spanish Civil War. His recurring motif here is a rough black oval, repeated in varying sizes and degrees of compression and distortion. Instead of appearing as holes leading into a deeper space, these light-absorbent blots stand out against a ground of relatively even, predominantly white upright rectangles. They have various associations, but Motherwell himself related them to the display of the dead bull's testicles in the Spanish bullfighting ring.

Motherwell described the Elegies as his "private insistence that a terrible death happened that should not be forgot. But," he added, "the pictures are also general metaphors of the contrast between life and death, and their interrelation."

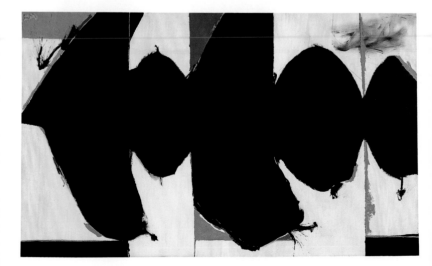

Shomei Tomatsu Japanese, born 1930

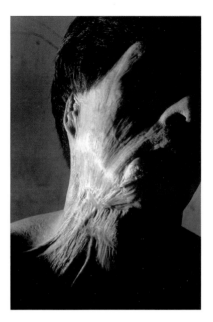

Man with Keloidal Scars. 1962

Gelatin silver print, 13 × 8¹³⁄₁₆" (33 × 22.4 cm)
Gift of the photographer

This picture appeared in Tomatsu's first book, *Nagasaki 11:02*, whose title marks the minute that the American atomic bomb devastated Nagasaki on August 9, 1945, precipitating the end of World War II. The subject is a man who survived but was permanently scarred by the explosion. Tomatsu has cast the man's face in shadow and has sharply illuminated his scars to register a frightening, irregular form—a striking metaphor for violence and suffering. The picture was made in the 1960s, during Japan's extraordinary economic recovery from the war, and it may be interpreted not only as a cry of protest against the bomb but as a call to memory to the Japanese people.

The war deeply affected Japanese photographers of Tomatsu's generation in two key respects: it compelled them to confront the unprecedented catastrophe that had been unleashed on their people, and it opened a path for them to do so, for the American occupation dismantled the Shinto state, dissolving the emperor's autocratic rule. Liberated from the weight of ancient cultural strictures, Tomatsu and his contemporaries created a highly expressive style of photography, full of dramatic forms and abrupt contrasts of light and dark, through which they were able to address the profound events that had shaped their lives.

Morris Louis American, 1912–1962

Beta Lambda. 1960

Synthetic polymer paint on canvas,
8' 7⅜" × 13' 4¼" (262.6 × 407 cm)
Gift of Mrs. Abner Brenner

Beta Lambda belongs to Louis's Unfurled series, in which diagonal bands of paint at both sides of each picture are widely separated by an expanse of bare canvas, a powerful emptiness. Each band contains multiple rivulets of color, which now progress evenly through the spectrum, now pop with contrast, like the blue at the right of *Beta Lambda*. The pared-down simplicity of Louis's work focused a concern in the painting of the time: a concentration on the art's essential elements—line, color, ground.

Chronologically, Louis came from the Abstract Expressionist generation, but he mostly worked at a geographical and psychological remove from the New York School, and although he was crucially influenced by a member of that circle—Helen Frankenthaler—she was rather younger than its pioneers.

As a result, his work both reflects and departs from Abstract Expressionist ideas. Like Frankenthaler, Louis used unprimed canvas, which absorbs paint into its fabric, so that it retains a presence in the finished work. (Primed canvas, conversely, takes paint as a discrete layer resting on and hiding its surface.) Louis also invented brush-less techniques of applying paint, leaning the canvas against the wall and pouring the liquid down the tilted plane. The method deflates the Abstract Expressionist stress on the artist's hand and psyche, making *Beta Lambda* a visual field to be appreciated for its own sake.

Robert Ryman American, born 1930

Twin. 1966

Oil on cotton, 6' 3¾" × 6' 3⅞"
(192.4 × 192.6 cm)
Charles and Anita Blatt Fund and purchase

Ryman describes his working process as an attempt to "paint the paint." If his all-white surfaces represent anything, it is the manipulation of paint itself. He restricts his materials to various types of white pigment—gouache, oil, enamel, gesso, acrylic, and encaustic, among others—laid down on a wide range of supports—newsprint, gauze, tracing paper, cardboard, linen, jute, etc.—and applied with a variety of tools, from brushes of different widths to palette knives and spatulas. In *Twin*, he used a brush roughly twelve inches wide to paint horizontal bands across the surface of the canvas. The uniform thickness of the pigment conceals the direction of the strokes as well as the length of each individual application of paint. The broad swaths extend from edge to edge, suggesting the possibility that the artist's gestures continued beyond the painting's bounds.

Ryman is sometimes called a Minimalist painter for his seemingly ascetic monochromes—of which no two are identical—but the label belies the intricate painterliness of a work such as *Twin*. The painting's subtle shifts in texture and tone are notoriously difficult to reproduce in photographs.

Lee Bontecou American, born 1931

Untitled. 1961

Welded steel, canvas, black fabric, rawhide,
copper wire, and soot, 6' 8¼" × 7' 5" × 34¾"
(203.6 × 266 × 88 cm)
Kay Sage Tanguy Fund

Painting or sculpture? Organic or
industrial? Invitation or threat? This
untitled work is a rectangle of canvas,
like a painting, but one that pushes its
faceted, equivocally machinelike mouth
out from the wall. What many have
seen in Bontecou's works of this kind,
with their built-up rims and hollow
voids, are the nacelles or casings of jet
engines. The artist, too, acknowledged
their influences: "Airplanes at one
time, jets mainly." Interest in the
streamlined products of modernity may
link Bontecou to Pop art, a movement
developing at the time, but her work's
dark and restricted palette gives it a
sobriety distant from much of Pop, and
she describes the world more obliquely.
Also, instead of replicating an engine's
metallic surfaces, she stitches panels
of canvas over a steel skeleton. If this
is a machine, it is a soft one—which,
again, leads many to think of the body,
and its charged interiors and openings.

Mystery is one quality Bontecou
is interested in, and also "fear, hope,
ugliness, beauty." As for those inky
cavities, a consistent theme, she
remarks, "I like space that never stops.
Black is like that. Holes and boxes
mean secrets and shelter."

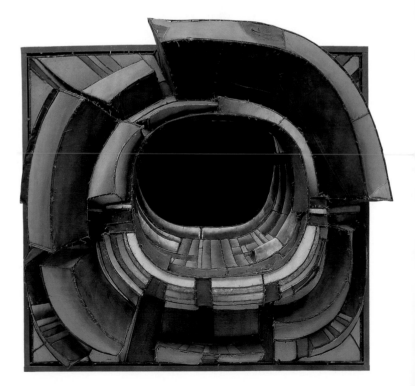

George Segal
American, born 1924

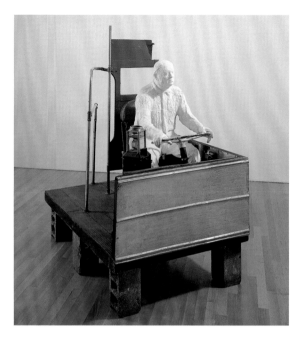

The Bus Driver. 1962

Plaster over cheesecloth; bus parts including coin box, steering wheel, driver's seat, railing, dashboard, over wood and cinder blocks; figure, 53½ × 26⅞ × 45" (136 × 68.2 × 114 cm), overall 7' 5" × 51⅝" × 6' 4¾" (226 × 131 × 195 cm)
Philip Johnson Fund

The idea for *The Bus Driver* came to Segal on a late-evening bus from New York to New Jersey. The driver was grim, sullen, and arrogant, and Segal caught himself thinking, "My God, dare I trust my life to this prig?" Soon afterward he found a derelict bus in a junkyard and hacked out the driver's platform. Incorporated in *The Bus Driver*, this metal armature pens in a plaster figure—a life cast.

When they first appeared, in the early 1960s, Segal's plaster molds of people in fragments of real environ-

ments were considered Pop art, since they described the everyday life of public places. But where Pop often focused on mass-media images and mass-produced objects, Segal is interested in individuals, their gestures, statures, stances, and also their inner, psychological or spiritual condition. He often leaves his plaster molds unpainted, valuing their whiteness for "its special connotations of disembodied spirit, inseparable from the fleshy corporeal details of the figure." In the bus driver (who has been likened to Charon, the ferryman of Greek myth who guides dead souls to the underworld), Segal saw "the dignity of helplessness—a massive, strong man, surrounded by machinery, and yet basically a very unheroic man trapped by forces larger than himself that he couldn't control and least of all understand."

Cy Twombly American, 1928–2011

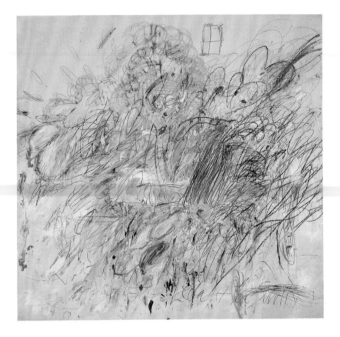

Leda and the Swan. 1962

Oil, pencil, and crayon on canvas,
6' 3" × 6' 6¾" (190.5 × 200 cm)
Acquired through the Lillie P. Bliss Bequest
and The Sidney and Harriet Janis Collection
(both by exchange)

Interest in the mural form was wide-spread among the Abstract Expressionists, who often worked on a scale far larger than that of most easel paintings. Twombly, a member of a younger generation, transposed that interest in the wall to a different register: no painter of his time more consistently invited association with the language of graffiti. His scrawled calligraphic markings may recall the automatic writing of Surrealism, another inheritance passed on to him through Abstract Expressionism, but they also evoke the scratches and scribbles on the ancient walls of Rome (his home beginning in 1957).

Rome supplied another touchstone for Twombly, who was fascinated by classical antiquity. Here he referred to the myth in which Jupiter, lord of the gods, took the shape of a swan in order to ravish the beautiful Leda. (This violation ultimately led to the Trojan War, fought over Leda's daughter Helen.) Twombly's version of this old art-historical theme supplies no contrasts of feathers and flesh but an orgiastic fusion and confusion of energies within furiously thrashing overlays of crayon, pencil, and ruddy paint. A few recognizable signs—hearts, a phallus—fly out from this explosion.
A drier comment is the quartered, windowlike rectangle near the top of the painting, an indication of the stabilizing direction that Twombly's art was starting to take.

Jasper Johns American, born 1930

Diver. 1962–63

Charcoal, pastel, and watercolor on paper
mounted on canvas, two panels
7' 2½" × 71¾" (219.7 × 182.2 cm)
Partial gift of Kate Ganz and Tony Ganz in
memory of their parents, Victor and Sally
Ganz, and in memory of Kirk Varnedoe;
Mrs. John Hay Whitney Bequest Fund; gift of
Edgar Kaufmann, Jr., gift of Philip L. Goodwin,
bequest of Richard S. Zeisler, and anonymous
gift (all by exchange). Acquired by the Trust-
ees of The Museum of Modern Art in memory
of Kirk Varnedoe

Diver is the largest and arguably the most important work on paper from Johns's entire career, now spanning over fifty years. Although dated 1963, it was begun the previous year in advance of the large painting of the same title, completed in 1962. Johns then returned to the drawing, completing it after the painting.

The title *Diver* could refer to the poet Hart Crane, whose work Johns strongly admired and who had committed suicide in 1932 by jumping off a ship in the Gulf of Mexico. Johns told scholar Roberta Bernstein that the figure in the drawing is doing a swan dive, and that the directional shift of handprints, footprints and arms, as implied by the arrows, indicates the different stages of the dive. While the diagrammed action suggests the themes of restrained but intense emotion, loss and memory, the convergence of the hands at the bottom center creates the image of a skull, a *memento mori* motif that would recur in Johns's art.

The work's formal devices—its material and composition, mark and gesture, tone and color—are as rich as the existential issues it presents. *Diver* is astonishing in its boldness and nuance; it is meant to be read at a grand distance and also to seduce the observer into intimate encounter. Its force and beauty are a reckoning with the sublime.

Edward Ruscha American, born 1937

OOF. 1962–63

Oil on canvas, 71½ × 67" (181.5 × 170.2 cm)
Gift of Agnes Gund, the Louis and Bessie Adler Foundation, Inc., Robert and Meryl Meltzer, Jerry I. Speyer, Anna Marie and Robert F. Shapiro, Emily and Jerry Spiegel, an anonymous donor, and purchase

"The single word, its guttural monosyllabic pronunciation, that's what I was passionate about," Ruscha has said of his early work. "Loud words, like *slam, smash, honk.*" The comic-book quality of these words reflects the Pop artists' fascination with popular culture. (This interest is even more explicit in Ruscha's images of vernacular Los Angeles architecture.) Lettered in typography rather than handwriting, the words are definite and impersonal in shape; unlike the Abstract Expressionists of the 1940s and 1950s, Ruscha had no interest in letting a painting emerge through an introspective process: "I began to see that the only thing to do would be a preconceived image. It was an enormous freedom to be premeditated about my art."

Words like *oof, smash,* and *honk* all evoke sounds, and loud and sharp ones. They also, as Ruscha says, have "a certain comedic value," and their comedy is underlined by the paradox of their appearance in the silent medium of paint, and with neither an image nor a sentence to help them evoke the sounds they denote. *Oof* is particularly paradoxical, as a word describing a wordless grunt. In Ruscha's hands, its double O's also pun on recent paintings—the Targets and Circles of Jasper Johns and Kenneth Noland. Works like this one wryly point up the arbitrariness of our agreements on the meanings of our visual and verbal languages.

Robert Venturi American, born 1925

Vanna Venturi House, Chestnut Hill, Pennsylvania. 1959–64

Model, Scheme VI (final): cardboard and paper,
7¾ × 20½ × 6¾" (19.7 × 52 × 17.1 cm)
Gift of Venturi, Rauch and Scott Brown, Inc.

The design represented by this modest, cardboard study model of a house for the architect's mother is deceptively simple. The front facade of Venturi's design, for example, has the elements of a conventional house: large gable, chimney, front door, and windows. Yet throughout the building, the adept juxtaposition of big and little elements and the intentional distortion of symmetry establish a richness of meaning and perceptual ambiguity that make the Vanna Venturi residence one of the most important houses of the second half of the twentieth century.

The design for the house coincided in 1961–62 with Venturi's writing of *Complexity and Contradiction in Archi-* *tecture* (published by The Museum of Modern Art in 1966). This brilliant architectural critique, supported by numerous illustrations of historical buildings, sought to overturn the limitations and reductive simplicity of orthodox modern architecture. Describing his own inclusive, mannerist sensibility as "both-and," as opposed to "either-or," Venturi wrote: "If the source of the both-and phenomenon is contradiction, its basis is hierarchy, which yields several levels of meanings among elements with varying values. It can include elements that are both good and awkward, big and little, closed and open, continuous and articulated, round and square, structural and spatial. An architecture which includes varying levels of meaning breeds ambiguity and tension." The Vanna Venturi House is one of the earliest demonstrations of the architect's highly influential ideas.

Various artists

Fluxkit. 1965

Vinyl-covered attaché case containing objects in various mediums, designed and **assembled by George Maciunas** (American, born Lithuania, 1931–1978), overall (closed): 13⅜ × 17½ × 4¹⁵/₁₆" (34 × 44.5 × 12.5 cm)
Publisher: Fluxus Editions, announced 1964
The Gilbert and Lila Silverman Fluxus Collection Gift

Together with festivals, street actions, and musical events, artists' editions played an essential role in Fluxus, a network of artists that emerged in the early 1960s in the United States, Europe, and Japan. Fluxus Editions, an ambitious publishing program conceived by artist and designer George Maciunas—a central figure in the group—comprises affordable items made in multiples and intended to communicate the group's ideas and activities on an international scale.

The *Fluxkit* is among the primary formats adopted by the group and is comprised of a briefcase divided into compartments holding a selection of printed materials and small boxes.

Like many Fluxus editions, the *Fluxkit* is an anthology of works produced collectively. Maciunas solicited concepts from colleagues such as George Brecht, Nam June Paik, and Ben Vautier, then often designed and assembled the projects himself. Reflecting an interdisciplinary and playful approach to art-making, the *Fluxkit* contains a range of items, including performance scores, film loops, flipbooks, musical instruments, and games intended to be held, read, and manipulated. Portable by design and modestly priced, the case, as Maciunas envisioned, would introduce art into everyday experience.

Hélio Oiticica Brazilian, 1937–1980

Box Bolide 12, 'archeologic.'
1964–65

Synthetic polymer paint with earth on wood structure, nylon net, corrugated cardboard, mirror, glass, rocks, earth, and fluorescent lamp, 14½ × 51⅝ × 20½" (37 × 131.2 × 52.1 cm)
Gift of Patricia Phelps de Cisneros in honor of Paulo Herkenhoff

Oiticica's practice was marked by a basic assumption that cultural change can precipitate social transformation, a belief shared by many artists of his generation in Latin America and Europe. As a student in the 1950s, Oiticica studied painting, especially experiments with color by European painters like Kandinsky, Klee, and Mondrian. In the early 1960s, he turned to making three-dimensional works that were intended to engage viewers physically. *Box Bólide 12* represents a transitional point between Oiticica's early abstract paintings and the large-scale installations he would make later in his career.

Around 1963 Oiticica began work on his series of Bólides, assemblages of different colors and textures expressed in simple materials. Here a painted wooden box contains pigment in the form of textiles. In Portuguese, the word "bólide" has geological and biological associations; its meanings include "fireball," "nucleus," and "glowing meteor." With these works, the artist aimed to explore the structure and physical properties of color. Inside them he placed glass vessels and other containers holding bright pigments, fabric, liquids, sand, or crushed shells. Equipped with doors, shelves, and drawers, the Bólides were meant to be handled by the viewer. They embody Oiticica's desire to translate the language of hard-edged geometric abstraction into expressive and lyrical forms of participation and interaction.

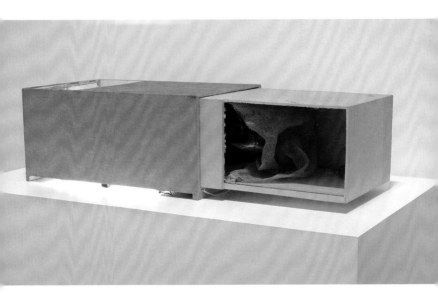

Hans Hollein
Austrian, born 1934

Highrise Building: Sparkplug.
Project, 1964

Perspective: cut-and-pasted printed paper on gelatin silver photograph, 4¾ × 7¼"
(12.1 × 18.4 cm)
Philip Johnson Fund

The surreal juxtaposition of a giant sparkplug and a rural landscape is a deliberately provocative gesture. This fantastic collage registers Hollein's dissatisfaction with the architectural status quo of the early 1960s and invites speculations about the future of architecture. Declaring all forms of architecture, even the vocabulary of modernism, to be inadequate, Hollein drew upon the consumer products of science and technology to create images he believed appropriate to the times.

While Hollein's transformations of commonplace objects and the landscape in a number of photomontages have certain parallels with Pop art, he shared the larger concerns of polemical architects, such as his countryman Walter Pichler and members of the British group Archigram. The proposals for imaginary buildings, cities, and services made in the early 1960s by Hollein and other visionary architects anticipated the radical, often utopian, statements of the Italian groups Archizoom Associati and Superstudio toward the end of the 1960s, a decade that culminated in cultural upheavals throughout much of the world. By this time, however, Hollein was redirecting his focus. In interiors and buildings of the late 1960s and the 1970s, he included references to historical Viennese architecture while continuing to juxtapose the built and the natural landscape.

Claes Oldenburg
American, born Sweden, 1929

Red Tights with Fragment 9. 1961

Muslin soaked in plaster over wire frame,
painted with enamel
69⅝ × 34¼ × 8¾" (176.7 × 87 × 22.2 cm)
Gift of G. David Thompson

In December 1961, Claes Oldenburg
rented a small storefront on East
Second Street in New York and filled
it with handmade, brightly painted
objects that recalled the products—
shirts, dresses, hats, watches,
sausages, candy bars, slices of
pie—available for purchase in stores
throughout the neighborhood. Among
the works on view was *Red Tights with
Fragment 9*, a wall-mounted relief fea-
turing the eponymous undergarment
rendered larger than life-size, paired
with a yellow number nine, and set
against a bright-blue ground. The com-
position was inspired by an advertise-
ment the artist had ripped from a
newspaper or magazine, a process
hinted at by the relief's uneven borders
and the solitary number, likely the
final digit of an "unbeatably low" price.
The fragmentary nature of the piece
bespeaks a fragmented field of vision
such as that experienced in a bustling
urban environment. It also heightens
the work's abstract qualities. Despite
their evocation of commercial commod-
ities and comestibles, Oldenburg's
Store sculptures refuse to approximate
the look of manufactured goods.
Beginning with armatures of chicken
wire, Oldenburg constructed these
objects from plaster-soaked canvas
and then colored them with enamel
paint, loosely applied straight from the
can. Lumpy, occasionally crude, and
generally unruly, the finished products
re-defined the possibilities of modern
sculpture.

Piero Manzoni Italian, 1933–1963

CONTIENE UNA LINEA LUNGA 1000 METRI
ESEGUITA DA PIERO MANZONI
IL 24 LUGLIO 1961

Line 1000 Meters Long. 1961

Chrome-plated metal drum containing a roll
of paper with an ink line drawn along its
1000-meter length, 20¼ × 15⅜"
(51.2 × 38.8 cm) diam.
Gift of Fratelli Fabbri Editori and purchase

Manzoni began his career as a painter,
but his later work anticipated the
Conceptual art of the 1960s. *Line
1000 Meters Long* reflects both sides
of his thought. Regarding a painting not
as "a surface to be filled with colors
and forms" but as "a surface of unlim-
ited possibilities," he imagined in that
"total space" a line going "beyond all
problems of composition and size."
This was what he produced in his many
works on the pattern of *Line 1000
Meters Long*—each a tube or drum
containing a roll of paper marked with
a single continuous line. The length of
the roll varies from work to work, but in
theory, Manzoni believed, the line
could stretch to infinity.

Despite its relationship to painting,
Line 1000 Meters Long is more con-
ceptual than visual. Indeed the line
that is its heart eludes the eye, for
these canister works are usually shown
closed. Art that is invisible raises the
act of thinking above the act of seeing,
as Manzoni also did when, for exam-
ple, he signed eggs with his thumbprint
and asked a show's visitors to eat
them. A line in a can is itself a concep-
tual conundrum. Playful but acute, *Line
1000 Meters Long* invites us to ques-
tion our expectations of the artwork,
and our responses to it.

Marcel Broodthaers

Belgian, 1924–1976

White Cabinet and White Table.
1965

Painted cabinet, table, and eggshells; cabinet
33⅞ × 32¼ × 24½" (86 × 82 × 62 cm), table
41 × 39⅜ × 15¾" (104 × 100 × 40 cm)
Fractional and promised gift of Jo Carole and
Ronald S. Lauder

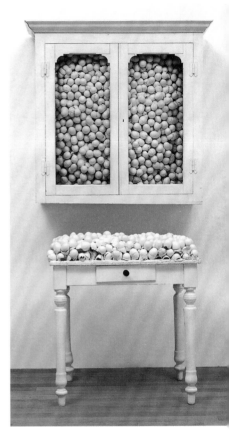

Explaining his beginnings in art,
Broodthaers once wrote, "The idea of
inventing something insincere . . .
crossed my mind and I set to work at
once." Anyone upset to find a cabinet
of eggshells presented as art might
take this to mean that the work is a
joke. But there is another possibility:
Broodthaers is warning us not to take
him at face value, but to look for hid-
den meanings.

White Cabinet and White Table
has aesthetic ancestors in Marcel
Duchamp's Readymade objects and
in the surprises of Surrealism. It also
reflects the concern with everyday
reality in the Pop and Neorealism
of Broodthaers's own time. But
Broodthaers wanted to avoid glamoriz-
ing modern products, and eggshells
have nothing uniquely contemporary
about them. They interested
Broodthaers, rather, as empty con-
tainers—containers "without content
other than the air."

There are other containers in *White
Cabinet and White Table*: the cabinet
and table themselves, both stuffed
with content, but an apparently empty
or meaningless one. If the table stands
on the floor like a sculpture's pedestal
while the closet hangs on the wall
like a painting's frame (Broodthaers
described himself as "painting with
eggs"), then the work subtly analyzes
art itself: how does art contain mean-
ing for its viewers? Or has it been
drained of meaning, like an eggshell
minus its egg?

Achille Castiglioni Italian, 1918–2002
Pier Giacomo Castiglioni Italian, 1913–1968

Arco Floor Lamp. 1962

Marble and stainless steel, 8' 2½" × 6' 7" ×
12½" (2.5 × 2 × .32 m)
Manufacturer: Flos S.p.A., Italy
Gift of the manufacturer

Achille Castiglioni designed more than
sixty lamps and a host of other objects,
working from 1945 until 1968 with his
brother Pier Giacomo and then on his
own. One of their best-known lamp
designs, Arco, came about through the
challenge of a practical problem: how
to provide a ceiling lamp that would not
require drilling a hole in the ceiling.
Castiglioni's motto, "design demands
observation," proved accurate, for it
was a street lamp that gave the broth-
ers the inspiration for this fixture.
Street lamps, affixed to the ground,

have a shape that enables them to
project their light beams several feet
away from their bases.

In this domestic adaptation, the
Castiglionis were able to illuminate
objects eight feet away from the lamp's
base—far enough to light the middle
of a dining table—by inserting a steel
arch into a heavy Carrara marble ped-
estal. They studied the span of the
arch to be sure that its form would
provide enough space for one person
carrying a tray to pass behind some-
one sitting at the table. In addition,
they made sure the heavy lamp could
be moved by two people by inserting
a broomstick through the hole in the
marble base. Arco is a prime example
of the Castiglionis' rigorous approach
to design solutions.

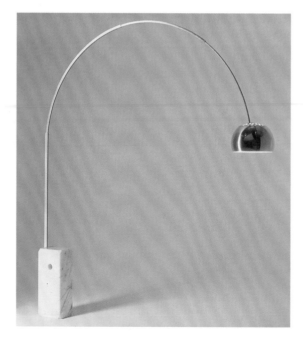

Federico Fellini Italian, 1920–1993

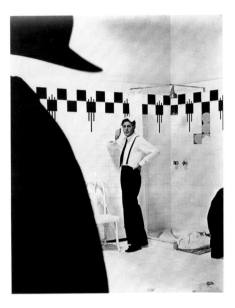

8½ (Otto e mezzo). 1963

35mm film, black and white, sound,
135 minutes
Gift of Mediaset S.p.A.
Marcello Mastroianni

Fellini created a remarkably personal cinematic confession in this film about a director who is mentally unable to commence work on his latest production. Suffering from a psychosomatic liver ailment, Guido Anselmi (Marcello Mastroianni) takes to a spa for physical and spiritual rejuvenation, only to be haunted by the specter of his professional and personal life. In the black-and-white-tiled world of the spa, Anselmi confronts his problems, his boyhood memories, and his lusty fantasy world. Yet interruptions keep coming at him—from his producer, who wants to get the production of an outer-space adventure underway, and from his wife Luisa, upset about his mistress. His imagination serves as his escape: in imaginary sequences, he brandishes a whip instead of a megaphone to orchestrate his actors, and he also fantasizes that he is the master of a harem of women demurely under his control.

The containment of 8½ within the artificial world of the spa manifests a subjective, self-created reality, one that Fellini populates with priests, journalists, and Saraghina, the mythical prostitute who initiated Anselmi into the self-created mysteries of sex in his youthful days. Like Anselmi's incomplete film script in the story, 8½ relied a great deal on Fellini's gift for improvisation. The film's title represents the total number of films made by Fellini before this production: seven plus three collaborations (each counting as one-half). This uniquely autobiographical work is enhanced by a musical score written by Nino Rota.

Andy Warhol
American, 1928–1987

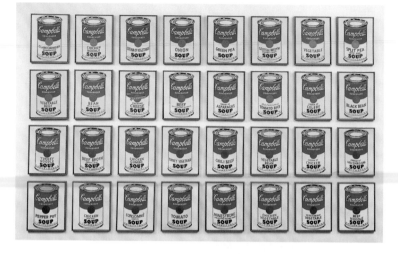

Campbell's Soup Cans. 1962

Synthetic polymer paint on thirty-two canvases, each 20 × 16" (50.8 × 40.6 cm)
Partial gift of Irving Blum. Additional funding provided by Nelson A. Rockefeller Bequest, gift of Mr. and Mrs. William A.M. Burden, Abby Aldrich Rockefeller Fund, gift of Nina and Gordon Bunshaft in honor of Henry Moore, Lillie P. Bliss Bequest, Philip Johnson Fund, Frances Keech Bequest, gift of Mrs. Bliss Parkinson, and Florence B. Wesley Bequest (all by exchange)

"I don't think art should be only for the select few," Warhol believed, "I think it should be for the mass of the American people." Like other Pop artists, Warhol used images of already proven appeal to huge audiences: comic strips, ads, photographs of rock-music and movie stars, tabloid news shots. In *Campbell's Soup Cans* he reproduced an object of mass consumption in the most literal sense. When he first exhibited these canvases—there are thirty-two of them, the number of soup varieties Campbell's then sold—each one simultaneously hung from the wall, like a painting, and stood on a shelf, like groceries in a store.

Repeating the same image at the same scale, the canvases stress the uniformity and ubiquity of the Campbell's can. At the same time, they subvert the idea of painting as a medium of invention and originality. Visual repetition of this kind had long been used by advertisers to drum product names into the public consciousness; here, though, it implies not energetic competition but a complacent abundance. Outside an art gallery, the Campbell's label, which had not changed in over fifty years, was not an attention-grabber but a banality. As Warhol said of Campbell's soup, "I used to drink it. I used to have the same lunch every day, for twenty years, I guess, the same thing over and over again."

Lee Friedlander American, born 1934

Galax, Virginia. 1962

Gelatin silver print, 5⅞ × 8⅞" (14.9 × 22.5 cm)
Acquired through the generosity of Celeste Bartos

The bare facts of the picture are bare indeed: an undecorated room, a plain blanket, a sturdy bed with rails like prison bars or like the slats of a crib. All that animates the room is the electronic image on the television screen. That image is human, nonetheless, and it serves as a companion of sorts for the occupant of the room.

Televisions became common in living rooms (and motel rooms) in the early 1950s, so it is fair to say that this picture confronts a significant aspect of the then contemporary American "social landscape," a term coined by Friedlander. But unlike the photographs that *Life* and other magazines had made familiar to millions, this picture declines to state a case—to judge or explain. Alertly engaged with the material of contemporary life, it fiercely resists the ready conclusions of journalism or sociology. In this respect, it is exemplary of the most adventurous American photography of the 1960s, whose leaders opened new artistic territory by transforming the pictorial vocabulary of photojournalism into a means of asserting and exploring their distinctly individual sensibilities.

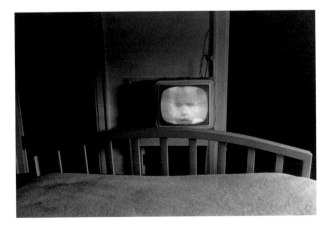

Dieter Roth Swiss, born Germany, 1930–1998

Literaturwurst. 1961/69

Multiple of ground paper, gelatin, lard, and spices in natural sausage casing, overall (top, approx.): 9¼ × 3⁹⁄₁₆ × 3⁹⁄₁₆" (23.5 × 9 × 9 cm); overall (bottom, approx.): 4⅛ × 3⁹⁄₁₆ × 3⁹⁄₁₆" (10.5 × 9 × 9 cm).
Publisher: the artist (nos. 1-15) and René Block (nos. 16-50)
Edition: 50 unique examples (few surviving)
The Print Associates Fund in honor of Deborah Wye

A prolific artist in many mediums, Dieter Roth perhaps made his most important, lasting, and influential contributions in the area of prints, books, and multiples. Challenging traditional notions of art and blurring the boundaries between mediums, he often forged innovative approaches to techniques, formats, and materials. Roth sent slices of greasy sausage and cheese through the printing press, stuck strips of licorice onto etchings, and glued croissants onto the covers of his book works.

Roth's experiments with books encompass Op and kinetic works, miniature volumes, and his most radical effort, the Literaturwurst (literature sausage), which consists of a sausage made in accordance with traditional recipes, calling for ingredients such as salt, garlic, and fennel, but with one critical substitution: minced books in place of meat. The mixtures were stuffed into sausage casings, and the resulting Literaturwursts playfully proposed to viewers and readers another means by which to ingest and digest information. While the Literaturwursts comprise an edition of multiple variants, each piece is unique—different in shape and size, and containing a different book, magazine, or newspaper. This example was made from Robert Kennedy's 1967 volume of essays *To Seek a Newer World*. Emblematic of Roth's unconventional approach to editioned formats, the organic contents of the *Literaturwurst* are bound to rot and molder over time, embodying his embrace of metamorphosis and decomposition in his work.

Philip Guston
American, born Canada. 1913–1980

City Limits. 1969

Oil on canvas, 6' 5" × 8' 7¼"
(195.6 × 262.2 cm)
Gift of Musa Guston

A three-man crew of slapstick thugs cruises a vacant metropolis in a beat-up jalopy. Wearing Ku Klux Klan hoods, they are plainly up to no good; but rather than invoking a specific evil, these men are symbolic embodiments of a general know-nothing violence. The principal story told here is that of an America run afoul of its democratic promise. Guston refused to exempt himself from responsibility: in other paintings he depicted an artist in Klan robes at his easel.

Guston began his career as a figurative painter, then, around mid-century, developed a lyrical Abstract Expressionism, a typical path for a member of the New York School. In the late 1960s, however, Guston made a surprising return to narrative painting—but not in the vein of the classic studio tradition in which he had trained. The art of Guston's last decade is antically cartoonlike. It has precedents in his earlier figurative period (and in his occasional satiric drawings of artists and writers), but rephrases them in a type of caricature dating to his child-hood imitations of comic strips such as Krazy Kat. At the same time, paintings like *City Limits* have a strange baroque grandeur and a bitter undertow—an insistence on the fascination of cruelty.

Alex Katz American, born 1927

Passing. 1962–63

Oil on canvas, 71¾"× 6' 7⅝"
(182.2 × 202.2 cm)
Gift of the Louis and Bessie Adler Foundation,
Inc., Seymour M. Klein, President

Ambitious, elegant, impersonal, large in scale, and simultaneously timeless and reflective of its time—these, according to Katz, are the qualities of "high style" in painting, and they are also the qualities of many of his own works. Believing that "you have no power unless you have traditional elements in your pictures," Katz achieves high style by integrating familiar traditions with avant-garde practice. *Passing* belongs to a venerable genre—it is a self-portrait—but has the scale of Abstract Expressionism. Another inspiration is the advertising billboard; like the Pop artists, Katz pays attention to

the cultural scene. Meanwhile, his reductive approach and his conception of pictorial space match those in the formalist painting of the 1960s.

The ground in *Passing* is a flat monochrome, and Katz's face and shoulders are so simplified that it is mainly their clarity as parts of a figure that insinuates their volume. Neither smiling nor frowning, Katz meets our gaze frankly, but his character is muted by the artifice of the painting's design: the perfect ellipse of the hat brim; the asymmetry in the height of the shoulders; the limited palette, all near-flat blacks, whites, and grays except for the face. Far from the bohemian artist, Katz looks coolly imperturbable in his businessman's suit and hat—stylish not only in his painting but in his person.

William Eggleston
American, born 1939

Memphis. 1969–70

Dye transfer print, 11¾ × 18" (29.9 × 45.8 cm)

Purchase

The tricycle may be a little worse for wear, but it is pictured here as the most important thing in the world. To make the photograph, Eggleston adopted a viewpoint even lower than the eye-level of the tricycle's owner, so as to give us a clear view between its wheels to the grown-up sedan parked in the carport across the street.

Eggleston's photographs began as Kodachrome slides, a popular medium of amateur photography, and they resemble snapshots in the way they forthrightly describe ordinary people and objects, framed squarely in the center of the picture. Critics who found this resemblance grounds for dismissing the work overlooked the paradoxical power of snapshots. To the insider, snapshots are keys that open reservoirs of memory and feeling; to the outsider, who does not recognize the faces or know the stories, they are for-

ever opaque. But because we all have snapshots of our own, we know the habit of understanding them and of projecting ourselves into the dramas and passions they conceal.

Color became available to the ordinary photographer in the 1950s and 1960s, but before then photography had been a black-and-white medium for more than a century. Not only did color photographers have to master a new medium, they also had to forget the distinguished precedents that had drawn them to photography in the first place. The conviction that serious photographs are made in black and white has not entirely disappeared, even today.

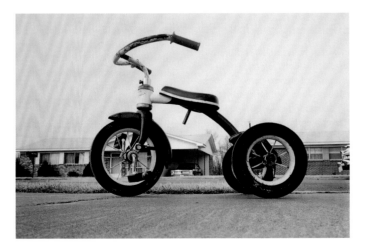

Agnes Martin American, born Canada, 1912–2004

Red Bird. 1964

Synthetic polymer paint and colored pencil
on canvas
71⅛ × 71⅛" (180.5 × 180.5 cm)
Gift of Philip Johnson

A fine grid of lines, ruled and then
drawn over by hand in pencil on a thinly
primed six-foot-square canvas—these
were the method and format that
Martin developed in 1963 and kept to
thereafter. Inspiration for early variants
such as *Red Bird* often came from the
natural world, but her means of expres-
sion was always purely abstract. "My
paintings have neither object nor space
nor line nor anything—no forms,"
she stated in 1966. "They are light,
lightness, about merging, about . . .
breaking down forms."

The resulting work is nearly
impossible to reproduce effectively,
since apprehending its full range
requires approaching the surface and
then stepping back from it in what has
been likened to a mating dance. At
close range, the material specificity of
Martin's process takes over. The
uneven deposit of red pigment on the
tooth of the canvas becomes visible,
telling the tale of a pencil's bumpy
ride. As one backs away, the horizontal
lines resolve into a more precise
pattern and then merge into an
atmospheric mist. Finally the canvas
solidifies into an opaque monochrome
faintly pink in hue. The encounter is
meditative, equal parts active and
receptive, turning our attention to the
juncture of self and world.

Robert Irwin American, born 1928

Untitled. 1968

Synthetic polymer paint on aluminum and
light, 60⅜" (153.2 cm) diam.
Mrs. Sam A. Lewisohn Fund

This untitled work is a convex, spray-painted disk held a foot or so out from the wall by a central post. Its subtle, tactile surface modulates delicately from center to edge, and it is softly lit from four angles, creating a clover-leaf pattern of shadow. The white center of the disk can seem to lie level with the white wall, so that the eye spends time trying to understand what it sees—what is nearer and what is farther, what is solid and what is immaterial light, or even light's absence. For Irwin, the result is "this indeterminate physicality with different levels of weight and density, each on a different physical plane. It [is] very beautiful and quite confusing, everything starting and reversing."

Evading confinement by the rectangle of the conventional painting, Irwin's disks literally extend past their own boundaries—spread out into their environment, which is as much a part of them as their own substance. The idea, in part, extends the Abstract Expressionist notion of an infinite, all-encompassing, allover field, but with the qualification that for Irwin, "To be an artist is not a matter of making paintings or objects at all. What we are really dealing with is our state of consciousness and the shape of our perceptions."

Robert Smithson American, 1938–1973

Corner Mirror with Coral. 1969

Mirrors and coral, 36 × 36 × 36"
(91.5 × 91.5 × 91.5 cm)
Fractional and promised gift of Agnes Gund

Smithson's three mirrors in a corner create a structure both lucid and elusive: as each mirror reflects the space around it, it multiplies the reflections in the other mirrors, creating an image with the symmetry of a crystal. Mirrors appear often in Smithson's art, as do fragments of the natural world—here, there are pieces of coral piled in the angle where the mirrors meet. Smithson also combined mirrors with heaps of sand, gravel, and other rocks, matching nature's brute rubble with its precise visual twin. (The delicacy of the lacy pink coral is unusual in his work.) The pairing of matter and reflection corresponds to another duality: on the one hand, unshaped shards of stone or reef; on the other, art, sculpture, and the indoor space of the gallery.

In other pieces, Smithson, who was one of the earthworks artists of the 1960s and 1970s, manipulated the natural landscape, sometimes simply and temporarily, using mirrors, sometimes drastically, with a bulldozer. *Corner Mirror with Coral* relates to his Non-Sites, indoor works containing substances from outdoor sites elsewhere. Both cerebral and powerfully material, his art shows a fascination with entropy, the tendency of all structures and energies to lose their integrity. In this work a perfect form—the mirrors make three sides of a cube—is made illogical and illusory, for the coral seems to float in midair.

Eva Hesse
American, born Germany. 1936–1970

Repetition 19, III. 1968

Fiberglass and polyester resin, nineteen units,
19 to 20¼" × 11 to 12¾" diam.
(48 to 51 cm × 27.8 to 32.3 cm)
Gift of Charles and Anita Blatt

Repetition 19, III comprises nineteen bucketlike forms, all the same shape but none exactly alike. Nor do they have a set order, since Hesse allowed latitude in placing them: "I don't ask that the piece be moved or changed, only that it could be moved and changed. There is not one preferred format." The Minimalist artists, who emerged a little before Hesse did, had explored serial repetitions of identical units. Hesse loosened that principle: *Repetition 19* is simultaneously repetitive and irregular. She also tended to work on a humbler scale than the Minimalists often had, and her forms and materials are less technocratic; she herself called the forms in *Repetition 19* "anthropomorphic," and recognized sexual connotations in these "empty containers."

This fiberglass work, *Repetition 19, III*, is the third version Hesse planned. (The first is in papier-mâché; the second, which she imagined first in metal, then in latex, was never completed.) Besides beautifully modulating the light, the fiberglass seems both soft and hard, contributing to the richly paradoxical character of these subtle objects: nonconformist individuals somehow make a group; the arrangement, whatever it is, is both random and coherent, unified by the similarity preserved through difference. And paradox is fitting here: Hesse wanted, she said, to make an art object that "accedes to its nonlogical self. It is something, it is nothing."

Sol LeWitt American, 1928–2007

Serial Project, I (ABCD). 1966

Baked enamel on steel units over baked
enamel on aluminum, 20" × 13' 7" × 13' 7"
(50.8 × 398.9 × 398.9 cm)
Gift of Agnes Gund and purchase (by
exchange)

LeWitt's work emerged alongside
the Minimalist and Conceptual art
movements of the 1960s, and com-
bines qualities of both. Like the
Minimalists, he often used simple
basic forms, in the belief that "using
complex basic forms only disrupts
the unity of the whole"; like the Con-
ceptualists, he started with an idea
rather than a form, initiating a process
that obeyed certain rules and that
determined the form by playing itself
out. The premise of *Serial Project*
demands the combination and recombi-
nation of both open and closed enam-
eled aluminum squares, cubes, and
extensions of these shapes, all laid in
a grid. Both intricate and methodical,
the system produces a visual field that
gives its viewers all the evidence they
need to unravel its logic.

In a text accompanying *Serial
Project*, LeWitt wrote, "The aim of
the artist would not be to instruct the
viewer but to give him information.

Whether the viewer understands this
information is incidental to the artist;
he cannot foresee the understanding of
all his viewers. He would follow his pre-
determined premise to its conclusion
avoiding subjectivity. Chance, taste,
or unconsciously remembered forms
would play no part in the outcome. The
serial artist does not attempt to pro-
duce a beautiful or mysterious object
but functions merely as a clerk catalog-
ing the results of his premise."

William Wegman American, born 1943

Family Combinations. 1972

Six gelatin silver prints, each 12⅞ × 10³⁄₁₆"
(31.6 × 25.9 cm)
Gift of Robert and Gayle Greenhill

The top row of this tableau of six
pictures represents, from right to left,
Wegman, his mother, and his father.
The bottom row consists of superimpo-
sitions of all possible combinations of
any two of the three images above. The
combinations resemble the sorts of
pictures that once circulated as scien-
tific illustrations of racial and social
types. The humor of Wegman's tableau
derives from the deadpan sincerity with
which he has reenacted this absurd
operation.

Photographs perform many banal
functions in our everyday lives, so
banal that we rarely stop to think about
them. The head shots that appear on
identity cards and drivers' licenses are
good examples. In the early 1970s
Wegman helped to lead an artistic
movement that emulated the look of
such photographs but short-circuited
their functions. The idea was to invite
us to consider the meanings we
attach to these pictures, and so to
explore our habits of thought and our
social arrangements. Wegman's talent
for comedy has been evident from the
beginning, but it took a while to see
that his playful wit is colored by kind-
ness and warmth.

Peter Cook British, born 1936

Plug-In City. 1964

Cut-and-pasted printed papers with graphite
and clear and colored self-adhesive polymer
sheets on gray paper-covered board with ink,
27⅜ × 29⅞"
Gift of the Howard Gilman Foundation

Peter Cook's *Plug-In City* was one of
many vast, visionary creations pro-
duced in the 1960s by the radical, col-
laborative British architectural group
Archigram, of which Cook was a found-
ing member. Between 1960 and 1974
the group published nine provocative
issues of their magazine, *Archigram*,
and produced over nine hundred exu-
berant drawings illustrating imaginary
architectural projects ranging in inspira-
tion from technological developments
to the counterculture, from space
travel through science fiction. Their
work opposed the period's functionalist
ethos; they liked to design nomadic
alternatives to traditional ways of living,
including wearable houses and walking
cities—mobile, flexible, impermanent
architectures that they hoped would
be liberating.

Plug-In City was designed to span
the English Channel. An urban environ-
ment as a "megastructure" incorporat-
ing residences, access routes, and
essential services for the inhabitants,
it was intended to accommodate and
encourage change through obsoles-
cence: each building outcrop (houses,
offices, supermarkets, hotels) would
be removable, and a permanent
"craneway" would facilitate continual
rebuilding and updating. The life of the
units would vary in length, and the
main structure itself would last only
forty years. The network would include
a high-speed monorail; hovercrafts
would serve as moving buildings.

The comic book style, popular with
Archigram members and characteristic
of the counterculture of the 1960s,
conveys a youthful excitement with form
in a technologically enhanced world.

Lygia Clark
Brazilian, 1920–1988

O dentro é o fora (The Inside Is the Outside). 1963

Stainless steel, 16 × 17½ × 14¾"
(40.6 × 44.5 × 37.5 cm)
Gift of Patricia Phelps de Cisneros through the Latin American and Caribbean Fund in honor of Adriana Cisneros de Griffin

Brazilian artist Lygia Clark began her career in the early 1950s as a painter working in the abstract, geometric style that defined Concrete Art. By the end of that decade, she had come to regard the flat support of painting as a source of undesirable oppositions. "The plane arbitrarily marks off the limits of a space," she wrote, and "from this are derived the opposing concepts of high and low, front and back—everything that contributes to the destruction in humankind of the feeling of wholeness." In *O dentro é o fora*, Clark defies the strictures of the flat plane by transforming a sheet of stainless steel into an open spatial volume with no clear front or back, interior or exterior. By executing linear cuts and exploiting the natural pliancy of the metal, she fashions biomorphic curves, uniting dualisms such as subjective and objective, organic and inorganic, erotic and ascetic. Challenging the notion of the work of art as a fixed and static object, Clark envisioned this sculpture as participatory and invited viewers to manipulate its shape. *O dentro é o fora* courts contingency, which in turn imbues the loosely geometric form with expressive content, a hallmark of Neo-Concretism, the movement Clark co-founded in 1959.

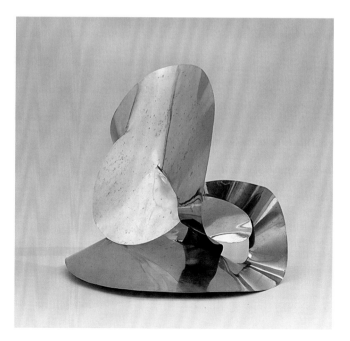

Dan Graham American, born 1942

Homes for America. 1965–67 / 2010

Slide projection, 20 35mm color slides.
Pictured above: *Tract Houses, Bayonne, NJ, 1966*
Gift of the Michael H. Dunn Memorial Fund

Homes for America is an extensive series of images taken by Graham using a Kodak Instamatic camera and, later, a 35mm camera, in New York and New Jersey between 1965 and 1967. With this body of work, the artist circumvented the gallery setting as a framework for art-making and turned to the suburban city plan. The images document the sprawling landscape Graham has described as "a kind of false arcadia," defined by post-World War II highway culture, mass-produced tract housing, and fake Baroque décor. Characterized by geometric seriality

and a luminescent quality, Homes for America evokes formal references to Minimalism; moreover, Graham cites Donald Judd's and Sol LeWitt's interests in city planning as a key inspiration for the work. Homes for America has taken many forms, including this 35mm slide projection, photographic prints, as well as a magazine layout and intervention. Graham synthesized many of the concepts behind Homes for America in a text parodying sociological commentary on suburbia. The piece was published in *Arts Magazine* in 1966; the editors gave it the title "Homes for America," which has since been used to designate all iterations of the series.

Bernd Becher German, 1931–2007

Hilla Becher German, born 1934

Winding Towers. 1966–97

9 gelatin silver prints, 68¼ × 56¼"
(173.4 × 142.9 cm)
Acquired in honor of Marie-Josée Kravis
through the generosity of Robert B. Menschel

For over forty years, German artists
Bernd and Hilla Becher photographed
winding towers, blast furnaces, silos,
cooling towers, gas tanks, grain
elevators, oil refineries, and the like—
all examples of the European and
American industrial architecture that
had begun to disappear in the transi-
tion from an industrial to an information
society. Their works typically present
each structure frontally against flat,
evenly gray backgrounds. By using large-
format cameras and finely grained
black-and-white film, they ensured that
the motifs they photographed were ren-
dered with a high degree of precision
and clarity.

The Bechers organized the images
into groupings assembled in grids,
classified by function into types. In this
strict layout, each structure may easily
be compared with the others. The nine
separate pictures in *Winding Towers*
together transform the specificity of
the individual towers into variations
on an ideal form and, conversely, pre-
serve their individual characteristics
within a typology.

Dan Flavin American, 1933–1996

untitled (to the "innovator" of Wheeling Peachblow). 1968

Fluorescent lights and metal fixtures, 8' ½" ×
8' ¼" × 5¾" (245 × 244.3 × 14.5 cm)
Edition: 2/3
Helena Rubinstein Fund

Dan Flavin began working with commer-
cially available fluorescent light tubes
in 1963. He exhibited them singly or in
combination, creating a complicated
and varied range of visual effects using
minimal means. *untitled (to the "inno-
vator" of Wheeling Peachblow)* derives
its palette from Wheeling Peachblow,
a type of Victorian art glass first made
in Wheeling, West Virginia, that shades
from yellow to deep red, producing a
delicate peach color in between. Flavin
creates a similar color on the walls

of the gallery by placing one yellow and
one pink fluorescent tube on each of
the two vertical elements of a square
metal armature. Two horizontal daylight
bulbs, facing the viewer, complete the
structure.

Rather than hanging the work flush
against the wall, Flavin positions it on
the floor across the corner of a gallery,
where the square frames a monochro-
mic plane of colored light and simulta-
neously defines an opening onto a
three-dimensional space. *untitled (to
the "innovator" of Wheeling Peachblow)*
creates a visual effect that invokes the
conditions of painting's flatness and
sculpture's depth without employing
materials traditionally associated with
either discipline.

Dorothea Rockburne American, born Canada 1932

Scalar. 1971

Chipboard, crude oil, paper, and nails,
overall 6' 8" × 9' 6½" × 3½"
(203.2 × 289.5 × 8.9 cm)
Gift of Jo Carole and Ronald S. Lauder
and Estée Lauder, Inc.
in honor of J. Frederic Byers III

Scalar inherits the geometry and literalness of Minimal art but softens these qualities through variations in its tones and in the disposition of its forms. Tacked-up rectangles (and one cylinder) of paper and chipboard suggest a modular order, but differ in size and proportion. Sometimes they overlap, sometimes leave the wall bare; their placement seems both careful and irregular, as in Incan masonry. Unpigmented oil applied to their surfaces has left gentle mottlings and stains, which have spread through an interaction between oil and support that must have lain largely outside the artist's control. These planes against the wall invoke paintings, but at the bottom they rest on the floor, so that they also cite sculpture and weight.

In reaction against Abstract Expressionism, many American artists of the 1960s, such as Rockburne, tried to minimize or erase signs of their own individuality in their art. Instead, their work drew attention to the process by which it was made and to impersonal agents in its making: its physical context, the qualities of its materials, the force of gravity, a system or procedure that might generate a form independently of the artist's aesthetic judgment. *Scalar* is party to these ideas, but with its blotched surfaces, its echoes of painting, and its rhythmic arrangement of uprights and horizontals, it remains subtly pictorial, in a powerful combination of rigor and delicacy.

Garry Winogrand American, 1928–1984

Centennial Ball, Metropolitan Museum, New York. 1969

Gelatin silver print, 10⅝ × 15⅞" (27 × 40.3 cm)
Purchase

This photograph invites any number of scenarios to explain the intimate drama at this fancy party, but declines to endorse any single one. Who, for example, might be romantically involved with whom? What has provoked the anxious stare of the woman in the background? We shall never know the answers to these questions.

Winogrand loved to observe the behavior of humans and other animals, and he loved photography's voracious capacity for description, but he did not confuse the two. In his pictures he created a parallel theater of experience, the force of which resides not in the reliability of its facts but in the liveliness of its fictions.

This picture belongs to a long series, begun in the late 1960s, made at demonstrations, press conferences, and other gatherings whose participants expected to be noticed and, often, photographed. For the photographer Tod Papageorge, Winogrand's series vividly evokes the 1960s by offering "a unilateral report of how we behaved under pressure during a time of costumes and causes, and of how extravagantly, outrageously, and continuously we displayed what we wanted."

Chuck Close American, born 1940

Robert/104,072. 1973–74

Synthetic polymer paint and ink with graphite on gessoed canvas, 9 × 7' (274.4 × 213.4 cm)

Gift of J. Frederic Byers III and promised gift of an anonymous donor

"No work of art was ever made without a process," Close has said, and *Robert/104,072* was made by a painstaking process indeed: it is composed of tiny black dots, each set inside a single square of a 104,072-square grid. The sense of shape and texture—of the distinction between metal and skin, between knitted sweater and bushy mustache—depends on the density of the paint, which Close applied with a spray gun, revisiting each square an average of ten times. Not surprisingly, the work took fourteen months to make.

When Close began to paint portraits, in 1967–68, figurative painting was widely considered exhausted. The figures in Pop art were coolly ironic; and other artists were painting abstractions, or were abandoning painting altogether for more conceptual systems of art-making. Close preferred to apply a conceptual system to a traditional mode of painting. The aggressive scale makes the system clear—close up, the gridded dots in *Robert/104,072* are quite apparent—and the black-and-white palette reflects the image's source in a photograph.

Robert/104,072 announces itself as less illusion than code. For Close, a picture like this one is not "a painting of a person as much as it is the distribution of paint on a flat surface. . . . You really have to understand the artificiality of what you are doing to make the reality."

Louis I. Kahn American, born Estonia, 1901–1974

**Alfred Newton Richards Medical
Research Building, University
of Pennsylvania, Philadelphia.**
1957–65

Model: basswood, 13½ × 14¾ × 22¾"
(34.2 × 37.5 × 57.8 cm)
Gift of the architect

The design of the Richards Medical
Research Building, as shown in this
model, was a reaction against the prev-
alent idea in modern architecture that
a single envelope of space should
encompass all parts of a building.
The distinction between what Kahn
called "served" and "servant" spaces
underlies the highly articulated mass-
ing and overall structure of the
Richards Medical Research Building.
Kahn explained that he conceived its
design "in recognition of the realiza-
tions that science laboratories are stu-
dios and that the air to breathe should
be away from the air to throw away."

By placing the "servant" spaces—
stairs, elevators, and air-handling tow-
ers—on the periphery, Kahn was also
able to provide the "served" spaces—
the laboratories—maximum flexibility
by means of their uninterrupted floor
areas. While Kahn developed a practi-
cal response to programmatic needs,
he made aesthetic choices as well:
the towers echo the lively silhouette
of the neighboring turn-of-the-century
dormitories.

The model shows the innovative
structural system of precast, post-
tensioned concrete that Kahn designed
with structural engineer August
Komendant. The clear division between
the concrete structural members (the
trusses and cantilevered beams) and
the brick-and-glass infill is a further
indication of the hierarchical order
underlying Kahn's work.

Carl Andre American, born 1935

Equivalent V. 1966–69

Firebricks, 120 units, 5 × 45 × 54"
(12.8 × 114.3 × 137.2 cm)
Purchase

Equivalent V is part of a series of eight sculptures (*Equivalent I – VIII*) first exhibited in 1966 at the Tibor de Nagy Gallery in New York. Each of the works is composed of 120 bricks stacked two blocks high and placed directly on the gallery floor. Although all eight are precise equivalents in many respects (for example, in height, volume, and weight), each is unique in its configuration. The footprint of *Equivalent V* measures five brick-lengths by twelve brick-widths, while *Equivalent VIII* stretches ten lengths by six widths, and so on. By distinctly articulating the shape of each *Equivalent* and showing the various permutations alongside one another, Andre proposes that sculpture should define rather than simply occupy space, an idea that has remained important to him throughout his career.

The *Equivalents* were Andre's first flat floor works. They dispense with the traditional sculptural pedestal and the division between artistic and ordinary space that it implies. The viewer and the sculpture coexist in the same field, a fact further heightened by the artist's decision to use unexceptional, factory-made bricks rather than a material traditionally associated with fine art, such as bronze or marble. Most of the works in the 1966 series were destroyed. Andre re-created them in 1969 using firebricks, because the original material, sand-lime brick, was no longer available.

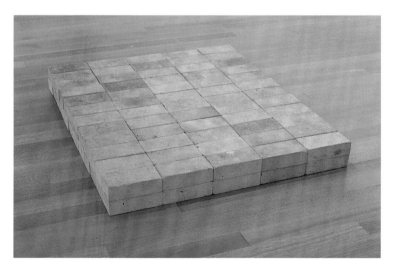

Henry Moore
British, 1898–1986

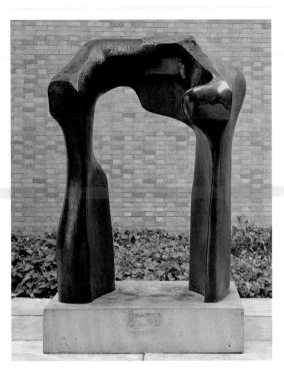

Large Torso: Arch. 1962–63

Bronze, 6' 6⅛" × 59⅛" × 51¼"
(198.4 × 150.2 × 130.2 cm)
Edition: 3/7
Mrs. Simon Guggenheim Fund

Invited by the title of this sculpture to expect a likeness of a human torso, the viewer may notice a striking absence of the solid body that lies below the shoulders, at least in a living being. Basing the piece on the shoulder-bone structure of a male torso, Moore actually made a simplified skeleton. The shapes of bones fascinated Moore. He was also one of the many artists of his generation who wanted to escape the classical tradition—in his words, to remove "the Greek spectacles from the eyes of the modern

sculptor"—and who therefore studied objects of many eras and areas, from Cycladic art to pre-Columbian art to African and Oceanic art of relatively recent times. "Keep ever prominent the world tradition—the big view of Sculpture," Moore once wrote, and the near-abstract forms of his art show how far he left classical naturalism behind.

In its scale and weight, *Large Torso* evokes a natural form—perhaps an arch of wind-smoothed rock. The word *Arch* in the work's title also asks viewers to look at that central vacancy, as important formally as the solid bronze. Stripping the skeleton of flesh and melding it with landscape, Moore gives his work the sense of having been shaped by the long passage of time.

Tony Smith American, 1912–1980

Die. 1962 (fabricated 1998)

Steel, 6 × 6 × 6' (182.9 × 182.9 × 182.9 cm)
Edition: 2/3
Gift of Jane Smith in honor of Agnes Gund

A six-foot cube of rolled steel, *Die* is a remarkably concise example of Tony Smith's sculptural practice. Despite its rigid geometry, the work is inherently anthropomorphic. Its dimensions derive from Leonardo da Vinci's drawing of Vitruvian Man, a depiction of an ideally proportioned male figure positioned within a circle and a square. As Smith later explained, he wanted to create something smaller than a monument and larger than an object. Echoing the size of the human body, *Die* confronts the viewer physically. Its dimensions also enhance the multilayered meanings of the title. Quoting W. H. Auden, "Let us honor if we can the vertical man, though we value none but the horizontal one," Smith continued, "Six feet has a suggestion of being cooked. Six foot box. Six foot under."

Although Smith often worked with small-scale models to determine the final form of a sculpture, he skipped these steps when making *Die*. To realize the piece, he simply called the Industrial Welding Company in Newark, New Jersey, conveyed his specifications for the sculpture, and placed his order by telephone.

Donald Judd American, 1928–1994

Untitled (Stack). 1967

Lacquer on galvanized iron, twelve units,
each 9 × 40 × 31" (22.8 × 101.6 × 78.7 cm),
installed vertically at 9" (22.8 cm) intervals
Helen Acheson Bequest (by exchange) and
gift of Joseph Helman

Sculpture must always face gravity, and the stack—one thing on top of another—is one of its basic ways of coping. The principle traditionally enforces a certain hierarchy, an upper object being not only usually different from a lower one but conceptually nobler, as when a statue stands on a pedestal. Yet in Judd's stack of galvanized-iron boxes, all of the units are identical; they are set on the wall and separated, so that none is subordinated to another's weight (and also so that the space around them plays a role in the work equivalent to theirs); and their regular climb—each of the twelve boxes is nine inches high, and they rest nine inches apart—suggests an infinitely extensible series, denying the possibility of a crowning summit. Judd's form of Minimalism reflected his belief in the equality of all things. "In terms of existing," he wrote, "everything is equal."

The field of Minimalist objects, however, is not an undifferentiated one—Judd also believed that sculpture needed what he called "polarization," some fundamental tension. Here, for example, the uniform boxes, their tops and undersides bare metal, suggest the industrial production line. Meanwhile their fronts and sides have a coat of green lacquer, which, although it is auto paint, is a little unevenly applied, and has a luscious glamour.

Robert Morris American, born 1931

Untitled. 1969

Gray-green felt, draped, 15' ¾" × 6' ½" × 1"
(459.2 × 184.1 × 2.5 cm)
The Gilman Foundation Fund

Although Morris helped to define the principles of Minimal art, writing important articles on the subject, he was also an innovator in tempering the often severe appearance of Minimalism with a new plasticity—a literal softness. In works like this one, he subjected sheets of thick industrial felt to basic formal procedures (a series of parallel cuts, say, followed by hanging, piling, or even dropping in a tangle), then accepted whatever shape they took as the work of art. In this way he left the overall configuration of the work (a configuration he imagined as temporary) to the medium itself. "Random piling, loose stacking, hanging, give passing form to material," Morris wrote. "Chance is accepted and indeterminacy is implied. . . . Disengagement with pre-conceived enduring forms and orders for things is a positive assertion."

This work emphasizes the process of its making and the qualities of its material. But even if Morris was trying to avoid making form a "prescribed end," as a compositional scheme, the work has both formal elegance and psychological suggestiveness: the order and symmetry of the cut cloth is belied by the graceful sag at the top. In fact, a work produced by rigorous aesthetic theory ends up evoking the human figure. "Felt has anatomical associations," Morris has said, "it relates to the body—it's skinlike."

Stan Brakhage American, 1933–2003

The Text of Light. 1974

16mm film, color, silent, 68 min.
Jerome Foundation Purchase Fund

Starting in the 1950s, Stan Brakhage, widely considered to have been the most prolific and preeminent American independent filmmaker of his time, pursued what he called the "art of vision," using processes of layering, repetition of elements, and accumulation of visual details and non-narrative sequences in his experimental films.

In the 1970s Brakhage and other American filmmakers such as James Herbert and Andrew Noren intensified their explorations of cinema's formal properties. The richest areas of investigation were two of film's basic means of expression: the apparent motility of light and the resultant texture of the ephemeral image.

In the Museum of Modern Art's Cineprobe program note from February 1977, Brakhage memorably explains:

"Why this film is called *The Text of Light* is that here in the ashtray I found a way to metaphor things I had seen but could not photograph around me. It's a text because always there are presented patterns and shapes of pure light that then seem to be followed by once again pure light, but of more seeming substance. This is the first sense I had that light might actually precede substance. Here I had a literal example of the ideas found in Duns Scotus and Ezra Pound . . . that all that is, is light."

Richard Diebenkorn American, 1922–1993

Ocean Park 115. 1979

Oil on canvas, 8' 4" × 6' 9" (254 × 205.6 cm)
Mrs. Charles G. Stachelberg Fund

Diebenkorn's Ocean Park series, begun in 1967, makes general reference to the beachside land- and cityscape around the artist's studio in Santa Monica, California. The series is the work of an artist who, after painting representationally, synthesized the principal currents of the twentieth century's most rigorous abstract art, joined it to a painterly 1950s sensibility, and created a new style with the seriousness and the decorativeness of his exemplars and a gentle but firm sensuousness that is entirely his own. The work uses the components of Piet Mondrian's mature art, but escapes from the form of geometry that Mondrian had adapted from Cubism to learn more from the less confining structures, and the breathing surfaces, of Barnett Newman and Mark Rothko. Diebenkorn recomplicates the spareness of those artists' fields, reintroducing a searching, durational record of the work's creation.

The influence of another touchstone for Diebenkorn, Henri Matisse, is apparent in *Ocean Park 115*, as in the rest of the series, in the way the space is divided into flat planes and bands of color. Built up of successive layers of pigment, the painting's blues and greens shift in their density, invoking a translucent luminosity.

Jackie Winsor American, born Canada 1941

Burnt Piece. 1977–78

Cement, burnt wood, and wire mesh,
33⅞ × 34 × 34" (86.1 × 86.4 × 86.4 cm)
Gift of Agnes Gund

A member of the post-Minimalist generation, Winsor has inherited the Minimalists' preference for simple geometric shapes, but her works are handmade, and their surfaces are more various and tactile than Minimalism's impersonal, machine-honed planes. They also show slotlike openings that invite us to peer into their dark interiors: "You go up to the windowed cubes and touch them," says Winsor. "You peek, you use your eyes, your nose." In this way "the cubes parallel and are metaphors for the body."

For *Burnt Piece* Winsor built a cube out of wood and wire-reinforced concrete. Then she set this cube over a bonfire, burning away the wood and turning the concrete brown, black, and ash gray. This volatile process has created a dramatic narrative. Winsor burned the cube for about five hours, until, she says, it "began to expand and round slightly. As it cooled later, it contracted and the cube became slightly concave. During the firing, fragments of concrete popped off the main body to a distance of twenty feet. I had researched the material's properties because I wanted to push to its structural limit, to where the concrete was actively, dangerously, responding to the heat but was not overwhelmed or destroyed. . . . That is what physically happened to the form and material. That is its history."

Pino Pascali Italian, 1935–1968

Ponte (Bridge). 1968

Braided steel wool, 26' 3" × 39' ⅜" ×
35' ⁷⁄₁₆" (800 × 100 × 90 cm)
Scott Burton Fund and Committee on
Painting and Sculpture Funds in honor of
Kynaston McShine

This seemingly primitive structure is
fashioned from steel wool, a modern
material and humble household prod-
uct. Steel wool is made up of fine
metal threads similar to those used in
the steel-cord cables that support sus-
pension bridges. To make his *Bridge*,
Pino Pascali braided vast quantities
of steel wool into bundles and wrapped
them over a wire armature. *Bridge*
thus evokes feats of industrial engi-
neering and commercial manufacturing.
Its means are characteristic of Arte
Povera, the postwar Italian art move-
ment with which Pascali was associ-
ated and whose young exponents
substituted ordinary, inexpensive mate-
rials for the "noble" substances, such
as marble and bronze, that have long
been associated with monumental
sculpture.

Pascali once said, "Art means find-
ing a method for change: like the man
who first invented a bowl to hold
water." Unlike many American artists
of his generation who employed
mechanical techniques and electronic
tools, Pascali, who lived in Rome,
played with twentieth-century under-
standings of pre-industrial technolo-
gies. He was especially interested in
how popular culture romanticized the
primitive. An avid fan of Tarzan movies
and the *B.C.* comic strip, he substi-
tuted Hollywood and other founts of
popular culture for the ethnographic
museums that had inspired early mod-
ernists like Kandinsky and Picasso.

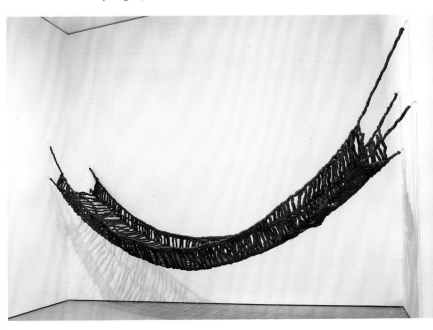

Joseph Beuys
German, 1921–1986

Eurasia Siberian Symphony 1963.
1966

Panel with chalk drawing, felt, fat, hare, and
painted poles
6' × 7' 6¾" × 20" (183 × 230 × 50 cm)
Gift of Frederic Clay Bartlett (by exchange)

Assuming multiple roles of artist, teacher, and modern-day shaman, Beuys developed a highly personal iconography for addressing problems haunting postwar Germany. The objects in *Eurasia Siberian Symphony 1963* were props from a 1966 performance he staged in Copenhagen and Berlin. They include an armature of intersecting poles, a taxidermied hare (for Beuys, a totemic animal), triangles of fat and felt, and a blackboard marked with chalk. Among the inscriptions, the word "Eurasia," naming the continental landmass as well as the borderless state that Beuys often invoked, appears prominently. The truncated cross above represents division between East and West. Two numbers below indicate the angles of the felt and fat triangles; a third corresponds to the temperature of a high human fever (42° C).

One key to deciphering the cryptic presentation is Beuys's oft-told narrative of being shot down in Crimea during World War II and saved by local Tatars, who wrapped his body in fat and felt, materials he subsequently associated with Eastern methods of holistic healing. Although expressed in mythical terms, the work's themes relate to Cold War politics of division. "1963" may refer to the high note of hope struck that year by John F. Kennedy's address to West Berliners. Beuys may be suggesting that healing lay in such face-to-face encounters, then impeded by walls both physical and ideological.

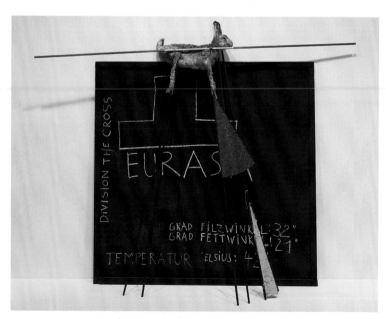

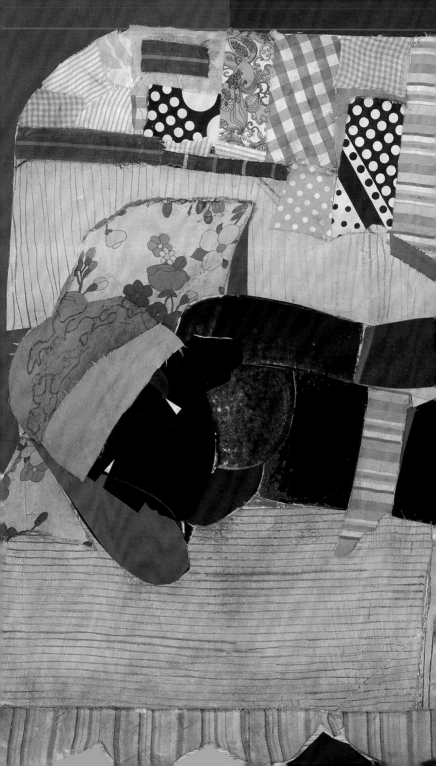

Romare Bearden
American, 1914–1988

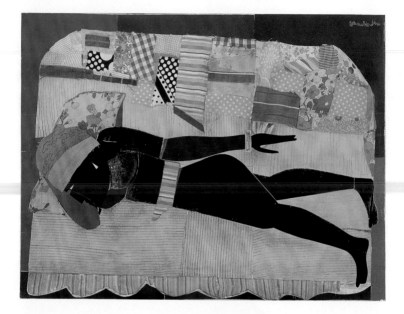

Patchwork Quilt. 1970

Cut-and-pasted cloth and paper with
synthetic polymer paint on composition board,
35¾ × 47⅞" (90.9 × 121.6 cm)
Blanchette Hooker Rockefeller Fund

"I try to show," Bearden once said,
"that when some things are taken out
of the usual context and put in the
new, they are given an entirely new
character." And a patchwork quilt, no
matter how rich its pattern, is always
made out of remnants cut from their
context—out of scraps of outworn cloth
now put to a new use and acquiring a
nobler quality. Whether faded or frayed,
their role in a new design refreshes
their meaning and beauty.

Bearden's *Patchwork Quilt*, made
up, in part, of exactly such fragments
of cloth, has a share in this kind of
ennoblement. A student of many cul-
tures, Bearden took Egyptian tomb
reliefs as his inspiration for the figure,

with its graceful lines, its distinctive
left arm and hand, its sideways posture,
and its legs parted as if in midstride.
Another influence was the centuries-
old sculpture of Benin. These bases in
high, specifically African aesthetics
claim a regal ancestry for Bearden's
lounging African American woman. In
fact, his work fuses the cosmopolitan
and democratic. It melds the distin-
guished heritage of painting and the
domestic practice of quilting (in which
there is a distinct African American tra-
dition), analytic art (in the echoes
of Cubism) and household decoration,
and everyday leisure and utter
elegance.

Stephen Shore American, born 1947

Breakfast, Trail's End Restaurant, Kanab, Utah. 1973

Chromogenic color print, 9 × 11⅛"
(22.9 × 28.3 cm)
Purchase

Juicy cantaloupe, a stack of pancakes topped with frothy butter, and a filled-to-the-brim glass of pure white milk are ready to be devoured by the traveler who has stopped for breakfast in a dusty western town. This photograph is part of Shore's series Uncommon Places, which was shot with an 8-by-10-inch view camera during the artist's road trips across the United States. Like photographers before him (Walker Evans, Robert Frank), Shore, a native New Yorker, set out to capture daily life across the country, though in his case, the camera was a device by which to frame unexpected—and often seem-ingly unremarkable—aspects of the scenery. His focus on small-town street corners, modest store fronts, and other run-of-the-mill sights of the 1970s implies the influence of Conceptual artists of this same period, who often utilized a vernacular style of photography to capture the mundane American landscape.

Unlike some of his predecessors, however, Shore presents his pictures in vibrant color and vivid detail. Snapping a 35mm picture "just like that," he has said, is quite different from setting up the shot with a large-format camera. At Trail's End Restaurant, he stood on a chair to find the view he wanted and later recalled, "the food was cold by the time I took the picture."

Jan Lenica Polish, 1928–2001

Polske Surrealister (Polish Surrealists). 1970

Offset lithograph, 38¼ × 26⅝"
(97.2 × 67.5 cm)
Gift of the designer

This poster for a German exhibition of Polish Surrealist art and design exemplifies the remarkable vitality and international popularity of Polish poster design during the Cold War. Its designer, Jan Lenica, studied architecture and music before turning to graphics. Starting in 1954, he worked in the poster studio at the Warsaw Academy of Fine Arts, where a group of designers in the circle of Henryk Tomaszewski was developing a sophisticated new visual language characterized by surreal and expressionist tendencies, macabre and often satirical humor, and bold use of color. Their posters had little to do with commercial advertising;

in general they were made to commemorate or publicize cultural events—opera, theatre, films, and exhibitions. The Communist state monopolized the commissioning, production, and distribution of such work and exercised censorship, but it also recognized the "soft" propaganda value of poster art in the context of Cold War politics.

From 1963 on, Lenica was based mainly in Paris and Berlin, although he continued to accept commissions from Polish state agencies. This poster's image of pulsating pink brains in a bowler hat is a witty adaptation of imagery by the Belgian artist René Magritte. It indicates the pervasive Polish fascination with Surrealism as well as the characteristic Central European interest in the concealed interior life of the individual.

George Maciunas American, born Lithuania, 1931–1978

One Year. 1973–74

Empty containers and packaging, dimensions vary
Publisher: Fluxus Editions, announced 1973
The Gilbert and Lila Silverman Fluxus Collection Gift

One Year consists of the empty containers of food and household products that George Maciunas consumed over the course of one year. Tiled together, packages that once contained concentrated frozen orange juice, powdered milk, frozen strawberries, toothpaste, antacid medication, and adhesive bandages, among other items, extend over twenty feet in length. Overall, there is very little diversity among the types of items eaten and used, with large quantities of a single product repeated across the panels. The accumulation offers a glimpse into the American consumer landscape of the early 1970s and highlights the artist's monotonous daily regimen.

Maciunas created this work while living in downtown Manhattan, in the then-gritty, postindustrial area now known as SoHo. He helped regenerate the neighborhood for the burgeoning art community, purchasing cheap buildings from defunct manufacturing companies and converting them into "Fluxhouse cooperatives," which he envisioned as collective living and working environments. Fluxus, a network of artists that emerged in the early 1960s in the United States, Europe, and Japan, encouraged activities facilitating the interpenetration of life and art. As demonstrated by projects such as *One Year*, they recognized the creative potential in cooking, eating, grooming, and cleaning, among many other everyday tasks. Maciunas, like many of his fellow Fluxus artists, employed humor and provocation in his work to question accepted modes of artistic expression and presentation.

Daniel Buren French, born 1938

Tissu en coton rayé de bandes verticales blanches et colorées de 8,7cm (+/- 0,3 cm) chacune. Les deux bandes extrêmes blanches recouvertes de peinture acrylique blanche recto-verso.
(Striped cotton fabric with vertical white and colored bands of 8,7cm (+/- 0,3 cm) each. The two external white bands covered over with acrylic white paint recto-verso). 1970

Synthetic polymer paint on striped cotton fabric, 12 works, overall dimensions variable. Each of the 12 paintings is an autonomous work that can be shown separately.
Gift of Herman J. Daled

Buren's work can be recognized instantly by his trademark visual device: alternating colored and white stripes, each exactly 8.7 centimeters wide (about 3.5 inches), the standard size of stripes on commercial awning fabric used in France. The artist began using store-bought fabric or paper printed with this pattern in the late 1960s. He exhibited the works in urban locations—on exterior and interior walls, in store windows, and in subway stations—emphasizing his concept of *in situ*, the dependence of an artwork on its ideological and spatial context.

This suite of twelve canvases was purchased by the collectors Herman and Nicole Daled on a monthly basis throughout the year it was produced. Each canvas can also be shown as an independent work. As the title indicates, the two white stripes at the vertical edges are covered in white paint on the front and the back of the piece. The paint is nearly imperceptible. Still, it subtly transforms the readymade stripes it overlies, recording a trace of the artist's hand and highlighting the ambiguity in Buren's work between art and the everyday.

Lawrence Weiner American, born 1942

Moved from Up Front. 1970

Language + the materials referred to
Wall text (vinyl or paint on wall) with
certificate, sketch, and envelope,
dimensions variable
Art & Project/Depot VBVR Gift

A sculpture made of language, this work is realized anew each time it is installed. It consists of the statement that constitutes its title, which can be presented in any number of ways but is most often realized as text on a gallery wall. *Moved from Up Front* belongs to a group of works Weiner calls Statements. Devoid of emotional expression, these short texts often evoke sculptural procedures or materials and seem to refer to actions of the artist in the studio. They emerged from the artist's rejection of the privilege attached to traditional mediums like painting and sculpture and from his desire to overcome the exclusivity attached to the ownership of art objects.

A leading figure in Conceptual Art, Weiner values the accessibility and transmissibility of language. As a material, language offers him a way to circumvent the elitism of "high art" and, by emphasizing the role of the viewer or reader, to reverse the longstanding hierarchy that places the artist's intentions over other interpretations. He uses varied and flexible methods of distribution, including books and posters, to reach new audiences and present his work in contexts other than museums and galleries.

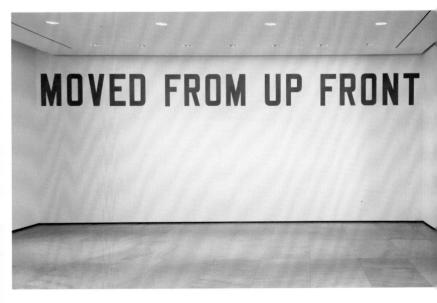

Vito Acconci American, born 1940

Following Piece. 1969

Gelatin silver prints, felt-tipped pen, and map on board, 29¹⁵⁄₁₆ × 40³⁄₁₆" (76 × 102 cm) Partial gift of the Daled Collection and partial purchase through the generosity of Maja Oeri and Hans Bodenmann, Sue and Edgar Wachenheim III, Marlene Hess and James D. Zirin, Agnes Gund, Marie-Josée and Henry R. Kravis, and Jerry I. Speyer and Katherine G. Farley

In *Following Piece*, Acconci gave himself a single instruction: "Follow different person every day until person enters private place." The commitment this piece demanded during its twenty-three-day run is not immediately apparent in the work's current form: a seemingly slapdash composition consisting of photographs of peoples' backs, a hand-altered map of New York City, and scrawled notes and itineraries. Similarly, the simplicity of Acconci's directive masks the dense knot of social, political, and geographic issues that the performance addresses.

The work ultimately throws into doubt its initial premise—that clear boundaries exist between private and public space. Indeed, blurring these categories, along with issues of surveillance, submission, and control, is central to the piece. On the one hand, Acconci wielded power. He alone made the decision of whom to follow, and only he was aware of his rules and operations. On the other hand, he relinquished control by allowing his movement, speed, direction, safety, and the duration of the performance to be determined unwittingly by the people he followed, creating a relationship of reliance and near-intimacy (albeit of a one-sided and limited type).

That Acconci's behavior seems so unusual underscores an unspoken rule of conduct in public space: namely, one goes about one's business and does not follow others. By breaking the rule, Acconci shows that even public space is governed by profoundly private and regimented parameters.

Martha Rosler American, born 1943

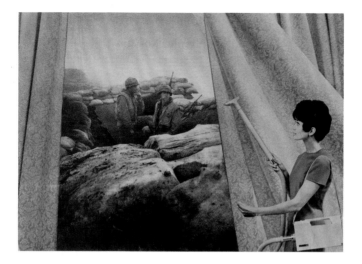

Cleaning the Drapes from the series **House Beautiful: Bringing the War Home.** c. 1967–72

Cut-and-pasted printed paper on board, 10¼ x 14" (26 x 35.6 cm)
Richard S. Zeisler Bequest (by exchange) and The Modern Women's Fund Committee of The Museum of Modern Art

Rosler's House Beautiful: Bringing the War Home is a series that strongly critiques America's role in the Vietnam War. In making these photomontages— a collage technique of cutting and pasting photographs, famously associated with Dada artists of the early twentieth century—Rosler inserted graphic journalistic images of war casualties from Life magazine into decorating spreads and advertisements from such publications as House Beautiful, creating an unsettling collision between violence abroad and consumer comfort at home.

In Cleaning the Drapes, a fashionable housewife parts the living room curtains, revealing several soldiers awaiting action. Rosler's careful arrangement of images coaxes the figures into an intimate relationship. Next to the soldiers' rifles, the woman's vacuum cleaner also seems like a weapon. Her expectant look meets the glance of the soldier on the far right, hinting at additional conflicts of class and gender that lurk within the perfect home.

For Rosler, the conventions of the popular media not only insinuated a problematic image of femininity but also created a false sense of distance between the American public and the brutal conflict in Vietnam. Through these photomontages she insisted that "the separation of the here and the elsewhere . . . was not simply illusory but dangerous." The works were made to be reproduced, to be handed out as flyers at antiwar rallies and published in alternative newspapers. In photographing the collages for reproduction, Rosler pushed the images farther toward the plausibility of commercial advertising, while refusing to completely erase the traces of their production.

Gordon Matta-Clark American, 1943–1978

Bingo. 1974

Building fragments: painted wood, metal, plaster, and glass, three sections
Overall 69" × 25' 7" × 10"
Nina and Gordon Bunshaft Bequest Fund, Nelson A. Rockefeller Bequest Fund, and the Enid A. Haupt Fund

The city planning commission of Niagara Falls allotted Matta-Clark ten days to carve up a condemned house at 349 Erie Avenue before it was demolished. He divided the façade into a grid and then removed each rectangle individually. The result was eight separate sections (MoMA's *Bingo* is comprised of three of them) and a Super-8 film documenting the deconstruction of the building. In Matta-Clark's process of removal and its attendant aesthetics of subtraction and destruction, those things which are conventionally associated with a house—domesticity, comfort, privacy—are replaced by a disorienting physical experience in which the house becomes strange, a simple container for space now opened and incomplete.

Matta-Clark trained as an architect before developing the practice of "anarchitecture," his term for the attacks he staged on the structural foundations of the built environment. As the prefabricated houses of postwar suburban America began to decay in the 1970s, he sought to unearth the ideological assumptions attached to structures like the single-family dwelling demolished for *Bingo*. "Social mobility is the greatest spatial factor How one maneuvers in the system determines what kind of space [one] works and lives in," Matta-Clark said, emphasizing the sociological critique that underpinned his work.

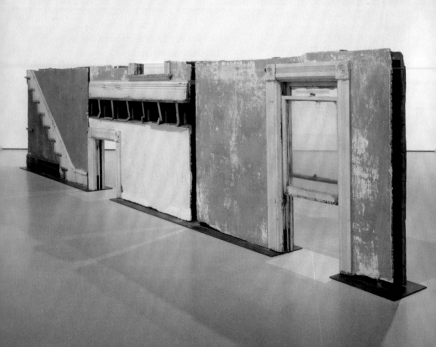

Ousmane Sembene Senegalese, 1923–2007

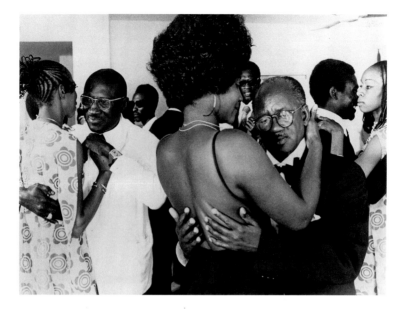

Xala. 1975

35mm film, color, sound, 123 min.
Gift of Dan Talbot

Before he became a filmmaker, Ousmane Sembene was a writer. He wrote books in French, the language of the colonizers and of the educated in West Africa, but most of the people of Senegal did not read French. The author became a filmmaker in order to "speak to" a public at home. He did this most successfully, and in the process his Senegalese-based films engaged audiences globally.

Xala, Sembene's film about a modern, corrupt, and prosperous businessman stymied by what he believes to be a curse, is in both French and Wolof, one of Senegal's principal languages. The word "xala" means "curse" in Wolof, and the curse visited upon the protagonist, a respected member of the Chamber of Commerce in Dakar, is one of sexual impotency. This is an embarrassment, as he has just taken a young woman as his third wife, much to the displeasure of his other two. Thinking he is the victim of domestic witchcraft, he tries ancient remedies. The contradictions between the old and the new, between acceptable and questionable behavior, extravagant consumption and true need are the juicy and enjoyable tensions of this dark social satire, which portrays Senegal's new ruling class as comical and potentially ruinous.

Carolee Schneemann American, born 1939

Up to and Including Her Limits.
1973–1976

Crayon on paper, rope, harness, and two-channel analog video, with audio, transferred to digital video. Drawing made in performance at the Kitchen, New York, in 1976
Purchase

Carolee Schneemann is most often associated with her performance art of the 1960s and 1970s, bold actions addressing feminist and political themes that shocked and engaged viewers. Yet Schneemann has always considered herself a painter, a fact often overlooked in discussions of her larger body of work, which extends to all mediums. Her explorations of the boundaries of painting and drawing are often at the heart of her practice and relate to the work of her contemporaries in New York's 1960s art scene.

Schneemann performed *Up to and Including Her Limits* nine times between 1971 and 1976, always intending to make the piece into an installation. In a comment on what she has described as the "physicalized painting process" of Jackson Pollock, she marked the walls and floor of a paper-covered corner with crayons as she raised and lowered herself in a tree surgeon's harness, hovering just above the surface of the drawing; ultimately, the work records the lines her body made in space. The performances were videotaped, and that footage, along with the harness, rope, and drawings, constitute the installation which now finds its home in the Museum's collection.

Hannah Wilke American, 1940–1993

S.O.S.—Starification Object Series. 1974–82

Gelatin silver prints with chewing gum sculptures, 40 × 58½ × 2¼"
(101.6 × 148.6 × 5.7 cm)
Purchase

Hannah Wilke first performed *S.O.S.—Starification Object Series* for the public in 1975. Visitors were given colored gum, which they were asked to chew and then return to a topless Wilke, who stretched and folded the pliable wads into small, labia-shaped sculptures that she stuck on her body. These hand-wrought anatomical forms were read as both sensual fetishes and unsightly scars emblematic of the power, and also the stigma, of the female sex.

Interested in how these transitory actions could outlive the moment, Wilke posed for photographs for the S.O.S. series, making what she called "performalist self-portraits." She hired a professional photographer to take editorial-style portraits of her while she expertly performed rote poses from fashion and advertising: hand on a thrust-out hip, mouth suggestively agape, fingers buried in voluminous hair. These facile displays of her sexuality are clearly farcical, but the success of the work hangs on the simple truth of her good looks. Here Wilke challenges the viewer-voyeur to resolve the tension between revulsion at the sight of the gnashed forms scarring her body and pleasure at being given such access to her beauty. As the title of the project suggests, Wilke explores the relationships between prescribed constructs of beauty and femininity, states of seduction and distress, and the entangled roles of victim and aggressor.

Richard Sapper German, born 1932

Tizio Table Lamp. 1971

ABS plastic and aluminum, max. 44½ × 42½"
(113 × 108 cm)
Manufacturer: Artemide S.p.A., Italy
Gift of the manufacturer

Sapper claimed that he designed the Tizio lamp because he could not find a work lamp that suited him: "I wanted a small head and long arms; I didn't want to have to clamp the lamp to the desk because it's awkward. And I wanted to be able to move it easily." The designer's dream lamp, the Tizio is an adjustable table fixture that can be moved in four directions. It swivels smoothly and can be set in any position, its balance ensured by a system of counterweights. The halogen bulb, adjustable to two different light intensities, is fed through the arm from a transformer concealed in the base. In 1972, when the Tizio lamp was first produced, the use of the arms to conduct electricity was an innovation seen in few other lamp designs.

From a formal point of view, the Tizio lamp was revolutionary. Black, angled, minimalist, and mysterious, the lamp achieved its real commercial success in the early 1980s, when its sleek look met the Wall Street boom. Found in the residences of the young and successful and in the offices of executives, the lamp has become an icon of high-tech design.

Milton Glaser American, born 1929

I♥NY. 1976

Ink and collage on board, 6½ × 16½"
(16.5 × 41.9 cm)
Gift of William S. Doyle

In February 1975, the City of New York was in dire straits. With a billion dollar deficit and bankruptcy looming, 300,000 workers freshly laid off, crime on the rise, and, to top everything off, a week-long garbage collection strike, the city was in desperate need of an injection of hope. With this in mind, the New York State Department of Commerce and Deputy Commissioner Bill Doyle commissioned the advertising agency Wells Rich Greene to develop a campaign to boost the city's image. Many people contributed to shaping it, from Governor Hugh Carey, who first pointed out that, despite everything, people still loved New York, to the Wells Rich Greene associates who created a Broadway-centered pitch, with its infectious musical refrain by Steve Karmen. Milton Glaser, a designer of star quality, was asked to capture the campaign graphically, which he famously did with a quick, instinctive sketch.

I♥NY is a rudimentary rebus with letters set in American Typewriter, a rounded slab serif typeface. Glaser compares it to a declaration of love carved into a tree trunk. Designed pro bono, the wildly successful design has been copied and reinterpreted millions of times all over the world. It has become a lasting icon for New York City and one of the most frequently imitated logos in history, a template for declarations of love for multitudes of people, places, and things. The design was copyrighted after about ten years of open use.

I♥NY used with permission of the NYS Dept. of Economic Development.

Rem Koolhaas Dutch, born 1944
Elia Zenghelis British, born Greece 1937

The Voluntary Prisoners from **Exodus, or the Voluntary Prisoners of Architecture.** 1972

Collage, watercolor, and ink on paper,
19¾ × 25⅞" (50 × 65.7 cm)
Associates: Madelon Vriesendorp (Dutch, born 1945), Zoe Zenghelis (Greek, born 1937)
Gift of Patricia Phelps de Cisneros, Takeo Ohbayashi Purchase Fund, and Susan de Menil Purchase Fund

Koolhaas completed a series of eighteen drawings, watercolors, and collages in his last year of study at the Architectural Association in London, a virtual incubator for radical architectural theory in the 1970s. Presented at his final thesis review, *Exodus* was a collaborative effort that was also submitted jointly to an Italian urban design competition and, ultimately, served as a catalyst for the formation of the Office for Metropolitan Architecture, in 1975.

The immediate inspiration for this series, to which *The Voluntary Prisoners* belongs, was the Berlin Wall. Images of the Wall are juxtaposed with those of the American suburbs and of Manhattan; and superimposed over a collage of rock-and-roll, Cold War, and pornographic imagery is text from Charles Baudelaire's *Les Fleurs du mal*. Multiple symbolic references to historical and contemporary architectural movements intensify the portrayal of urban "delirium" and reflect contemporaneous urban theory, pop culture, and post-1968 politics.

In a text referring to *The Voluntary Prisoners,* the architects explained: "Suddenly, a strip of intense metropolitan desirability runs through the center of London. . . . From the outside this architecture is a sequence of serene monuments; the life inside produces a continuous state of ornamental frenzy and decorative delirium, an overdose of symbols."

Cindy Sherman American, born 1954

Untitled Film Still #21. 1978

Gelatin silver print, 7½ × 9½" (19.1 × 24.1 cm)
Horace W. Goldsmith Fund through Robert B. Menschel

Each of Sherman's sixty-nine Untitled Film Stills (1977–80) presents a female heroine from a movie we feel we must have seen. Here, she is the pert young career girl in a trim new suit on her first day in the big city. Among the others are the luscious librarian (#13), the chic starlet at her seaside hideaway (#7), the ingenue setting out on life's journey (#48), and the tough but vulnerable film noir idol (#54). To make the pictures, Sherman herself played all of the roles or, more precisely, played all of the actresses playing all of the roles. In other words, the series is a fiction about a fiction, a deft encapsulation of the image of feminity that, through the movies, took hold of the collective imagination in postwar America—the period of Sherman's youth, and the crucible of our contemporary culture.

In fact, only a handful of the Untitled Film Stills are modeled directly on particular roles in actual movies, let alone on individual stills of the sort that the studios distribute to publicize their films. All the others are inventive allusions to generic types, and so our sure sense of recognition is all the more telling. It tells us that, knowingly or not, we have absorbed the movie culture that Sherman invites us to examine as a powerful force in our lives.

Jacques de la Villeglé
French, born 1926

122 rue du temple. 1968

Torn-and-pasted printed paper on canvas,
62⅝ × 82¾" (159.2 × 210.3 cm)
Gift of Joachim Aberbach (by exchange)

The title of this work derives from the street in Paris from which these torn posters were taken. The layers of fragmentary color, words, and images of faces were pasted onto linen in a technique called *décollage* (literally, uncollage). By means of this technique, posters or other promotional materials are torn up to create new compositions, with one image often superimposed over another. Villeglé stated that *122 rue du temple,* a combination of movie posters and political advertisements for a legislative election instigated by the events of May 1968 in Paris, is a reflection of reality. Thus, not only is he interested in the visual impact and pictorial construction of his works, but he also confers upon them a sociological status.

Villeglé has devoted his entire career to *décollage*. He was affiliated with Nouveau Réalisme, a French art movement of the late 1950s and early 1960s devoted to transforming everyday objects and detritus into art in the belief that painting was incapable of conveying the actuality of postwar society. Villeglé sees the street as a repository of readymade art. He invented the persona of the anonymous passerby, or common man, whose random tears are "discovered" by the artist and thereby poeticized. Through this incorporation of chance and choice, Villeglé assumes the role of a conservator of works of art unconsciously created by others. ·

Jenny Holzer American, born 1950

Truisms. 1978–87

Photostat, 8' × 40" (243.8 × 101.6 cm)
Publisher: the artist. Edition: unlimited
Gift of the artist

Holzer's Truisms have become part of the public domain, displayed in storefronts, on outdoor walls and billboards, and in digital displays in museums, galleries, and other public places, such as Times Square in New York. Multitudes of people have seen them, read them, laughed at them, and been provoked by them. That is precisely the artist's goal.

The Photostat, *Truisms*, seen here presents eighty-six of Holzer's ongoing series of maxims. Variously insightful, aggressive, or comic, they express multiple viewpoints that the artist hopes will arouse a wide range of responses. A small selection includes: "A lot of professionals are crackpots"; "Abuse of power comes as no surprise"; "Bad intentions can yield good results"; and "Categorizing fear is calming."

Holzer began creating these works in 1977, when she was a student in an independent study program. She hand-typed numerous "one liners," or Truisms, which she has likened, partly in jest, to a "Jenny Holzer's *Reader's Digest* version of Western and Eastern thought." She typeset the sentences in alphabetical order and printed them inexpensively, using commercial printing processes. She then distributed the sheets at random and pasted them up as posters around the city. Her Truisms eventually adorned a variety of supports, including tee-shirts and baseball caps.

A LITTLE KNOWLEDGE CAN GO A LONG WAY
A LOT OF PROFESSIONALS ARE CRACKPOTS
A MAN CAN'T KNOW WHAT IT'S LIKE TO BE A MOTHER
A NAME MEANS A LOT JUST BY ITSELF
A POSITIVE ATTITUDE MAKES ALL THE DIFFERENCE IN THE WORLD
A RELAXED MAN IS NOT NECESSARILY A BETTER MAN
A SENSE OF TIMING IS THE MARK OF GENIUS
A SINCERE EFFORT IS ALL YOU CAN ASK
A SINGLE EVENT CAN HAVE INFINITELY MANY INTERPRETATIONS
A SOLID HOME BASE BUILDS A SENSE OF SELF
A STRONG SENSE OF DUTY IMPRISONS YOU
ABSOLUTE SUBMISSION CAN BE A FORM OF FREEDOM
ABSTRACTION IS A TYPE OF DECADENCE
ABUSE OF POWER SHOULD COME AS NO SURPRISE
ACTION CAUSES MORE TROUBLE THAN THOUGHT
ALIENATION PRODUCES ECCENTRICS OR REVOLUTIONARIES
ALL THINGS ARE DELICATELY INTERCONNECTED
AMBITION IS JUST AS DANGEROUS AS COMPLACENCY
AMBIVALENCE CAN RUIN YOUR LIFE
AN ELITE IS INEVITABLE
ANGER OR HATE CAN BE A USEFUL MOTIVATING FORCE
ANIMALISM IS PERFECTLY HEALTHY
ANY SURPLUS IS IMMORAL
ANYTHING IS A LEGITIMATE AREA OF INVESTIGATION
ARTIFICIAL DESIRES ARE DESPOILING THE EARTH
AT TIMES INACTIVITY IS PREFERABLE TO MINDLESS FUNCTIONING
AT TIMES YOUR UNCONSCIOUS IS TRUER THAN YOUR CONSCIOUS MIND
AUTOMATION IS DEADLY
AWFUL PUNISHMENT AWAITS REALLY BAD PEOPLE
BAD INTENTIONS CAN YIELD GOOD RESULTS
BEING ALONE WITH YOURSELF IS INCREASINGLY UNPOPULAR
BEING HAPPY IS MORE IMPORTANT THAN ANYTHING ELSE
BEING HONEST IS NOT ALWAYS THE KINDEST WAY
BEING JUDGMENTAL IS A SIGN OF LIFE
BEING SURE OF YOURSELF MEANS YOU'RE A FOOL
BELIEVING IN REBIRTH IS THE SAME AS ADMITTING DEFEAT
BOREDOM MAKES YOU DO CRAZY THINGS
CALM IS MORE CONDUCIVE TO CREATIVITY THAN IS ANXIETY
CATEGORIZING FEAR IS CALMING
CHANGE IS VALUABLE BECAUSE IT LETS THE OPPRESSED BE TYRANTS
CHASING THE NEW IS DANGEROUS TO SOCIETY
CHILDREN ARE THE CRUELEST OF ALL
CHILDREN ARE THE HOPE OF THE FUTURE
CLASS ACTION IS A NICE IDEA WITH NO SUBSTANCE
CLASS STRUCTURE IS AS ARTIFICIAL AS PLASTIC
CONFUSING YOURSELF IS A WAY TO STAY HONEST
CRIME AGAINST PROPERTY IS RELATIVELY UNIMPORTANT
DECADENCE CAN BE AN END IN ITSELF
DECENCY IS A RELATIVE THING
DEPENDENCE CAN BE A MEAL TICKET
DESCRIPTION IS MORE VALUABLE THAN METAPHOR
DEVIANTS ARE SACRIFICED TO INCREASE GROUP SOLIDARITY
DISGUST IS THE APPROPRIATE RESPONSE TO MOST SITUATIONS
DISORGANIZATION IS A KIND OF ANESTHESIA
DON'T PLACE TOO MUCH TRUST IN EXPERTS
DON'T RUN PEOPLE'S LIVES FOR THEM
DRAMA OFTEN OBSCURES THE REAL ISSUES
DREAMING WHILE AWAKE IS A FRIGHTENING CONTRADICTION
DYING AND COMING BACK GIVES YOU CONSIDERABLE PERSPECTIVE
DYING SHOULD BE AS EASY AS FALLING OFF A LOG
EATING TOO MUCH IS CRIMINAL
ELABORATION IS A FORM OF POLLUTION
EMOTIONAL RESPONSES ARE AS VALUABLE AS INTELLECTUAL RESPONSES
ENJOY YOURSELF BECAUSE YOU CAN'T CHANGE ANYTHING ANYWAY
EVEN YOUR FAMILY CAN BETRAY YOU
EVERY ACHIEVEMENT REQUIRES A SACRIFICE
EVERYONE'S WORK IS EQUALLY IMPORTANT
EVERYTHING THAT'S INTERESTING IS NEW
EXCEPTIONAL PEOPLE DESERVE SPECIAL CONCESSIONS
EXPIRING FOR LOVE IS BEAUTIFUL BUT STUPID
EXPRESSING ANGER IS NECESSARY
EXTREME BEHAVIOR HAS ITS BASIS IN PATHOLOGICAL PSYCHOLOGY
EXTREME SELF-CONSCIOUSNESS LEADS TO PERVERSION
FAITHFULNESS IS A SOCIAL NOT A BIOLOGICAL LAW
FAKE OR REAL INDIFFERENCE IS A POWERFUL PERSONAL WEAPON
FATHERS OFTEN USE TOO MUCH FORCE
FEAR IS THE GREATEST INCAPACITATOR
FREEDOM IS A LUXURY NOT A NECESSITY
GIVING FREE REIN TO YOUR EMOTIONS IS AN HONEST WAY TO LIVE
GOING WITH THE FLOW IS SOOTHING BUT RISKY
GOOD DEEDS EVENTUALLY ARE REWARDED
GOVERNMENT IS A BURDEN ON THE PEOPLE
GRASS ROOTS AGITATION IS THE ONLY HOPE
GUILT AND SELF-LACERATION ARE INDULGENCES
HABITUAL CONTEMPT DOESN'T REFLECT A FINER SENSIBILITY
HIDING YOUR MOTIVES IS DESPICABLE

Robert Adams American, born 1937

Pikes Peak Park, Colorado Springs. 1970

Gelatin silver print, 5⅞ × 6" (14.8 × 15.2 cm)
David H. McAlpin Fund

Vacationers often turn their cameras away from the crowded highway toward a pristine mountain range, taking care to exclude power lines and other tourists from the beautiful view. They are performing a ritual of homage to the ideal of the American West, and to its grand tradition in photography. In the late 1960s, Adams, an inhabitant of the West, pioneered an alternative landscape tradition, which included man and his creations in the picture. "We have built these things and live among them," his photographs seem to say, "and we need to take a good, hard look at them."

Photography had never before been so plain and brittle, so lacking in embellishment and seduction. Yet the very aridness of Adams's early style introduced to the medium a new kind of beauty, rooted in the frankness of his acknowledgment that what we see in his photographs are our own creations, our own places.

Francis Ford Coppola American, born 1939

The Conversation. 1974

35mm film, color, sound, 113 minutes
Gift of the artist
Gene Hackman

Hidden within the confines of an electronically outfitted van, Harry Caul (Gene Hackman) is capable of wiretapping even the most remote whisper of a conversation. While he is often at the epicenter of moral corruption, Caul remains fastidious with respect to his own conduct and usually takes no interest in the content of what he overhears transpire between lovers and thieves. But, when he believes he hears plans for a murder, he desperately tries to prevent the event. Yet, his talent lies in his technical abilities, not in his skill in interpreting nuances.

Coppola's most claustrophobic and meticulous film, *The Conversation* was released at the height of the Watergate investigation. It is a slow yet harrowing film conveying the repulsiveness of surveillance, the loss of personal liberty, and our inability to reverse the catastrophic end results of technology once it has been set into motion. Keenly aware of the fact that invasion is possible by even the most amateur eavesdropper, Caul is enormously protective of his private life. His San Francisco apartment, although nearly empty, is secured with multiple door locks and a burglar alarm, and he wears a plastic raincoat as a metaphoric protectant against the unwelcome intrusion of society.

VALIE EXPORT Austrian, born 1940

Zeit und Gegenzeit (Time and Countertime). 1973/2011

Video, black and white, silent, 36-hr. loop,
CRT monitor, aluminum-and-glass table, glass
bowl, water
Purchase

For this deceptively simple video sculpture, EXPORT juxtaposed a bowl of melting ice with a TV monitor displaying a video recording of the same bowl of ice. While the ice in the real bowl slowly melts, the video, shot in real time over a period of thirty-six hours, is played backwards and shows the water solidifying into ice cubes. Realized by EXPORT in the early 1970s, when consumer video technology had only recently become available, *Zeit und Gegenzeit* concisely addresses topics intrinsic to the medium, such as the representation of time and movement and the manipulation of reality through editing, which in this piece is conspicuously absent.

In 1967, in what is considered to be her first performance action, the artist shed her married name, Waltraud Höllinger, and took on her new permanent identity, VALIE EXPORT. She attained the status of feminist icon through her photographic works and radical public actions made in response to the restrictive social environment and male-dominated art scene that prevailed in post-war Austria.

Yvonne Rainer American, born 1934

Trio A (The Mind is a Muscle, Part 1). 1978

16mm film transferred to digital file, black and white, silent, 10 min. 30 sec., camera work by Robert Alexander
Purchase

Trio A is a highly influential solo dance that was choreographed and initially performed as a trio by Yvonne Rainer, David Gordon, and Steve Paxton in 1966 under the title The Mind is a Muscle, Part 1. During the premiere at New York City's Judson Church, the work was repeated twice to the sound of wooden slats thrown from the balcony, one at a time. Since then it has been presented in various forms—sometimes integrated into other Rainer pieces or adapted and interpreted by other choreographers. To create the film of Trio A, Rainer performed it as a solo in 1978, several years after she had stopped dancing to become a film-maker. In 2000, a commission from the Baryshnikov Dance Foundation marked her return to choreography.

The gestures introduced in Trio A were swiftly assimilated into post-modern dance vocabulary. The work is based on a single four-and-one-half to five-minute phrase of continuous, low to the ground movements that, with the exception of walking, are never repeated. Although it appears effortless, the dance is exacting in its precise angling of hands, arms and shoulders, feet, and legs. It is a signature work by Rainer, who in the 1960s transposed to dance ideas that were giving shape to Minimalist sculpture and painting. In a radical break with tradition, Trio A abandoned classical and modern dance aesthetics rooted in virtuosic technique and expression in favor of an unenhanced physicality and uninflected continuity of motion.

Michael Snow
Canadian, born 1929

Sink. 1970

Color photograph, and eighty 35 mm color slides projected in a 20 min. loop, installation 48 × 25" (121.9 × 63.5 cm)
Committee on Media and Performance Art Funds

Celebrated internationally as a leading interdisciplinary artist, Michael Snow is recognized for the groundbreaking films, videos, photographs, and sound installations he has made throughout a productive career. It all began in the 1950s when Snow turned from painting to time-based media. He came into his

own while living on Canal Street in Lower Manhattan between 1962 and 1972, when that area was a cauldron of new ideas. It was during that time that Snow made *Sink*, based on the image of his paint-spattered slop sink. In this installation, eighty looped 35mm slides are arranged in a filmic sequence and projected at fifteen-second intervals. Flanking the projected images and equal to them in size is a printed photograph of the same sink.

The installation directs viewers' attention to the artist's interest in how any physical subject is "reduced" to light when captured on film. During production, two standing lamps were set up on each side of the sink, and for each of the eighty slide images, different-colored gels were held in front of the lamps. The light they cast was used to mix the colors, which became the projected light seen in the final work. The material of *Sink* was, and is, light.

Nam June Paik
American, born Korea, 1932–2006

Zen for TV. 1963/1975

Altered television set
22¹³⁄₁₆ × 16¹⁵⁄₁₆ × 14³⁄₁₆" (58 × 43 × 36 cm)
The Gilbert and Lila Silverman Fluxus
Collection Gift

A pioneer in the field of media art, Nam June Paik is considered to have been among the first artists to experiment with video and television as art mediums. *Zen for TV*, one of his earliest works, consists of a rewired television set in which the picture has been reduced to a single line by disconnecting the tube's deflection unit. Manipulating the unit even further, Paik turned the set on its side, treating this familiar household object in a very unconventional manner.

Paik first exhibited *Zen for TV* at his groundbreaking 1963 exhibition *Exposition of Music, Electronic Televi-*sion in Wuppertal, Germany. In one of the show's many rooms, he installed approximately twelve televisions, each altered internally or connected to additional electrical equipment to distort the images they displayed. Some of the pieces were interactive, including sets attached to tape recorders and radios. When adjusted, these created new, unpredictable shapes on the screens. Paik encouraged and delighted in these chance effects. His appreciation for them developed in part through his encounters with John Cage. Like Cage, he aligned ideas of indeterminacy and variability with those of Zen and Eastern philosophy. On one occasion, Paik claimed that his inspiration for *Zen for TV* came from a television that was damaged during transport, and that the title refers to this felicitous accident.

Richard Serra
American, born 1939

Untitled (14-part roller drawing).
1973

Ink on paper, each part 33 × 49"
(83.8 × 124.5 cm)
Fractional and promised gift of Sally and
Wynn Kramarsky

Best known for his monumental sculptures, Richard Serra has sustained a drawing practice that foregrounds the importance of process to his work. In *Untitled (14-part roller drawing)*, he used a roller and lithographic ink to apply a predetermined number of marks to a series of sheets. The first example has fourteen roller marks on the left side of the paper, and none on the right; the second has thirteen marks on the left and one on the right; and so on, until the right side of the last sheet is black with fourteen strokes, and the left side is blank.

Employing the language of Minimalism, Serra has described the work as "a very serial proposition . . . I could care less about what it looks like. I'm just staying faithful to the process." Despite this conceptual scheme, the result is powerfully expressive. The overall progression even offers a kind of visual narrative, as if tracking the transition from night's darkness to day's light.

"Drawing is a verb," Serra once claimed, and the *14-part roller drawing* embodies several of the actions the artist famously outlined in his *Verb List* (1967–68; also in MoMA's collection). "To roll" is at the very top of the list; "to mark," "to modulate," and "to systematize" all describe aspects of the method Serra used in making this work.

Vija Celmins American, born Latvia, 1938

Moon Surface (Surveyor I).
1971–72

Graphite on synthetic polymer ground on
paper, 14 × 18½" (35.6 × 47 cm)
Gift of Edward R. Broida

Vija Celmins's exploration of unfathomably deep space, shimmering light, and craggy or rippling surfaces has led her to depict oceans, celestial bodies, constellations, and the galaxy. Using a photograph as a starting point, Celmins creates her dense, meticulous, and labor-intensive graphite drawings employing a palette of grays, white, and black. In *Moon Surface (Surveyor I)*, she depicts a section of the lunar ground seen in a photograph taken in 1966 by Surveyor I, a space vehicle that NASA sent to the moon in preparation for the 1969 Apollo flights. Mesmerized by the series of photographs from seven successive Surveyor missions between 1966 and 1968, Celmins selected this particular image, cropping it to focus on the moon's cratered

surface, with the spacecraft appearing on the lower left-hand corner. A selection of the Surveyor photographs was originally printed in *Scientific American* in November 1967 to illustrate "The Feel of the Moon," an article by Ronald F. Scott. Scott examined the images from a technical perspective to highlight the scientific accomplishment of humankind. Celmins's drawings, much like the photographs on which they are based, provide detailed visual information about the physical universe and also invite reflection on humankind's place and role in it.

Brice Marden American, born 1938

Lethykos (for Tonto). 1976

Oil and beeswax on canvas, four panels
Each panel (left to right) 7' × 24" (213.4 × 61 cm), 7' × 12" (213.4 × 30.5 cm), 7' × 12" (213.4 × 30.5 cm), and 7' × 24" (213.4 × 61 cm); overall 7' × 6' (213.4 × 182.9 cm)
Fractional and promised gift of Marie-Josée and Henry R. Kravis. Collection Helen Marden, New York

In 1971, Brice Marden visited the Greek Island of Hydra. After living and working primarily in New York for most of his career, he was drawn to the austere beauty of an island where rugged cliffs and whitewashed houses were set against the azure blue Aegean Sea. He studied the subtly shifting light effects of the Greek summer sun and the interplay of stark geometric forms against the landscape. Marden returned to Hydra yearly after this first visit, and the impact on his paintings was notable, particularly with regard to the richness and range of his palette. "If I make a painting in Greece, it looks like it was made in Greece," Marden has said. "I'm responding to that place."

The title of this work derives from the Greek "lekythos," a vessel used in antiquity for storing oil and anointing the dead. Lekythoi are typically decorated with painted scenes narrating the transition between life and death, usually in the form of a single figure depicted in both states. One of Marden's earliest four-panel works, *Lethykos (for Tonto)*, dedicated to a deceased friend, reinterprets this narrative progression chromatically. From left to right, the colors shift from warm to cool tones, an effect achieved by painting the leftmost panel orange and the rightmost panel blue, before overlaying both with gray.

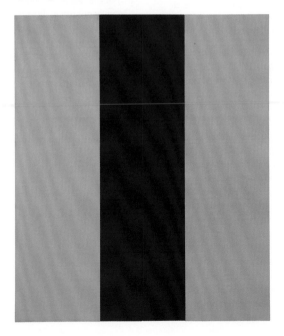

Gego Venezuelan, born Germany. 1912–1994

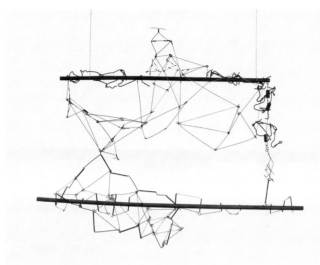

Dibujo sin papel (Drawing without Paper). 1988

Enamel on wood and stainless-steel wire,
23⅝ × 34⅝ × 16¾" (60 × 88 × 40 cm)
Fractional and promised gift of Patricia Phelps
de Cisneros in honor of Susan and Glenn
Lowry

"My work is based on doing," Gego said. This piece has a handmade quality and a sense of spontaneity, as though it was made without an overarching structural plan. Fulfilling the promise of its title, it is installed close to a wall, as any drawing would be. The shadows that play on the wall behind it and in the space confined within its spindly components are incorporated into the work and help *Dibujo sin papel* simultaneously present a flat and a volumetric surface. An emphasis on line is implicit; line, Gego felt, could express "visually human descriptive thought."

Gego, born Gertrude Goldschmidt in Germany, immigrated to Venezuela in 1939. She is best known for her work *Gran reticulárea* (1969), a room installation (now at the Galería de Arte Nacional, Caracas) with weblike, radiating forms created by latching together short pieces of stainless-steel wire. *Dibujo sin papel* is one in a series of works of the same title that Gego began to make in the late 1970s from scrap metal left over after the creation of other works of art, including fragments of interwoven wire that resemble *Gran reticulárea*'s geometric yet organic form.

Bruce Nauman American, born 1941

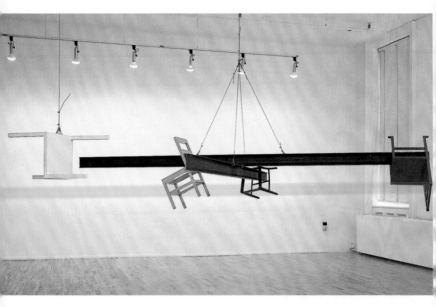

White Anger, Red Danger, Yellow Peril, Black Death. 1984

Two steel beams, four painted metal chairs, and cable,
overall 62¾" × 17' 11⅛" × 16' (159.4 × 546.4 × 487.7 cm)
Gift of Werner and Elaine Dannheisser

Two steel girders hang in an X-shape. Slid over them are three chairs (variously seatless, backless, and legless) in different metals, one red, one yellow, one black, while a fourth metal chair, in white, hangs adjoining—the girders may hit it if they swing or spin. Usually designed for rest and comfort, chairs here grow precarious, both menaced and menacing.

Escaping convenient labeling by school or style, Nauman has explored many materials and art forms—fiberglass, video, neon, installation, drawing, and more. He emerged alongside the Conceptual artists of the

1960s, and although his work is often more concretely physical than theirs, he shares their interest in the functioning of language. Nauman sees art-making not primarily as the creation of aesthetic form but as a question of picking apart the habits of perception and structures of language that dictate the meaning of the work of art.

The title *White Anger, Red Danger, Yellow Peril, Black Death* invokes perennial fears and prejudices: racism, xenophobia, plague. Nauman's art, he says, "comes out of being frustrated about the human condition. And about how people refuse to understand other people." Given the animosities and anxieties cited in the work's title, the chairs' tensely dangling balance can be seen as conjuring the instability of the global equilibrium, but with a stringency surpassing verbal metaphor.

Sigmar Polke German, 1941–2010

Hochsitz (Watchtower). 1984

Synthetic polymer paints and dry pigment on
fabric, 9' 10" × 7' 4½" (300 × 224.8 cm)
Fractional and promised gift of Jo Carole and
Ronald S. Lauder

The high scaffold in *Hochsitz* could be
a hunters' blind but also whispers of
the guards' post—perhaps on the East-
West border within a still-divided
Germany, perhaps on a concentration-
camp fence. Polke stenciled this
skeletal frame in a series of paintings
begun in 1984, varying the imagery
around it. Here, he clothed the watch-
tower in a baleful phosphorescent
glow, which sends up a hollow arm to
catch the tower's top.

In the 1960s Polke produced what
he called "Capitalist Realism," a Ger-
man variant of Pop art. An element of
Pop survives in *Hochsitz*'s support,
made of commercial yard goods printed,
respectively, with a cheerful floral and
with a weave or mesh. Refusing consis-
tency, however, Polke combined these
with both the sinister tower image and
an abstraction (which, with its alter-
nately smooth and spidery lines, sug-
gests more than one painting process).
Images and styles from different eras,
and associated with different moods
and intentions, jostle and layer in the
same work—a "postmodern" approach
that Polke pioneered, and that a variety
of artists explored in the 1980s.

Visual layering brings a layering
of sense. In *Hochsitz*, painted and
printed images compete for visibility; if
the watchtower is haunted and haunt-
ing, the prints connote a banal daili-
ness. It is as though different registers
of consciousness and of memory were
struggling for resolution.

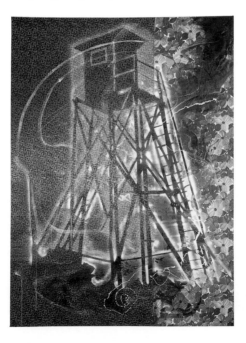

Nan Goldin American, born 1953

Nan and Brian in Bed, New York City. 1983

Silver dye bleach print, 15⁹⁄₁₆ × 23¼"
(39.5 × 59 cm)
Acquired through the generosity of Jon Lloyd Stryker

Goldin's personal life is the raw material of her art, and this picture intimately evokes the pathos of her own passionate romance. The artist lies on a bed gazing at her lover, Brian, with a mixture of longing and resignation as he turns away from her. A soft yellow light bathes the scene, suggestive of the rays of a setting sun and a waning relationship.

 Nan and Brian in Bed, New York City is included in Goldin's influential work *The Ballad of Sexual Dependency*, a sequence of more than seven hundred color slides of Goldin's friends and family, accompanied by a sound track. The forty-five-minute slide show, which borrows its title from a song in *The Threepenny Opera* by Kurt Weill and

Bertolt Brecht, presents an intimate, visceral image of a fringe community in downtown New York in the 1980s. Goldin has described *The Ballad* as "the diary I let people read"; the informal, snapshot style of her photographs lends their private dramas a powerful sense of immediacy. While the work captures the shared experience of a generation ravaged by drug excesses and AIDS, its central, driving theme is the intensity—the highs and the lows—of amorous relationships.

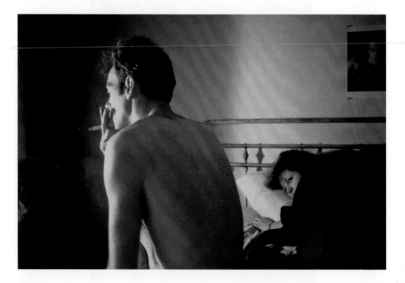

Gerhard Richter German, born 1932

October 18, 1977. 1988

Fifteen paintings, oil on canvas, installation variable, from 13¾ × 15½" (35 × 40 cm) to 6' 6¾" × 10' 6" (200 × 320 cm); shown: *Man Shot Down*, 39½ × 55¼" (100.5 × 140.5 cm) The Sidney and Harriet Janis Collection, gift of Philip Johnson, and acquired through the Lillie P. Bliss Bequest (all by exchange); Enid A. Haupt Fund; Nina and Gordon Bunshaft Bequest Fund; and gift of Emily Rauh Pulitzer

On October 18, 1977, Andreas Baader, Jan-Carl Raspe, and Gudrun Ensslin were found dead in their cells in a Stuttgart prison. The three were members of the Red Army Faction, a coalition of young political radicals led by Baader and Ulrike Meinhof, who had earlier hanged herself in police custody. Turning to violence in the late 1960s, the Baader-Meinhof group had become Germany's most feared terrorists. Although the prisoners' deaths were pronounced suicides, the authorities were suspected of murder.

The fifteen works in *October 18, 1977* evoke fragments from the lives and deaths of the Baader-Meinhof group. Richter has worked in a range of styles over the years, including painterly and geometric abstraction as well as varieties of realism based on photography. The slurred and murky motifs of this work derive from newspaper and police photographs or television images. Shades of gray dominate; the absence of color conveys the way these secondhand images from the mass media sublimate their own emotional content. An almost cinematic repetition gives an impression, as if in slow motion, of the tragedy's inexorable unfolding. Produced during a prosperous, politically conservative era eleven years after the events, and insisting that this painful and controversial subject be remembered, these paintings are widely regarded as among the most challenging works of Richter's career.

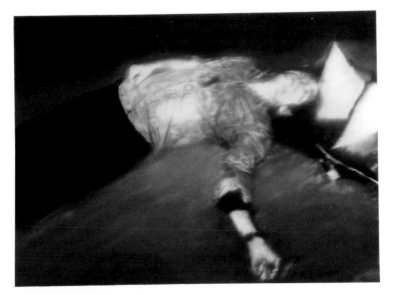

Sanja Iveković Croatian, born 1949

Sanja Iveković
TROKUT (TRIANGLE)
1979

Performance / photographs
Time: 18 min.

The action takes place on the day of the President Tito's visit to the city, and it develops as intercommunication between three persons:
1. a person on the roof of a tall building across the street of my apartment;
2. myself, on the balcony;
3. a policeman in the street in front of the house.
Due to the cement construction of the balcony, only the person on the roof can actually see me and follow the action. My assumption is that this person has binoculars and a walkie - talkie apparatus. I notice that the policeman in the street also has a walkie - talkie.
The action begins when I walk out onto the balcony and sit on a chair. I sip whiskey, read a book, and make gestures as if I perform masturbation. After a period of time the policeman rings my doorbell and orders that «the persons and objects are to be removed from the balcony»

Sanja I
Zagreb, 10 May 1979

Triangle. 1979

Four gelatin silver prints, text, printed paper
Each print 12 × 16" (30.5 × 40.6 cm)
unframed
Committee on Media and Performance
Art Funds

Sanja Iveković is one of the first feminist artists to have emerged in Croatia and the former Yugoslavia. Since the mid-1970s, she has used a wide variety of mediums—photography, sculpture, performance, and installation—to draw out the urgent political, cultural, and bodily complexities of women's position in society.

In *Triangle*, presented here as a set of four black and white photographs and a text, Iveković staged a performance during President Tito's official visit to Zagreb in May 1979. On this day, huge crowds stood along the streets, which were lined with police as the Yugoslav president's motorcade passed by. The artist, meanwhile, sat in a chair on her balcony overlooking the scene, drinking whiskey, smoking cigarettes, and reading Tom Bottomore's *Elites and Society*, a 1964 sociological study of power relationships in modern society. Juggling these tasks, she also simulated masturbation.

Eighteen minutes later, a security guard who had been stationed on the roof across the street interrupted the performance and ordered all "persons and objects to be removed from the balcony." In *Triangle*, Iveković tested and shifted the boundaries between private and public, and between the erotic and the ideological. Taking a feminist stand, and heedless of consequences, she insisted on the inextricability of the personal and political.

Martin Scorsese American, born 1942

Raging Bull. 1980

35mm film, black and white and color, sound,
119 minutes
Robert De Niro

This is a film about the escalation of
domestic violence that begins with a
family sitting around the kitchen table,
bantering, bickering, goading, and then
exploding into rage. Boxer Jake La
Motta (Robert De Niro) was no artist
but, rather, a club brawler whose singu-
lar gift was a tolerance for absorbing
his opponent's punishment. Outside
the ring, he was more likely to be the
one providing the punishment, to his
brother (Joe Pesci) and his platinum-
blonde wife (Cathy Moriarty). In life,
there are no referees, no mandatory
eight counts, no limits. For La Motta,
whose real-life story inspired the film,
brutality was a career as well as a
compulsion; for those who watched
his progress toward the middleweight
crown, it was blood sport masquerad-
ing as entertainment.

Scorsese has studied urban man's
connection to violence for thirty years
in film after powerfully charged film.
Raging Bull is his simplest, most direct
demonstration of what turns tough
guys into mayhem machines. It was
shot in grainy black and white; its
potent chiaroscuro is reminiscent of
old tabloid photos of "the big fight."
The image that lingers longest from
this painful, poignant film is the face
of the middle-aged Jake, broken and
bloated. He has suffered much and
inflicted much more, yet, over a lifetime
of pain, he has learned nothing.

Jeff Koons
American, born 1955

New Shelton Wet/Dry Doubledecker. 1981

Vacuum cleaners, Plexiglas, and fluorescent lights, 8' ⅝" × 28" × 28" (245.4 × 71.1 × 71.1 cm)
Gift of Werner and Elaine Dannheisser

Two immaculate, unused wet/dry vacuum cleaners are stacked one atop the other and hermetically sealed in Plexiglas boxes lit from below with fluorescent lights. Separated from their domestic role as cleaning machines, the objects are elevated to sculpture. "I chose the vacuum cleaner because of its anthropomorphic qualities," Koons has said. "It is a breathing machine. It also displays both male and female sexuality. It has orifices and phallic attachments." The curving armature of the hose circles the canister in an embrace, and the machine's bold maroon and gold stripes are colorful flourishes within an otherwise sterile environment.

In his varied professional past, Koons has sold memberships for MoMA and worked as a commodities broker on Wall Street. As an artist he blends the worlds of advertising, commerce, and high culture to alter the way we perceive quotidian objects and to question the boundary between art and popular culture. Like Andy Warhol with his Campbell's Soup cans and Brillo boxes, Koons elevates artifacts from everyday life, transforming mundane consumer appliances into immortal art objects. He leaves their interpretation up to the viewer.

Rosemarie Trockel German, born 1952

Untitled. 1987

Wool, 8' 2½" × 70⅞" (250 × 180 cm)
Edition: 2/2
Scott Burton Fund

During the 1980s, Rosemarie Trockel gained international recognition for her pointed and witty feminist critiques of the art world and of patriarchal structures in modern society at large. *Untitled* belongs to a group of "knitting pictures" that she began making in 1985. The works hang on the wall like paintings but are made of machine-knitted wool rather than oil on canvas. Alluding to feminine occupations like knitting and fashion, their material and method of fabrication flout traditional hierarchies of genre and gender.

In *Untitled*, the words "Made in Western Germany" are repeated in an all-over pattern in a blocky digital font. Working in West Germany shortly before reunification, Trockel produced a series of works emblazoned with this phrase, which she appropriated from the stamp that was used to mark manufactured products destined for export. The word "Western" was added in the mid-1970s after the initial postwar economic boom, when capitalist West Germany wanted to distinguish itself clearly from its communist neighbor to the east. Traditionally, written text on the surface of a picture is limited to the artist's signature. In *Untitled*, the words refer to Trockel's national identity and at the same time comment critically on the commodification of artists and art in capitalist society.

Martin Puryear
American, born 1941

Greed's Trophy. 1984

Steel rods and wire, wood, rattan, and leather,
12' 9" × 20" × 55" (388.6 × 50.8 ×
139.7 cm)
David Rockefeller Fund and purchase

The wire and the cagelike form of
Puryear's sculpture may suggest a
hunter's trap or a fisherman's basket;
another allusion could be to sport, and
the lacrosse stick. These different
echoes resonate with the title *Greed's
Trophy*, but the work has no single
model among human artifacts, and its
traces of them fuse with hints of the
human body: the dark eye and the
lolling tongue at the bottom evoke a
head, while the shape—dwindling at
the foot, expanding at the "chest,"
and swelling slightly into a circle at the
top of the armature on the wall—is
subtly figural. Meanwhile, as *Greed's
Trophy* is taking us in these various
interpretive directions, it remains con-
spicuously empty and open, its tense
curves a sculptural essay in shape
without physical substance.

"I was never interested in making
cool, distilled, pure objects," Puryear
has said, and his work is deliberately
associative. Minimalism has informed
his involvement with materials, but
whereas the classic Minimalist object
is industrially fabricated and imper-
sonal in shape and surface, Puryear's
art is steeped in cultural and historical
reference, and he is enormously adept
at carpentry and other manual skills.
In fact *Greed's Trophy*, in evoking the
tools of the American outdoorsman,
claims a place for the history of craft in
our understanding of the country's art.

Elizabeth Murray American, 1940–2007

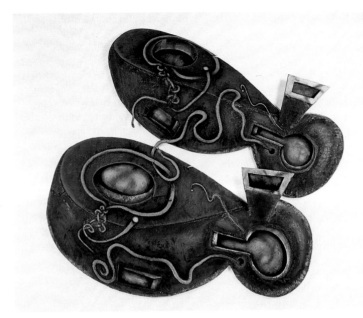

Dis Pair. 1989–90

Oil and synthetic polymer paint on two can-
vases and wood, overall 10' 2½" × 10' 9¼" ×
13" (331.3 × 328.3 × 33 cm)
Gift of Marcia Riklis, Arthur Fleischer, Jr., and
Anna Marie and Robert F. Shapiro; Blanchette
Hooker Rockefeller Fund; and purchase

Great blue ovals collide against stiff
trapezoids, twining yellow tendrils tie
them all together: as abstract form,
Dis Pair has a springy rhythmic dyna-
mism. Yet it also applies the stylistic
vocabulary of the comic strip to depict-
ing a pair of shoes. Besides being
wittily distorted and distended, these
shoes are over ten feet high, using a
strategy of enlargement prefigured
in Claes Oldenburg's Pop sculpture;
and Pop art also anticipated Murray's
interest in the commonplaces of
domestic life, which she painted on an
undomestic, even heroic, scale. Murray

dramatized the beautiful ordinariness
of familiar objects. "I paint about the
things that surround me," she said,
"things that I pick up and handle every
day. That's what art is. Art is an epiph-
any in a coffee cup."

Standing out from the wall in relief,
the surface of Dis Pair suggests a
stretched and rounded skin—perhaps
these curving forms humorously evoke
heads and faces, and their visual rela-
tionship the relationship of a human
couple. The title of the work certainly
puns on the slang word "dis," or
"disrespect," and also, more gravely,
on "despair." The household bond
described here must be strained, but
the tension seems more everyday than
tragic: the suspense in the airborne
lift of these grand swelling forms, and
in their taut interaction, is subverted
by their humor and their clunky
domesticity.

Frank O. Gehry American, born Canada 1929

Bubbles Chaise Longue. 1987

Corrugated cardboard with fire-retardant coating,
35" × 28½" × 6' 1" (88.9 × 72.4 × 185.4 cm)
Manufacturer: New City Editions, U.S.A.
Kenneth Walker Fund

Gehry worked with an unexpected, throwaway material—corrugated cardboard—in two series of surprisingly sturdy and humorous home furnishings. The instant success of the first series, Easy Edges, introduced in 1972, earned him national recognition. Gehry conceived its cardboard tables, chairs, bed frames, rocking chairs, and other items to suit the homes of young as well as old, of urban sophisticates as well as country dwellers. The Bubbles Chaise Longue belongs to Experimental Edges, the second series, which was introduced in 1979. These objects were intended to be artworks, yet they are sturdy enough for regular use. As the cardboard wears, it begins to appear suedelike and soft. Gehry's material lends itself to the curving form of this chair; its rollicking folds are, perhaps, a play on the corrugations themselves.

Heavily marketed and intentionally inexpensive, this furniture epitomized Gehry's interest in promoting affordable good design. The choice of humble cardboard for Bubbles reflects his broad interest in using industrial, commercial, and utilitarian materials. An award-winning architect, Gehry has worked with exposed chainlink fencing, corrugated metal, and plywood in concurrent architectural projects. In both the furniture series and the buildings, he has given value to seemingly worthless materials by using them to create lasting designs.

John Barnard British, born 1946
Ferrari S.p.A. Established 1946

Formula 1 Racing Car 641/2.
1990

Body materials: composite with monocoque
chassis in honeycomb with carbon fibers
and Kevlar, 40½" × 7' × 14' 8½" (102.9 ×
213.4 × 448.3 cm)
Manufacturer: Ferrari S.p.A., Italy
Gift of the manufacturer

This Formula 1 Racing Car—with an
exterior body designed by Barnard
and interior chassis engineered and
designed by the Ferrari company—
clearly illustrates the modernist dictum
"form follows function." The shape of
its exterior has been determined by the
laws of physics and aerodynamics, and
falls within the rules and guidelines
set up by the governing body of the
sport of automobile racing. The sleek
and sculptural silhouette of this Ferrari
allows air to pass over the body with
minimal drag and maximal down-force,
which ensures precision handling even
at speeds in excess of two hundred
miles per hour.

High-performance racing cars rep-
resent the ultimate achievement of
one of the world's largest industries.
Painstakingly engineered to go faster,
handle better, and stop more quickly
than any other kind of automobile, they
are the most technologically rational
and complex type of motorcar pro-
duced. Experimentation and innovation
in design, stimulated by the desire to
win, are constants in the ongoing quest
for the optimal racing machine.

Louise Lawler American, born 1947

Does Andy Warhol Make You Cry?
1988

Silver dye bleach print (Cibachrome) and Plexiglas wall label with gilded lettering; photograph, 27⁹⁄₁₆ × 39⅜" (70 × 100 cm); label, 4⁵⁄₁₆ × 6⁵⁄₁₆" (10.2 × 15.1 cm)
Gift of Gabriella de Ferrari in honor of Karen Davidson

Since the early 1980s, Lawler has photographed in galleries, private collections, storage facilities, auction houses, and museums, persistently reminding her audience that a work of art is an object, that it is bought and sold and owned, and that who owns it and how it is displayed are part of its meaning.

A New York auction of art from the collection of Burton and Emily Tremaine in November 1988 included Andy Warhol's 1962 painting *Round Marilyn*. Lawler photographed this iconic image (itself derived from a photograph of the screen goddess) at a preview of the sale, and in her finished work the painting, seventeen inches in diameter, appears at full scale, with the auction-house label (including the estimated sale price) clearly legible. Lawler's piece includes a label of its own that directly addresses the viewer, asking, "Does Andy Warhol make you cry?" It's difficult to imagine being moved to tears by a reproduction of a work of art, or even the work of art itself, while being forced to consider it as a commodity. Warhol's own hyper-awareness of that consideration no doubt helps to explain the prominence Lawler's art has granted to his.

Tadanori Yokoo Japanese, born 1936

Japanese Society for the Rights of Authors, Composers, and Publishers. 1988

Poster: silkscreen, 40½ × 28⅝"
(102.9 × 72.7 cm)
Gift of the designer

Yokoo's designs characteristically possess a level of personal expression that is remarkable within the graphic arts; the subjects being publicized frequently seem only incidental to the overall design. Craftsmanship is also of paramount importance to Yokoo, who utilizes an elaborate silkscreen process that is unusual in the production of posters, which are ephemeral. His challenges to the commercial nature of the poster are in many respects an homage to traditional Japanese *ukiyo-e* prints, woodblocks produced for the popular market.

In contemporary culture, the individual is increasingly bombarded with vast amounts of visual information relayed by a variety of means, including television, film, digital media, and print. Combining visual motifs from many cultures and periods, Yokoo's eclectic graphic art reflects this complexity. Included in this poster are references to Édouard Manet's painting *The Fifer*, Michelangelo's Medici tombs, and traditional and contemporary Japanese images. The complicated appropriation in Yokoo's work echoes Japan's evolution in the 1960s and 1970s from an insular culture to an economic world power.

Günter Brus Austrian, born 1940

Wiener Spaziergang (Vienna Walk). 1965

15 gelatin silver prints, each 15⁷⁄₁₆ x 15½"
(39.2 x 39.3 cm)
Photographer: Ludwig Hoffenreich
Acquired through the generosity of Claudia Oetker

Austrian performance artist, painter, draftsman, and writer Günter Brus was a core member of the movement known as Vienna Actionism, defined by a group of artists who, through transgressive actions, staged a radical critique of Austria's oppressive postwar society.

Wiener Spaziergang, Brus's first public action, evolved out of the artist's dissatisfaction with Galerie Junge Generation, a Viennese gallery where a solo exhibition of his work was scheduled to open. In response to the gallery director's proposal that Brus perform his action *Selbstbemalung* (*Self-Painting*) during the opening event, Brus instead performed the day prior to the opening and in full view of the public, sabotaging what he viewed as nothing more than a marketing strategy. Painted in white from head to toe with a black line of paint visually bisecting his body, Brus walked through the center of Vienna as a "living painting." This performance emphasized the importance of live action within Brus's practice while simultaneously alluding to the vulnerability of the artist in society. Minutes into the action, a police officer arrested Brus for public disturbance, fulfilling the photographer Ludwig Hoffenreich's prediction: "Oh boy, this will get us into either jail or the madhouse."

Mike Kelley American, 1954–2012

Exploring from Plato's Cave, Rothko's Chapel, Lincoln's Profile. 1985

Synthetic polymer paint on paper pinned to canvas
76½ × 64" (194.3 × 162.6 cm)
Gift of the Friends of Contemporary Drawing, the Contemporary Arts Council, and The Junior Associates of The Museum of Modern Art

Among the most influential artists to emerge from the now legendary California conceptualist movement, Mike Kelley, with his large-scale installations featuring the abject souvenirs—dirty stuffed animals to crocheted couch throws—of middle-class adolescence, his scatological performance pieces, and his prolific writing, has had a profound impact on American art on both coasts. In Kelley's multimedia work, high and low are combined to create a kind of détente between the academic and the everyday. In this world, old toys and groups of drawings executed in the style of mid-1950s comic books are marshaled together to examine the most intricate metaphysical problems.

This large drawing is from a group of ten works that together form a series dedicated to exploring the perennial artistic conundrum: truth versus illusion. In *Exploring . . .* Kelley compares the experience of viewing art to that of spelunking. Rendering the interior of a cave in a style that recalls both comic illustration and film, he asks the viewer to enter into his illusion, dripping with curiously scatological stalactites and stalagmites.

Jean-Luc Godard French, born 1930

Histoire(s) du Cinéma. 1988–1998

Video, black and white and color, sound,
266 min.
Gift of the artist

Godard's operatic *Histoire(s) du cinéma* is an allusive video collage of film clips, still photographs, on-screen text, and images of the filmmaker and other performers. The cascade of visuals is matched aurally by a profusion of narration, sound bites, and musical passages, mixed in with a variety of other sound devices. Utilizing an array of editing strategies and optical effects, Godard created a subjective essay born out of his disappointment with cinema's inability to effect profound revolutionary change and save the world from horror. The professed theme of *Histoire(s)* is the death of cinema, and Godard's analytical use of video to synthesize images from the entire history of cinema results in a kind of requiem for the indelible power of film over our collective subconscious.

The full cycle of *Histoire(s)*, which is comprised of four two-part chapters made over the course of ten years, set standards for the future of video. Godard had been attracted to the medium since the early 1970s. Because of its flexibility—it lends itself readily to editing and radical change—he felt that video was closer to writing than celluloid; and because of its relatively low cost and easy distribution, he considered it a more democratic medium. *Histoire(s) du cinéma* remains a rarely screened, towering achievement and the artist's most passionate self-portrait in image and sound.

Rody Graumans Dutch, born 1968

85 Lamps Lighting Fixture. 1992

Standard lightbulbs, cords, and sockets,
39⅜ × 39⅜" (100 × 100 cm) diam.
Manufacturer: DMD, the Netherlands
Gift of Patricia Phelps de Cisneros

Contemporary Dutch designers have
been markedly innovative in experi-
menting with materials, a trend that
crosses international boundaries.
Readily available at any hardware
store, Graumans's simple materials—
eighty-five black cords, sockets, and
lightbulbs—yield a grand chandelier
through the strength of his design.
Gathered in a unified bundle at the ceil-
ing, the cords flare out to accommo-
date the mass of lightbulbs below.
 Graumans's 85 Lamps was
selected for inclusion in the first design
collection offered by Droog Design,
established in 1994 by designers and
theorists Gijs Bakker and Renny
Ramakers. It is a firm that has captured
much attention for its stance against
consumerism and its use of industrial
and recycled materials. The diverse
works of the talented young designers
chosen for The Museum of Modern Art
design collection celebrate ingenuity,
economy of form, and a minimalist aes-
thetic, as does this lamp by Graumans.

Charles Ray American, born 1953

Family Romance. 1993

Painted fiberglass and synthetic hair, 53" ×
7' 1" × 11" (134.6 × 215.9 × 27.9 cm)
Gift of The Norton Family Foundation

Two parents, two young children: "It's
a nuclear family," as Ray says, the
model of American normalcy. Yet a
simple action has put everything
wrong: Ray has made all of them the
same height. They are also naked, and
unlike the store-window mannequins
they resemble, they are anatomically
complete. This and the work's title, the
Freudian phrase for the suppressed
erotic currents within the family unit,
introduce an explicit sexuality as dis-
turbing in this context as the protago-
nists' literally equal stature.

Early works of Ray's submitted the
forms and ideas of Minimalism to the
same kind of perceptual double-take
that *Family Romance* works on the
social life of middle-class Anglo-Saxon
America. He has worked in photography
and installation as well as sculpture,
and his art has no predictable style or
medium; but it often involves the sur-
prise of the object that seems familiar
yet is not. Like other works of Ray's
involving mannequins, *Family Romance*
suggests forces of anonymity and stan-
dardization in American culture. Its
manipulations of scale also imply a dis-
ruption of society's balance of power:
not only have the children grown, but
the adults have shrunk.

Cady Noland American, born 1956

The American Trip. 1988

Wire racks, steel pipes, chrome cuffs,
American flag, pirate flag, leather straps, blind
man's cane, and metal parts, 45" × 8' 8" × 57"
(114.3 × 264.2 × 144.8 cm)
Purchase

This work takes as a starting point the
idea that, historically, the United States
has embraced violence. The artist has
said, "Violence used to be a part of life
in America and had a positive reputa-
tion. . . . There was a kind of righteous-
ness about violence—the break with
England, fighting for our rights, the
Boston Tea Party." Through her sculp-
tures Noland asserts that the United
States continues to sanction violence,
if more covertly, through its inherently
masculine ideals and cultural practices.

The American Trip is an assem-
blage of objects that subtly allude to
violence, such as leather straps used
as handcuffs, chrome cuffs, and a wire
hunting trap. Noland has paired the
U.S. Stars and Stripes with the Jolly
Roger skull-and-crossbones flag that is
traditionally associated with pirates. A
white cane speaks to a project of arbi-
trary and instinctive territorial conquest.
It rests at an angle and reaches out
to cover more space, symbolizing, per-
haps, the blindness that may accom-
pany a nation's expansionist goals. *The
American Trip* invites a host of overlap-
ping allusions, including an art-historical
reference to the industrial materials
of Minimalist sculpture, but it departs
from its abstract predecessors through
its potent psychological charge.

Bruce Nauman
American, born 1941

Punch and Judy II Birth & Life & Sex & Death. 1985

Gouache and pencil on paper,
75½ × 72½" (191.8 × 184.2 cm)
Gift of Werner and Elaine Dannheisser

Like much of Bruce Nauman's work, *Punch and Judy II Birth & Life & Sex & Death* exposes essential, often harsh, realities of human experience. Life-size figures of a man and woman face each other across this large drawing, engaging in acts of sex and violence. They shoot each other, engage in erotic behavior, commit suicide, and collapse on the ground. The multiple silhouettes in this work relate to the neon sculptures Nauman was creating around the same time, in which overlapping figures appear individually as the illuminated tubes flash on and off. In this drawing,

the figures appear simultaneously, in continuous activity. They live and die, love and fight all at once.

Nauman frequently depicts particularly dysfunctional male/female relationships in his work, forcing viewers to confront the less savory aspects of their own behavior. Linking the couple with the classic, bickering puppet-show characters Punch and Judy adds a comic element, but ultimately the drawing makes a blunt statement about society's endless appetite for sex and violence, and suggests a disturbing link between the two.

Isa Genzken German, born 1948

Bild (Painting). 1989

Concrete and steel, 103⁹⁄₁₆ × 63 × 30⁵⁄₁₆"
(263 × 160 × 77 cm)
Gift of Susan and Leonard Feinstein and an
anonymous donor

Isa Genzken first gained international
recognition in the late 1980s for her
abstract sculptures imbued with histori-
cal and cultural allusions. In *Bild* she
evokes multiple facets of the history
of modern architecture. The choice of
concrete and steel and simple geome-
try conjures mid-century modernist
forms of the International Style and
Brutalist housing projects. The rough
texture of the concrete refers to a post-
World War II Germany shaped by the
ruins of bombed-out cities and to the
scarred surfaces of the Berlin Wall,
which was dismantled during the same
year in which this sculpture was made.

Despite its salvaged appearance,
this work was carefully constructed
using a wire armature on top of which
Genzken applied layers of wet con-
crete, molding it with wooden boards
to create distinctive horizontal ridges
on the surface. The outer layer of
concrete reveals and conceals a laby-
rinthine interior space. Elevated above
eye level on an open steel pedestal,
the sculpture resembles an architec-
tural fragment. *Bild* cites the utopian
legacy of avant-garde architecture only
to memorialize it as a ruin.

Cildo Meireles Brazilian, born 1948

Fio (Thread). 1990–95

Forty-eight bales of hay, one 18-karat gold needle, 100 feet of gold thread, dimensions variable, approx. 7' 1" × 6' 1¹⁄₁₆" × 72" (215.9 × 185.5 × 182.9 cm)
Gift of Patricia Phelps de Cisneros

No ordinary needle in a haystack, the 18-karat gold needle in *Fio* has laced 190 feet of gold thread through forty-eight bales of hay. The needle is the same width as the flaxen strands of hay and is easily lost among them. The physical boundaries and economic limits of value are at the heart of this work, in which a precious material is used to package something relatively worthless. Meireles has identified this relationship as "a discrepancy between use and exchange value, symbolic and real value. My works that use money all refer to this dichotomy between work and the artwork, between hay and gold."

Fio addresses the abstract concept of value, but as with much of Meireles's work it also engages several of the viewer's senses. Entering the installation space, visitors smell the hay—an unexpected odor in the gallery environment—and perceive the weight and volume of the bales, even as the gold needle and thread remain imperceptible. Meireles, who was born in Brazil, lives and works in Rio de Janeiro. His artwork covers a broad spectrum of mediums, distinct in form yet unified by the strength, simplicity, and poignancy of his vision, wonderfully illustrated in this incisive work.

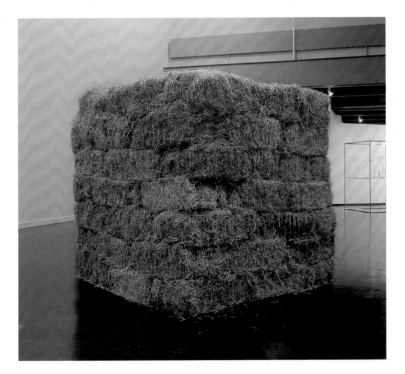

Lucian Freud
British, born Germany, 1922–2011

Large Head. 1993

Etching, plate: 27⁵⁄₁₆ × 21¼" (69.4 × 54 cm)
Publisher: Matthew Marks Gallery, New York.
Edition: 40
Mrs. Akio Morita Fund

The large man depicted here with great intensity and keen observation is Leigh Bowery, a favorite model of the German-born British artist and grandson of Sigmund Freud. Bowery's brief career as a brilliant but abrasive performance artist was cut short by his early death in 1995. He performed mainly in London, where Freud first saw him, but he also appeared in New York and elsewhere. His distinctive physiognomy and massive physicality attracted Freud, who depicted Bowery in a series of paintings and prints over a period of four years. The calm repose of the figure seen here contrasts sharply with more provocative and disturbing representations of this brash, eccentric artist, as shown in several large paintings.

Freud was not a traditional printmaker. Instead, he treated the etching plate like a canvas, standing the copper upright on an easel. He delineated his meticulously rendered composition across the plate, working day after day until the tightly woven representation was complete. The image is created with lines alone, which intersect, swell, and recede.

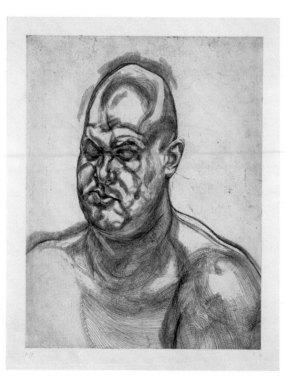

Reiko Sudo Japanese, born 1953

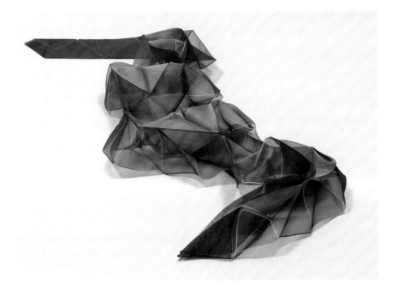

Origami Pleat Scarf. 1997

Hand-pleated and heat-transfer-printed
polyester, 17⁵/₁₆ × 59¹/₁₆" (43.9 × 150 cm)
Manufacturer: Nuno Corporation, Japan;
also Takekura Co., Ltd., Japan
Gift of the designer

Among The Museum of Modern Art's
holdings is a rich collection of contem-
porary Japanese textiles. Sublime and
surprising, solidly anchored in material
culture and at the same time represen-
tative of the latest technological inno-
vations, these textiles are revolutionary
in the way that they alter the habitual
relationship between the shape of the
body and the light and air around it.

The collection includes the produc-
tion of several notable designers, from
Junichi Arai and Hideko Takahashi to
Osamu Mita. None, however, is fea-
tured as often as Sudo, a disciple of
Arai and a virtuoso in her own right. In
1984, Arai and Sudo cofounded Nuno
Corporation, in Tokyo, and Arai intro-

duced his new partner to the use of
scanners and computers, providing her
with a fresh palette of artistic possibili-
ties. The Origami Pleat Scarf, which
Sudo designed in collaboration with
Mizue Okada, is just one example of
the company's unique production.

Emulating the Japanese art of
folding paper, this delicate-looking
scarf is creased repeatedly at sharp
angles and then permanently pressed
in a special heat-transfer pleating pro-
cedure. Its color gradation is achieved
by sandwiching colored dye-transfer
paper between the fabric and the outer
paper during the heat-transfer process.
The polyester retains memory of the
pleats to such an extent that the three-
dimensional scarf folds perfectly flat
onto itself when dropped. The scarf
represents the ideal balance between
functionality, technological innovation,
and art that the Museum seeks in its
collection of design objects.

Joan Jonas American, born 1936

Mirage. 1976/2005

Six videos, black and white, sound and silent, props, stages, photographs, duration variable
Gift of Richard J. Massey, Clarissa Alcock Bronfman, Agnes Gund, and Committee on Media Funds

Born in 1936 in Manhattan, Joan Jonas studied a wide range of subjects, including art history, sculpture, and modern poetry. In the late 1960s, inspired by an emerging practice that combined traditional performance mediums, such as dance, with avant-garde experimentation in the visual arts, she started to explore time as a material for art. Jonas was also profoundly affected by the feminist movement, and her work examines and questions the roles of women in society. Although she has been ever responsive to new ideas and new mediums, for nearly forty years she has kept performance and video at the center of her practice.

She conceived of *Mirage* in 1976 as a performance for the screening room of New York's Anthology Film Archives. In it she carried out a series of movements, including percussive running and drawing, while interacting with a variety of sculptural components, films, and videos. In 1994 Jonas reconfigured some of the components of *Mirage*—metal cones, footage of erupting volcanoes, wooden hoops, a mask, photographs, and chalkboards, among others—into a discrete installation, which she again repurposed in 2005. As an installation, *Mirage* incorporates six videos (*May Windows*, *Good Night Good Morning*, *Car Tape*, *Volcano Film*, *Mirage 1*, and *Mirage 2*) and combines ritual, memory, repetition, and rehearsal with games, drawing, and syncopated rhythms.

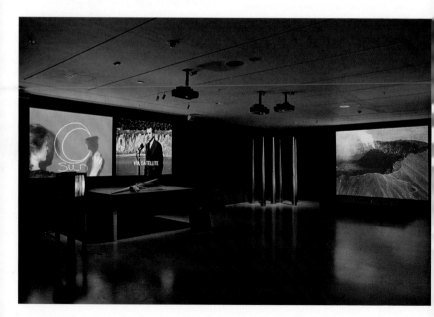

David Hammons American, born 1943

High Falutin'. 1990

Metal (some parts painted with oil), oil on
wood, glass, rubber, velvet, plastic, and
electric lightbulbs; installation 13' 2" × 48" ×
30½" (396 × 122 × 77.5 cm)
Robert and Meryl Meltzer Fund and purchase

Hammons's art is a reclamation project
of sorts; he revalues bits of street
flotsam and other unwanted debris by
assembling them in new combinations.
High Falutin', one of his several works
based on the basketball hoop, is a
battered wood window frame atop a
pole, crowned and fringed by ruffles of
rubber tire and glass candle holders,
which are wired to light up. The theme
of light and energy reappears in the
crinkled loop of wire around the frame,
a cartoon electric current.

The practice of working with found
objects has an ancestry in Surrealism,
and Hammons acknowledges the
influence of Marcel Duchamp, among
others, but he also remarks, "I feel it
is my moral obligation to try to graphi-
cally document what I feel socially."
The urban society to which he is so
attuned is crucially inflected by the
presence of African Americans, and if
Hammons admires basketball, it is as
a game of which African Americans
have made an "art of improvisation,"
"a whole other thing—ballet, theater."
High Falutin', which was originally
named *Spirit Catcher*, also relates to
African traditions of masks and other
spiritually protective sculpture. "Art,"
Hammons has said, "is a way to keep
from getting damaged by the outside
world, to keep the negative energy
away. Otherwise you absorb it."

Robert Gober
American, born 1954

Untitled. 1989–90

Beeswax, cotton, leather, human hair, and
wood, 11⅜ × 7¾ × 20"
(28.9 × 19.7 × 50.8 cm)
Gift of the Dannheisser Foundation

As a copy of a man's leg and foot,
this work is strikingly real: its fleshy
waxen skin, clad in leather shoe and
in cotton pant and sock, sprouts actual
human hair. Such exactitude becomes
unsettling and macabre, as the leg's
placement suggests that the rest of
the body to which it belongs is behind
the wall. For some, the work may also
have a subtle fetishistic eroticism,
inasmuch as it focuses on a narrow
band of the body where men routinely
and unself-consciously show their
nakedness.

 Many of the artists who emerged
alongside Gober in the 1980s were
interested in modern communications
media or in quoting from art history.

Gober, by contrast, insists on the hand-
made quality of his sculpture, and
although his works can remind us of
earlier art (this piece, for example, may
recall the body fragments in the sculp-
ture of Auguste Rodin), their disturbing
mood is entirely contemporary.

Martin Kippenberger German, 1953–1997

Martin, Stand in the Corner and Be Ashamed of Yourself. 1990

Cast aluminum, clothing, and iron plate,
71½ × 29½ × 13½" (181.6 × 74.9 ×
34.3 cm)
Blanchette Hooker Rockefeller Fund Bequest,
Anna Marie and Robert F. Shapiro, Jerry I.
Speyer, and Michael and Judy Ovitz Funds

Kippenberger cultivated his reputation as the bad boy of German art in the 1980s, acting deliberately and often outrageously provocative in both his art and his personal behavior. With this sculpture he reaps what he has sown, placing himself in a position all naughty schoolchildren know well: in the corner, alone with his enforced remorse. A particularly vicious article by a German art critic served as the catalyst for this and several other mock-apologetic Martin-in-the-corner sculptures. However, the work's resonance goes far beyond the specific occasion, deftly setting into a contemporary vernacular the Romantic identification of the artist as outcast, whether genius, prophet, beggar, or madman.

Each work in this series is uniquely made and clothed, and the faces and hands are cast in aluminum from molds of the artist's own body. While the other figures are dressed more formally, the Martin in this sculpture (commissioned by MoMA) wears Levi's jeans and a shirt with a globe on it. Kippenberger chose the shirt as a nod to MoMA's international role as a center of modern art. Its presence in the galleries is a witty upending of the museum's traditional glorification of the artist. Kippenberger zeros in on a trade secret: for contemporary museum officials, artists and the challenges their works present can be as vexatious as they are beloved.

Andrea Fraser
American, born 1965

The Public Life of Art:
The Museum. 1988–89

Video (color, sound), 13 min.
Production design: Louise Lawler
Produced by Terry McCoy
Committee on Media and Performance
Art Funds

For almost thirty years, the Los
Angeles-based artist Andrea Fraser
has been engaged in an ongoing
investigation of what we want from art.
Combining feminist perspectives on
subjectivity and desire with the site-
specific and research-based practices
that emerged with Conceptual Art
and Institutional Critique in the late
1960s, Fraser uses performance,
video, and a range of other mediums to
explore and critique the motivations
that drive artists, collectors, art deal-
ers, corporate sponsors, museum
trustees, and museum visitors.

The Public Life of Art: The Museum
is the first performance that Fraser
realized for video. Shot at The
Metropolitan Museum of Art and The
Museum of Modern Art, produced by
Terry McCoy, and created in collabora-
tion with New York-based artist and
photographer Louise Lawler, the work
features the artist discussing a social
history of the art museum, from topics
such as corporate sponsorship to eco-
nomic social policy. The piece is part
of a larger selection of single-channel
videos documenting a range of Fraser's
performances between 1988 and
2001 that MoMA acquired in 2011.
Performance is an integral aspect of
Fraser's practice, and the artist's care-
ful documentation of her earlier works
permits them to live on in these videos.

Michael Schmidt German, born 1945

EIN-HEIT (U-NI-TY). 1991–94

163 gelatin silver prints, each 19⅞ × 13½"
(50.5 × 34.3 cm)
Horace W. Goldsmith Fund through Robert B.
Menschel and purchase

Schmidt made *EIN-HEIT* in response to
the fall of the Berlin Wall in 1989 and
the subsequent reunification of East
and West Germany. (The German title,
which means "unity," is split in two.)
Composed of 163 pictures, some
taken by the artist, others culled from
newspapers, old and recent maga-
zines, propaganda journals, history
books, and related sources, this work
is a meditation on national identity.
Schmidt draws upon two artistic tradi-
tions: descriptive photography and pho-
tography as a vast resource of mass
imagery to be reduplicated and com-
bined. Bringing the two together, he
explores the relationship between the
individual and the state, from the
Nazi seizure of power in 1933 through
the more than fifty years of ideological
opposition that divided Germany
after 1945.

Schmidt intersperses contempo-
rary photographs of ordinary places
and individuals with archival images
of anonymous and famous people,
interiors and exteriors, mass scenes,
emblems, and monuments. History is
presented not as a linear sequence of
well-defined events but as a decen-
tered, simultaneous overlapping of
contingent frameworks. Viewers are
obliged to ponder whether a given
image was taken in East or West
Germany, before or after World War II,
during the period of separation, or
since reunification.

Marlene Dumas
South African, born 1953

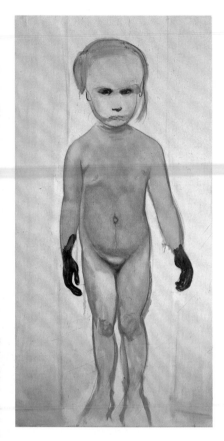

The Painter. 1994

Oil on canvas, 6' 7" × 39¼" (200.7 × 99.7 cm)
Fractional and promised gift of Martin and Rebecca Eisenberg

With her brooding dark eyes, green hair, and paint-smeared body, this child confronts us from the menacing height of six feet and appears as a force of destruction. Yet the title reveals her to be a creative force—a painter. She is the artist's daughter, Helena, aged five or six, and her babylike body, able hands dipped in black and red paint, and startling visage are completely alien to traditional notions of the artist and the muse. "Historically . . . it was always the male artist who was the painter and his model the female," Dumas has said of this work. "Here we have a female child (the source my daughter) taking the main role. She painted herself. The model becomes the artist."

South African by birth, Dumas studied art and psychology in the Netherlands, where she has spent the last three decades creating work that flouts the conventions of portraiture and artistic patriarchy and exposes the misunderstandings that arise between representation and interpretation. *The Painter* exemplifies her exceptional talent for psychological portraits of women and children, although rarely are they so autobiographical. The artist works from photographs from magazines or books, or those she shoots herself, usually removing identifying details as she composes her engrossing, nuanced portraits.

Gabriel Orozco Mexican, born 1962

Yielding Stone. 1992

Plasticine, 14½ × 15½ × 16" (36.8 × 39.4 × 40.6 cm)
Nina and Gordon Bunshaft Fund

Gabriel Orozco's artistic practice has been shaped in part by the artist's peripatetic lifestyle. During the 1990s, Orozco rejected the lure of the studio and created sculptures, drawings, and photographs wherever he found himself, using materials that were readily at hand. His works respond to and echo the character of the place where they were made, whether Paris or Istanbul, New York or Bangalore.

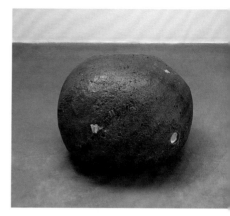

Yielding Stone is a gray globe Orozco hammered together from Plasticine, an oil-based modeling clay available in most art supply stores. While it lacks distinguished provenance, Plasticine appears with enough regularity in Orozco's early sculptures and photographs that it could be considered his signature material. In the case of *Yielding Stone*, made during the artist's first extended stay in New York City, Orozco gathered an amount of clay equal to his own weight and rolled it down Broadway, where it became encrusted with dirt and debris. A surrogate body standing in for Orozco's own, the sculpture bears a record of its journeys and continues to change, gathering dust and fingerprints even in the controlled environment of the Museum. As the artist has said, "It is the opposite of a static monument, but sculpture as a body in motion." In this way *Yielding Stone* can be seen to be emblematic of Orozco's general approach to making art.

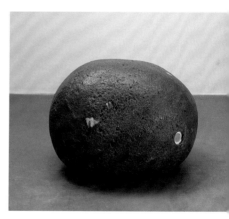

Clint Eastwood American, born 1930

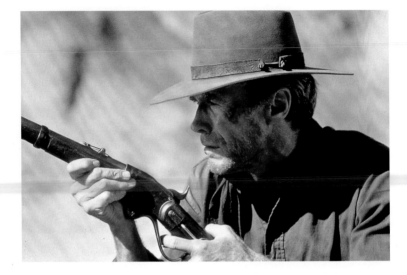

Unforgiven. 1992

35mm film, color, sound, 130 minutes
Gift of the artist and Warner Bros.
Clint Eastwood

A Western that is at once moody and ambivalent, comical and cruel, *Unforgiven* follows its unlikely, unheroic avengers across a broad, pristine landscape under bright skies to a frontier town where legend and death by violence are equally ridiculed. In the film, the aging Will Munny (Clint Eastwood) pleads with his former partner Ned Logan (Morgan Freeman) to come back just one more time to kill a man who slashed a prostitute. Although their task is dishonorable, their success will ensure them a peaceful old age. Bluffing his way as the third partner is a rookie outlaw (Jaimz Woolvett), who survives the unfolding events and learns a painful moral truth.

Also appearing in the film is a bogus legend, English Bob (Richard Harris), who is no verbal match for the acid-tongued sheriff (Gene Hackman). The mocking tone of the dialogue provides a counterpoint to the Western genre's rhythms of hit, run, and destroy. The idea that men who live by violence can also be brilliantly funny sharpens director Eastwood's steady gaze. With this film, which instills a new morality into the tradition of the Western, Eastwood single-handedly revived the genre.

An actor turned director, Eastwood depicts the ambivalence of his own screen characters in understated, spare terms, set against the stunning beauty of the deep landscape and culminating in fluid action scenes that end in loss and death. In this film violence is itself critiqued; there is no joyful ending for the traditional code of the West.

Richard Serra
American, born 1939

Intersection II. 1992–1993

Cor-Ten steel, four plates, each 13' 1½" ×
55' 9⅜" × 2" (400 × 1700 × 5 cm).
Gift of Jo Carole and Ronald S. Lauder

Slightly younger than the Minimalist
artists, Serra has intensified a quality
of their work—a heightening of the
viewer's physical self-awareness in
relation to the art object. In early works
of Serra's, heavy metal slabs stood in
precarious balance; any close look at
them was a charged affair. *Intersection
II*, similarly, sensitizes its visitors, invit-
ing them under and between its mas-
sive walls—which, they will find, exert
an enormous psychic pressure.

That pressure arises from the
weight, height, and leaning angles of
the walls, and from their variously dark
and rusted surfaces. It is tempered
by the elegant precision of their lines
and the satisfying logic of their arrange-
ment. The slopes and placements of
the great steel curves produce two outer
spaces that invert each other at floor
and ceiling, one being wide where the
other is narrow. Meanwhile the central
space is a regular yet biased ellipse.
Whether these spaces are experienced
as intimate or threateningly claustro-
phobic, what Serra has said of his ear-
lier work applies: "The viewer in part
became the subject matter of the work,
not the object. His perception of the
piece resided in his movement through
the piece, [which] became more
involved with anticipation, memory, and
time, and walking and looking, rather
than just looking at a sculpture the way
one looks at a painting."

Glenn Ligon

American, born 1960

Untitled (I am an invisible man).

1991

Oilstick on paper, 30 × 17¼" (76.2 × 43.8 cm)

Gift of The Bohen Foundation

Ligon addresses issues of race, gender, sexuality and marginalization in text-based works using language from appropriated sources. In *Untitled (I am an invisible man)* he extracts a passage from Ralph Ellison's 1952 novel *Invisible Man,* the story of a young African American growing up in the mid-twentieth century South. Ellison's text begins "I am an invisible man. No, I am not a spook like those who haunted Edgar Allan Poe; nor am I one of your Hollywood-movie ectoplasms. I am a man of substance, of flesh and bone, fiber and liquids—and I might even be said to possess a mind. I am invisible, understand, simply because people refuse to see me. . . ." Ligon fills the entire composition with text from Ellison's prologue, smearing the black oilstick on the paper and calling attention to Ellison's outcast by making him visible through the act of writing, thereby erasing his invisibility.

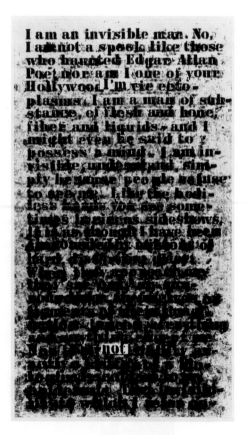

Philip-Lorca diCorcia · American, born 1953

Eddie Anderson; 21 Years Old; Houston, Texas; $20. 1990–92

Chromogenic color print (Ektacolor),
23⅝ × 35⅞" (60 × 91.1 cm)
Gift of the photographer

It is no accident that this picture has the slick feel of a Hollywood production or a magazine ad. DiCorcia casts, poses, lights, and frames his photographs with the same attention to detail that is lavished on a scene in a movie. The key difference is that his still dramas have no beginnings or endings, only middles, for which we are invited to write the scripts.

In diCorcia's earlier work the protagonists were mainly friends, deployed in familiar domestic settings; this picture belongs to a later series made in a Hollywood neighborhood frequented by male prostitutes, drug addicts, and drifters, whom the photographer hired to pose. The photographer asked each man for his name, age, and place of birth, and titled the picture with the answer, followed by the amount he paid the subject to pose.

The high artifice of diCorcia's photographs keeps us from reading the series as a straightforward record of a Hollywood street culture. In this sense, his work is representative of a widespread contemporary sensibility that has become weary or suspicious of the earnest realism of documentary photography. Nevertheless, the series gives us a picture of a world as persuasive as any we know from a traditional documentary project—and as moving.

Felix Gonzalez-Torres
American, born Cuba, 1957–1996

"Untitled" (Death by Gun). 1990

Print on paper, endless copies, stack is 9" at
ideal height × 44¹⁵⁄₁₆ × 32¹⁵⁄₁₆"
(22.9 × 114.1 × 83.6 cm)
Purchased in part with funds from Arthur
Fleischer, Jr. and Linda Barth Goldstein

The viewer's first reaction to *"Untitled"
(Death by Gun)* is one of uncertainty.
Is this stack of papers on the floor
meant to be walked around and viewed
from different angles, like sculpture?
Or did the artist intend these papers
to be picked up and examined? Listed
on the sheets are the names of 460
individuals killed in the U.S. by gunshot
during the week of May 1–7, 1989,
cited by name, age, city, and state,
with a brief description of the circum-
stances of their deaths, and, in most
cases, a photographic image of the
deceased. These images and words,
appropriated from *Time* magazine,

where they first appeared, reflect
Gonzalez-Torres's interest in gun
control.

Conceptually, *Death by Gun* is an
ongoing work of art. Viewer participa-
tion is an important element, and the
public is encouraged to read the sheets
and take them away to keep, display,
or give to others. While Gonzalez-Torres
determined that the stack is "ideally"
nine inches high, he arranged for the
depleted sheets to be continually
reprinted and replaced, thus insuring
that *Death by Gun* can be distributed
indefinitely. From its beginnings,
printed art has been made in multiple
copies for dissemination to a wide
audience. Here that idea is expanded
with an edition that is "endless."

Rirkrit Tiravanija
Thai, born in Argentina, 1961

Untitled (Free/Still).
1992/1995/2007/2011

Refrigerator, table, chairs, wood, drywall,
food, and other materials, dimensions variable
Gift of Mr. and Mrs. Eli Wallach (by exchange)

Untitled (*Free*) was the title of
Tiravanija's first solo exhibition, held in
1992 at the 303 Gallery in New York
City's SoHo. For the occasion, the art-
ist moved the contents of the gallery's
back spaces into the exhibition space,
placing the business of art on display,
and transformed the emptied office
into a temporary kitchen, where he pre-
pared Thai vegetable curry and served
it free to anyone who wanted it.

The work has had several iterations
since then. When it was re-presented at
the Carnegie International exhibition in
Pittsburgh in 1995,Tiravanija added
"Still" to the title. In 2007, he restaged
it at the David Zwirner Gallery, re-
creating the space of the original exhibi-
tion and re-employing the furnishings
and leftovers—crates, boxes, empty
cans, even food items—from the past
presentations. Now in the Museum's
collection, the piece can be displayed
either as a vestige of its earlier mani-
festations or reactivated with food pre-
pared in the Museum's kitchen.

Tiravanija's practice has grown
out of the playful aesthetics of Fluxus
and from a focus on social relations in
the work of artists such as Gordon
Matta-Clark, who in 1971 co-founded
Food, a restaurant in SoHo that
employed artists and hosted art/food
performances. Like so many of
Tiravanija's works, Untitled (*Free/Still*)
invites viewers to step out of their
habitual roles as observers and
become participants.

Rachel Whiteread British, born 1963

Water Tower. 1998

Translucent resin and painted steel, 12' 2"
(370.8 cm) high × 9' (274.3 cm) diam.
Gift of the Freedman Family in memory of
Doris C. and Alan J. Freedman

Commissioned by the Public Art Fund
and originally installed in 1998 on a
rooftop in the SoHo neighborhood of
New York, *Water Tower* is Whiteread's
first public sculpture to be conceived
and displayed in the United States. The
British artist scoured the city in search
of a quintessentially New York subject.
Looking across the East River to
Manhattan during a visit to Brooklyn,
she admired the water towers perched
high above the streets and was drawn
to their uniqueness and their ubiquity
in the architectural cityscape.

Whiteread is known for her cast-
ings in resin and plaster of familiar
objects and the spaces they surround,
such as the interiors of a bathtub and
a row house in London's East End,
and for her ability to make people see
these objects and spaces anew. *Water
Tower* is a resin cast of the interior of
a once-functioning cedar water tower,
chosen specifically for the texture
this type of wood would impart to the
surface. The translucent resin captures
the qualities of the surrounding sky;
the sculpture's color and brightness
change throughout the day, and it
becomes a near-invisible whisper at
night. Whiteread has called this work
"a jewel on the skyline of Manhattan."
Soaring and ephemeral, it inspires city-
dwellers and visitors alike to look again
at the solid, weighty water towers they
usually see without noticing.

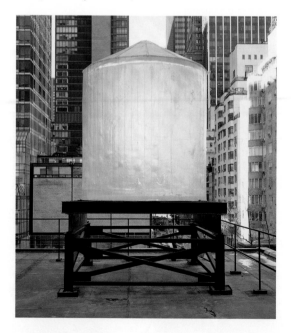

Andrea Zittel

American, born 1965

A–Z Escape Vehicle: Customized by Andrea Zittel. 1996

Exterior: steel, insulation, wood, and glass. Interior: colored lights, water, fiberglass, wood, papier-mâché, pebbles, and paint, 62" × 7' × 40" (157.5 × 213.3 × 101.6 cm) The Norman and Rosita Winston Foundation, Inc. Fund and an anonymous fund

A–Z Escape Vehicle: Customized by Andrea Zittel is one in a line of works inspired by the mobile home. All have the same stainless steel outer shell, but the interiors differ; each is customized according to its owner's specifications. Like trailers, these capsules can be hooked to a car and driven away, but they are actually designed to be installed in a garden or driveway, or even indoors. The "escape" of their title lies not so much in their mobility as in their provision of a retreat tailor-made for one individual's comfort.

Simultaneously aesthetic and useful, the escape vehicles challenge the idea of the artwork as an object of contemplation. They implicitly argue that artists can participate in their societies as designers and architects do—by producing works with practical and benign applications in daily life. In this way Zittel belongs to a tradition of social involvement running back to the Bauhaus and the Russian Constructivists. A more recent precedent of a different kind is Pop art, with its attraction to vernacular and commercial visual forms and production methods.

The name "A–Z" is a pun, fusing the idea of embracing inclusiveness with the artist's initials. Zittel customized this particular escape vehicle herself, creating a papier-mâché grotto in striking contrast to the sleek metal outer skin.

Christopher Wool American, born 1955

Untitled. 1990

Enamel on aluminum, 9' × 6'
(274.3 × 182.9 cm)
Gift of the Louis and Bessie Adler
Foundation, Inc.

An ominous phrase appears stenciled in black letters nearly two feet high on an aluminum panel. The absence of punctuation, conventional spacing, and definite articles heightens the sinister tone of the message by evoking the pared-down language of danger signs and telegrams, which typically deliver their urgent messages in the sparest of terms. A sense of detachment and expediency springs from the seemingly artless choice of letterforms, which resemble those of commercially available stencils used to mark shipping crates. In fact, the artist made his stencils by hand in order to achieve the large scale he desired.

Wool says that he began producing the word paintings in 1988 as a way of imposing limits on his abstract compositions, by tying them to phrases of his own invention or borrowed from other sources. The line "The cat's in the bag. The bag's in the river" comes from the 1957 film *Sweet Smell of Success*, where it served as film-noir code to convey the successful execution of a scheme to bring about the downfall of one of the characters. Wool's perfectly aligned columns and ragged right margin suggest the precision, both mechanical and crooked, of the villains' well oiled plan.

Carrie Mae Weems American, born 1953

You Became a Scientific Profile, A Negroid Type, An Anthropological Debate, & A Photographic Subject from From Here I Saw What Happened and I Cried. 1995

Four chromogenic color prints with sandblasted text on glass
Each 23⅞ × 19¹⁵⁄₁₆" (60.7 × 50.7 cm)
Gift on behalf of The Friends of Education of The Museum of Modern Art

These are four of the thirty-three images that compose *From Here I Saw What Happened and I Cried*, an elegiac work that addresses photography's complicity in the reinforcement of racist ideas. In photographs, African Americans have often been reduced to stereotypes and robbed of their individual identities. Weems's work is not only a commentary on the representation of black people in millions of photographs; it also responds to the status and perception of African Americans in the United States throughout history.

The artist rephotographed images—daguerreotypes to documentary photographs—from the time of the American Civil War through the period of the Civil Rights Movement. She used a red filter to diminish the pictures' documentary authority and cropped each image to create a kind of telescopic view that emphasizes the viewer's temporal distance from the subjects. Each picture is accompanied by text written by Weems, etched on a protective pane of glass. The series begins with a profile view of a dignified African woman looking to the right, as if toward the future, and it ends with the same image printed in reverse, so that she is seen looking back over the gathered pictures—hence the title of the series. When the work is seen in its entirety, the short texts inscribed on the glass read like a bitter poem.

The Atlas Group/Walid Raad Lebanese, born 1967

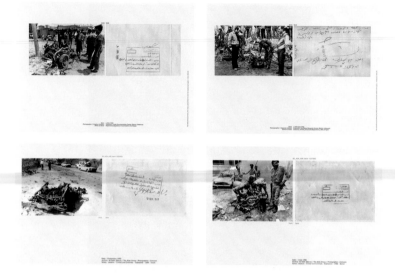

My Neck is Thinner Than a Hair: Engines. 1996–2004

One hundred pigmented inkjet prints,
each 9⁷⁄₁₆ × 13⅜" (24 × 34 cm)
Fund for the Twenty-First Century

The Atlas Group is a fictional non-profit research organization Raad founded in 1999. It presents itself to the public as a real collective with a mission to research and document the contemporary history of Lebanon, in particular the civil wars between 1975 and 1991. In the guise of The Atlas Group, Raad collects and fabricates photographs, videotapes, notebooks, and films and presents the findings in the form of exhibitions, video screenings, and lectures.

This work assembles one hundred photographs of car engines taken by amateur and professional photographers. During the civil wars, approximately 245 car bombs exploded in Lebanon, detonated by groups across the political and religious spectrums. The only part of the car that remained intact after the blast was the engine, and newspaper reports of car bombs consistently included photographs of engines and the police officers, politicians, and onlookers who gathered in the aftermath of the explosion. Raad collected the photographs from newspaper archives in Lebanon, scanned their fronts and backs, and printed them with the date of the explosion, the name of the photographer (when known), and an English translation of the notations on the backs of the pictures. From a complex political issue he extracts and clarifies one aspect: the photo opportunity. This is just one lens through which Raad examines the ways in which the economic, political, and social history of Lebanon has been recorded, recalled, and understood.

Doris Salcedo Colombian, born 1958

Untitled. 1995

Wood, cement, steel, cloth, and leather,
7' 9" × 41" × 19" (236.2 × 104.1 × 48.2 cm)
The Norman and Rosita Winston Foundation,
Inc., Fund and purchase

This sculpture is one in a series
Salcedo has created that commemo-
rates individual victims of the pro-
tracted violence and civil war in her
native Colombia. Salcedo spent weeks
with the families and loved ones of the
deceased, infusing herself with the
details of their lives. Based on these
experiences, she created sculptures
from domestic furniture and clothing
once touched by the warmth of daily
use. Complete with legs, backs, feet,
and handles, the dresser and chairs in
this untitled work may be seen as
stand-ins for the missing body of a
victim and the fractured lives of his or
her family.

The soft, warm grain of the wooden
furniture contrasts with the gray mass
of cold, hard concrete and rebar that
fills the interior spaces and violates the
structure of these objects. The furni-
ture, bulky and mute, has been ren-
dered useless by the sheer weight and
volume of the concrete. The objects
now mark time and space, bearing wit-
ness to an act of violence and function-
ing as *memento mori*. They are public
reckonings of private loss and personal
grief within a desperate, charged politi-
cal environment. "My work deals with
the fact that the beloved—the object of
violence—always leaves his or her trace
imprinted on us," Salcedo has said.

Janet Cardiff Canadian, born 1957

The Forty Part Motet. 2001

A reworking of *Spem in alium nunquam habui*, 1575, by Thomas Tallis. 40 speakers, 40-track sound recording, approx. 14 min. loop.
Gift of Jo Carole and Ronald S. Lauder in memory of Rolf Hoffmann

Cardiff's installation is a unique spatial treatment of a recorded performance of sacred choral music that was written in the sixteenth century by the English composer Thomas Tallis. It is likely that he composed the piece to honor Queen Elizabeth I on her fortieth birthday.

Written for forty male voices (bass, baritone, alto, tenor, and child soprano), *Spem in alium nunquam habui* is heard here in a performance by members of the Salisbury Cathedral Choir. During the performance, each singer's voice was recorded separately; in the installation, each one is played back on an individual loudspeaker. As visitors wander among the forty speakers, which are mounted on tripods arranged in an oval, they hear each distinct voice and also encounter various harmonies, as they would if they were walking among the actual performers. Standing at the center of the installation, a visitor hears all forty voices united in the grand musical composition.

Rineke Dijkstra Dutch, born 1959

Odessa, Ukraine. August 4, 1993

Chromogenic color print, 46⅜ × 37"
(117.8 × 94 cm)
Acquired through the generosity of Agnes
Gund

Odessa, Ukraine is one of twenty photographs of adolescents and teenagers that Dijkstra made between 1992 and 1998 on beaches in Belgium, Croatia, England, Poland, Ukraine, and the United States. Each of these portraits shows the full length of the figure standing in relief against a backdrop of sand, water, and sky. The simplicity of the pictures initially seems to deny the complexity of the content, but in fact it ultimately enhances it. While we first see each person as a shape and the pictures as interchangeable, we quickly become alert to the particulars

of a subject's posture, dress, economic status, and psychological state. In this picture the subject's gawkiness is clearly the result of his effort to present his boyish body with the confidence of an adult.

An exceptional range of vulnerability characterizes the portraits and becomes the subject of the series. This repetition of vulnerability from figure to figure creates a kind of abstraction that simultaneously describes the state of the individual and a universal human condition. In all Dijkstra's portraits, which include mothers who have just given birth and matadors who have just left the bullring, she captures people during moments of transition, when their heightened emotional or psychological states precipitate a change in their characters.

Joel Coen American, born 1955

Ethan Coen American, born 1958

Fargo. 1996

35mm, color, sound, 98 minutes
Acquired from the artists
Frances McDormand

From their very first feature film, *Blood Simple* (1984), the Coens have demonstrated an uncanny ability to find dark humor in any subject, no matter how tragic or absurd. Whether reimagining Hollywood à la Nathanael West in *Barton Fink* (1991), plumbing the depths of Depression-era noir in *Miller's Crossing* (1990), or adapting Homer for *O Brother, Where Art Thou?* (2000), this fraternal duo, who jointly write, direct, and produce, has consistently managed to draw laughter from material otherwise too sad or hopeless to endure. Conversely, in such outright comedies as *Raising Arizona* (1987) and *The Big Lebowski* (1998), the Coens explored undercurrents of pathos and sadness that other film-makers might have downplayed or ignored. In every case, they have appropriated genres with abandon in order to unveil the complexities of the human psyche.

In *Fargo* the Coens came up with the perfect combination of form and content, creating a black comedy of unusual scope and resonance. Viewed by some as a scathing attack on the Midwest (while defended by the film-makers as an homage to the region of their birth), *Fargo* deftly integrates the banal and the bizarre, the tender and the horrific. With Marge Gunderson and Jerry Lundegaard (played by Frances McDormand and William H. Macy), the Coens created characters of striking depth and emotion while at the same time presenting them as archetypes of midwestern stoicism and reserve. In *Fargo*, as in all of their works, the Coens demonstrate great affection for their characters without shying away from the potent stew of seeming con-tradictions we humans really are.

William Kentridge South African, born 1955

Telephone Lady. 2000

Linoleum cut, sheet: 7' 2⅝" × 39¹⁵⁄₁₆"
(220 × 101.5 cm)
Publisher: David Krut Fine Art, London
and Johannesburg
Edition: 25
Carol and Morton H. Rapp Fund

This towering, marching figure, with a
mid-century rotary phone in place of
a torso and head, appears at once
triumphant and astray in the barren
South African landscape. During the
1990s, a time of social and political
change in South Africa as the country's
racist apartheid government was
replaced by a democracy, Kentridge
invented a multitude of processional
figures that incorporate all manner of
quasi-mechanical objects—mega-
phones, typewriters, electrical pylons—
alluding to a bygone era and the slips
that can occur in communication. The
procession of figures also calls to mind
anti-apartheid protest marchers and
communities of uprooted families flee-
ing with their few possessions; it also
summons up the plight of refugees
worldwide.

But *Telephone Lady* is distinctly
exultant in her stride, a sign of the hope
that is part of her journey. The print
attests to the expressive potential of
the black-and-white patterning character-
istic of linoleum cut—a relief technique
with a strong tradition in South Africa.
It is one of two that Kentridge made in
2000 (the other, also in MoMA's collec-
tion, depicts a marching tree-man),
when the artist was creating oversized,
object-based props and figures for his
theatrical productions.

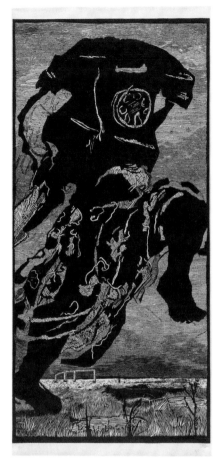

Louise Bourgeois American, born France, 1911–2010

Ode à l'oubli. 2002

Illustrated book with 32 fabric collages,
page: 11 × 12³⁄₁₆" (28 × 31 cm)
Unpublished, unique
Gift of the artist

Known for her sculptures, drawings and prints, Bourgeois made illustrated books, a format that she herself collected, from the late 1940s onward, incorporating her own texts and those of other authors. For Bourgeois, fabric had deep personal associations, as she spent her childhood living upstairs from her parents' tapestry restoration workshop and for years used textiles in sculptures or as the support for prints and drawings. She had long used her art as a means of exploring and exorcising her personal history, but this volume is unusually intimate, comprised entirely of pieces of textiles she had worn or saved since the 1920s, including nightgowns, scarves, hand towels, and table napkins from her wedding trousseau, monogrammed with her initials.

The pages of the volume, whose title translates as "Ode to Forgetting," display a variety of techniques—from appliqué and quilting to embroidery and weaving—and echo many of the forms that occupied the artist throughout her career, including totemic stacked towers, concentric circles and squares, tightly woven grids, and round organic shapes. The book incorporates two of her own texts: "I had a flashback of something that never existed" and "The return of the repressed," lines which are in keeping with the terse yet loaded prose she began publishing in the late 1940s.

Luc Tuymans
Belgian, born 1958

Lumumba. 2000

Oil on canvas, 24½ × 18" (62 × 46 cm)
Fractional and promised gift of Donald L.
Bryant, Jr.

Tuymans's painting, one of his series of works related to the history of the Congo, is based on a photograph of Patrice Lumumba, the first prime minister of what is now the Democratic Republic of the Congo. A visual reminder of an unresolved conflict in history that began with Belgian colonial rule and proceeded to Congolese independence and ongoing civil war, the painting was inspired by a debate, belatedly begun in Belgium in 2000, about the events surrounding Lumumba's assassination thirty-nine years earlier. But this stark portrait tells us nothing about Lumumba or Africa. By implication, the portrait leads our attention to Belgium's historical role in colonialism, and to the country's conflicted conscience as it confronts this past.

If, as Tuymans has said, the subject of this work is history, then the object is a vessel of historical memory. Working from his own visual memory of Lumumba's photograph rather than from the photograph itself, the artist re-created his subject through subtle changes. Lightening the shade of Lumumba's skin and altering the look in his eyes, Tuymans challenges the stereotype of the black man as "savage," a source of threat and apprehension. Is Lumumba, seen in lighter tones, a more "civilized" man? Tuymans seems to be asking us. Here, Lumumba's bemused gaze seems to question the very myth that he has become.

Tuymans's selection of this particular image recalls a mid-nineteenth-century European tradition in which vast archives of documentary photographs were built up as part of the control and surveillance of the colonized populations. Power, secrecy, and control laws stand at the origin of those archives. It is this ideological connotation of photography that Tuymans subverts by addressing it so forthrightly. The artist goes beyond photography's indexical representation, critiquing and twisting its original function in order to intertwine the representational contents of history, myth, and memory. Tuymans inspires the viewer to ponder the creation of cultural identity through political history. Through Lumumba's gaze we see the artist gazing at history.

Jonathan Ive
British, born 1967, and Apple Industrial Design Group, U.S.A., est. 1976

iPod. 2001

Polycarbonate plastic and stainless steel,
4 × 2½ × ⅞" (10.2 × 6.4 × 2.2 cm)
Manufactured by Apple, Inc.
Gift of the manufacturer

At the time the iPod was born, Jonathan Ive, the head of Apple's design group, had been overhauling the company's hardware design with his team since 1997, using a new palette of materials characterized most prominently by translucent polycarbonate plastic. The iPod, a portable hard drive initially used exclusively as an MP3 player, introduced stainless steel into Apple's material repertoire.

The iPod exponentially expanded the typical capacity of a music device within a physical framework that was significantly smaller, cleaner, and more intuitive than any similar player. The first-generation iPod features a mechanical scroll wheel, four navigational buttons along its circumference, and a black-and-white text screen.

The iPod's data and its power supply are transferred through a USB cord to a computer or other power outlet, thus eliminating the need for any additional detachable parts besides the earphones.

The first-generation iPod has substantially influenced the quality and elegance not only of portable music devices, but of electronic products in general. It has raised the public's expectations for all consumer products, thus stimulating manufacturers to recognize the importance of good design and to incorporate design considerations at the highest levels of their corporate structures.

The iPod, a feat of product and interface design, has had a dramatic effect on the way people live with technology. Coupled with its "mothership" application, iTunes, the iPod has launched a new way to buy, experience, and store music and audio entertainment, educational programs, information, and video.

Pipilotti Rist
Swiss, born 1962

Ever Is Over All. 1997

Video installation with two projections, dimensions variable
Fractional and promised gift of Donald L. Bryant, Jr.

Pipilotti Rist's imagery invites many interpretations. Culled from resources as rich and varied as fairy tales, feminism, contemporary culture, and her own imagination, the artist's color-saturated projections are a sophisticated visual amalgam of wit, humor, and irony.

In *Ever Is Over All,* two sharply contrasting videos are projected on adjacent walls. On the right is a field of bright red long-stemmed flowers filmed in close-up with a roving camera; on the left, filmed in medium- and long-shot, a smiling young woman wearing a blue dress and red shoes. Walking toward the viewer in slow motion along a car-lined sidewalk, she suddenly raises what appears to be one of the blooms seen in the projection to the right and, in a burst of inexplicable violence, uses it to smash the window of a parked vehicle. As she continues down the sidewalk and shatters another car window, a policewoman offers a friendly salute in passing. The young woman gleefully carries on breaking windows.

Fiction-versus-reality is an important theme for Rist, in whose work an odd combination of nightmare and magic prevails over the logic of common sense. In *Ever Is Over All*, the artist juxtaposes the field and its flowers with her magically powerful wand, and transmutes acts of aggression and annihilation into benevolent and creative deeds.

<div style="border:1px solid">

Verdana, Regular

Aa Bb Cc Dd Ee Ff Gg Hh Ii Jj Kk Ll Mm Nn Oo Pp Qq Rr Ss Tt Uu Vv Ww Xx Yy Zz 1 2 3 4 5 6 7 8 9 0

</div>

Verdana. 1996

Digital typeface
Gift of Microsoft Corporation

Verdana is part of a group of 23 digital fonts that form the initial core of a new section in MoMA's collection. Like the design of objects and buildings, typeface design reflects social developments, advances in materials and means of production, cultural biases, and technological progress. It is an essential dimension of the history of modern art and design.

The creator of Verdana, Matthew Carter, moved seamlessly from his beginnings in the field, when typefaces were families of lead blocks, into the digital realm. Unlike most digital typefaces—designed on a screen but intended to be read on paper—Verdana, commissioned by Microsoft Corporation, was made for use on the computer screen and was conceived to be easily readable at small sizes. Because of its simple curves and large, open letterforms, negative spaces do not fill in even when the character is formatted as bold, enhancing legibility. The letters are widely spaced on the screen so they are legible even when displayed in computer applications that don't control spacing, and they never touch, regardless of combination. Characters that look alike—such as i, I, and 1—are designed to be as dissimilar as possible. In addition, the bold version of Verdana is easy to recognize and distinguish from the "regular" (called "roman" in the typeface trade) style of the typeface onscreen.

Thomas Demand
German, born 1964

Poll. 2001

Chromogenic color print,
71" × 8' 6" (180.3 × 259.1 cm)
Fractional and promised gift of Sharon Coplan
Hurowitz and Richard Hurowitz

Most photographs in the press are consumed at a glance. A few become lasting symbols of famous events. In between lies Demand's raw material: images that might once have seemed to mean a lot, although we cannot quite remember why. Omitting the figures (if any), Demand remakes these scenes in crisp and colorful life-sized constructions of paper and cardboard. Photographing his elegant handiwork, he renders the original image with an uncanny clarity it never before possessed.

Poll applies this strategy to the bizarre flashpoint of the 2000 election for president of the United States: the site at which Florida's contested paper ballots were assembled for intense scrutiny. At once artificial and vivid, Demand's image explains the scene no better than the photograph on which it is based. But perhaps it is less likely to be forgotten.

Chris Ofili
British, born 1968

Prince amongst Thieves. 1999

Oil, paper collage, glitter, resin,
map pins, and elephant dung on linen,
8 × 6' (243.8 × 182.8 cm)
Mimi and Peter Haas Fund

Ofili's intensely worked, vibrant paintings combine a wide range of referents, from African burlesque to Western popular culture. Using a cut-and-mix technique and repetitive patterning, the works evoke the anarchic rhythm of hip-hop lyrics and performance. *Prince amongst Thieves* features the caricatured yet regal profile of a bemused man of African descent, set against a densely ornate background dotted with countless minute collages of the heads of illustrious black figures. The work's shimmering, psychedelic surface of sprayed pigment, synthetic polymer paint, glitter, elephant dung, and splashes of translucent resin produces a ritualistic effect that parodies stereotypes of black culture while celebrating difference. The lacquered clumps of elephant dung on which the canvas rests have become a signature for Ofili, and they confer on the painting a sculptural and perhaps even totemic presence, invoking African tribal art, with which Ofili (who is of Nigerian descent) became familiar during a visit to Zimbabwe, in 1992.

The artist uses elephant droppings procured from the London Zoo, thereby probing his cultural heritage and urban experience in ways that confound identity typecasting. Ofili's mix of hybrid sources culled from popular magazines, music, folk art, and the tough streets around his Kings Cross studio, in London, epitomizes a new form of counterculture that subtly reworks Western perceptions of blackness.

Mark Grotjahn American, born 1968

Untitled (Red Butterfly 112). 2002

Colored pencil on paper,
24 × 19" (61 × 48.3 cm)
The Judith Rothschild Foundation Contemporary Drawings Collection Gift

Mark Grotjahn's devotion to his distinctive format recalls the belief of early twentieth-century proponents of abstraction in the universal nature of their artistic language. His sense of the expressive possibilities of abstraction is demonstrated by his exploration of his signature motif, a butterfly form. In *Untitled (Red Butterfly 112)*, radiating lines of color in red, white and blue emerge from two distinct vertical vanishing points to form flanking wings, which are divided and bordered by additional bands of colored lines. Grotjahn has maintained this general format for his Butterfly series and has created endless possibilities for this particular theme, varying color, line, and shape.

In each drawing he commits to a limited but vibrant palette, covering the paper with controlled strokes of colored pencil in order to investigate perspective. His process is more intuitive than the works' consistent patterns may imply, as he uses the naked eye rather than a ruler or straightedge to determine the converging points of the wings' bands of color.

Matthew Barney American, born 1967

The Cabinet of Baby Fay La Foe.
2000

Polycarbonate honeycomb, cast stainless
steel, nylon, solar salt cast in epoxy resin,
top hat, and beeswax in nylon and plexiglass
vitrine, 59" × 7' 11½" × 38¼" (149.8 ×
242.6 × 97.2 cm)
Committee on Painting and Sculpture Funds

The Cabinet of Baby Fay La Foe is a
twenty-first-century cabinet of curiosi-
ties, a sculpture whose overall form
doubles as a display case, yet whose
enigmatic contents resist classifica-
tion. Preserved behind plexiglass are a
stylized séance table, a stack of bar-
bells cast in solar salt, and a veiled top
hat filled to the brim with honeycombed
beeswax. A vaguely anthropomorphic
recumbent shape made of cast solar
salt fixed with epoxy resin seems part
body fragment, part crystalline land-
scape, and appears suspended in a
state between becoming and unbecom-
ing. All, except the barbells, are attri-
butes of Baby Fay La Foe, a real-life
clairvoyant as well as a character in
Barney's gothic Western *Cremaster 2*

(1999), the fourth film in the artist's
epic, five-part Cremaster cycle.

Barney's overarching concerns are
with the mutability, metamorphosis,
and creation of form. Best known for
his feature-length films, he calls him-
self a sculptor, insisting that all of his
production—films, photographs, draw-
ings, sculptures, banners, and installa-
tions—exists as a series of discrete
yet interrelated objects within the multi-
dimensional space of the Cremaster
cycle's universe. *The Cabinet of Baby
Fay La Foe* recapitulates on a micro-
cosmic level key features of Barney's
expansive cosmology. Drawing on
Surrealist strategies of fragmentation,
uncanny juxtaposition, and fetishistic
display, the luminous nylon borders of
the cabinet's vitrine are a material
manifestation of film's (and photogra-
phy's) invisible frame. Filled with fan-
tasy objects constructed from the
artist's signature materials, the work is
nominally a symbolic portrait, yet any
fixed meanings remain sealed off, sub-
ject to transformation and thus tantaliz-
ingly out of reach.

Jeff Wall
Canadian, born 1946

After "Invisible Man" by Ralph Ellison, the Prologue. 2001

Silver dye bleach transparency (Cibachrome) on aluminum light box, 7' 2⅝" × 9' 6³⁄₁₆" (220 × 290 cm)
The Photography Council Fund, Horace W. Goldsmith Fund through Robert B. Menschel, and acquired through the generosity of Jo Carole and Ronald S. Lauder and Carol and David Appel

After a brief but eventful career that embodies the hopes and humiliations of African Americans at mid-twentieth century, the hero of Ralph Ellison's celebrated 1952 novel *Invisible Man* retreats to a secret basement room on the edge of Harlem. There he patiently composes and reflects upon the story we are about to read. "I am invisible," he explains, "simply because people refuse to see me."

Making pictures out of stories was once the main business of the visual arts. The rising modernist tradition con- signed the practice to the margins of advanced art; for most of the past century, "illustration" has been a term of contempt. In this large, richly detailed and thoroughly absorbing photograph, Wall has all but single-handedly reinvented the challenge.

The novel's eloquent prologue is short on specifics, except one: the 1,369 lightbulbs that cover the ceiling of the underground lair. Starting with this fantastic detail, Wall scrupulously imagined in his Vancouver studio the concrete form of Ellison's metaphorical space. Ambitiously reviving a forgotten art, he made visible the Invisible Man.

Francis Alÿs

Belgian, born 1959

Untitled (series for The Modern Procession, June 23, 2002, New York City). 2002

Pencil, colored pencil, ink, gouache, ballpoint pen, felt-tip pen, and cut-and-pasted printed paper on pieces of transparentized paper with pressure-sensitive tape, pressure-sensitive stickers, black-and-white instant prints, chromogenic color prints, postcards, paper clips, maps, and printed papers on pine tables with acrylic sheeting, metal architectural lamps, and two-channel video (sound, color) Installation approximately: 40 × 32 × 84" (101.6 × 81.3 × 213.4 cm)

Purchased with funds provided by The Silverweed Foundation

On Sunday, June 23, 2002, a procession set off from The Museum of Modern Art on West 53rd Street in Manhattan to MoMA QNS, the Museum's new temporary exhibition quarters across the Queensborough Bridge in Long Island City, Queens. The procession coincided with the closing of the Museum's Manhattan building for renovation, and was conceived by Alÿs especially for the occasion.

Participants in the parade, an adaptation of the religious processions held in Alÿs's native Belgium and his adopted home, Mexico, included art workers, a soccer team, a brass band whose music set the pace, a horse, several dogs, a "living icon"—the artist Kiki Smith, born aloft on a palanquin—and others, scattering flower petals and blowing soap bubbles. On three additional palanquins, marchers carried copies of famous works from MoMA's collection—Picasso's *Les Demoiselles d'Avignon*, Duchamp's *Bicycle Wheel*, and Giacometti's *Standing Woman #2*—ceremoniously transporting them to their new home.

The Modern Procession was filmed by the artist and his team and edited into several versions. This two-screen version, along with preparatory drawings, was exhibited at MoMA QNS in 2002 and acquired by the Museum shortly thereafter.

Kara Walker

American, born 1969

Exodus of Confederates from Atlanta from Harper's Pictorial History of the Civil War (Annotated). 2005

One from a portfolio of 15 lithograph and screenprints, sheet: 39¹⁄₁₆ × 52¹⁵⁄₁₆" (99.2 × 134.4 cm)
Publisher: LeRoy Neiman Center for Print Studies, Columbia University, New York
Edition: 35
General Print Fund and The Ralph E. Shikes Fund

"These prints are the landscapes that I imagine exist in the back of my somewhat more austere wall pieces," Walker has said of her portfolio of fifteen monumental prints—one of the artist's first direct engagements with the type of historical material that informs her work overall. Walker's art typically incorporates cut-paper silhouettes, based on a form popular in the nineteenth century, which she installs directly on white gallery walls. For this print portfolio, Walker layered her silhouettes over illustrations she reproduced from *Harper's Pictorial History of the Civil War* (1866), a compendium based on materials from *Harper's Weekly*, the most widely read periodical of the Civil War era. These illustrations, which provide insight into the racial injustices of the period, emphasize Walker's overall objective: to investigate race, gender, sexuality, and oppression in the antebellum South and American Civil War period and to examine the role they play in the stereotypes of today.

In each print Walker sets up a dialogue between new and old imagery, masking certain details and bringing others into focus and expanding the narrative beyond the conventional telling of history. In this example her use of positive and negative space (a silhouette within a silhouette) spotlights an African-American boy who is loading a caravan of white civilians ordered to evacuate following Confederate Army losses in Atlanta.

Paul Chan American, born Hong Kong 1973

1ˢᵗ ~~Light.~~ 2005

Video, color, silent, 14 min. loop
Acquired through the generosity of Maja Oeri
and Hans Bodenmann

This digital video animation is the first
work in Paul Chan's seven-part cycle
The 7 ~~Lights~~ (2005–2007). Projected
on the floor, *1st ~~Light~~* assumes the
form of a window opening onto surreal
imagery—dark silhouettes of large
objects such as a streetcar, a motor-
bike, debris—drifting above the ruins of
a ravaged city. Shadows of human bod-
ies plummet through the coldly lighted
sky, evoking the distressing images of
the attacks on New York's World Trade
Center in 2001 and inducing a sense of
looming disaster, which pervades all
seven works in the ~~Lights~~ cycle.

In the work's title, the word "light"
has been struck through, alluding
literally and figuratively to the simulta-
neous presence and absence of light.
Technically, a projected image is cre-
ated by a light source shining on a sup-
port located in a space largely purged
of light. Allegorically, Chan's choice of
title can also be related to biblical
accounts of the creation of the world
beginning, according to the Book of
Genesis, with God's separation of light
and darkness into day and night.

United Architects American, founded 2002

World Trade Center proposal.
2002

Milled acrylic, two maquettes, 6⅞ × 2 × 1½"
(17.5 × 5.1 × 3.8 cm); 5 × 2 × 1½"
(12.7 × 5.1 × 3.8 cm)
Gift of the architects

This scheme for five linked towers was designed by an ad hoc team of architects for the site of the former World Trade Center towers. The principal elements of each tower are a square concrete core and two or more column-free volumes of habitable space that wrap around it. The supporting framework is a diagonally braced skin; its flexibility and strength allow the exterior tubes to expand and contract as they wrap around the core, producing the dynamic appearance of the ensemble. Each of the five towers is a self-supporting structure. Conjoined, they are able to resist tremendous forces through mutual support, and unlike traditional freestanding vertical towers, they offer multiple routes of escape and firefighting access. A "sky park" creates a lofty horizon at the fifty-fifth floor, linking all the towers and bringing public access and social space to the highest common point.

This never-to-be-realized design celebrates the tall building as a technical and cultural achievement and represents the peak of the fervid creativity sparked by the tragic collapse of the Twin Towers on September 11, 2001, when New York City was faced with an opportunity to reconsider not only the World Trade Center but also the planning of Manhattan's historic downtown and waterfront. The soaring towers would have created a remarkable silhouette on the skyline, a symbol of collectivity.

Cai Guo-Qiang Chinese, born 1957

Drawing for Transient Rainbow.
August 2003

Gunpowder on two sheets of paper
179 × 159½" (454.7 × 405.1 cm) (overall)
Fractional and promised gift of Clarissa
Alcock Bronfman

Trained in stage design at the
Shanghai Theater Academy, Cai Guo-
Qiang has since worked in many medi-
ums, including drawing, installation,
video, and performance art. His
unusual choice of gunpowder and fire-
works as materials for his art stems
from his childhood in China, where fire-
works often mark celebratory events.
For this vast drawing, Cai exploded
gunpowder that he had sandwiched
between two sheets of paper, creating
the symmetrical traces of two arcs.

The sheer force of the explosion
is tangible. In places, the paper is
burned through or charred. The making
of the drawing is evident as a process
that is both raw and delicate, an
orchestrated and yet spontaneous
event of order as well as chance. Cai
explains, "I spend so much time pre-
planning how to lay the fuses so as
to have control and play against the
power of the powder and the fuses.
But . . . it doesn't always happen as
expected, even if preplanned."

Rainbows are a recurring motif in
Cai's projects. In 2002 his rainbow of
fireworks joining Manhattan and Queens
over the East River marked MoMA's
temporary move to Long Island City.
While fireworks produce fleeting sprays
of light that fade almost instantly, in
this drawing the artist has captured
their traces on paper, allowing the
image to outlive the event.

Trisha Donnelly · American, born 1974

Satin Operator. 2007

One from a series of thirteen digital prints,
sheet: 62½ × 44" (158.8 × 111.8 cm)
Publisher: the artist, New York and
San Francisco
Edition: 3
The Print Associates Fund and General Print
Fund

Since the late 1990s, Donnelly has developed an art practice that resists straightforward interpretation and categorization by medium. From a video of the artist performing a rain dance projected alongside a photograph of a misty landscape whose weather conditions were ostensibly brought on by her ritual, to an illustrated lecture on prismatic vision punctuated by phonograph recordings, Donnelly's works require a degree of commitment on the viewer's part, an openness to follow the artist through her explorations of space and time, fact and fiction, the physical and the metaphysical.

Satin Operator takes us on one such journey. A photograph of a Hollywood film starlet appears to be wrapped around a packing tube. As if unfolding cinematically, with each of the thirteen prints capturing a sequential frame, the tube is twisted and torqued, the cylindrical form stretching in one direction while the photograph rotates in another. The starlet is never fully seen; her face comes partially into view before turning away again.

Donnelly once described her experience of staring at an image for so long that it appeared to crack, splitting into a "stutter of multiple images." In *Satin Operator*, using digital imaging software to virtually render each permutation, Donnelly created a physical manifestation of this stutter—a sequence of transformations over space and time.

Andreas Gursky German, born 1955

Bahrain I. 2005

Chromogenic color print, 9' 10⅞" × 7' 2½"
(301.9 × 219.7)
Acquired in honor of Robert B. Menschel
through the generosity of Agnes Gund,
Marie-Josée and Henry R. Kravis, Ronald S.
and Jo Carole Lauder, and the Speyer Family
Foundation

In this monumental photograph, the flat, black curves of the Formula One racetrack snake in exaggerated arcs and twists across a sandy desert in Bahrain. Shot from a vantage point high above the ground, the complex network of the track resembles the gestural black strokes of an Abstract Expressionist canvas by Franz Kline. Indeed, this photograph, almost ten feet in height, dominates the wall in the manner of a painting.

After studying with the photographers Bernd and Hilla Becher at the Kunstakademie in Düsseldorf, Gursky went on to create large-scale photographs of contemporary urban and rural sights across the globe, including international business headquarters, undulating crowds of young partiers, and vast landscapes of vivid color. Astounding in their intricacy, the plentiful details in his images ground the subjects in specific times and places and at the same time highlight the pictures' patterns and surfaces. Directional markings, lights, and corporate logos are visible across the Bahrain raceway, but there are no apparent spectators or even workers maintaining the track.

In his recent work, Gursky has used digital manipulation to great effect. This picture has been created by splicing together multiple shots and eliminating specific details to create a multi-layered yet seamless web. Gursky has conjured a place that is at once hyper-real and implicitly artificial; a constructed reality in keeping with his contemporary subject.

Olafur Eliasson Icelandic, born 1967

I only see things when they move. 2004

Wood, color-effect filter glass, stainless steel, aluminum, HMI lamp, tripod, glass cylinder, motors, control unit, dimensions variable
Gift of Marie-Josée and Henry R. Kravis in Honor of Mimi Haas

The Danish-Icelandic artist Olafur Eliasson conceives of immersive environments. *I only see things when they move* is an installation in which bright light shines through rotating color-filtered glass panels, projecting shifting bands of colors on the surrounding walls. Probing the cognitive aspects of what it means to see, Eliasson creates complex optical phenomena using simple, makeshift technical devices such as mirrors that reflect spotlight beams, and kaleidoscopes that produce colorful prismatic effects. By making visible the mechanics of his work and laying bare the artifice behind the illusion, Eliasson points to the elliptical relationship between reality, perception, and representation. He presents perception as it is lived in the world. Because viewers do not stand in front of his works, observing them as they would a picture, but rather are situated and actively engaged within them, Eliasson's installations posit the very act of looking as a social experience. *I only see things when they move* literally stages perception in motion, demonstrating the artist's ongoing exploration of subjectivity, reflection, and the fluid boundary between nature and culture. Eliasson thus reveals the degree to which reality is constructed and engages people to reflect critically on their experience of it.

Laura Kurgan South African, born 1961;

Eric Cadora American, born 1962;

David Reinfurt American, born 1971;

Sarah Williams American, born 1974;

Spatial Information Design Lab U.S.A., est. 2004;

Columbia University Graduate School of Architecture, Planning and Preservation U.S., est. 1881

Architecture and Justice from the **Million Dollar Blocks project.** 2006

ESRI ArcGIS (Geographic Information System) software
Gift of the designers

Of the more than two million people in jails and prisons in the United States, a disproportionate number come from just a few neighborhoods in the country's biggest cities. In many places the concentration is so dense that states are spending more than $1 million a year to incarcerate the residents of single city blocks. Using rarely accessible data from the criminal justice system, the Spatial Information Design Lab and the Justice Mapping Center have created maps of these "million dollar blocks" and of the city-prison migration flow in five of the nation's cities.

Million Dollar Blocks introduces us to the political potential of visualization design, a form of design that has existed for centuries and that has recently developed exponentially because of the ever-increasing amount of data that can be processed by computers. "Guided by the maps of Million Dollar Blocks," explains Laura Kurgan, "urban planners, designers, and policy makers can identify those areas in our cities where, without acknowledging it, we have allowed the criminal justice system to replace and displace a whole host of other public institutions and civic infrastructures. . . . What if we sought to undo this shift, to refocus public spending on community infrastructures that are the real foundation of everyday safety, rather than on criminal justice institutions of prison migration?"

Andrea Geyer German, born 1971

Sharon Hayes American, born 1970

Ashley Hunt American, born 1970

Katya Sander Danish, born 1970

David Thorne American, born 1960

9 Scripts from a Nation at War.
2007

Ten-channel video installation, color, sound,
total 8 hrs. 53 min. 45 sec. loop
Committee on Media and Performance
Art Funds

In wartime, as governments, mass
media, and political parties carefully
craft and manage public opinion, art-
ists can create unique spaces that
allow for speech, performance, critical
thinking, and responses that might not
be possible or permitted elsewhere.
9 Scripts from a Nation at War responds
to conditions and questions that have
arisen since the invasion of Iraq that
was led by U.S. military forces in
March 2003.

A collaborative project created for
Documenta 12, the work is structured
around the roles engendered by and
particular to war that individuals fill,
enact, speak from, or resist. Displayed
in a circuitous, non-narrative structure,
both as wall projections and at seated
viewing stations, each of the ten
videos portrays a different perspective
on the involvement of U.S. troops
in global war zones. Presented are the
views of the Citizen, the Blogger, the
Overseas Correspondent, the Veteran,
Student, Actor, Interviewer, Lawyer,
Detainee, and Source. Using docu-
mentary and constructed footage,
the scripts are performed by actors
and non-actors: some speak their
own words; some recite the words of
others. Together these video perfor-
mances address the implications of
war for individual and collective experi-
ence and the role of language in struc-
tures of power during times of conflict.

Kathryn Bigelow

American, born 1951

The Hurt Locker. 2008

35mm film, color, sound, 131 min.
Gift of Summit Entertainment

Sergeant First Class Will James (Jeremy Renner) is a live wire. An accomplished bomb tech stationed with an Explosive Ordnance Disposal (EOD) unit in Baghdad, James seems at ease only when facing his own mortality. He shields his uncertainty and vulnerability behind bravado and exorcises his personal demons on the battlefield. His reckless courage, at once irksome and dangerous to his unit—no-nonsense Sergeant J. T. Sanborn (Anthony Mackie) and nervous newbie Specialist Owen Eldridge (Brian Geraghty)—compels a dissection of combat brotherhood.

Bigelow received widespread critical distinctions for this propulsive and penetrating film, which received Academy Awards for Director, Picture, Original Screenplay, Film Editing, Sound Editing, and Sound Mixing. Before moving into filmmaking, she studied at the San Francisco Art Institute and in the Whitney Museum of American Art's Independent Study Program. As a writer, director, and producer, she has created a canon of immersive films that exhilarate and affect audiences and defy expectations. Whether combining a vampire movie with a Western

(*Near Dark*, 1987), a surfing film with a heist thriller (*Point Break*, 1991), a film noir with science fiction (*Strange Days*, 1995), or embedding an intimate character study in a war movie (*The Hurt Locker*), Bigelow transforms the language of genre and challenges audiences to rethink filmic iconography.

Harun Farocki
German, born Czechoslovakia, 1944

Ernste Spiele I: Watson ist hin (Serious Games I: Watson is Down). 2010

Two-channel video installation, color, sound, 8 min. loop
Committee on Media and Performance Art Funds

Ernste Spiele I: Watson ist hin (*Serious Games I: Watson is Down*) is the first part in Farocki's series of four video installations titled *Ernste Spiele I-IV* (*Serious Games I-IV*) 2009–10, which explores the use of video game technology as an instrument of war. Filmed at the United States Marine Corps Air Ground Combat Center in Twentynine Palms, California, the piece juxtaposes footage of soldiers in combat-simulation training with their virtual counterparts and comments on the relationship between technology and violence.

Early on, galvanized by the international student protest movement of the late 1960s, Farocki explored the role of film in inciting political change and questioned the capacity of recorded images to communicate the realities of war. Known for his "essayistic" visual language exploring images through images, the artist integrates his own material with footage appropriated from a wide range of sources, including industrial and military surveillance and political propaganda. In the past decade, Farocki has translated this approach from the cinematic environment to video installations intended for a gallery setting. With *Ernste Spiele I-IV*, the artist continues to re-evaluate the impact of mass media on society.

Pentagram (UK and USA, est. 1972),

Lisa Strausfeld (American, born 1964),

Christian Marc Schmidt (German, born 1977),

Takaaki Okada (Japanese, born 1978),

Walter Bender (American, born 1956),

Eben Eliason (American, born 1982),

One Laptop per Child (USA, est. 2005),

Marco Pesenti Gritti (Italian, born 1978),

Christopher Blizzard (American, born 1973),

Red Hat, Inc. (USA, est. 1993)

Sugar Interface for the XO Laptop. 2006–07

Design: Illustrator, Photoshop, Flash, Inkscape, and GIMP (GNU Image Manipulation Program) software; implementation: Python, GTK+ (GIMP Toolkit), and Cairo software
Gift of the designers

One Laptop per Child (OLPC), a nonprofit program begun at the MIT Media Lab in 2005, envisioned an inexpensive computer that would be subsidized and distributed by governments and NGOs to schools all over the globe. XO, the first model, is sturdy, colorful, and tightly designed to be the size of a textbook and lighter than a lunchbox. Wireless-access antennas double as covers for the USB ports, and if electricity is not available, the laptop can be recharged by human-powered devices.

One of XO's remarkable features was Sugar, its dedicated interface, which was later abandoned in favor of an easier to maintain, modified version of Windows XP. Sugar was an icon-driven interface that recognized and exploited a child's potential to be "both a learner and a teacher." Collaboration is the core of the XO experience design, and the laptop encourages social interaction. Most activities center on the creation of an object—a drawing, a song, a story, a game—and on "real-world metaphors" such as chatting, sharing, and gathering. All the laptops are connected in a wireless network, both to the web and to one another. The more laptops that are connected, the more powerful the network becomes, a metaphor for the power of shared knowledge to overcome adversity and poverty.

Ellen Gallagher American, born 1965

Bad Skin and Blow up from DeLuxe. 2004–05

Two from a portfolio of sixty photogravure, etching, aquatint, and drypoints with lithography, screenprint, embossing, tattoo-machine engraving, laser cutting, and chine collé; additions of Plasticine, paper collage, enamel, varnish, gouache, pencil, oil, polymer, watercolor, pomade, velvet, glitter, crystals, foil paper, gold leaf, toy eyeballs, and imitation ice cubes, each: 13 × 10½" (33 × 26.7 cm)
Publisher and printer: Two Palms Press, New York. Edition: 20
Acquired through the generosity of The Friends of Education of The Museum of Modern Art and The Speyer Family Foundation, Inc. with additional support from the General Print Fund

A tour-de-force of contemporary printmaking, *DeLuxe* combines a veritable riot of mediums that span more than a century of printmaking's history, from the favored Victorian technique of photogravure to recent developments in digital printing and laser-cutting. The suite was produced using unorthodox tools such as tattoo machines and scalpels, and it incorporates materials ranging from velvet and gold leaf to slicks of greasy pomade. Other elements include Plasticine cutouts,

plastic ice cubes, googly eyeballs, and crystals.

Pages from Gallagher's collection of vintage African-American lifestyle magazines—issues of *Our World* and *Ebony* dating from the 1930s to the 1970s—serve as the base layer for *DeLuxe*. While some of the prints are based on celebrity features or news stories, most often the artist has chosen advertisements that appeal to the desire for transformation: wigs, girdles, skin bleaching creams, hair pomades, and acne treatments. The pages were cut up, then entirely recomposed in layouts that radically transform their original form and content.

In a reference to the project's source material, *DeLuxe* functions as a kind of exploded book or magazine. It features a cast of characters from vaudeville performer Bert Williams to invented personas, and suggests multiple non-linear narratives that address Gallagher's many concerns, including identity, portraiture, transformation, history, literature, advertising, and commodity, in a project that redefines printmaking for the twenty-first century.

Rachel Harrison American, born 1966

Alexander the Great. 2007

Wood, chicken wire, polystyrene, cement,
Parex, acrylic, mannequin, Jeff Gordon waste
basket, plastic Abraham Lincoln mask, sun-
glasses, fabric, necklace, and two unidentified
items, 7' 7" x 7' 3" x 40" (231.1 x 221 x
101.6 cm)
Purchase

Harrison first gained critical attention
in the late 1990s for her three-
dimensional assemblages that mix
popular culture, politics, and art his-
tory. By mixing unorthodox materials
into formally astute amalgamations,
she plays with the conventional opposi-
tions between painting and sculpture,
found and made, artwork and pedestal,
and high and low culture.

This work belongs to a group
Harrison made in 2007 and titled with
the names of famous men, including
Al Gore, Tiger Woods, and Johnny

Depp. Here, she references an ancient
emperor, and the brightly colored
grouping mimics the arrangement of a
parade float: a sexless store manne-
quin in a sequined cape assumes the
pose of a conqueror perched on top of
a large mass that evokes a meteorite
as well as a boat. The multihued pat-
tern painted on the lumpy base recalls
the elevated forms of abstract painting
as much as the kitsch of decorative
patterns of wallpaper or shag carpets.
The visage of President Lincoln attached
to the back of the figure's head in the
form of a child's Halloween mask dis-
rupts the convention of presenting soli-
tary figures in heroic statues. A trash
can held by the mannequin is branded
with the face of NASCAR driver Jeff
Gordon, introducing a contemporary
reference into Harrison's ambivalent
presentation of masculinity.

Katharina Fritsch German, born 1956

Figurengruppe (Group of Figures).
2006–08 (fabricated 2010–11)

Bronze, copper, and stainless steel,
lacquered, dimensions variable
Gift of Maja Oeri and Hans Bodenmann
(Laurenz Foundation)

Among the unlikely assortment of
characters and objects brought
together in *Figurengruppe*, Katharina
Fritsch's first work specifically created
for outdoor display, are a green Saint
Michael slaying the dragon, Saint
Nicholas in bishop's purple, a matte
black Saint Catherine with a serpent of
the same color at her feet, a towering
dove-gray giant balancing his weight
on an enormous club, a dove-gray urn,
and, in porcelain white, a woman's
nude torso and a pair of skeleton
feet. These sculptures were originally
made to be included in multi-media
installations that have been central to
Fritsch's sculptural practice of the past
decade. The last addition to the group
was the lemon-yellow Madonna, a fig-
ure that first appeared in the artist's
oeuvre more than twenty-five years ago.

While some of the pieces have
specific symbolic or autobiographical
significance for the artist, they all
share the odd sense of simultaneous
familiarity and strangeness typical of
Fritsch's work. Though clustered
together, the figures stare up, down,
or straight ahead, oblivious to the com-
pany. It is by means of this internal
incongruity, heightened by jarring color,
that *Figurengruppe* revitalizes the cen-
turies-old artistic tradition of figurative
garden sculpture.

Jennifer Allora American, born 1974
Guillermo Calzadilla Cuban, born 1971

Stop, Repair, Prepare: Variations on Ode to Joy for a Prepared Piano No. 1. 2008

Prepared Bechstein Piano, 40 × 67 × 84"
(101.6 × 170.2 × 213.4 cm), performance
duration 25 min.
Gift of the Julia Stoschek Foundation,
Düsseldorf
Pianist Amir Khosrowpour

Combining sculpture and performance, *Stop, Repair, Prepare: Variations on Ode to Joy for a Prepared Piano* involves a musician performing part of Beethoven's Ninth Symphony while standing up through a hole carved into the center of a grand piano. From his or her position within the circular gap in the instrument, the pianist leans out over the keyboard to play—upside down and backwards—the famous fourth movement of Beethoven's Ninth Symphony, usually referred to as the "Ode to Joy." The pianist walks while (s)he plays, propelling the instrument, which is mounted on wheels, slowly through the space.

What is heard in this piece conceived by the artist duo Allora & Calzadilla is a structurally incomplete version of the ode—the hole in the piano renders two octaves inoperative. The gap fundamentally changes the player/instrument dynamic as well as the signature melody, emphasizing the contradictions and ambiguities of a piece of music that has long been invoked as a symbol of humanist values and national pride by governments with widely divergent political agendas.

"We're asking the musicians to reinvent their skills, or to use their skills to make new gestures or forms that are not part of their standard vocabulary," the artists say. "And this idea of re-skilling doesn't end with the performer. The public is asked to re-skill its way of viewing." In this way Allora & Calzadilla are subverting the traditional and expected roles of the artist and the public.

El Anatsui
Ghanaian, born 1944

Bleeding Takari II. 2007

Aluminum and copper wire
12' 11" × 18' 11" (393.7 × 576.6 cm)
Gift of Donald L. Bryant, Jr. and Jerry Speyer

El Anatsui's large-scale tapestries are made of used bottle caps and foil seals from liquor bottles. The artist connects these materials with copper wire, then drapes the resulting "fabric" in horizontal folds and hangs it on the wall. Anatsui first achieved international recognition in the 1990s for his work in wood and ceramics. He began using discarded bottle caps at the end of that decade, attracted to them partly for the way their bent forms retain traces of the hands that pried them off and cast them away. Linked together, the bottle caps and foil seals allude to the importance of liquor as an international trade commodity in colonial and post-colonial Africa.

The red portions of the metallic surface of *Bleeding Takari II* appear to soak into the "cloth" and drip onto the floor like blood. Yet the violence implied need not be seen as entirely destructive. Regeneration, Anatsui says, "comes with blood as well, like childbirth," and brokenness and decay can also be "a condition for new growth, rebirth." Anatsui uses the term "Takari" freely to designate, in his words, "any thing, person, object, country, even continent." Thus the "bleeding" of the title, might describe the condition of an individual, a group, or all living things.

Thomas Schütte
German, born 1954

Krieger. 2012

Wood, two figures, 119¼ × 49½ × 45⅛"
(302.9 × 125.7 × 114.6 cm) and 117½ ×
57 × 56½" (298.5 × 144.8 × 143.5 cm)
Acquired through the generosity of a group
of Trustees and Committee Members of The
Museum of Modern Art, and Committee on
Painting and Sculpture Funds

Krieger, the German word for "warrior"
in both the singular and the plural,
identifies two towering wooden figures.
One, his right arm just a stump and
his torso missing its lower half, stands
on two gnarled, stilt-like legs that
extend to his chest. The other, his
whole length more fully defined, plants
his feet and clutches a staff as if
poised in defense. It is not clear if the
two are partners or opponents.

Although the figures join a tradition
of monumental figurative sculpture
that extends through the centuries,
the method of their making sets them
squarely in the twenty-first. Digital
scans of two small hand-carved
figures served as 3-D blueprints for
these modern-day colossi. (The size of
the source figures may be inferred
from the warriors' headgear, modeled
on bottle caps worn by the originals.)
Schütte hand-carved the sculptures'
surfaces in order to achieve precise
articulation of facial features and
bodily nuance. He then used a blow
torch to blacken them, dramatizing the
appearance of the pine.

Schütte's work of the past thirty
years has made him a leader within a
generation of sculptors who have
sought to invest the figurative tradition
with authenticity for the present. Like all
of Schütte's sculpture, the *Krieger* are
timeless and imaginary characters, but
they implicitly address the haunting his-
torical legacy of the twentieth century.

Index of Illustrations

Acknowledgments

The following are gratefully acknowledged for their important contributions to this book.

Project managers
Marisa Beard, David Frankel, Christopher Hudson, Charles Kim, Kara Kirk, Peter Reed, Marc Sapir

Picture selection
Barry Bergdoll, Sabine Breitwieser, Connie Butler, Christophe Cherix, Roxana Marcoci, Sarah Meister, Eva Respini, Rajendra Roy, Ann Temkin

Picture sequence
Mary Lea Bandy, John Elderfield, David Frankel, Beatrice Kernan

Authors
Introduction: Glenn D. Lowry. Architecture and Design: Paola Antonelli, Barry Bergdoll, Bevin Cline, Pedro Gadanho, Juliet Kinchin, Luisa Lorch, Matilda McQuaid, Christopher Mount, Peter Reed, Terence Riley. Drawings: Esther Adler, Mary Chan, Magdalena Dobrowski, Samantha Friedman, Geaninne Guimaraes, Kristin Helmick-Brunet, Laura Hoptman, Jordan Kantor, Ingrid Langston, Angela Meredith-Jones, John Prochilo, Margit Rowell, Rachel Warner. Film: Mary Lea Bandy, Sally Berger, Mary Corliss, John Harris, Jenny He, Steven Higgins, Jytte Jensen, Laurence Kardish, Anne Morra, Josh Siegel, Charles Silver. Media and Performance: Sabine Breitwieser, Martin Hartung, Ana Janevski, Barbara London, Leora Morinis, Erica Papernik, Stephanie Weber. Painting and Sculpture: Doryun Chong, Fereshteh Daftari, Leah Dickerman, David Frankel, Claire Henry, Megan Heuer, Laura Hoptman, Roxana Marcoci, Angela Meredith-Jones, Maria José Montalva, Paulina Pobocha, Kristin Romberg, Ann Temkin, Lilian Tone, Anne Umland. Photography: Marina Chao, Peter Galassi, Lucy Gallun, Susan Kismaric, Roxana Marcoci, Sarah Meister, Eva Respini. Prints and Illustrated Books: Katherine Alcauskas, Kim Conaty, Starr Figura, Judy Hecker, Carol Smith, Sarah Suzuki, Gretchen Wagner

Editors
Harriet Schoenholz Bee, Joanne Greenspun, Cassandra Heliczer, Sarah McFadden, Laura Morris

Photography
Peter Butler, George Calvo, Robert Gebhardt, Thomas Griesel, Kate Keller, Paige Knight, Erik Landsberg, Jonathan Muzikar, Mali Olatunji, John Wronn

Design
Katy Homans, Tina Henderson (typesetting)

Production
Matthew Pimm

Associates
Genevieve Allison, Klaus Biesenbach, Connie Butler, Marina Chao, Leah Dickerman, Starr Figura, Paul Galloway, Lucy Gallun, Blair Hartzell, Jodi Hauptman, Caitlin Kelly, Danielle King, Stephanie Kingpetcharat, Tasha Lutek, Cara Manes, Anne Morra, John Prochilo, Justin Rigby, Ashley Swinnerton, Lilian Tone, Stephanie Weber, Catherine Wheeler, Makiko Wholey, Ashley Young

Photography credits

Individual works of art appearing herein may be protected by copyright in the United States of America, or elsewhere, and may not be reproduced in any form without the permission of the rights holders. The copyright credit lines listed below are in some instances provided at the request of the rights holders. In reproducing the images contained in this publication, the Museum obtained the permission of the rights holders whenever possible. Should the Museum have been unable to locate the rights holder, notwithstanding good-faith efforts, it requests that any contact information concerning such rights holders be forwarded to that they may be contacted for future editions.

The following artists' works in this book are all © 2012 in their own names: Vito Acconci, Robert Adams, Jennifer Allora and Guillermo Calzadilla, Francis Alÿs, El Anatsui, The Atlas Group/Walid Raad, Ay-O (p. 226), Matthew Barney, Hilla Becher, Lee Bontecou, Günter Brus, Daniel Buren, Cai Guo-Qiang, Janet Cardiff, Vija Celmins, Paul Chan, Chuck Close, Philip-Lorca diCorcia, Rineke Dijkstra, Trisha Donnelly, Marlene Dumas, William Eggleston, Olafur Eliasson, Lee Friedlander, Isa Genzken, Andrea Geyer, Robert Gober, Nan Goldin, Dan Graham, Mark Grotjahn, David Hammons, Rachel Harrison, Sharon Hayes, Hans Hollein, Jenny Holzer, Ashley Hunt, Robert Irwin, Sanja Iveković, Joan Jonas, Alex Katz, Ellsworth Kelly, William Kentridge, Alison Knowles (p. 226), Rem Koolhaas, Jeff Koons, Yayoi Kusama, Louise Lawler, Jacob Lawrence, Glenn Ligon, Cildo Meireles, Robert Morris, Bruce Nauman, Cady Noland, Chris Ofili, Claes Oldenburg, Pentagram, Martin Puryear, Charles Ray, Gerhard Richter, Pipilotti Rist, Dorothea Rockburne, Martha Rosler, Edward Ruscha, Robert Ryman, Doris Salcedo, Katya Sander, Richard Sapper, Michael Schmidt, Carolee Schneemann, Richard Serra, Cindy Sherman, Mieko Shiomi (p. 226), Stephen Shore, Michael Snow, Frank Stella, Reiko Sudo, Rirkrit Tiravanija, David Thorne, Shomei Tomatsu, Rosemarie Trockel, Luc Tuymans, Robert Venturi, Kara Walker, Jeff Wall, Carrie Mae Weems, William Wegman, Rachel Whiteread, Jackie Winsor, Christopher Wool, Tadanori Yokoo, Andrea Zittel

The following copyrights are also claimed: © 2012 The Ansel Adams Publishing Rights Trust: p. 150. © 2012 The Josef and Anni Albers Foundation/Artists Rights Society (ARS), New York: p. 107. © Carl Andre/Licensed by VAGA, New York: p. 255. © Aperture Foundation, Inc., Paul Strand Archive: p. 76. © The Estate of Diane Arbus: p. 212. © Archangel 1964: p. 246. © 2012 Artists Rights Society (ARS), New York: pp. 146, 203 241, 251, 259, 271, 276, 283, 290, 315, 329. © 2012 Artists Rights Society (ARS), New York/ADAGP, Paris: pp. 16, 21, 37, 43, 48, 49, 54, 58, 70, 75, 83, 87, 136, 141, 142, 148, 162, 164, 186, 188, 210, 226 (Ben Vautier), 268, 270, 282. © 2012 Artists Rights Society (ARS), New York/ADAGP, Paris/Estate of Marcel Duchamp: p. 71, 73. © 2012 Artists Rights Society (ARS), New York/ADAGP, Paris/FLC: p. 123. © 2012 Artists Rights Society (ARS), New York/Beeldrecht, Amsterdam: p. 69. © 2012 Artists Rights Society (ARS), New York/DACS, London: p. 209. © 2012 Artists Rights Society (ARS), New York/Pro Litteris, Zurich: pp. 42, 131. © 2012 Artists Rights Society (ARS), New York/SABAM, Brussels: pp. 29, 231. © 2012 Artists Rights Society (ARS), New York/SIAE, Rome: pp. 62, 230. © 2012 Artists Rights Society (ARS), New York/VEGAP, Spain: p. 134. © 2012 Artists Rights Society (ARS), New York/VG Bild-Kunst, Bonn: pp. 34, 46, 63, 66, 72, 80, 95, 96, 98, 103, 104, 106, 111, 113, 139, 190, 226 (for George Brecht), 264, 301, 349, 360, 369, 372. © 2012 Estate of Francis Bacon/Romare Bearden Foundation/Licensed by DACS, London: p. 187. © Romare Bearden Foundation/Licensed by VAGA, New York: p. 266. © 2012 Caroline Bos: p. 357. © 2012 Louise Bourgeois Trust: pp. 161, 344. © Estate Brassaï–RMN–Grand Palais: p. 140. © 2012 Estate of Manuel Alvarez Bravo/Artists Rights Society (ARS), New York/ADAGP, Paris: p. 143. © 2012 Burle Marx & Cia. Ltda: p. 191. © 2012 Calder Foundation, New York/Artists Rights Society (ARS), New York: p. 135. © 2012 The Estate of Harry Callahan: p. 178. © 2012 Henri Cartier-Bresson/Magnum Photos: p. 132. © 1981 Center for Creative Photography, Arizona Board of Regents: p. 128. © World of Lygia Clark Cultural Association: p. 62. © Columbia Pictures Corp.: p. 152. © The Joseph and Robert Cornell Memorial Foundation/Licensed by VAGA, New York: 149. © 2012 Salvador Dalí, Gala-Salvador Dalí Foundation/Artists Rights Society (ARS), New York: p. 126. © Estate of Stuart Davis/Licensed by VAGA, New York: p. 158. © 2012 Sherry Turner DeCarava: p. 192. © Dedalus Foundation, Inc./Licensed by VAGA, New York, NY: p. 216. © 2012 The Estate of Richard Diebenkorn: p. 261. TM Marlene Dietrich Collection GmbH, Munich: p. 109. © Disney: pp. 114, 163. © 2012 Walter Evans Archive, The Metropolitan Museum of Art: p. 133. © 2012 VALIE EXPORT/Artists Rights Society (ARS), New York/VBK, Austria: p. 286. © 2012 Harun Farocki Filmproduktion: p. 365. © Fischinger Trust, photo courtesy Fischinger Trust: p. 195. © 2012 Estate of Dan Flavin/Artists Rights Society (ARS), New York: p. 250. © 2012 Estate of Sam Francis/Artists Rights Society (ARS), New York: p. 196. © Robert Frank, from The Americans: p. 200. © 2012 Helen Frankenthaler/Artists Rights Society (ARS), New York: p. 193. © The Lucian Freud Archive: p. 318. © 2012 Ellen Gallagher and Two Palms Press: p. 367. © Gaumont, photo Production Gaumont, 1996: p. 311. © 2012 Fundación Gego: p. 293. © The Felix Gonzalez-Torres Foundation: p. 332. © 2012 Estate of Arshile Gorky/Artists Rights Society (ARS), New York: p. 160. © Estate of George Grosz/Licensed by VAGA, New York: p. 110. © 2012 The Estate of Philip Guston: p. 237. © 2012 C. Herscovici, Brussels/Artists Rights Society (ARS), New York: p. 88. © 2012 Estate of Eva Hesse, Galerie Hauser & Wirth, Zurich: p. 243. © 2012 Hannah Höch/Artists Rights Society (ARS), New York/VG Bild-Kunst, Bonn: p. 97. © 2007 Timothy Hursley: back cover. © International Center of Photography/Magnum Photos: p. 144. © Jasper Johns/Licensed by VAGA, New York: pp. 202, 223. © Judd Foundation/Licensed by VAGA, New York: p. 258. © 2012 Frida Kahlo/Artists Rights Society (ARS), New York/SOMAAP, Mexico: p. 156. © 2012 Estate of Louis I. Kahn: p. 254. © Alex Katz/Licensed by VAGA, New York: p. 238. © 2012 Mike Kelley Foundation for the Arts: p. 310. © 2012 Estate of Martin Kippenberger, Galerie Gisela Capitain, Cologne: p. 323. ©

2012 The Franz Kline Estate/Artists Rights Society (ARS), New York: p. 177. © 2012 The Willem de Kooning Foundation/Artists Rights Society (ARS), New York: p. 180. © Laura Kurgan, Spatial Information Design Lab, GSAPP, Columbia University: p. 362. © L&M SERVICES B.V., The Hague, 20120506: p. 61. © Estate of Helen Levitt: p. 153. © 2012 Sol LeWitt/Artists Rights Society (ARS), New York: p. 244. © Estate of Roy Lichtenstein: p. 208. © 1961 Morris Louis: p. 218. © Billie Maciunas: p. 269. © 2012 Man Ray Trust/Artists Rights Society (ARS), New York/ADAGP, Paris: p. 108. © 2012 Estate of John Marin/Artists Rights Society (ARS), New York: p. 77. © 2012 Estate of Agnes Martin/Artists Rights Society (ARS), New York: p. 240. © 2012 Succession H. Matisse, Paris/Artists Rights Society (ARS), New: pp. 51, 59, 184. © 2012 Estate of Gordon Matta-Clark/Artists Rights Society (ARS), New York: p. 274. © Terry McCoy/McCoy Projects, Inc.: p. 324. © 1980 Metro-Goldwyn-Mayer Studios Inc., all rights reserved: p. 299. © 2012 Microsoft Corporation: p. 348. © 2012 Successió Miró/Artists Rights Society (ARS), New York/ADAGP, Paris: pp. 82, 158. © Estate of Joan Mitchell: p. 197. © 2012 Mondrian/Holtzman Trust c/o HCR International USA: pp. 53, 159. © 2012 The Munch Museum/The Munch-Ellingsen Group/Artists Rights Society (ARS), New York: p. 32. © 2012 Estate of Elizabeth Murray/Artists Rights Society (ARS), New York: p. 303. © 2012 Estate of Louise Nevelson/Artists Rights Society (ARS), New York: p. 194. I ♥ NY used with permission of the NYS Dept. of Economic Development: p. 279. © 2012 Barnett Newman Foundation/Artists Rights Society (ARS), New York: p. 166. © Nolde Stiftung Seebuell: p. 33. © 2012 Projeto Hélio Oiticica: p. 227. © 2012 The Georgia O'Keeffe Foundation/Artists Rights Society (ARS), New York: p. 119. © 1996 Orion Pictures Corporation, all rights reserved: p. 342. © 2012 Estate of Nam June Paik: pp. 226, 289. © 1974 Paramount Corporation: p. 285. © 1933 Paramount Productions, Inc.: p. 124. © 2012 Estate of Pablo Picasso/Artists Rights Society (ARS), New York: pp. 50, 52, 137, 138. © 2012 Estate of Sigmar Polke/Artists Rights Society (ARS), New York/VG Bild-Kunst, Bonn, Germany: p. 295. © 2012 Pollock-Krasner Foundation/Artists Rights Society (ARS), New York: p. 65. © Yvonne Rainer: p. 287. © Robert Rauschenberg Foundation/Licensed by VAGA, New York: pp. 181, 201. © 2012 Estate of Ad Reinhardt/Artists Rights Society (ARS), New York: p. 215. © James Rosenquist/Licensed by VAGA, New York: p. 206. © 2012 Dieter Roth Estate: p. 236. © 1998 Kate Rothko Prizel & Christopher Rothko/Artists Rights Society (ARS), New York: p. 168. © Estate Oskar Schlemmer, Munich: p. 99. © The George and Helen Segal Foundation/Licensed by VAGA, New York: p. 221. © 2012 Gino Severini/Artists Rights Society (ARS), New York/ADAGP, Paris: p. 57. © Estate of Charles Sheeler: p. 122. © 2012 David Alfaro Siqueiros/Artists Rights Society (ARS), New York/SOMAAP, Mexico: p. 147. Art © Estate of David Smith/Licensed by VAGA, New York, NY: p. 175. © 2012 Estate of Tony Smith/Artists Rights Society (ARS), New York: p. 257. © Estate of Robert Smithson/Licensed by VAGA, New York: p. 242. Permission The Estate of Edward Steichen: p. 38. © 2012 Estate of Alfred Stieglitz/Artists Rights Society (ARS), New York: p. 118. © The Clyfford Still Estate: p. 165. © 1937 STUDIOCANAL: p. 112. © 2012 Joaquín Torres-García © 1946 Twentieth Century Fox, all rights reserved: p. 171. © 2012 Cy Twombly Foundation: p. 222. © 1936 Warner Bros.: p. 125; © 1941 Warner Bros.: p. 154; © 1944 Warner Bros.: p. 198; © 1968 Warner Bros.: p. 207; © 1992 Warner Bros.: p. 328; all photos courtesy Warner Bros. © 2012 Andy Warhol Foundation for the Visual Arts/Artists Rights Society (ARS), New York: front cover, pp. 211, 213, 234. © Weegee/International Center of Photography: pp. 155. © 1958 The Charles White Archives: p. 179. © 2012 Marsie, Emanuelle, Damon, and Andrew Scharlatt–Hannah Wilke Collection and Archive, Los Angeles: p. 277. © The Estate of Garry Winogrand, courtesy Fraenkel Gallery: p. 252. © 2012 Frank Lloyd Wright Foundation/Artists Rights Society (ARS), New York: pp/ 68, 81. Photo © 2012 Yi-Chun Wu/The Museum of Modern Art, New York: p. 370. © Andrew Wyeth: p. 336.

The following photographs are by and courtesy: El Anatsui and Jack Shainman Gallery, New York: p. 371. Archive L'Attico: p. 263. Janet Cardiff, Luhring Augustine, New York, and Galerie Barbara Weiss, Berlin: p. 340. Fondation Henri Cartier-Bresson, Paris: p. 132. Corinth Films: pp. 182, 233. Heike Curtze Gallery: p. 308. Electronic Arts Intermix (EAI), New York: p. 276. Fraenkel Gallery, San Francisco: p. 284. Tavia Ito: p. 151. Kadokawawa Shoten Co., Ltd.: p. 176. MGM Media Licensing: pp. 299, 342. New Yorker Films: p. 275. Chris Ofili and David Zwirner, New York: p. 350. Orcutt & Van Der Putten, courtesy Andrea Rosen Gallery, New York: p. 335. Gabriel Orozco and Marian Goodman Gallery, New York: p. 327. P-P-O-W, New York: p. 276. Sonnabend Gallery, New York: p. 249. Matthew Suib: title page, p. 334. Video Data Bank: p. 287. James Welling: p. 129. David Zwirner, New York: p. 331.

The Museum of Modern Art, Department of Imaging and Visual Resources. Photo David Allison: pp. 300, 351. Photo Peter Butler: pp. 29, 138, 226, 269. Photo George Calvo: p. 63. Photo Robert Gerhardt: pp. 34, 98, 201. Photo Thomas Griesel: pp. 23, 24, 26, 37, 43, 51, 54, 57, 61, 62, 87, 101, 110, 117, 123, 134, 173, 179, 181, 197, 227, 236, 255, 272, 291, 301, 310, 317, 319, 326, 340, 341, 344–46, 359, 369. Photo Kate Keller: pp. 56, 62, 66, 72, 82, 83, 131, 136, 156, 158, 208, 253, 261, 313, 315. Photo Paige Knight: pp. 14, 16, 47, 50, 70, 71, 111, 157, 162, 170, 223, 237, 295. Photo Erik Landsberg: pp. 115, 148, 192, 258, 325, 339. Photo Jonathan Muzikar: pp. 40, 52, 53, 102, 144, 159, 206, 220, 230, 242, 271, 290, 296, 316, 320, 327, 330, 333, 337, 343, 354, 362, 363, 365, 371. Photo Mali Olatunji: pp. 84, 149, 187, 210, 228. Photo John Wronn: pp. 21, 22, 25, 27, 36, 38, 41, 46, 48, 58, 60, 65, 67, 73, 75, 81, 96, 97, 106, 122, 126, 130, 135, 137, 142, 143, 146, 153, 160, 165–68, 174, 177, 178, 180, 185, 186, 188, 194, 196, 202, 209, 211, 215, 243, 249, 250, 251, 256, 263, 266, 267, 293, 297, 302, 303, 306, 314, 338, 350, 355, 357, 358, 367, 368, 372

Trustees of The Museum of Modern Art

David Rockefeller*
Honorary Chairman

Ronald S. Lauder
Honorary Chairman

Robert B. Menschel*
Chairman Emeritus

Agnes Gund
President Emerita

Donald B. Marron
President Emeritus

Jerry I. Speyer
Chairman

Marie-Josée Kravis
President

Sid R. Bass
Leon D. Black
Mimi Haas
Richard E. Salomon
Vice Chairmen

Glenn D. Lowry
Director

Richard E. Salomon
Treasurer

James Gara
Assistant Treasurer

Patty Lipshutz
Secretary

Wallis Annenberg
Lin Arison**
Celeste Bartos*
Sid R. Bass
Lawrence B. Benenson
Leon D. Black
Eli Broad*
Clarissa Alcock Bronfman
Patricia Phelps de Cisneros
Mrs. Jan Cowles**
Douglas S. Cramer*
Paula Crown
Lewis B. Cullman**
David Dechman
Glenn Dubin
Joel S. Ehrenkranz*
John Elkann

Laurence Fink
H.R.H. Duke Franz of Bavaria**
Kathleen Fuld
Gianluigi Gabetti*
Howard Gardner
Maurice R. Greenberg**
Anne Dias Griffin
Agnes Gund
Mimi Haas
Alexandra A. Herzan
Marlene Hess
AC Hudgins
Barbara Jakobson*
Werner H. Kramarsky*
Jill Kraus
Marie-Josée Kravis
June Noble Larkin*
Ronald S. Lauder
Thomas H. Lee
Michael Lynne
Donald B. Marron*
Wynton Marsalis**
Robert B. Menschel*
Philip S. Niarchos
James G. Niven
Peter Norton
Maja Oeri
Richard E. Oldenburg**
Michael S. Ovitz
Richard D. Parsons
Peter G. Peterson*
Mrs. Milton Petrie**
Gifford Phillips*
Emily Rauh Pulitzer*
David Rockefeller*
David Rockefeller, Jr.
Sharon Percy Rockefeller
Lord Rogers of Riverside**
Richard E. Salomon
Marcus Samuelsson
Ted Sann**
Anna Marie Shapiro*
Gilbert Silverman**
Anna Deavere Smith
Jerry I. Speyer
Ricardo Steinbruch
Yoshio Taniguchi**
David Teiger**
Eugene V. Thaw**
Jeanne C. Thayer*

Alice M. Tisch
Joan Tisch*
Edgar Wachenheim III
Gary Winnick

Ex Officio

Glenn D. Lowry
Director

Agnes Gund
Chairman of the Board of MoMA PS1

Michael R. Bloomberg
Mayor of the City of New York

Christine C. Quinn
Speaker of the Council of the City of New York

John C. Liu
Comptroller of the City of New York

Sharon Percy Rockefeller
President of The International Council

Christopher Lee Apgar and Franny Heller Zorn
Co-Chairmen of The Contemporary Arts Council

*Life Trustee
**Honorary Trustee